A Garland Series

OUTSTANDING
DISSERTATIONS
IN THE

FINE
ARTS

Girodet-Trioson:
An Iconographical Study

George Levitine

Garland Publishing, Inc., New York & London

1978

All volumes in this series are printed
on acid-free, 250-year-life paper.

Library of Congress Cataloging in Publication Data

Levitine, George.
 Girodet-Trioson : an iconographical study.

 (Outstanding dissertations in the fine arts)
 Originally presented as the author's thesis, Harvard,
1952.
 1. Girodet-Trioson, Anne Louis Girodet de Roussy,
known as, 1767-1824. 2. Neoclassicism (Art)--France.
I. Series.
ND553.G6L48 1978 759.4 77-94702
ISBN 0-8240-3235-7

Printed in the United States of America

INTRODUCTORY NOTE - 1978

The historical image of an artist--any artist--is constantly
affected by the capricious meandering of the perspective of time.
Things change. At the risk of appearing equally trite, one can
safely add that, in the light of the critical and biographical
writings of the last three or four centuries, the image of
virtually every known artist has been shaped and re-shaped from
one scholar to another, and from one "scholarly period" to
another. The latter term probably offers the most useful
guide mark for such changes, since it evokes the unavoidably
episodic nature of scholars' activity. Admittedly, we are
speaking here of a very fluid concept; and, in this regard,
it might be pointed out that the chronological limits of any
given "scholarly period" are particularly difficult to establish,
as they are linked to such notions as cultural climate, popular
taste, history of scholarship, and, to put it bluntly, scholarly
fashions.

Despite this fluidity, a "scholarly period" is an undeniable
and recognizable fact: I am certainly aware that the twenty-six
years span, that separates this Introductory Note (1978) from
my original thesis (1952), represents a considerable volume of
water under the bridge. It washed away the vestiges of more
than one "period" of this kind. I am also fully aware that this
passage of time is especially significant in the study of a painter,

like Anne-Louis Girodet-Trioson, whose personality and works
emerged to comparatively recent scholarly prominence after
some one hundred and thirty odd years of clichés-studded neglect.
I must admit that one cannot solely rely in such circumstances on
the concept of a changing image, modeled by a succession of
"scholarly periods." It is evident that, in the case of this
artist, it is equally necessary to take into account the
growing mass of factual information accumulated by scholars
who came to be attracted by what increasingly began to appear
as an interesting and important subject of study.

Today, Girodet is most definitely in, a fact which is
colored with a touch of poetic justice. Actually, I am nursing
very personal feelings in this matter. I have good reasons to
vividly remember the occasion, at the time I was working on my
thesis, when a prominent Curator of the Louvre Museum told me
that "Girodet n'est pas à la mode!" Some clarification is probably
in order. Independently of the present most conspicuously
widespread acknowledgment of Girodet's talent and originality,
it is quite manifest that this painter's regained celebrity is
linked to the scholars' prevailing fascination with French
Neo-Classical art and the related problems of Pre-Romanticism.
This assertion can be easily corroborated by recalling the number
and the success of recent exhibitions such as Dessins français de
1750 à 1825 dans les collections du musée du Louvre; le néo-
classicisme (1972);[1] Autour du néo-classicisme (1973);[2] Ossian
(1974);[3] and Le néo-classicisme français; dessins des musées de
province (1974-1975).[4] One must, of course, underline the

particular importance of two, truly monumental shows: The Age
of Neo-Classicism (1972)[5] and French Painting 1774-1830: The
Age of Revolution (1975).[6]

Needless to say, all of these exhibitions included some
examples of Girodet's art, and their catalogues made available
seriously documented entries related to these works. However,
above all, our knowledge of the painter was, somewhat earlier
(1967), enhanced by an exhibition felicitously organized by
the Musée de Montargis on the occasion of the bicentennial of
his birth: Girodet, 1767-1824. This exhibition, held in the
artist's native town, was exclusively devoted to him; and, I am
happy to note that it succeeded in resurrecting a number of his
productions that I was not in a position to see at the time I
was preparing my thesis. In my defense, I am taking the liberty
to mention that most of these particular productions were, and
still are, in private collections inaccessible to graduate
students. This is the case, for instance, of the famous
Pygmalion and Galatea, some portraits of Girodet's family, two
beautiful landscapes representing respectively a view of the
region of Naples and an eruption of Vesuvius, and several important
drawings. The brief catalogue of this aptly organized exhibition
is a valuable tool. Written with great clarity by Madame
Jacqueline Pruvost-Auzas, the late Conservateur of the Musée de
Montargis, this booklet offers a succinct, but precise chronological
account of the artist's life, abundant documentation, and an
excellent bibliography.

Most of the other recent studies are less comprehensive in scope. They address themselves to a small group of Girodet's works, or even only to a single production; in other cases, they consider a limited aspect of the artist's style or career. A few specific examples can characterize the orientation adopted by these studies. A small number of them make a straightforward factual contribution to the field. For instance, in his "Girodet et Fabre; camarades d'atelier,"[8] Philippe Bordes introduces some peripheral, but interesting data related to Girodet's career. Other scholars, concerned with some aspects of the stylistic unity of the period, project a particular Girodet problem into a more general context. This is the case, for example, of J.J.L. Whiteley's "Light and Shade in French Neo-Classicism."[9] The approach of this interesting article brings it very closely to the consideration of the same problem in my doctoral thesis (a consideration which, of course, is focused on Girodet). It may be observed parenthetically that J.J.L. Whiteley, who apparently did not have the opportunity to read my doctoral dissertation, would undoubtedly have pursued his important investigation even further if he had not been forced to rebuild an already existing foundation.

Naturally, it would have been vain to expect a total concurrence with the points of view expressed in my thesis from my fellow scholars. Thus, in his "An Early Romantic Polemic: Girodet and Milton,"[10] James Henry Rubin shows some awareness of my thesis treatment of the problem of Girodet's Deluge, but he chooses nevertheless to advance a different hypothesis.

While I disagree with his interpretation, I certainly admire
the imagination and the scholarship displayed in his article.
I should only like to note my disappointment at the fact that
he did not read my own re-evaluation of this question, in
"Some Unexplored Aspects of the Illustrations of Atala: The
surenchères visuelles of Girodet and Hersent,"[11] before com-
mitting himself to his position. Naturally, this is no longer a
question of my doctoral thesis per se.

The present Introductory Note is not an arena, and I should
like to keep it free from one-sided argumentativeness. I must
confess, nevertheless, that it has become very difficult for me
to preserve my scholarly equanimity in the case of a recent
publication which gave some new life to a very old, politically
oriented, and totally erroneous interpretation (which should
have been put to rest long ago). In such a situation--I am
referring to Louis Aragon's partisan explanation of the eagle
depicted in Girodet's Ossian, which was exhumed in one of the
entries of the catalogue of the Ossian exhibition--I felt that it
was indispensable to elucidate the matter. Since the author of
the entry placed my interpretation of this question, found in
my thesis and further developed in my "L'Ossian de Girodet et
l'actualité politique sous le Consulat,"[12] in parallel with that
of Aragon, I was compelled to write another article devoted to the
problem. This is the reason behind my "L'aigle épouvanté de
'l'Ossian' de Girodet et l'aigle effrayée du Mausolée de
Turenne:"[13] I do hope that this problem is clarified once and
for all.

Everything being taken into account, my personal agreement or disagreement in the matter of "Girodet's eagle" is of secondary importance. One must keep in mind that this case is only one of several other "Girodet controversies," involving the previously mentioned cases of his Ossian, and his Deluge, the dating of his drawings, and several other related topics (as a rule, these differences of opinion are kept on a very high scholarly level). At any rate, such controversies as well as the proliferation of publications inspired by the painter clearly point to the vitality of the subject. Exciting or controversial, these publications suggest to me that, among many other factors, my old-established interest might have played some role in stirring a renewed vigor of Girodet research in the midst of our scholarly tribe. Whatever their focus and scope, these publications enrich the field of Girodet study and embody a promise: they are all welcome!

It would be futile to claim that, after twenty-six years, my thesis could hold an answer to all the Girodet problems. In fact, my "Quelques aspects peu connus de Girodet,"[14] "Girodet's New Danaë: The Iconography of a Scandal,"[15] as well as the several other, already mentioned, of my articles devoted to the painter--written after 1952--vouch for my awareness that my doctoral thesis should be viewed as a pioneering effort, only a beginning. Nevertheless, I must admit that, until now, I have failed to discover any serious reasons to change radically the direction of my thinking about Girodet. Perhaps I am too presumptuous, but I am tempted to believe that my thesis could

provide some elements of a foundation, perhaps even a springboard for the many scholars who are already sharing, or will share, my interest in the painter.

During recent years, I have been approached, with an increasing frequency, by a number of people (established scholars as well as students) who queried me about the contents of my thesis. It was obviously very difficult for me to answer every question put to me in an appropriately detailed manner, and, for this reason, I am truly delighted that the results of my early research are now made available to anyone who wishes to consult this publication. I should only like to express the hope that the present reproduction of my thesis will be understood and used for what it is: a doctoral dissertation--with all its imperfections--written twenty-six years ago.

The Institute for Advanced Study,
Princeton, New Jersey
January 1978.

FOOTNOTES

1. Louvre, Paris, 1972.

2. Galerie Cailleux, Paris, 1973.

3. Grand Palais, Paris, and Kunsthalle, Hamburg, 1974.

4. Grand Palais, Paris, and Copenhagen, 1974-1975.

5. Royal Academy and Victoria and Albert Museum, London, 1972.

6. Grand Palais, Paris, The Detroit Institute of Arts, and
 The Metropolitan Museum of Art, New York, 1975.

7. Girodet, 1767-1824; Exposition du deuxième centenaire,
 Musée de Montargis, 1967, with a Préface by Michel Laclotte
 and an Avant-propos by Jacqueline Pruvost-Auzas.

8. La Revue du Louvre et des musées de France, 1974, 1,
 pp. 393-399.

9. The Burlington Magazine, December 1975, pp. 768-773.

10. The Art Quarterly, XXXV, 3, 1972, pp. 210-238.

11. Chateaubriand, Proceedings of the Commemoration of the
 Bicentenary of the Birth of Chateaubriand, 1968, Richard
 Switzer ed., Geneva, Droz, 1970, pp. 139-145.

12. Gazette des Beaux-Arts, October 1956, pp. 39-56.

13. Gazette des Beux-Arts, December 1974, pp. 319-323.

14. Gazette des Beaux-Arts, April 1965, pp. 231-246.

15. The Minneapolis Institute of Arts Bulletin, LVIII, 1969,
 pp. 69-77.

GIRODET-TRIOSON, AN ICONOGRAPHICAL STUDY

by

George Levitine

Thesis submitted in partial fulfillment of the
requirements for the degree of
Doctor of Philosophy

Department of Fine Arts
Harvard University
Cambridge, Massachusetts

May 1, 1952

TO MY WIFE

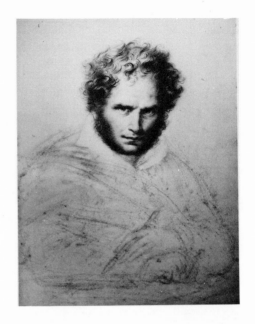

a

b

c

TABLE OF CONTENTS

Page

LIST OF ILLUSTRATIONS ii

INTRODUCTION. viii

CHAPTER I. Prix de Rome and Classical History . . . 1

CHAPTER II. Early Religious Painting 73

CHAPTER III. Early Mythological Painting. 94

CHAPTER IV. La Grande Manière. 223

CHAPTER V. Portraits. 301

CHAPTER VI. Landscape. 335

CHAPTER VII. Last Years: Minor Productions and
 Late Classical Themes 358

CONCLUSION. 398

BIBLIOGRAPHY. 407

LIST OF ILLUSTRATIONS

Frontispiece: a. Girodet, Self-portrait, Orléans, Drawing.
 b. Girodet, Letter to Gros, Amiens, Maignan Collection.
 c. Brushes having belonged to Girodet, Amiens, Maignan Collection.

1. Girodet, Montargis Castle, Museum of Montargis, Drawing.

2. Girodet, Horatius Killing His Sister, Museum of Montargis, Painting.

3. Girodet, Death of Tatius, Museum of Angers, Painting.

4. Girodet, Joseph Making Himself Known to his Brothers, Paris, Ecole des Beaux-Arts, Painting.

5. Girodet, Joseph Making Himself Known to his Brothers, Museum of Montargis, Drawing.

6. Girodet, Hippocrates Refusing the Presents of Artaxerxes, Paris Ecole de Médecine, Painting.

7. Girodet, Hippocrates Refusing the Presents of Artaxerxes, Paris, Ecole des Beaux-Arts, Drawing.

8. Girodet, Hippocrates Refusing the Presents of Artaxerxes, Bayonne, Bonnat Museum, Drawing.

9. Girodet, Hippocrates Refusing the Presents of Artaxerxes, Montpellier, Fabre Museum, Painting.

10. Girodet, Caricatures from the Carnet de Rome, Paris, Bibliothèque Nationale, Cabinet des Estampes, Drawing.

11. Girodet, Pietà, Montpellier, Fabre Museum, Painting.

12. Girodet, Pietà, Church of Montesquieu-Volvestre (Haute-Garonne), Painting.

13. Girodet, Democritus, Montpellier, Fabre Museum, Painting.

14. Girodet, The Sleep of Endymion, Paris, Louvre, Painting.

15. Raphael, Jacob's Ladder, Vatican, Painting.

16. Girodet, Spring, Engraved by Lingée.

17. Girodet, Summer, Engraved by Lingée.

18. Girodet, Autumn, Engraved by Lingée.

19. Girodet, Winter, Engraved by Lingée.

20. Percier and Fontaine, View of the Gabinete de Platina, Aranjuez, Engraving.

21. Girodet, Spring, Château de Compiègne, Painting.

22. Girodet, Summer, Château de Compiègne, Painting.

23. Girodet, Autumn, Château de Compiègne, Painting.

24. Girodet, Winter, Château de Compiègne, Painting.

25. Girodet, The First Danaë, Leipzig, Painting, Lithographed by Aubry-Lecomte.

26. Girodet, The New Danaë, New York, Wildenstein Gallery, Painting.

27. Les Inséparables.

28. St. V., La Moderne Danaë ou La Maîtresse à la mode.

29. Girodet, Ossian, Château de La Malmaison, Painting.

30. Girodet, Ossian, detail, Lithographed by Aubry-Lecomte.

31. Girodet, Ossian, detail, Lithographed by Aubry-Lecomte.

32. Girodet, Ossian, Paris, Louvre, Painting.

33. Girodet, Ariadne, Paris, Dreyfus Collection, Painting.

34. Girodet, Nymph, Nice, Musée Chéret, Painting, Lithographed by Aubry-Lecomte.

35. Girodet, The First Exploit of Ascanius, Engraving.

36. Girodet, The Arrival of Aeneas at Latium, Montpellier, Fabre Museum, Drawing.

37. Girodet, The Manes of Aeneas, Engraved by Godefroy.

38. Girodet, Illustration from Didot's edition of Racine's Works, Phèdre, Acte II, Scene V, Engraved by Massard.

39. Girodet, Phaedrae and Oenone, Museum of Lyon, Painting.

40. Girodet, Antiochus and Stratonice, Bayonne, Bonnat Museum, Drawing.

41. Girodet (?), Le Grand chiffonnier-critique.

42. Girodet, Scene of a Deluge, Paris, Louvre, Painting.

43. Girodet, Scene of a Deluge, Carnet de Rome, Paris, Bibliothèque Nationale, Cabinet des Estampes, Drawing.

44. Girodet, Scene of a Deluge, Carnet de Rome, Paris, Bibliothèque Nationale, Cabinet des Estampes, Drawing.

45. Girodet, Scene of a Deluge, Delamarre Collection, Painting.

46. Girodet, Scene of a Deluge, Montpellier, Fabre Museum, Drawing.

47. Regnault, Deluge, Painting, Engraved by Normand.

48. Clodion, Deluge, Sculpture, Engraved by Normand.

49. Girodet, The Entombment of Atala, Paris, Louvre, Painting.

50. Girodet, Studies for the Entombment of Atala, Museum of Besançon, Drawing.

51. Girodet, The Entombment of Atala, Angers, Turpin de Crissé Museum, Drawing.

52. Girodet, Paul et Virginie, Drawing, Engraved by B. Roger.

53. Gautherot, The Funeral Procession of Atalan, Painting, Engraved by Normand.

54. Lordon, The Last Communion of Atala, Painting, Engraved by Lingée.

55. Girodet, Napoleon Receiving the Keys of Vienna, Versailles, Painting.

56. Girodet, The Rebellion of Cairo, Versailles, Painting.

57. Girodet, Study for one of the figures of The Rebellion of Cairo, Paris, Louvre, Pastel.

58. Girodet, Portrait of Gérard, Drawing, Engraved by François Girard.

59. Girodet, Portrait of Dr. Trioson, Museum of Montargis, Painting.

60. Fragonard, Inspiration, Paris, Louvre, Painting.

61. David, Portrait of Lavoisier, Rockefeller Collection, Painting.

62. Girodet, Portrait of Guiseppe Favrega, Marseille, Painting.

63. Girodet, Portrait of Raymond de Sèze, De Sèze Collection, Painting.

64. Girodet, Portrait of Bougeon, Chaix d'Est-Ange Collection, Painting.

65. Girodet, Portrait of J.-J. Belley, Versailles, Painting.

66. Girodet, Portrait of Chateaubriand, Versailles, Painting.

67. Girodet, Portrait of Charles de Bonchamps, Museum of Cholet, Engraving.

68. Girodet, Portrait of Cathelineau, Museum of Cholet, Engraving.

69. Girodet, Portrait of Raphael, Drawing, Lithographed by Sudre.

70. Girodet, Portrait of Michelangelo, Drawing, Lithographed by Sudre.

71. Girodet, Studies of Napoleon's Head, Drawing, Reproduced by Maile.

72. Girodet, Portrait of Canova, Paris, Louvre, Drawing.

73. Girodet, Portrait of Firmin Didot, Paris, Louvre, Drawing.

74. Girodet, Portrait of Napoleon, Bourges, Painting.

75. Girodet, Portrait of Charles Bonaparte, Versailles, Painting.

76. Girodet, Portrait of Larrey, Paris, Louvre, Painting.

77. Girodet, Portrait of Queen Hortense, Montargis, Filleuil Collection, Painting.

78. Girodet, Portrait of Madame de Prony, Museum of Orléans, Painting.

79. Girodet, Portrait of Madame de Prony, Painting, Lithographed by Aubry-Lecomte.

80. Girodet, Portrait of a Young Girl, Museum of Besançon, Drawing.

81. Girodet, Portrait of Romainville Trioson, Montargis, Private Collection, Painting.

82. Chardin, The House of Cards, Washington, D.C., National Gallery, Painting.

83. Girodet, Portrait of Romainville Trioson, Montargis, Filleuil Collection, Painting.

84. Girodet, Portrait of Romainville Trioson, Detail, Montargis, Filleuil Collection, Painting.

85. Girodet, Self-Portrait, Versailles, Painting.

86. Girodet, Self-Portrait, Dijon, Magnin Museum, Painting.

87. Girodet, Dr. Trioson Giving a Lesson of Geography to his Son, Itasse Collection, Painting.

88. Girodet, Landscape with a Snake, Dijon, Magnin Museum, Drawing.

89. Girodet, Italian Landscape, Dijon, Magnin Museum, Painting.

90. Girodet, A Lake in the Mountains, Dijon, Magnin Museum, Painting.

91. Girodet, The Torrent, Dijon, Magnin Museum, Painting.

92. Girodet, Landscape, Carnet de Rome, Paris, Bibliothèque Nationale, Cabinet des Estampes, Drawing.

93. Girodet, Landscape, Carnet de Rome, Paris, Bibliothèque Nationale, Cabinet des Estampes, Drawing.

94. Girodet, Mountainous Seashore at the End of the Day, Dijon, Magnin Museum, Wash Drawing.

95. Girodet, Landscape, Carnet de Rome, Paris, Bibliothèque Nationale, Cabinet des Estampes, Drawing.

96. Girodet, Landscape, Carnet de Rome, Paris, Bibliothèque Nationale, Cabinet des Estampes, Drawing.

97. Girodet, Odalisque, Painting, lithographed by Aubry-Lecomte.

98. Girodet, Odalisque, Montargis, Filleuil Collection, Painting.

99. Girodet, Genius of Greece, Drawing, Engraved by Muller.

100. Girodet, Turk, Museum of Avignon, Painting.

101. Girodet, Janizary, Paris, Louvre, Pastel.

102. Girodet, The Legend of the Dog of Montargis, Museum of Montargis, Drawing.

103. Girodet, Illustration from Bathilde reine des Francs, Drawing, Engraved by B. Roger.

104. Girodet, Illustration from Bathilde reine des Francs, Drawing, Engraved by Pigeot.

105. Girodet, Frontispiece from Agnès de France ou Le XIIeme siècle, Drawing, Engraved by P. Adam.

106. Girodet, An Atelier of the Renaissance, formerly in Compiègne, Vivenel Museum, Drawing.

107. Girodet, Raphael Painting Amidst his Pupils, Montpellier, Fabre Museum, Drawing.

108. Girodet, Michelangelo Taking Care of his Sick Servant, Montpellier, Fabre Museum, Drawing.

109. Girodet, Dante Swooning in the Arms of Virgil upon Seeing the Torments of Paolo and Francesca, Montpellier, Fabre Museum, Painting.

110. Girodet, Apparition of the Ancestors of Abdalonymus, Dijon, Magnin Museum, Painting.

111. Girodet, The Virgin, Painting, Engraved by Normand.

112. Girodet, The Seven Chiefs Against Thebes, Bayonne, Bonnat Museum, Painting.

113. Girodet, The Seven Chiefs Against Thebes, Drawing, Lithographed by Aubry-Lecomte.

114. Girodet, Apelles and Campaspe, Drawing, Engraved by Bein.

115. Girodet, The Departure of the Warrior, Château de Compiègne, Painting.

116. Girodet, The Combat of the Warrior, Château de Compiègne, Painting.

117. Girodet, The Triumph of the Warrior, Château de Compiègne, Painting.

118. Girodet, The Return of the Warrior, Château de Compiègne, Painting.

119. Girodet, Anacreon and a Young Girl in a Grotto, Montpellier, Fabre Museum, Painting.

120. Girodet, Dibutades, Drawing, Engraved by Henriquel Dupont.

121. Girodet, The Birth of Venus, Paris, Louvre, Drawing.

122. Girodet, Tithonus and Aurora, Château de Compiègne, Painting.

123. Girodet, Dance of the Graces, Château de Compiègne, Painting.

124. Girodet, Dance of the Nymphs, Château de Compiègne, Painting.

125. Girodet, Pygmalion and Galatea, Painting, Engraved by Normand.

126. Girodet, Pygmalion and Galatea, Painting, Engraved by Mansard.

127. Girodet, Study for Pygmalion and Galatea, Museum of Orléans.

128. Girodet, Study for Pygmalion and Galatea, Museum of Orléans.

129. C'est à tort qu'on croirait qu'il prend la mouche, Paris, Bibliothèque Nationale, Cabinet des Estampes, Drawing.

Tailpiece: Caricature-Medallion of Girodet, Drawing.

INTRODUCTION

INTRODUCTION

The purpose of the present thesis is to consider the iconography of the works of Anne-Louis Girodet-Trioson[1] (1767-1824) in the light of the contemporary cultural background and of the biography of the artist. This study does not intend to depict Girodet as a forgotten great artist. His name has seldom been omitted from histories of French art, and some of his major paintings have received an honorable place in the Louvre. However, these signs of apparent recognition do not mitigate the deep neglect of the painter by the art historians. Moreover, under the influence of the prolonged disfavor surrounding the French Neo-Classical period, his personality and his contribution have often been blurred or distorted. Astonishingly enough, only two books, Coupin's OEuvres posthumes de Girodet-Trioson[2]

1. The name of Trioson was added only after the painter's adoption by Dr. Trioson.
2. Girodet-Trioson, OEuvres posthumes, P. A. Coupin ed., Paris, Renouard, 1829, 2 vols. The publication of Girodet's own writings was the primary aim of Coupin. His personal comments on the painter, found in his Notice historique and in his Notes, form a very small part of the first of the two volumes.

and Leroy's <u>Girodet-Trioson, peintre d'histoire</u>,[1] were ever
exclusively devoted to the artist. Their dates of publica-
tion, the former in 1829 and the latter in 1892, are signi-
ficant in themselves. While including a great number of
documentary data and interesting biographical anecdotes,
these works cannot be considered serious attempts at critical
analysis. Furthermore, aside from these books few articles
of any importance were published on Girodet. The limited
scope of these articles did not allow their authors to con-
sider any of the basic problems suggested by Girodet's works.
The writers seldom avoided the tendency to reduce the painter's
individuality to a series of stereotyped ideas, based on the
vague concepts of Neo-Classicism or Pre-Romanticism. Thus,
the best study of Girodet's art is still the four pages
found in Bonoit's <u>L'Art français sous la Révolution et l'Em-
pire</u>, published in 1897.[2]

The general lack of interest in Girodet by learned
criticism is difficult to understand. One must admit that
the painter's <u>machines</u> exhibited in the Louvre do show a
monotonous finish and a glacial quality which probably dis-
couraged the investigation of generations of scholars. Yet,
less conspicuous works, in the Louvre, in Montpellier, Bayonne,
Orléans, and in various private collections, reveal a surprising

1. Leroy, A., <u>Girodet-Trioson, peintre d'histoire</u>, 2 ed.,
Orléans, Herluison, 1892.
2. Benoit, François, <u>L'Art français sous la Révolution
et l'Empire</u>, Paris, Henry May, 1897, pp. 318-323.

pictorial animation which should have commanded the attention
of modern students. The intriguing iconography of other
paintings, such as The New Danaë and Ossian, should also
have warranted their study. Moreover, their interest should
have been awakened by the very versatility and sensitiveness
of Girodet's character: his intense intellectual curiosity,
his fervent awareness of all the contemporary cultural cur-
rents, and his literary productivity, were unparalleled by
any French painter of his time. It is sufficient to open
at random the volumes of his OEuvres posthumes to discover,
amidst the usual pious affirmations of classical conformity,
a series of startlingly rebellious statements which one
would never have thought possible from a pupil of David.
What other Neo-Classical artist would ever have written:
". . . in choosing between two defects . . . I prefer the
bizarre to the dull"? Finally, one cannot but wonder at the
fact that Girodet's pathetic personality, which attracted the
sympathetic interest of Vigny and Balzac, and his life, full
of Cellini-like incidents, notorious scandals, bitter polem-
ics, and ending in a monumental isolation, failed to inspire
any serious biography, in spite of

In his Histoire de la peinture en Italie, Stendhal
isolated Prud'hon and Girodet from other contemporary
painters by placing both of them in the same, unique cate-
gory.[1] Nothing can better reflect the aura of originality

1. Stendhal, Histoire de la peinture en Italie, Paris,
Le Divan, 1929, I, p. 324, note 1.

which surrounded the name of Girodet during his lifetime.
He was undoubtedly one of the most independent artists of
the Davidian circle. Yet, this quality in itself is not
the principal source of his historical significance. The
unorthodoxy of his ideas is less important than the fact
that they vividly reflect the character of the then current
cultural trends. It must be said that the atmosphere of the
period of the Revolution and the Empire was extremely com-
plex. The Davidian school, or, more exactly, its ideological
crystallisation in the writings of the neo-classical theorists
like Quatremère de Quincy, was basically an artificial phen-
omenon having very little direct bearing on the deep emotional
upheavals of these years. To be convinced of this fact, it
is sufficient to compare Benoit's L'Art français sous la Ré-
volution et l'Empire[1] with Monglond's Le Préromantisme fran-
çais,[2] or Viatte's Les Sources occultes du Romantisme.[3] The
same period is in turn characterized as classical, Pre-
Romantic, and esoteric. Considering the diversity of the age,
Girodet was infinitely more representative than David, Gros,
or Prud'hon, because his extreme sensitivity, his scholarly
attitude, his contempt for what he called "execution manu-
elle,"[4] and his efforts to approach painting from a purely

1. Op. cit.
2. Monglond, André, Le Préromantisme français, Grenoble,
Arthaud, 1930, 2 vols.
3. Viatte, Auguste, Les Sources occultes du Romantisme,
Paris, Champion, 1928, 2 vols.
4. Girodet, OEuvres posthumes, op. cit., II, Correspondance,
Letter III, to Bernardin de Saint-Pierre, p. 275.

literary point of view, enabled him to grasp the multiplicity
of the tendencies which were only partially expressed by
the other artists.

This particular capacity of Girodet to reflect the
cultural and emotional currents of his period is the prin-
cipal subject of the present thesis. Its aim precludes an
exhaustive analysis or an all-inclusive survey of the painter's
works. Any pretension to completeness would be vain in view
of the numerous losses, and the present dispersion of the
artist's productions, as well as the prolonged confusion
surrounding them. In spite of their potential interest, it
was necessary to sacrifice the consideration of doubtful
works[1] and to base this study only on fully documented or
unquestionably authenticated productions. Moreover, in
order to limit the scope of this thesis, it was necessary to
emphasize the major aspect of Girodet's contribution, his
iconography, and to give less consideration to other ques-
tions, such as those involving technique or style. The study
of Girodet's iconography required, on the one hand, the dis-
cussion of minute problems relative to individual works, and,
on the other, the development of these problems in relation
to the painter's biography and to the general contemporary

1. Such as Daphnis and Chloe in Nice, the Death of Malvina
at Varzy, and the portrait of Murat in the Ganay collection,
the attribution of which to Girodet rested on superficial
resemblance, unverified tradition, or a doubtful signature.
In general, the question of authorship will not be discussed
in this study.

cultural background. It has been frequently and justly
pointed out that Girodet's art had an historical significance
as one of the intellectual links between the period of Louis
XVI and that of Romanticism. This transitional importance
of Girodet made it necessary for this study to follow a
chronological pattern as closely as possible. The considera-
tion of the evolution of Girodet's iconography was facilitated
by the successive shifts of the painter's interest from one
type of iconographical theme to another. In spite of a num-
ber of exceptions, this sequence can be followed in the major
works of the artist, and it will be respected insofar as it
does not obscure the basic problems involved in Girodet's art.

I wish to express my great appreciation for the help
and advice which I received from the members of the Depart-
ment of Fine Arts of Harvard University, especially Miss
Agnes Mongan, Dr. Wilhelm R. Koehler, and Dr. Charles L. Kuhn.
I feel particularly indebted and deeply grateful for the con-
stant and invaluable assistance so generously given to me by
Dr. Frederick B. Deknatel.

CHAPTER I

PRIX DE ROME AND CLASSICAL HISTORY

CHAPTER I

PRIX DE ROME AND CLASSICAL HISTORY

Girodet's historical paintings form a group which reflects his earliest artistic efforts. This group is composed of four major works, executed between 1785 and 1792:

Horatius Killing his Sister[1] (fig. 2)

Death of Tatius[2] (fig. 3)

Joseph Making Himself Known to his Brothers[3] (fig. 4)

Hippocrates Refusing the Presents of Artaxerxes[4] (fig. 6).

In the study of this phase of Girodet's activity, one must consider the following questions:

I. The early years of the painter's life and his relations to the atelier of David.

II. Girodet's interpretation of historical and archaeological data.

III. Girodet's interpretation of the human figure as a medium of expression.

I. During these years, Girodet, studying in the

1. 1785, Museum of Montargis.
2. 1788, Museum of Angers.
3. 1789, Ecole des Beaux-Arts, Paris.
4. 1792, Ecole de Médecine, Paris.

atelier of David, acquired the basic elements of his artistic
education. His close collaboration with his teacher is fully
reflected in his early paintings, which justify more than any
others of his works his character as a Davidian. However,
already in this period of his life, one can note the affirma-
tion of his personality and the first signs of his striving
for independence.

II. In the paintings of this period, Girodet's attitude
toward the current emphasis on historical accuracy in art,
can be seen in a parallel development of two contrasting
trends. On the one hand, Girodet believed that a painter did
not have to follow his sources literally, and he himself
never hesitated to freely reinterpret history; on the other,
he showed an almost pedantic predilection for archaeological
exactness of details. These details, and practically all the
accessories of Girodet's paintings, were organized into a
coherent system of allusions centered around the major theme
of the subject. Finally, the content of these paintings,
like the great majority of the works of the period, stressed
the patriotic and moral lessons which could be derived from
antiquity.

III. Nevertheless, in the productions of this period,
Girodet gave the major role to the human figure. From the
earliest work of the group, <u>Horatius Killing his Sister</u> (fig.
2), to the latest, <u>Hippocrates Refusing the Presents of Arta-
xerxes</u> (fig. 6), the painter, through the study of gestures

and of facial expressions, attempted to convey what his con-
temporaries called the "sentiments of the soul."[1] Girodet's
interpretation of these "sentiments of the soul" seems to
have evolved toward a greater complexity, from a concept of
abstract emotion to one of character.

1. <u>Infra</u>, pp. 30 ff.

I.

GIRODET IN THE ATELIER OF DAVID

Anne-Louis Girodet de Roussy was born on January 5,
1767 in Montargis, a small town of the Orléanais, approxi-
mately one hundred miles south of Paris. Girodet's birth-
place had always been known for its fifteenth-century royal
castle (fig. 1) (destroyed during the Revolution), its oaks
planted by Sully, and the legend of its heroic dog, the vic-
tor of a famous medieval jugement de Dieu. In his later
years, the artist dedicated a sentimental passage of his poem
Le Peintre to the Sweet land where my eyes opened to light. [1]
However, during his youth, Girodet seems to have resented the
provincial atmosphere of Montargis, which he described in one
of his early letters as "the extinguisher of genius and of
talent."[2] Girodet's parents were related to the Becquerels,
the well-known family of scientists.[3] The painter's father,
Antoine-Florent Girodet, was a well-to-do directeur des
domaines of the Duke of Orléans, and his mother, Anne-Angé-
lique Cornier du Colombier, was the daughter of an

1. Girodet, OEuvres posthumes, op. cit., II, Le Peintre,
Chant II, p. 82.
2. Bellevue, Count X. de, ed., Lettres inédites du peintre
Girodet-Trioson, de Suvée, et du Général Gudin à Ange-René
Ravault, peintre, graveur et lithographe de Montargis, Letter
of Girodet to Ravault, Paris, March 25, 1789.
3. Pommier, "Notes sur des manuscrits et lettres autographes
du peintre Girodet," Bulletin historique et philologique du
Comité des travaux historiques et scientifiques, Paris, Impr.
Nationale, 1908, p. 355.
4. Girodet, OEuvres posthumes, op. cit., I, Notice his-
torique by Coupin, p. 1.

expéditionnaire at the Papal Court.[1] The death of Girodet's
parents left him an orphan at a very early age.[2] However,
his inheritance, plus the help of his foster father, Dr.
Trioson, who was the consultant of Mesdames[3] and the official
physician of the Camps et Armées de France,[4] insured the
financial security of the artist throughout his life.

The young Girodet was sent to Paris, where he com-
pleted his secondary education and received a solid back-
ground in the humanities.[5] Even during these early studies,
he seems to have shown an inclination for both poetry and
drawing; however, in the end, "letters gave way to art.[6]
Girodet's early taste for painting is suggested in Le Peintre,
in which he probably portrayed himself when he described the
beginnings of a child-artist, painting with brushes made of
chalk and coal prepared in secret," and using his desk as a
palette.[7] A great variety of subjects attracted his interest.
He painted all that struck him," all that his eyes distin-
guished "from the crowd."[8] Thus, a "fiery courser" seems to

1. Stenger, Gilbert, La Société française pendant le Con-
sulat, 5e série, Les Beaux-Arts, La Gastronomie, Paris, Perrin
and Cie., 1907, p. 109.
2. After the death of his father, Girodet lost his mother
in 1787 (Pommier, op. cit., p. 355).
3. Girodet, OEuvres posthumes, op. cit., I, Notice his-
torique by Coupin, p. vij.
4. This title appears in an engraving of Girodet's Endymion
by Châtillon (1810), which was dedicated to Dr. Trioson.
5. Girodet, OEuvres posthumes, op. cit., I, Notice Histo-
rique by Coupin, p. 1; Quatremère de Quincy, Recueil de notices
Historiques, Paris, A. Le Clere, 1834, Eloge Historique de M.
Girodet, p. 309.
6. Quatremère, op. cit., p. 310.
7. Girodet, OEuvres posthumes, op. cit., I, Le Peintre,
Chant I, p. 55.
8. Idem., p. 54.

have excited his imagination as much as a "crumbling bridge" or a "grotesque face."[1] At the end of his career, the painter came to look at these 'crude attempts" with a "sweet feeling of regret and joy."[2]

Girodet's parents, who had hoped to see him become an architect, or an officer of the king's army like his brother,[3] did not look favorably upon these artistic activities. Yet they allowed him to take lessons with Luquin, an obscure art teacher.[4] Finally, Girodet's determination triumphed, and he was introduced to David by the architect Boulé.[5] Madame Girodet showed some of her son's drawings to the author of the Horatii, and the master uttered the decisive prophecy: "There is nothing you can do, madame, your son will be a painter."[6] Thus, in 1785, Girodet became the pupil of David.[7]

During the years spent in the atelier of David, Girodet concentrated all his energy on one goal: the Prix de Rome. He was a serious, hard-working young man, endangering his health by spending the major part of his days and nights in

1. Girodet, OEuvres posthumes, op. cit., I, Le Peintre, Chant I, p. 54.
2. Idem, p. 55.
3. Girodet, OEuvres posthumes, op. cit., I, Notice historique by Coupin, pp. 1-1j.
4. Saunier, Charles, La Peinture au XIXe siècle, Paris, Larousse, facing p. 20.
5. David, J. L. Jules, Le Peintre Louis David: Souvenirs et documents inédits, Paris, Havard, 1880, I, p. 502.
6. Girodet, OEuvres posthumes, op. cit., I, Notice historique by Coupin, p. 1j.
7. A note of Beaucamp suggests a possible doubt as to the exactness of this date (Beaucamp, Fernand, Le Peintre lillois Jean-Baptiste Wicar, Lille, E. Raoust, 1939, I, p. 74, Note I).

study.[1] Though sometimes doubting his talent,[2] he was,
nevertheless, obstinate and full of ambition:

"Day and night, he has no longer any peace,
Until, at last, he conquers the laurels from his rivals."[3]

With the _Prix de Rome_ as his aim, Girodet tried his hand at
Concours themes even before entering the competition.[4] More-
over, he did not hesitate to use somewhat unorthodox methods.
He broke the rules of the Academy and brought to his _loge_[5]
drawings hidden under his clothes. As a result, in 1787, he
was denounced by Fabre, one of his fellow students, and was
excluded from his first _Concours_. He repeated, more success-
fully, the same deception at the occasion of his final triumph
of 1789. This time, he introduced his drawings by concealing
them in a hollow cane, his "Trojan horse."[6] This incident is
suggestive of the atmosphere of ruthless competition which
existed in the atelier of David.

With the exception of Gérard, Péquignot, and Gros,[7]

1. Bellevue, Count X. de, ed., _op. cit._, letter of Girodet
to Ravault, Paris, March 25, 1789.
2. _Idem._
3. Girodet, OEuvres posthumes, _op. cit._, I, _Le Peintre_,
Chant I, p. 57.
4. Girodet, OEuvres posthumes, _op. cit._, I, _Liste des prin-
cipaux ouvrages de Girodet_ by Coupin, p. lv.
5. Name given to the atelier in which the young painters
admitted to compete for the _Grand Prix_ worked under a strict
supervision (Girodet, OEuvres posthumes, _op. cit._, I, _Notice
Historique_ by Coupin, note, p. iij).
6. _Idem._, p. iij. Coupin wrote that similar devices were
used by "almost all the pupils."
7. Girodet's friendship with Gérard can be seen throughout his
letters from 1788 to 1791 (Lettres adressées au baron François
Gérard, published by Baron Gérard, Paris, A. Quantin, 1886, I).
Péquignot was Girodet's most intimate friend in Rome and Naples.
Finally, Gros took care of Girodet during the latter's illness
in Genoa.

Girodet seems to have had very few intimate friends among the young painters of the school of David. His suspicious nature led him to see in the manifestations of conventional politeness only "hostile, indifferent, or false faces."[1] Similarly, his relations with David do not appear to have been very warm. The latter in 1822, recalled the "tender affection which seemed to sleep' in his heart[2] during Girodet's sojourn in his atelier. In return, the pupil did not show much respect for his teacher. Writing to Gérard, he said that David's "faction" lacked "a good head,"[3] and declared the master to be a "fourbe et fourbissime."[4] He wished Gérard could share his good-hearted, cynical laugh in reading one of his hypocritical letters to David.[5]

However, the social coolness between Girodet and David did not impair a professional collaboration. Thus Girodet helped his teacher in painting some of the figures in the background of the Death of Socrates. Also, he took part in the execution of several copies from David, such as the small Bélisarius (in 1784 in collaboration with Fabre), the Oath of the Horatii (in 1787 commissioned by Didot), and the Paris and Helen (in 1789 commissioned by the Maréchale Lubomirka).[6]

1. Lettres adressées au baron François Gérard, op. cit., I, Letter of Girodet, Rome, September 1790, p. 157.
2. Girodet, OEuvres posthumes, op. cit., II, Correspondance, Letter XV, David à Girodet, Bruxelles, October 6, 1822, p. 315.
3. Lettres adressées au baron François Gérard, op. cit., I, Rome, September 1790, p. 160.
4. Lettres adressées au baron François Gérard, op. cit., I, Châtillon, January 17, 1790, p. 133.
5. Lettres adressées au baron François Gérard, op. cit., I, Châtillon, December 30, 1789, p. 130.
6. J. L. Jules David, op. cit., I, p. 59.

Unquestionably, the young Anne-Louis had a great professional admiration for the painter who "regenerated the School and dictated its laws."[1] While painting for the Concours, "every day, before entering his loge," Girodet "prepared his palette in front of the Horatii."[2] He particularly admired this work, because, as wrote Coupin, "it was the painting in which he found the most verve."[3] A little later, in Italy, the young painter, though intoxicated with a feeling of independence, still sent to his teacher the preliminary drawings of his own compositions,[4] and eagerly awaited Gérard's sketch of the Serment du Jeu de Paume.[5]

On the other hand, David respected the education and the "great knowledge"[6] of Girodet. Classical culture was highly regarded in his atelier, and the master considered familiarity with Latin as a minimum requirement of acceptance.[7] Girodet's learning went far beyond that of his fellow students. Moreover, he was a great reader[8] and bibliophile.[9] Very early

1. Girodet, OEuvres posthumes, op. cit., I. Le Peintre, Chant VI, p. 196.
2. Girodet, OEuvres posthumes, op. cit., I, Notice Historique by Coupin, p. iv.
3. Idem., p. xxxix.
4. Lettres adressées au baron François Gérard, op. cit., I, Letter of Girodet, Rome, August 11, 1790, p. 156.
5. Lettres adressées au baron François Gérard, op. cit., I, Letter of Girodet, Rome, July 13, 1791, p. 178.
6. Beaucamp, op. cit., I, p. 44.
7. Idem.
8. Girodet, OEuvres posthumes, op. cit., II, Correspondance, letter XXXVII, to Trioson, Rome, September 28, 1790, p. 373.
9. Idem.; also see the impressive list of books mentioned by Pérignon in his Catalogue des Tableaux, Esquisses, Dessins et Croquis de M. Girodet-Trioson, Paris, chez Pérignon et Bonnefons-Lavialle, 1825.

he acquired a scholarly reputation which was acknowledged by
David as well as by young artists, like Ange-René Ravault,
who came to him for advice.[1]

Girodet's early historical paintings, executed under
the direct influence of David, constitute the most Davidian
group of his entire production. Perhaps it is because of
this Davidian quality that Girodet, usually so prolix about
his other works, almost completely neglected this series in
his writings. This neglect was continued by later writers,
in spite of the relatively large number of paintings in this
group.

1. Bellevue, Count X. de, ed., op. cit., letter of Girodet
to Ravault, Paris, March 25, 1789.

II.

GIRODET'S INTERPRETATION OF HISTORICAL
AND ARCHAEOLOGICAL DATA

Great importance was ascribed by Locquin to the "need
for truth" which became the "obsession"[1] of historical paint-
ers at the end of the eighteenth century. This trend under-
lines the necessity for evaluating the relative importance of
history in Girodet's paintings of this group. An instructive
preliminary step may be taken by a brief consideration of the
Oath of the Horatii unquestionably the most significant his-
torical painting of the last quarter of the eighteenth cen-
tury. As shown by Edgar Wind,[2] David's theme was based
neither on a historical source, nor on Corneille's Horace.
It was derived from the livret of Noverre's ballet Les
Horaces. On the other hand, the treatment of the architec-
ture and accessories in the same painting, without achieving
a scientific exactness indicates a serious attempt at archaeo-
logical verisimilitude. One may note that contemporary writ-
ings seldom questioned the historical origin of David's theme
(only once to my knowledge)[3] but concentrated the discussion

1. Locquin, Jean, La Peinture d'histoire en France de 1747
à 1785 Paris, H. Laurens, 1912, p. 167.
2. Edgar Wind, "The Sources of David's Horaces," Journal
of the Warburg and Courtauld Institutes, Volume IV. 1941-1942,
nos. 3 and 4 April-July, pp. 124 ff.
3. Lettres analytiques critiques et philosophiques sur
les tableaux du salon, Paris, 1791, in the Collection de
pièces sur les beaux-arts imprimées et manuscrits recueillis
par Pierre Jean Mariette, Charles Nicolas Cochin et M. De-
loynes, known as Collection Deloynes, Cabinet des Estampes,
Bibliothèque Nationale, Paris, XVII, 441, p. 54

on the accuracy of archaeological details. This seems to
have been the general attitude of contemporary art critics.
One may find occasional comments on historical errors;[1] how-
ever, the maximum attention was undoubtedly paid to the
question of "costume," defined by Locquin as the "science of
accessories."[2]

A consideration of Girodet's interpretation of his-
torical subjects suggests a similar approach, combining a
liberal handling of sources with an attempt at archaeologi-
cal exactness.

The subject of Girodet's earliest historical painting,
Horatius Killing his Sister (fig. 2),[3] is related to an epi-
sode of early Roman history: the fight between the three
Horatii and the three Curatii which decided the supremacy of
Rome over Alba. The young Horatius, triumphantly returning
after his victory, kills his sister in a burst of patriotic
indignation at her lamentation over his slaying of her lover
Curatius, who had fought on the side of Alba. Girodet col-
lected and combined the best-known accounts of the subject.
The general idea of the theme was inspired by Livy[4] and

1. [Chaussard, Pierre Jean Baptiste7, Le Pausanias fran-
çais; état des arts du dessin en France à l'ouverture du XIXe
siècle: Salon de 1806, Paris, Buisson, 1806, p. 87.
2. Locquin, op. cit., p. 166.
3. 1785 -- Montargis.
4. Titus Livius, The History of Rome, D. Spillan, trans.,
New York, Harper & Brothers, 1889, I, Book I, chap. XXVI,
pp. 48-49.

Dionysius of Halicarnassus.[1] However, the classical accounts were vague, and Girodet freely introduced incidents borrowed from more recent authors. The presence of the old Horatius (on the left of the composition) at the scene of the drama was mentioned only by Corneille[2] and Noverre.[3] The death of Horatius' sister (Camille[4]) in the arms of the Roman women was also inspired by the latter.[5] This seems to be confirmed by the gestures of the figures which exactly correspond to the text of the Maître de ballet.[6] Moreover, the attitude of the young Horatius illustrates Corneille's famous verses:

"Ainsi reçoive un châtiment soudain
Quiconque ose pleurer un ennemi romain"[7]

In the case of the Death of Tatius (fig. 3), for which Girodet received the second prize in the Concours of 1788,[8] there was no modern source on which the painter could rely to enrich the accounts of Livy,[9] Plutarch,[10] or Dionysius of

1. Dionysius of Halicarnassus, The Roman Antiquities, The Loeb Classical Library ed., Earnest Cary, trans., Cambridge, Harvard University Press, London, Heinemann, II, Book III, chap XXI, pp. 79-85.
2. Corneille, Horace, Paris, Classiques Illustrés Vaubourdolle, Hachiette, 1935, Acte IV, Scène VII, p. 64.
3. Noverre, Jean Georges, Les Horaces, ballet-tragique, Paris, Delormel, 1777, troisième partie, Scène II, p. 25.
4. This name was traditionally associated with Horatius' sister after Corneille's play.
5. Noverre, Les Horaces, op. cit., p. 22.
6. Idem., p. 25.
7. Corneille, op. cit., Acte IV, Scène V, p. 63.
8. Girodet, OEuvres posthumes, op. cit., I, Liste des principaux ouvrages de Girodet by Coupin, p. lvj. The painting is in the museum of Angers.
9. Titus Livius, op. cit., I, Book I, chap. XIV, p. 33.
10. Plutarch, Lives, The Loeb Classical Library ed., Bernadotte Perrin, trans., New York, G. P. Putnam's Sons, London, Heinemann, 1914, I, Romulus, XXIII, p. 163.

Halicarnassus.[1] They succinctly related how Tatius, ruling
with Romulus over the politically united Rome and Alba, was
murdered, during a sacrifice at Lavinium, by the relatives of
the Laurentes to whom he had been unjust. Thus, Girodet had
to invent his own incidents. He also took the liberty of
representing, in the background of his painting, the killing
of the ambassadors of the Laurentes, an event which is chron-
ologically separated from the main theme in the classical
sources.

In interpreting <u>Joseph Making Himself Known to his
Brothers</u> (fig. 4), for which he finally received the <u>Prix de
Rome</u> in 1789,[2] Girodet, though limited to a single source,
was nevertheless respectful of it. This can probably be ex-
plained by the fact that the Biblical account[3] of the story
of Joseph's forgiveness provided enough interesting incidents
to make any further inventions superfluous.

While the three previous subjects were imposed by the
Academy, the theme of <u>Hippocrates Refusing the Presents of
Artaxerxes</u> (fig. 6),[4] painted in 1792 in Rome as an homage
to Dr. Trioson, was freely chosen by Girodet. Following the

<hr>

1. Dionysius of Halicarnassus, <u>op. cit.</u>, I, Book II, chap.
LII, p. 461.
2. Girodet, OEuvres posthumes, <u>op. cit.</u>, I, <u>Liste des prin-
cipaux ouvrages de Girodet</u> by Coupin, p. lvj. The painting is
in the <u>Ecole des Beaux Arts</u>.
3. Gen. 45, 14.
4. Girodet, OEuvres posthumes, <u>op. cit.</u>, I, <u>Notice his-
torique</u> by Coupin, p. vij. The painting is in the <u>Ecole de
Médecine</u> of Paris.

example of the <u>Oath of the Horatii</u>, the painter transformed
history. However, while David only added an invented inci-
dent, Girodet consciously distorted the existing account of
Plutarch.[1] This author very briefly told how the Persians
asked Hippocrates' help in fighting the plague which was
devastating their country. The painter boldly remodeled his
source, and explaining his attitude in one of his letters, he
wrote:

> I have put the account of history in action, for the
> Persian king, as you know, did not send any ambassador
> nor any gift to Hippocrates. He was content to have one
> of his satraps write to him, making the most magnificent
> promises. [2]

Thus, very frankly, Girodet stated that he did not believe in
having to "follow step by step the historical truth."[3] From
this point of view, he seems to have been inspired by Quatre-
mère de Quincy's idea of "recomposition" of history.[4]

This tendency toward a more liberal handling of his-
torical sources in Girodet's works was in contrast to a
parallel tendency toward archaeological verisimilitude.

This development can be observed in Girodet's growing in-
terest in architectural refinements. In <u>Horatius Killing his</u>

1. Plutarch, <u>op. cit.</u>, II, Marcus Cato, XXIII, p. 373.
2. Girodet, <u>OEuvres posthumes, op. cit.</u>, II, <u>Correspondance</u>,
Letter XXVII, to Pastoret, p. 340.
3. Idem.
4. Quatremère de Quincy, <u>Essai sur la nature, le but et les
moyens de l'imitation dans les Beaux-Arts</u>, Paris, Strasbourg
et Londres, Treuttel and Würtz, 1823, p. 354.

Sister (fig. 2), the painter, following the description of
Livy[1] and the plan of Rollin,[2] set his drama at the end of
the Via Appia, marked by the Servian walls and the Porta
Capena. In the background of the painting, between the
Capitoline hill and the gate, one can see the Temple of Mars.
In this early work, Girodet's architectural treatment shows a
certain vagueness, and his archaic details are not very con-
vincing. For instance, in his representation of the Porta
Capena, he merely combined an arch inspired by the Colosseum
with a medallion derived from the Arch of Constantine; while
the Temple of Mars is conceived as a Doric version of the
Maison Carrée. In the interpretation of the Death of Tatius
(fig. 3), Girodet had no plan of Lavinium, which was described
by the historians as the scene of the tragedy.[3] However, the
temple (probably that of Vesta[4]), with its heavy pediment,
capitals without abaci, and bulging echini, shows a serious
step forward in the realization of an archaeologically accu-
rate depiction of a Roman archaic building. In the case of
Hippocrates (fig. 6), there was no need of an archaic archi-
tectural treatment. Yet, the room of what is probably the

1. Titus Livius, op. cit., I, Book I, chap. XXVI, p. 49.
2. Rollin, Charles, Histoire romaine, Paris, Vve. Estienne
et fils et Desaint et Saillant, 1752, I, facing p. 15.
3. For instance, Dionysius of Halicarnassus, op. cit., I,
Book II, chap. LII, p. 461.
4. The cult of the Penates and that of Vesta were tradi-
tionally attached to Lavinium. Dionysius wrote that Tatius
and Romulus went to Lavinium "in order to perform a sacrifice,
which it was necessary for the kings to offer to the ances-
tral gods for the prosperity of the city." (Idem.)

famous physician's house, with its hypaethral system of
lighting,[1] suggests an archaeological refinement which was,
as far as I know, unparalleled in contemporary historical
paintings.

This growing archaeological interest can also be
traced in Girodet's treatment of various accessories. In
<u>Horatius Killing his Sister</u> (fig. 2), the painter derived
his details from various <u>recueils d'antiquités</u>. Yet, Hora-
tius' armor was borrowed from his counterpart in David's
<u>Horatii</u>, while the garments of the lictor behind Horatius,
as well as the bucoinae appearing on the right of Girodet's
composition, were copied from Giulio Romano.[2] It may be
noted that some of the accessories, such as the helmets, are
still strongly reminiscent of the traditional baroque para-
phernalia. Although derived from the same general sources,
the details of the <u>Death of Tatius</u> (fig. 3) show a definite
abandonment of baroque influence.

The interpretation of the accessories of <u>Hippocrates</u>
(fig. 6) marks the culmination of Girodet's archaeological
interest. The artist himself wrote that he had taken for

1. It seems that Girodet's first idea was to let the light
come through a door, as is suggested by the high, ornate
doorway of the drawing in the <u>Ecole des Beaux-Arts</u> (fig. 7).
This door is replaced by a small, low, and inconspicuous open-
ing in the drawing of the Bonnat Museum (fig. 8) (Inv. LB 2134),
the oil sketch of the Fabre Museum (fig. 9), and the final ver-
sion of the Ecole de Médecine (fig. 6).
2. <u>Sigismundi Augusti Mantuam adventis perfectio ac. trium-
phus Iulii Romani in Ducali Palatio quod del T</u>, Romae, typ.
Iacobi de Rubeis, 1680, Pls. 12-19.

this painting all the "precautions which were not possible
during the Concours because of lack of time."[1] He seems to
have been very happy at his opportunity to depict "various
costumes" of antiquity.[2] He made "special studies" on the
subject of the attire of the Persians represented in "long
white robes as a sign of mourning."[3] This truthful archaeo-
logical treatment presented a challenge to the artist, be-
cause white created "a difficulty to overcome in the effects
and in the harmony of the painting."[4] Thus, Girodet was ex-
tremely proud, as he stated himself, that "The details of
the costume have been faithfully studied from the monuments
and the engravings of the ruins of Persepolis, published by
the travelers in Persia."[5] This minute care explains the
shapes of the shields of the Persians, represented in the
wall frieze which appears in the background of the painting;
the decoration of the sword, and of the tiara, seen in the
center of the composition; and the attire of the satraps,
with their hair arranged in small ringlets and their upturned
shoes. For the sake of ethnic exactness, Girodet did not
hesitate to give to the Persians a slightly yellowish com-
plexion. This refinement seems to have been misunderstood by

1. Girodet, OEuvres posthumes, op. cit., II, Correspondance,
Letter XLVII, to Trioson, Rome, March 27, 1792, p. 408.
2. Girodet, OEuvres posthumes, op. cit., II, Correspondance,
Letter III, to Bernardin de Saint-Pierre, p. 277.
3. Idem.
4. Idem.
5. Girodet, OEuvres posthumes, op. cit., II, Correspondance,
Letter XXVII, to Pastoret,.. p. 341.

some of the painter's critics. Polyscope felt the need to explain the coloring; he wrote: "The satraps offering Darius's gifts to Hippocrates are not pale and dying from the plague; they have the complexion of their country."[1] Girodet's concern for accuracy was not limited to the representation of the Persians, and can be seen in all the details of the painting. For instance, the very head of Hippocrates, as was related by the artist, was copied from the well-known Capitoline bust, a cast of which was made especially for him.[2]

It must be noted that Girodet's archaeological concern is particularly apparent in his treatment of subjects derived from classical history. In the Biblical theme, Joseph Making Himself Known to his Brothers (fig. 4), the artist seems to have followed the old Academic tradition. In this painting, with the exception of a few Egyptian details, such as the hieroglyphs and the sarcophagi, Girodet's rendering of the architecture and of the attire of the personages reveals an evident classical origin.[3]

In general, Girodet's approach, paradoxically combining

1. Polyscope, Quatrième Lettre sur les ouvrages de peinture, sculpture, etc., exposés dans le Grand Salon du museum, Deloynes, op. cit., XVIII, 474, p. 589. Perhaps written by Dr. Trioson (?)

2. Girodet, OEuvres posthumes, op. cit., II, Correspondance, Letter XLIX, to Trioson, Rome, July 25, 1792, p. 415. The same bust can be seen in the background of the Lesson of Geography (fig. 87).

3. In the drawing of the Ecole des Beaux-Arts (fig. 5), Joseph wears a phrygian cap as a very classical mark of his emancipation. In the final version, this detail is replaced by a vaguely oriental head-band.

the "recomposition" of history with a pedantic archaeological
accuracy, suggests that the painter's aim was not so much to
reconstruct an event recorded by the sources, as to provide,
through a minute exactness of details, a convincing setting
for his themes.

However, this conception, which perhaps reflects what
Locquin described as the rising taste for local color,[1] was
still very far from creating anything similar to the Romantic
idea of atmosphere. Girodet's archaeology is not merely an
undiscriminating accumulation of suggestive details: almost
all the accessories in his paintings are organized into a
coherent system of allusions centered around the main theme.
This tendency is reflected in all of Girodet's early histori-
cal works, with the exception of Joseph Making Himself Known
to his Brothers (fig. 4), the interpretation of which was
based, as was seen, on a different tradition.

In Horatius Killing his Sister (fig. 2), this trend is
exemplified by such details as the medallion of the Porta
Capena, referring to the oath of the Roman and Alban officials
taken before the decisive fight.[2] The trend can be seen also

1. Locquin, op. cit., p. 169 .
2. Titus Livius, op. cit., I. book I, chap. XXIV, pp. 45-
46, and Dionysius of Halicarnassus, op. cit., II, Book III,
chap XVIII, p. 71. Naturally, the oath of the officials
could not yet have been commemorated in sculpture at the
time of the death of Horatius's sister. However, Girodet,
by depicting the ceremony of an oath in an inconspicuous
medallion, could allude to the immediate past without break-
ing the unity of time.

in the life-like armor of the dead Curatii, facing Rome and
silhouetted against the cloudy sky, which seems to suggest
the sorrowful longing of the vanquished Albans.[1] Finally,
it is reflected in Horatius' sword, the direction of which
symbolically unites the dying Camille with the armor of her
slain lover.[2] The same tendency can be noted in the Death of
Tatius (fig. 3), in which a statue of Clio, conceived as a
witness, it represented holding a scroll and making a gesture
which seems to signify that the depicted event will be re-
corded in the annals of history.

The best example of Girodet's predilection for details
with an allusive meaning can be seen in his Hippocrates Re-
fusing the Presents of Artexerxes (fig. 6), the last painting
of the historical group. In this work all the accessories
seem to have been selected to reinforce and to explain the
central theme. Some of the details are immediately and
directly understandable. Thus, the sculptured group of As-
clepius and Hygiae, appearing in the background behind the

1. There seems to be no doubt that Girodet purposely at-
tempted to suggest the occult present of the slain Curatii
by giving a life-like quality to their armor held as trophies
by the Roman lictors. The impression of life is stressed by
the fact that they are seen from the back, and by such details
as the leaning helmet, the shield hiding the hollow area cor-
responding to the face, and the wind-blown mantle. The gen-
eral effect is almost reminiscent of some of Chrico's mannequins.
2. It is impossible to believe that the position of this
sword is accidental. In extending upward and downward the gen-
eral axis of Horatius' sword, one can create an imaginary line
which, on one end, will reach Curatius' armor at a spot cor-
responding to the heart and, on the other end, will touch the
visible wound of Camille. Girodet's device obviously alludes
to the idea that Camille and her lover were killed by the same
sword, and, by it, were united in death.

figure of Hippocrates, was evidently meant to underline the
nature of his profession.[1] However, Girodet appears to have
been especially interested in stressing the motives for
Hippocrates' refusal, as well as revealing his reasons for
any possible hesitation. The reasons for the doctor's denial
of the Persians' pleas for help for their plague-stricken
country, are alluded to on the sculptured frieze which is de-
picted in the background of the painting. In this frieze,
one can see, from right to left, the Persian soldiers invad-
ing Athens, killing Greek citizens, setting a temple afire,
and fighting the Greek soldiers.[2] The motives for Hippocrates'
possible hesitation are referred to by the various objects
displayed by the Persians at the feet of the Greek physician.
With the exception of the gold coins, such objects as the
tiara, the sword, and the red mantle do not seem to have been
meant by the painter to represent merely the gifts brought by
the Persians. Rather, they are conceived as allusions to the
insignia of rank and power, the "purple" promised in Arta-
xerxes' letter, which can be seen lying at the feet of

1. Asclepius can be identified by his staff with a winding
snake, and Hygiae, by the dish she is offering to the snake.
This group corresponds to one of the examples given by Noël
(Noël, François, Dictionnaire de la fable, new édition, Paris,
Le Normant, 1803, I, pp. 506-507).
2. The olive tree, seen on the very left of the temple repro-
sented on the frieze, suggests that the location is the Acro-
polis of Athens. The hexastyle Doric temple is probably the
temple dedicated to Athena and destroyed by the Persians before
the construction of the Parthenon. The final triumph of the
Greeks is suggested, on the left of the frieze, by figures of
winged victories and trophies made of Persian shields and
armor.

Hippocrates.[1] The three black statuettes placed among these objects allude to a much more morally fitting source of Hippocrates' temptation. These three feminine figures, wearing a mural crown, a veil, errings, and a double necklace, must be undoubtedly understood as traditional classical personifications of Asian cities,[2] and their black color was probably chosen by the painter to suggest the epidemic of plague which compelled the Persian king to seek Hippocrates' help. This reference to the plight of Persia provides an honorable and humanitarian cause of temptation for the Greek physician, more in keeping with the duties of his profession.[3] It may be seen that all these details are organized in a logical, though pedantically refined, system of allusions. From 1785 to 1792, Girodet's use of meaningful accessories progressed toward an ever-increasing complexity. This complexity was to reach a peak of preciosity in the painter's interpretation of mythological subjects during the periods of the Directory and the Consulate.

1. Writing to Bernardin de Saint-Pierre, Girodet described his painting as representing "Hippocrates refusing the purple and gold displayed before his eyes by the envoys of the king of Persia" (Girodet, OEuvres posthumes, op. cit., II, Correspondance, Letter III, to Bernardin de Saint-Pierre, p. 270). Artaxerxes' letter to Hippocrates is mentioned in Girodet's letter to Pastoret (Girodet, OEuvres posthumes, op. cit., II, Correspondance, Letter III, to Pastoret, p. 340).

2. Numerous examples of this type of classical personification of cities can be found in the work of Bergerus (Bergerus, L., Thesaurus ex Thesauro Palatino Selectus, Heidelberg, P. Delboin, 1685, pp. 269, 271, 273, 280, 281 and 283). This work was listed by Pérignon among the books of Girodet's library (Pérignon, op. cit. pp. 99 and 294). The ornate attire of Girodet's statuettes corresponds to Noël's description of the personification of Asia: "a woman dressed with magnificence" (Noël, op.cit.I,p.148).

3. Significantly, the Persians display the "purple" and gold, but their gestures point toward those three statuettes only.

It may be observed that Girodet's "recomposition" of history, and his use of allusive archaeological details, stress the concept of a moral and patriotic lesson, exemplified by illustrious men of antiquity. This tendency, as has been frequently remarked, was common to all the members of the Davidian school. Though evident, the moralistic and patriotic aspects of Girodet's historical paintings must be briefly considered in view of the different attitude taken on the subject by Friedrich Antal in his article in The Burlington Magazine.[1]

Antal based his argument neither on the internal evidence of Girodet's productions nor on the contemporary writings of the artist. He founded his proofs on an a priori interpretation of the paintings, from the point of view of the political ideas and the social origins of the artist. He defined Girodet as a "conservative" and an "anti-revolutionary," as well as "a very wealthy man." From these premises he derived the interpretation of one of Girodet's minor drawings, Bayard Refusing the Presents of his Hostess at Brescia,[2] as a royalist subject. It was obviously impossible to apply the same qualification to Girodet's classical historical paintings. Thus, Antal could not but characterize Hippocrates as a "moralizing classicistic picture." However, he was careful to avoid calling it patriotic, and immediately attempted

1. Antal, Friedrich, "Reflections on Classicism and Romanticism - II," The Burlington Magazine lxviii, Number CCCXCVI, March 1936, pp. 130-139.
2. 1789.

to minimize the "moralizing" factor by adding: "though char-
acteristically enough it is at the same time a collection of
psychologically interesting character-studies. [1]

As was seen, Girodet unquestionably originated from a
well-to-do family strongly attached to the monarchic milieu.
However, it is not too difficult to show that, neither a con-
servative nor an anti-revolutionary, Girodet may be best de-
scribed as a political opportunist. During the periods of the
Consulate and the Empire, the painter indulged in exalted
flatteries addressed to Napoleon, speaking about the latter's
"wisdom in counsel . . . audacity in combat . . . modesty af-
ter victory." Indeed, he wrote, Bonaparte's glory "claims
the pen of Plutarch, the lyre of Homer, and the brush of
Apelles."[2] After 1815, Girodet, with the same enthusiasm,
wrote about the "noble blood of kings," the "empire of the
lilies,"[3] and recalled with veneration the "good deeds of
Louis XVI."[4] Yet, the Revolutionary period, during which the
painter executed two of his most important historical works,
showed him in a completely different mood. Writing from Rome,
he regretted having to miss the "majestic and patriotic fête
de la Fédération,[5] sorrowfully mentioned the death of

1. Antal, op. cit., p. 132.
2. Girodet, OEuvres posthumes, op. cit., II, Correspondance,
Letter IV, to Bonaparte, p. 284.
3. Girodet, OEuvres posthumes, op. cit., I, Le Peintre,
Chant I, p. 79.
4. Girodet, OEuvres posthumes, op. cit., I, Notes du Chant
I, p. 206.
5. Lettres adressées au Baron François Gérard, op. cit., I,
Letter of Girodet, Rome, July 21, 1790, p. 144.

Mirabeau,[1] and spoke ironically about the royalism of Ména-geot, the director of the French Academy at Rome.[2] Girodet even went so far as calling the king "Louis le Sournois" and suggesting that it would be necessary to give him a formal trial; and . . . a good smell of the scaffold."[3]

One must not take all these political affirmations without a grain of salt. Girodet's capacity to harmonize his political beliefs with the prevailing opinions of the time was paralleled by many of his contemporaries, such as David, Gérard, and Gros. At any rate, neither Girodet's Jacobinism nor any other political belief is necessary to prove or to reject the patriotic and moral implications of historical paintings like Hippocrates. They were stated without any trace of ambiguity by the artist himself:

"This subject has appeared to me as one of the most beautiful of antiquity, as much by the veneration attached to the memory of Hippocrates as by the great example of patriotism and integrity.[4]

Similarly, it seems that Girodet's Bayard, far from showing any perceptible signs of royalism,[5] was conceived along the

1. Lettres adressées au Baron François Gérard, op. cit., I, Letter of Girodet, Rome, September 28, 1790, p. 166.
2. Lettres adressées au Baron François Gérard, op. cit., I, Letter of Girodet, Rome, July 13, 1791, p. 179.
3. Idem., p. 176.
4. Girodet, OEuvres posthumes, op. cit., II, Correspondance, Letter III, to Bernardin de Saint-Pierre, pp. 276-277; also Girodet, OEuvres posthumes, op. cit., II, Correspondance, Letter XXVII, to Pastoret, p. 340.
5. In 1789 (date of the drawing), to be a royalist did not yet imply anything very definite. Such liberals as Mirabeau and Bailly were royalists.

same moralizing and patriotic lines. This conception is
clearly suggested in the painter's <u>Veillées</u>:

> ". . . without looking far away in Greece or Rome
> For these types of virtue renowned by history,
> Those which the happy land of the French is proud of
> Alone promise to the arts as noble successes.
> In vain does Scipio's continence shine,
> Bayard tips the scale to his side."[1]

This passage of Girodet's poem was only echoing an already
old and widespread idea. For instance, the <u>Journal Encyclo-
pédique</u>, among many other writings, expressed in 1761 the
opinion that the greatest use of one's talent was "to retrace
the events which concern and honor the fatherland."[2] Thus,
Girodet's <u>Bayard</u> can be understood as an example of the long
series of virtuous refusals varying on the theme of the <u>Con-
tinence of Scipio</u>.[3] Naturally, <u>Hippocrates Refusing the
Presents of Artaxerxes</u> was following the same conception al-
ready so often illustrated by such subjects as <u>Curius Dentatus
Refusing the Presents of the Samnites</u>,[4] <u>Fabricius Surrounded
by his Family Refuses the Presents Sent to him by Pyrrhus</u>,[5]
or <u>The Prophet Eleazar Refusing to Eat the Forbidden Meat</u>.[6]

1. Girodet, <u>OEuvres Posthumes, op. cit.</u>, I, <u>Veillées</u>, I,
p. 355.
2. <u>Journal Encyclopédique</u>, September 1761, II, p. 59
(quoted by Locquin, <u>op. cit.</u>, p. 165).
3. As for instance exemplified by the painting of Vien in
the Museum of Aix (1779). This idea was already noted by
Henri Jacoubert (<u>Le Genre troubadour et les origines fran-
çaises du Romantisme</u>, Paris, Les Belles Lettres, 1929, pp.
195-196).
4. As exemplified by Peyron or by Vincenzo Camuccini.
5. As exemplified by the painting of Lagrenée, the elder,
in the Museum of Libourne (1777).
6. As exemplified by the painting of Barthélémy in the Mu-
seum of Angers.

In the case of <u>Horatius Killing his Sister</u> and the <u>Death of Tatius</u>, the selection of the subjects, which were imposed by the <u>Académie</u>, cannot be considered as having any special significance. However, nothing in Girodet's interpretation of these themes suggests any particular political leanings which would reveal what Antal called the "conservative" beliefs of the painter. For instance, in the <u>Death of Tatius</u> (fig. 3), Girodet did not attempt in any way to weaken the lesson of history justifying the killing of a bad king. On the contrary, the artist's sympathy seems to have been with the youthful murderer, the avenger of the people, whom he represented in a dignified, heroic attitude, pressing under his knee the fear-stricken, almost grotesque figure of Tatius. It may be noted that Garnier, the winner of the <u>Concours</u> of 1788, in his interpretation of the same subject did not stress this contrast between the murderer and his evil victim.[1] Moreover, the titles of a great number of Girodet's studies mentioned by Pérignon provide a clear refutation of Antal's theory. They show Girodet's interest in such typically patriotic themes as the <u>Departure of Regulus</u>,[2] <u>Mucius Scaevola</u>,[3] or the <u>Death of Virginia</u>.[4] Finally, one must note that, as late as 1814, Girodet made a drawing representing <u>Belisarius and his Young Guide</u>.[5] It is amusing to see Antal,

1. École des Beaux-Arts, Paris.
2. Oil sketch mentioned by Pérignon, <u>op. cit.</u>, p. 22 No. 97.
3. Two drawings, <u>Idem.</u>, p. 42 No. 299 and p. 44 No. 318.
4. One drawing, <u>Idem.</u>, p. 42 No. 299.
5. One drawing, <u>Idem.</u>, p. 25 No. 133.

obviously unaware of this drawing, contrasting David's inter-
pretation of Belisarius with Girodet's Bayard, in order to
stress the "diverging paths along which the art of David and
of Girodet was bound to proceed."[1]

Thus it may be said that Girodet did not neglect the
patriotic and moralizing factors in the choice or the inter-
pretation of his historical themes. However, these factors
reflect a very general contemporary trend and cannot be
taken as an indication of any kind of political inclination
of the painter. The didactic aims of the Davidians' moraliz-
ing and patriotic interpretation of historical themes were
often emphasized[2] and do not need any further discussion.

1. Antal, op. cit., p. 132.
2. As for instance by Locquin (op. cit., pp. 162-165).

III.

THE HUMAN FIGURE AS A MEDIUM OF THE "EXPRESSION OF THE SENTIMENTS OF THE SOUL"

During the Revolutionary period, historical painters, in spite of their archaeological interest, gave the major role to the human figure. Louis Réau strongly underlined this fact: "classical art, strictly anthropocentric, only admits one object as worthy of attention: man. Nature intervenes only as a setting in order to accompany and bring out the human figure."[1] Almost any historical painting of the period, with its gesticulating personages agitated by various emotions and isolated against an austere, comparatively neutral setting, may be used as an example of this conception. In the contemporary writings of the salons, one may find occasional remarks on the emotional participation of the setting,[2] but, in general, for the critics of the time, the human figure was "that which expresses life and all the passions."[3] It was the basic medium of the "expression of the sentiments of the soul, the essential part of painting."[4]

1. Michel, André, Histoire de l'Art, Paris, A. Colin, 1925, VIII, 1ère partie, chap. III: La peinture française de 1785 à 1848 by Louis Réau, p. 152.

2. Encore un coup de patte, pour le dernier, ou dialogue sur le Salon de 1787, 1ère partie, Deloynes, op. cit., XV, 378, p. 25.

3. Vieil de Saint-Mart, Observations philosophiques sur l'usage d'exposer les ouvrages de peinture et de sculpture. A Madame la Baronne de Vasse, La Haye, Bluet, 1785, Deloynes, op. cit., XIV, 365, p. 550 (p. 7).

4. "Observations" contenues dans L'Année littéraire, Deloynes, op. cit., XV, 397, Ms., p. 864.

The consideration of this aspect of Girodet's art is greatly facilitated by the Théorie du geste of Paillot de Montabert.[1] Though written in 1813, this work, far from contributing the individual ideas of the author, is in reality a compendium of theories already prevailing at the end of the eighteenth century. A study of the salon writings of this period clearly reveals the importance of Montabert as a compiler. Thus, it may be safely said that already in the '80's Girodet had ample opportunity to become acquainted with the ideas expressed in the Théorie du geste, ideas which will be later echoed in the very writings of the painter.

The aim of Montabert seems to have been the formulation of a complete theory on the physical and intellectual interpretation of the human figure in art. Human beings, as they are represented in painting or sculpture, are qualified, according to the author, by three major factors:

1. "Natures dan l'espèce humaine"
2. "Caractères ou moeurs"
3. "Passions ou moeurs en action."

For Montabert, the 'natures dan l'espèce humaine" are chiefly defined by the factors of sex, age, and condition (social or divine).[2] The 'caractères ou moeurs" must be understood as the manner of being of the individuals, in respect to their

1..Paillot de Montabert, Théorie du geste (1813), included in his Traité complet de la Peinture, Paris, Bossange, 1829, V.
2. Idem., p. 366.

intellectual faculties, their feeling, or the disposition of
their soul."[1] Finally, the "passions ou les moeurs en action"
can be described as "the great agitations of the soul," when
the feeling reaches a "great intensity."[2]

The depiction of these three elements, forming the
foundation of Montabert's conception of the human figure,
was the major aim of the artist. The author of the Théorie
du geste believed that the painter and the sculptor could
convey these elements in their works through the physical
type,[3] and especially through the expressive quality of the
features[4] and of the gestures[5] of their personages -- in
other words, through what was often referred to as physiog-
nomy and pantomime.

Montabert's emphasis on the importance of rationalism
and clarity in the interpretation of the human figure in art
reflected the current conception of the second half of the
eighteenth century. In the first half of the same century,
the expressive vigor of the gestures of Poussin's personages,
following the principle of Desfresnoy's "Mutorumque silens
positura imitabitur actus,"[6] were replaced by the manneristic

1. Idem., p. 363.
2. Idem., p. 385. The "passions" can also be sometimes
understood as "lesser emotions" or even only as the "sentiment
of the soul which . . . never ceases to feel" (Idem.).
3. Montabert, op. cit., V, chaps. 201-207, pp. 317-362.
4. Idem., chap. 210, pp. 393-498.
5. Idem., chap. 211, pp. 498-519.
6. Quoted in Dimier, Louis, Histoire de la peinture française
du retour de Vouet à la mort de Lebrun, Paris et Bruxelles, Van
Oest, 1926, I, p. 61.

ambiguity and the decorative vagueness of the gestures of the
figures of Coypel. This change was held by the Davidians to
be one of the major causes of the decadence of rococo paint-
ings. Girodet himself remarked in his Veillées: "The grimace
succeeded the play of passions."[1] In 1759, Caylus' founda-
tion of the Concours de la tête d'expression echoed the resur-
rection of seventeenth century ideas. Again, the painter had
to strive for a clear "Expression of Passions,"[2] the absence
of which was considered to be one of the greatest sins. It
is significant that contemporary painting at the turn of the
century was satirized by a feminine figure, represented with
a head "without expression and adorned with donkey ears."[3]
Although all the contemporaries seemed to agree on this neces-
sity for expression, one can observe two parallel and contrast-
ing trends generally corresponding to what Benoit called the
"ultra idealist" and the "liberal" attitudes.[4] The first ten-
dency was expressed by the followers of Winckelmann, who
preached that "tranquillity is the state most fitting to
Beauty . . ." and that "the idea of a sublime Beauty can
only originate in the quiet contemplation of a soul detached
from all particular images."[5] This ideal being impossible to

1. Girodet, Oeuvres posthumes, op. cit., I, Veillées, I,
p. 350.
2. Locquin, op. cit., p. 80.
3. Revue du Salon de l'an X ou examen critique de tous les
tableaux qui ont été exposés au Museum, Paris, Surosne, An X,
IIe Supplement, Engraving p. vij.
4. Benoit, op. cit., pp. 26 ff.
5. Winckelmann, Histoire de l'art de l'antiquité, Huber,
trans., Leipzig, Breitkopf, 1781, II, pp. 92-93.

fulfill, the artist must strive to achieve "delicate expres-
sions" and a "gentle and subdued feeling."[1] This teaching
naturally led toward a maximum of idealization, restrained
gestures, and subdued facial expressions, as well as a gen-
eral softening of characterizations and emotions. The second
trend was represented by Emeric-David, who believed that the
artist should represent "the picture of human passions," and
that the emotions of the soul should be expressed with energy.
According to Emeric-David, one often admires figures "which
are far from being ideal, but the expression of which strikes
and grasps the spectator. Thus, the greatness of human rep-
resentation in art "is not caused by the forms but by the
feeling which animates them."[2]

This second point of view, expressed by Emeric-David,
was by far the most significant in relation to the general
cultural background of the period. It corresponded to simi-
lar developments in the fields of the ballet and the theater.
In his Lettres sur la danse, Jean-Georges Noverre wanted ballet
to abandon "the effects . . . of these fire-works executed
simply to amuse the eyes."[3] He wished to "revive the art of
the gesture and of the pantomime, so well known in the cen-
tury of Augustus."[4] Thus, his aim was to "depict the movements

1. Winkelmann, quoted in Montabert, op. cit., V, p. 376.
2. Emeric David, Art stat., pp. 228, 232, 235, quoted in
Benoit, op. cit., p. 73.
3. Noverre, Lettres sur la danse et sur les ballets, Stut-
gard, Lyon, chez Aimé Delaroche, 1700, Letter I, pp. 4-5.
4. Idem., p. 3.

of the soul by gestures."[1] The end of the eighteenth century
and the beginning of the nineteenth century showed a general
fascination for the art of pantomime. Girodet himself ex-
pressed his interest and his knowledge of some of Noverre's
ideas:

> ". . . by dance, we do not mean here the idle art of mak-
> ing difficult and meaningless steps; but the expressive
> art of pantomime, the art in which the Pylades and the
> Bathylles had displayed such a naive and eloquent grace."[2]

Scholars attempted to resurrect the art of the pantomime of
the ancients.[3] Moreover pantomime invaded the stage.[4] At
the same time Talma's style of acting, "more real and true to
nature, but less noble," replaced that of Lekain;[5] and under
the influence of Dugazon, Talma gave a greater importance to
facial expression.[6] Thus simultaneously, the visual arts,
the ballet, and the theater attempted to rationalize panto-
mime and physiognomy into an effective, emphatic, and clearly
understandable vehicle for the expression of emotions. Prais-
ing the figures of David's Death of Socrates, a contemporary

1. Noverre, Lettres sur la Danse, op. cit., Letter II, p. 15.
2. Girodet, OEuvres posthumes, op. cit., II, Dissertation
sur la grâce, p. 169.
3. For instance: De l'Aulnay, De la Saltation théatrale
ou recherches sur l'origine, les progrès, et les effets de la
pantomime chez les anciens, Paris, Barrois, 1790.
4. Before the Revolution, the theatre Nicolet was the cen-
ter of pantomime plays (Mantzius, K., A History of Theatrical
Art, Archer, trans., New York, P. Smith, 1937, VI). During
Revolutionary and Imperial times, pantomime representations
multiplied.
5. Idem., p. 165.
6. Idem., pp. 134-135.

critic described how in each figure "the soul . . . is depicted in all the movements, animates all the parts of the body."[1] Rosenthal went so far as to say that an "exaggerated importance" was given to the gestures during this period.[2] The "painters of history" were now becoming the "painters of the soul."[3]

These general trends, as well as Montabert's Théorie du geste, provide a useful basis for the study of the human figure in Girodet's historical painting from 1785 to 1792, the period during which the artist executed Horatius Killing his Sister, the Death of Tatius, Joseph Making Himself Known to his Brothers, and Hippocrates Refusing the Presents of Artaxerxes.

Horatius Killing his Sister (fig. 2)

In considering this painting one can immediately note that many types, gestures, and facial expressions have an evident eclectic origin. Thus, it is possible to recognize the old Horatius[4] as a variation of the soldier from David's Belisarius;[5] the kneeling woman as a repetition of J. B. Drouais'

1. M. l'A. P., L'ami des artistes au salon, Paris, Esclapart, 1787, p. 36.
2. Rosenthal, Léon, La Peinture romantique, Paris, Henry May, 1900, p. 7.
3. Locquin, op. cit., p. 162.
4. His figure with raised hands appears on the extreme left of the composition.
5. Belisarius as a Beggar Recognized by One of his Soldiers, 1781, Museum of Lille.

Canaanite woman;[1] and the dying Camille as inspired by A.
Coypel's Dido,[2] with her facial expression repeating that of
David's Andromache.[3]

However, for his own purposes, Girodet reinterpreted
his models. The physical types are simplified and reduced to
a few archetypes, such as the young woman, the young man, the
mature man, and the old man. These are repeated several times
in the painting, practically without any change and with very
little differentiation. Thus, the two Roman women and Camille
are of an almost identical type seen in different attitudes. The
same tendency toward simplification can be noted in Girodet's
interpretation of gestures and facial expressions. The artist
gave a special importance to the movements of the arms, which are
depicted slightly bent, strongly separated from the body, and
with open fingers. This characteristic movement is repeated
with little change by various personages, at least five times in
the picture.[4] Similarly, the physiognomical play of Girodet's
figures is reduced to a few types of clear-cut expressions,
ranging from a kind of impassive gravity,[5] to pain[6] or anger.[7]

1. The principal figure of The Canaanite Woman at the Foot
of Christ, 1784, Ecole des Beaux-Arts.
2. In Dido on her Pyre, Museum of Montpellier.
3. In Andromache Lamenting over the Body of Hector, 1783,
Ecole des Beaux-Arts.
4. As for instance in the figure of the old Horatius, the
standing Roman woman, and the kneeling Roman woman.
5. Exemplified by the lictors appearing on the right of the
picture.
6. As can be seen in the figure of Camille.
7. As can be seen for instance in the figure of the young
Horatius.

The physical types of the figures in <u>Horatius Killing</u>
<u>his Sister</u> reveal very little of Montabert's conceptions, be-
yond the factor of the "natures dan l'espèce humaine" -- in
other words, the elements of sex and age. Girodet seems to
have concentrated his efforts on the expressive possibilities
of pantomime and physiognomy. In most cases, the psychologi-
cal meaning of a personage is a result of the combination of
two elements: the relative position of his arm, used as a
signal, and one of the few simplified facial expressions.

Though having an almost abstract simplicity, this
combination of gestures and facial expressions successfully
fulfills one of the most important requirements of Montabert:
"clarity of meaning."[1] The spectator is left very little
doubt as to the terror of the standing Roman woman, the sup-
plication of her kneeling companion, or the anger of the
young Horatius. These personages, as well as the great major-
ity of the figures of Girodet's painting, are completely de-
void of any signs of "equivocal attitudes," for which so many
works were criticized in the salons of the last years of the
monarchic regime.[2] Because of its emphatic clarity, the panto-
mime of these personages comes very close to Montabert's ideal
of gestures which, in his opinion, should be used in art as
"general signs of the universal language."[3]

1. Montabert, op. cit., V, p. 472.
2. "Observations" contenues dans L'Année littéraire, De-
loynes, op. cit., XV, 397, Ms., p. 864.
3. Montabert, op. cit., V, p. 417.

However, the almost signal-like quality of the ges-
tures of Girodet's figures considerably limits their expres-
sive possibilities. Locquin's remark about the personages
appearing in classical subjects between 1775 and 1785 can be
applied to the figures of Horatius Killing his Sister:
"their pantomime is reduced to summary gestures, to indicate
rather than to express the emotion which penetrates them."[1]
In Girodet's painting, the gestures are completely devoid of
any individual quality. They do not directly violate Monta-
bert's rule of "suitability,"[2] in other words, they do not
contrast with the physical type of the personages."[3] On the
other hand, neither do they reveal what Montabert called the
"caractère" of these personages. They are conceived only as
emphatic vehicles of abstract emotions, the "passions" of the
Théorie du geste.

From the point of view of Montabert's ideas, the
greatest shortcoming of Girodet's interpretation of the panto-
mime of his personages can be seen in its complete lack of
"unity." The artist in his Horatius Killing his Sister never
achieved "the concurrence of all the acting parts" of his

1. Locquin, op. cit., p. 242.
2. Montabert, op. cit., V, p. 490.
3. In relation to this rule of suitability, Girodet wrote:
"The laws of poetical ordinance will be violated if an old man
acts like a young one or a young man like an old one; a com-
moner like a man of high rank; a king like a shepherd; if the
characteristic features of the personages, if the shades of
the passions which they must express are not perfectly suited
to their sex, their age, and their position." (OEuvres post-
humes, op. cit., II, De l'Ordonnance, pp. 211-212.)

figures "toward his chosen goal," which was required in the
Théorie du geste.[1] In several instances, each gesture or
facial expression seems to define a separate emotion or ac-
tion. The total meaning of the pantomime results from a com-
bination of these units of emotion or energy. A characteristic
example can be seen in the attitude of the standing Roman
woman, whose pantomime evidently expresses fright. This
"passion" can be decomposed into its components. The woman's
face turned toward the young Horatius, the causal factor, ex-
presses horror, while her half-bent arms stretched in the
opposite direction suggest her attempt to flee from Camille's
brother. Girodet's interpretation of this personage strik-
ingly exemplifies Lebrun's definition of "fear," as it appears
in his Conférence sur l'expression générale et particulière
des passions: "Fear is the apprehension of ill to come, which
precedes the harms by which we are threatened."[2] Thus, Giro-
det did not apply the principle of "unity" and followed Le-
brun's theory of "composite passions." In this theory, the
seventeenth-century painter stated that there is a series of
complex "passions" which are the psychological combination of
other simpler, but otherwise self-sufficient, emotions.[3] The
pantomime of Girodet's standing Roman woman naturally continues
a long series of attitudes frequently exemplified in the

1. Montabert, op. cit.,V,p. 482.
2. Lebrun, Conférence sur l'expression générale et parti-
culière des passions, Vérone, chez Augustin Carattoni, 1751,
p. 20.
3. Idem.

paintings of Lebrun or Poussin.[1] An even more convincing proof of
Girodet's assimilation of the idea of "composite passions" can be seen
in the figure of the old Horatius. His pantomime somewhat sins in
respect to the principle of "clarity of meaning" and may be fully
understood only from the written sources. It was seen that the general
idea of this figure is derived from the soldier of David's Belisarius.
However, Horatius' uplifted left arm does not express the surprise
indicated by his right arm, but corresponds to Corneille's verses:
"Retirons nos regards de cet objet funeste."[2] Girodet, applying
Lebrun's principle, changed the Davidian pantomime to adapt it to his
subject matter. Thus, each arm of the old Horatius is given a separate
meaning. This type of combination of several "passions" in the same
figure presented a difficult problem, and its successful solution seems
to have been particularly admired by the contemporary critics. This
is illustrated in a conversation between the "frondeur" and the "musicien,"
appearing in Le Frondeur ou dialogue sur le salon. The subject of the
discussion is the expression of one of the personages of Vincent's
Paetus and Arria in the salon of 1785:

 "F.: The expression
 M.: You find it
 F.: Admirable

1. As for instance in the figure of Terror from Lebrun's Battle
of Arbela or in the figure of Eurydice from Poussin's Orpheus and
Eurydice.
 2. Corneille, op. cit., Acte V, Scène I, p. 67.

M.: It is perfect, but are there none here as beautiful?
P.: No, because, all factors being equal, you won't
find any as difficult.
M.: Where do you see the difficulty?
P.: It is in the art of uniting in the same features
two complicated feelings."[1]

However, there were other guiding motives for Giro-
det's use of "composite passions." Coupin, a pupil of the
artist, praised his master's application of this principle
for a different reason:

"Poetry describes . . . all the principal circumstances
of an event . . . it makes them pass successively under
the eyes of the reader. . . Painting exposes to the spec-
tators the very personages who have taken part in this
event . . . it can represent them only in a given moment:
all that precedes, all that follows cannot be exposed
completely and can only be indicated."[2]

Thus Coupin explained how Girodet, "a skillful painter," was
using the gestures "to establish the relation of the chosen
moment with what preceded or will follow it."[3] Therefore,
the constituent gestures of this type of pantomime must be
read in succession. For instance: the standing Roman woman
at first is moved by a feeling of horror, a "passion" which is
followed by her attempt to flee; and the old Horatius signi-
fies his order, only after having expressed his surprise.
This interpretation of "composite passions" implies Girodet's

1. Le Frondeur ou dialogue sur le sallon par l'auteur du
Coup-de-Patte et du Triumvirat, 1785, Deloynes, op. cit., XIV,
329, p. 43.
2. Girodet, OEuvres posthumes, op. cit., Notice historique
by Coupin, p. xxvv.
3. Idem.

consciousness of a complete psychological and chronological dissection of the personality of these figures. It also resulted in a complete lack of organic coördination reflected in the rigid isolation of the different anatomical parts of the body of the figures and in the mechanical quality of their pantomime.

Thus, Girodet conceived some of the figures of Horatius Killing his Sister in the manner of Condillac's "homme-statue."[1] Psychologically and chronologically isolated actions and emotions are combined with the quasi-neutral physical core. The personality of these figures is the result of this addition of "passions," and has little unity or coördination. Finally, the very emphatic but almost abstract expression of "passions" suggests practically nothing of the permanent elements of the "caractère."

It can be suggested that the conception of Horatius Killing his Sister reflects the general contemporary effort to reconstruct pantomime as an effective vehicle of expression. At this stage, the obviousness of Girodet's pantomime is that of a student who applies current theories with an excessive literality. However, it is also already a reflection of his typical inclination to exaggerate contemporary tendencies.[2]

1. Condillac, Traité des sensations, Londres, Paris, chez de Bure l'aîné, 1754, I, pp. 5 ff.
2. Naturally, the concept of "composite passions" is frequently exemplified in the paintings of the Davidian School, as for instance can be seen in such characteristic works as

Death of Tatius (fig. 3)

The basic idea of the analytic pantomime of Horatius Killing his Sister is preserved in the Death of Tatius. Yet, besides the simplified facial expressions and the half-bent arms which were so typical of the earlier painting, other elements are given a role in the pantomime of the personages of the painting. The whole figure now seems to participate in the expression of actions and emotions.

Moreover, in this painting, Girodet was forced by his new subject matter to find a more convincing application of the principle of "suitability." Historical sources described the two leading personages of the drama, the kings Romulus and Tatius, as having different moral dispositions. Girodet's difficulty, in suggesting this factor, was increased by the impossibility of relying on the elements of sex, age, or social rank, which were the same in both cases. To solve this problem, the artist tried to introduce a moral factor in the definition of the physical types and of the pantomimes of the two kings. Romulus is given a traditional dignified kingly attitude, which seems to have been somewhat inspired by his counterpart in Poussin's Rape of the Sabines.[1] However, the

[1] (continued from preceding page). Phaedra and Leonidas at Thermopylae, the Plague of Jaffa, and Hippolytus. Yet, in these works, the principle is seldom applied with Girodet's literality.
1. Louvre. This attitude can be traced back to the Augustus of the Prima Porta in the Vatican.

serenity of his facial expression, as well as the weakness of
his gesture indicating a desire to save Tatius, cast a light
on another aspect of his "caractère" suggested by the classi-
cal sources.[1] The pale figure of Romulus, with his black,
uncouth beard, is contrasted with the ruddy complexion, and
the curly blond hair, of Tatius.[2] His physical characteris-
tics, combined with a desperate, one might even say grotesque,
pantomime,[3] suggest the ignoble end of a sensual and corrupt
ruler implied in the classical accounts.[4]

Though less studied than the two kings, the remaining
personages of the Death of Tatius are better defined than the
figures of Horatius Killing his Sister. To a certain degree,
their characterization is stressed by an effect of contrast.
Thus, the grotesque pantomime of Tatius is opposed by the

1. For instance in Plutarch: "This led some to say and
suspect that he /Romulus/ was glad to be rid of his colleague."
(Op. cit., I, Romulus, XXIII, p. 165.)
2. This sensual bearded type was often associated with the
so-called "Indian Bacchus" (Winckelmann, op. cit., II, p. 235).
3. This attitude often appears in the Roman representations
of barbarians, as for instance on the Column of Trajan. In
Renaissance art, it was occasionally given to the depictions
of Orpheus dying at the hands of the Thracian women, as can
be seen in a drawing of Giulio Romano, in the Louvre; in an
engraving by an anonymous Ferrarese master, reproduced by
Panofsky (Albrecht Dürer, Princeton, Princeton University
Press, 1945, II, fig. 50), and in a drawing of Dürer in the
Kunsthalle of Hamburg. The resemblance of Girodet's Tatius
to Dürer's Orpheus is striking. It is moreover stressed by
the position of the fleeing boy and the laurel wreath of the
Death of Tatius, which respectively correspond to the cupid
and the lyre of Dürer's drawing.
4. Titus Livius, op. cit., Book I, chap. XIV, p. 33 ;
Plutarch, op. cit., I, Romulus, XXIII, pp. 163-164.

heroic, victorious attitude[1] of the Laurente pressing the
king under his knee. On the other hand, the aristocratic
quality of this figure is contrasted by the ruder physical
features and the more matter-of-fact pantomime of the Laurente
whose Phrygian cap identifies him as a former slave.

Yet, one should not exaggerate the importance of
these characterizations. Thus, the abstract quality of Hora-
tius Killing his Sister is still strongly marked, and identi-
cal physical types are multiplied in different attitudes.
For instance, the type of the Laurente raising a knife is re-
peated in his companion holding Tatius by the shoulder, as
well as in the figure of the sacrificer kneeling on the left
of the picture.[2]

Joseph Making Himself Known to his Brothers (fig. 4)

Hailed by Coupin as the first example of Girodet's
"own feeling" and the "point of departure of his talent,"[3]
this painting represents a new step in the evolution of the
artist. As in the case of Tatius, the content provided by
the source suggested to the painter a new interpretation of
his figures.

1. This attitude frequently appears in classical victorious
figures, such as Mithras (Montfaucon, Bernard de, L'Antiquité
expliquée et représentée en figures, 2 ed., Paris, F. Delaulne,
1722, Seconde partie, Pls. 215, 216, 217), or Lapiths (Les anti
pitture della terme di Tito, no. 24; Willemin, Choix de costumes
civils et militaires, 1798, Pl. 60, no. 260).
2. His attitude imitates one of the figures of Poussin's
Saint John Baptising (Louvre).
3. Girodet, OEuvres posthumes, op. cit., I, Xtice historique
by Coupin, p. iv.

The figures of Joseph's brothers are arranged in a
sequence of emotions. Each personage corresponds to a moment
of the Biblical account. The sequence begins when Joseph,
having sent his servants away, makes himself known to his
brothers[1] and asks them if his father is still living: "And
his brethren could not answer him; for they were troubled at
his presence."[2] This passage corresponds to the manifesta-
tions of shame, remorse, veneration, and mixed confusion
which can be seen in the four figures of the background.
Then, Joseph asks his brothers to come near him.[3] Girodet
depicted the brothers coming from the background toward Jo-
seph and kneeling before him. On the left of the composition,
the brother removing his hat relates the group of the back-
ground to the foreground figures and suggests respect mixed
with fear. Then, in the foreground, from left to right, one
can see in succession the expression of prayer, submission,
humble expectation of hope, and joyful gratitude as the broth-
ers listen to the reassuring words of Joseph: "Now therefore
be not grieved, nor angry with yourselves, that ye sold me
hither: For God did send me before you to preserve life."[4]
They become aware of his pardon: "And God sent me before you
to preserve you a posterity in the earth, and to save your
lives by a great deliverance."[5] The sequence ends with

1. Gen. 45, 1.
2. Idem., 45, 3.
3. Idem., 45, 4.
4. Idem., 45, 5.
5. Idem., 45, 7.

Girodet's depiction of the passage: "And he fell upon his brother Benjamin's neck, and wept; and Benjamin wept upon his neck."[1] Finally, in the painter's interpretation, Joseph's right arm stretched toward his brother suggests the following moment of the Bible: "Moreover he kissed all his brethren and wept upon them."[2]

In spite of Winckelmann's ideal of "beauty at rest"[3] and a general emphasis on a statuesque immobility,[4] it seems that the contemporaries were particularly conscious of the painful fact that "a painted picture is not a moving picture."[5] One frequently finds, in the writings of the time, references to the limitations of the painter "who has only one moment to represent," while poetry "tells what has happened in a succession of moments."[6] Perhaps this was one of the reasons for the vogue of Séraphin's ombres chinoises,[7] and for the enthusiasm which greeted the inventions of Robertson's Fantasmagories[8] and Fulton's Panoramas,[9] devices which created an illusion of movement on a flat

1. Idem., 45, 14.
2. Idem., 45, 15.
3. Rosenthal, op. cit., p. 5.
4. Idem., p. 7.
5. Encore un coup de patte, pour le dernier, ou dialogue sur le Salon de 1787, Deloynes, op. cit., XV, 378, p. 14.
6. Idem., p. 12.
7. Saint-Marc, B. and Boubonne, Marquis de, Les Chroniques du Palais-Royal, Paris, Bolin, 1881, pp. 257-259.
8. Robertson, E. G., Mémoires récréatifs scientifiques et anecdotiques, Paris, 1831, 2 vols.
9. Le Breton, Rapport sur les Beaux-Arts, 1803, pp. 89-92.

surface. It is significant to note that all these devices
were attempting to solve the problem of progression in time.

In spite of the example of Michelangelo[1] and many
others, the representation of the same personage several
times in one painting was strictly forbidden in the French
academic tradition. Thus, Girodet himself wrote: "Poetical
ordinance will not allow /the artist7 to . . . represent the
same /personage7 at different ages and circumstances of his
life."[2] However, a scheme in which different personages are
placed so as to indicate the successive stages of a progres-
sion in time provided an acceptable solution which supple-
mented the chronological suggestiveness of the "composite
passions." On a limited scale, Girodet had already applied
this idea in Horatius. In that painting, the figures of the
three women (fig. 2) are arranged in an order which suggests
the consecutive moments of Camille's reaction to Horatius'
threats: fear, supplication, and death.[3] Similar effects
had already been used frequently before Girodet's time, as
may be seen in Raphael's Finding of Moses[4] or Poussin's Saint
John Baptizing.[5] David was to use an identical device in the

1. Temptation and Expulsion from Paradise, Sistine Chapel.
2. Girodet, OEuvres posthumes, op. cit., II, De l'Ordon-
nance en peinture, p. 212.
3. This group, composed of the dead Camille and of the
Roman women, seems to have been inspired by the description of
Noverre (Les Horaces, op. cit., Troisième partie, scene II,
pp. 25-26.
4. Loggia.
5. Louvre.

central group of women of the Sabines.[1] In this type of com-
position, the painter forcefully establishes "the relation of
the moment which he has chosen to that which must follow."[2]
This effect is achieved by the figures in relation to each
other, by allusion. Still, their respective individual,
literal meaning is preserved, and the painter remains faith-
ful to the "unity of action, time, and place, rigorously re-
quired by reason."[3] In Girodet's Joseph Making Himself Known
to his Brothers (fig. 4), this idea was used to the fullest
possible extent. It is, perhaps, the most perfect example of
its kind. The pantomimes of the personages of the foreground
are almost conceived like links of a continuous chain or like
consecutive images of a slow-motion film.

While still borrowing from the repertory of the David-
ian circle,[4] Girodet's painting shows signs of a new and im-
portant influence, that of the "divine Raphael."[5] Thus, the
general idea of the composition is reminiscent of The Meeting
of Solomon and the Queen of Sheba,[6] and the "slightly mannered"[7]

1. In 1799 (Louvre).
2. Girodet, OEuvres posthumes, op. cit., I, Notice his-
torique by Coupin, p. xxxv.
3. Girodet, OEuvres posthumes, op. cit., II, De l'Ordon-
nance en peinture, pp. 209-210.
4. For instance the half-hidden figure of one of Joseph's
brothers in the background of the painting was taken over, with-
out any change, from J. B. Drouais' Canaanite Woman. Another ex-
ample can be seen in the figure of the oldest of Joseph's brothers,
in the left foreground, evidently inspired by David's Saint Roch.
5. Girodet, OEuvres posthumes, op. cit., I, Le Peintre, Chant
VI, p. 197.
6. Loggia.
7. Girodet, OEuvres posthumes, op. cit., I, Notice histo-
rique by Coupin, p. iv.

movement of Benjamin is derived from one of the flying fig-
ures of the Transfiguration, from which also comes the head
of the oldest brother. Besides this influence, the person-
ages of Joseph Making Himself Known to his Brothers, in com-
parison to the types of Horatius (fig. 2) and Tatius (fig. 3),
show a more subtle age scale and a more individual quality,
which can be seen in such details as the shape of a nose or
the baldness of a head.

Moreover, it may be noted that in this painting, the
pantomimes seem to be rounder, more organic, and devoid of
the automaton-like rigidity of the earlier figures. Girodet's
interpretation indicates certain refinements in the applica-
tion of the ideas of the "composite passions." One of them
may be seen in the introduction of the principle of "opposi-
tion." Montabert explained this concept by saying that in
regard to gestures, "certain movements manifest themselves
with much more meaning and power, when they are opposed to
movements of another character."[1] The basic theory of the
"composite passions" is preserved, and complex "passions" are
still understood as combinations of simpler emotions. How-
ever, it is necessary, "in order to express life and to extend
the realm which the painter leaves to the imagination,"[2] to
select the constituent gestures and emotions of a given panto-
mime for their contrasting qualities. It is significant to

1. Montabert, op. cit., V, p. 486.
2. Idem., p. 487.

note that the figure of Arria in Vincent's Paetus and Arria
was praised in 1775 by one of the critics of the salon be-
cause it showed "the most happy and most ingenious accordance
of the most violent and most contrasting emotions."[1] Besides
being applied to underline the psychological conflicts within
the same figure, the principle of "opposition," in Montabert's
opinion, could also be used to stress the element of time.
This application of "opposition" was called by the author of
the Théorie du geste "demi-chemin d'action,"[2] showing "what
the figure has just done and what it will do later."[3]

In Joseph Making Himself Known to his Brothers (fig.
4), the figure with a bare shoulder stooping in the fore-
ground provides the best illustration of Girodet's applica-
tion of these ideas. In this figure, the body and the legs
describe the action of stooping, which, in relation to the
Biblical account, suggests self-abasement and submission.
However, the half-bent arm and the raised head indicate a
contrasting movement upward, which must be understood as the
hopeful expectation caused by the first words of Joseph. The
transitory quality of this attitude is stressed by the shift-
ing equilibrium of the body, the left foot resting only on
the toes, and the right arm represented in an intermediary
position. Thus, the conception of this pantomime emphasizes

1. Madame E. A. R. T. L. A. D. C. S., Avis important d'une
femme sur le Salon de 1785, Deloynes, op. cit., XIV, 344, p. 25.
2. Montabert, op. cit., V, p. 486.
3. Idem., p. 487.

the interruption of one movement and its change into another,
opposed movement: the transformation of one "passion" into
another contrasting "passion." This accentuation of the ele-
ments of interruption, opposition, and transformation under-
lies the difference between the "demi-chemin d'action" of the
foreground figures of Joseph and the "composite passions" of
the personages of Horatius.

However, from the point of view of characterization,
the improvement is only a limited one. The pantomimes and
the "passions" of the personages of Joseph are not particu-
larly adapted to their physical types or specified so as to
suggest the elements of their "caractères." The latter are
indicated in Joseph's brothers only by the factors of age, a
few physical differentiations, and general opposition to the
personality of Joseph. This opposition emphasizes the social
rank and the moral nobility of the latter, but gives very
little definition to the remaining personages.

The interpretation of the pantomimes as transitory
"demi-chemins d'action" stresses their interdependence. The
meaning of individual figures can only be completely grasped
in their relation to each other. Thus, Girodet stressed a
unified emotional progression through several figures. The
changing quality of the attitudes underlines the emotional-
ism of this general movement of "passion" by bringing about
an element of speed.

Hippocrates Refusing the Presents of Artaxerxes (fig. 6)

This last work of the classical historical series
was painted in Italy, outside the immediate influence of
David. Perhaps for this reason, it shows definite signs
pointing toward an evolution of Girodet away from orthodox
Davidism.

It must be noted that these new trends did not lead
the artist to abandon whatsoever the eclectic approach which
so frequently appeared in his earlier paintings. Eclecticism,
far from being considered as blameworthy, was practically
raised by Girodet to the dignity of a theory. From this
point of view, he made his own J.- J. Rousseau's idea that

"nothing is more proper to elevate our soul and fill it
with this warmth which produces great things than the
admiration which we feel at the sight of the works of
great men."[1]

Thus, in his Veillées, Girodet unequivocally gave the follow-
ing advice to the young painters:

"The warrior in the camps must study Caesar:
As for you, imitate Poussin, Raphael, Leonardo."[2]

Naturally, he did not advocate unqualified plagiarism, and
believed that "The work of a copyist is a banal work."[3] The

1. Quoted in Girodet, OEuvres posthumes, op. cit., I, Le
Peintre, Notes du Chant I, p. 233.
2. Girodet, OEuvres posthumes, op. cit., I, Veillées, I,
p. 352.
3. Idem., p. 365.

painter imitating the great masterpieces should, in his opin-
ion, follow a more subtle path:

> "Know therefore how to marry with discernment
> Your real feeling to the feeling of others."[1]

According to Girodet, this method was sanctified by the ex-
ample of the greatest masters and particularly by Raphael:

> "In this path again let Raphael guide you:
> From the old Tuscan masters, from the timid Perugino
> He ravishes beauties of which he was fond,
> And which under his brushes have contupled in value."[2]

Even the errors of the great masters can become profitable.
Thus, a painter whose style has a tendency toward an exces-
sive softness may usefully undergo a cure of Michelangelo,
who "has too much austerity in his line."[3] Girodet believed
that, as a result, beauty would be created "from a double
defect."[4]

In Hippocrates, as in the earlier works of the group,
J. B. Drouais is still one of the most important sources of
inspiration. The attitude of the old man in the foreground
of the Canaanite Woman is imitated in Hippocrates by the
satrap holding the tiara and the sword. The hand gestures of
the same model are given to Artaxerxes' envoy extending his

1. Girodet, OEuvres posthumes, op. cit.,I,Veillées, I,p.365.
2. Idem.
3. Idem., p. 347.
4. Idem.

empty hands toward the physician. Similarly, the pantomime
of Hippocrates himself was borrowed by Girodet from another
of Drouais' paintings, Marius at Minturnae.[1] Considering
other contemporary influences, one may note that the group-
ing of the personages at the extreme left of the composition
of Hippocrates is strongly reminiscent of the corresponding
part of Vincent's Zeuxis Choosing his Models among the Most
Beautiful Maidens of Crotona.[2] It is almost needless to
stress the obvious influence of the antique. It will be suf-
ficient to recall that the Capitoline bust of Hippocrates
served as a model for its counterpart in Girodet's painting.[3]
Raphael, whose influence had been so important in Joseph, was
not forgotten in Hippocrates. This may be seen in the dis-
position of the figures in the central part of Girodet's
painting, which is strongly reminiscent of the grouping of
the Apostles of the Delivering of the Keys to Saint Peter.[4]

In the midst of this eclectic mixture, several borrow-
ings from the Last Supper show the appearance of the new in-
fluence of Leonardo. The figure of the Greek leaning on a
table beside Hippocrates imitates the attitude of the Apostle
on the extreme left of the painting in Milan. Similarly, the
gesture of Saint Thomas is given to a young Persian on the

1. Louvre.
2. Louvre. 1789.
3. Girodet, OEuvres posthumes, op. cit., II, Correspondance,
Letter XLIX, to Trioson, Rome, July 25, 1792, p. 415.
4. Reproduced in the Vatican tapestry.

right of Girodet's composition. Moreover, beside the latter
figure, a satrap seems to repeat in reverse the attitude of
Judas. Finally, it may be said that the general arrangement
of Hippocrates, with its distinct and compact groups, suggests
Girodet's awareness of the composition at Santa Maria delle
Grazie. The sight of Leonardo's fresco seems to have made a
tremendous impression on the young Girodet, who, passing in
1790 through Milan on his way to Rome, wrote to a friend:
"It is one of the most beautiful and most admirable paintings
that I have yet seen."[1] At the end of his life, the painter
recalled his youthful fervor and especially his admiration
for the head of Leonardo's Christ, which he still remembered
"after more than thirty years."[2] At the end of the monarchic
period, Girodet's attitude was paralleled only by the enthu-
siasm of Prud'hon, who spoke of the "father, the prince, and
the first of all painters."[3]

It must be emphasized that Girodet's eclecticism sel-
dom implied an undiscriminating and unqualified borrowing.
In his Hippocrates, as well as in his earlier paintings, the
artist used his sources as a mine, from which he could derive
material which was to be re-modelled and re-adapted to new

1. Letter to a friend, June 1790, quoted in Girodet, OEuvres
posthumes, op. cit., I, Le Peintre, Notes du Chant I, p. 214.
2. Girodet, OEuvres posthumes, op. cit., I, Le Peintre,
Notes du Chant I, p. 213.
3. Letter quoted in Goncourt, Edmond et Jules, L'Art du
XVIIIme siècle, Paris, Bibliothèque-Charpentier, E. Fasquelle
ed., 1914, III, p. 374.

content. It may be recalled that this was the accepted
method of all the Davidians, who never hesitated to use for
their own ends the repertory of images provided by Antiquity
or any other period of art history. Thus the eclectic atti-
tude of Girodet is not in any way suggestive of sterility.
Its significance lies in the fact that it reflects the typi-
cal contemporary approach to the concept of invention.

At any rate, Girodet's inventiveness is clearly mani-
fested in his reinterpretation of the previously mentioned
borrowed elements. Reminiscent of the conception seen in
Joseph (fig. 4), the various psychological attitudes of the
personages of Hippocrates (fig. 6) are arranged so as to form
a sequence. Thus, in reaction to the negative answer of the
Greek doctor, the Persians show in succession hypocrisy, im-
patience, tearful sorrow, humiliation, lack of understanding,
attempt to find new arguments, anger, melancholy resignation,
and final despair. On the opposite side, the Greeks express
stoic aloofness, greed, and hesitation. However, in contrast
to Joseph, the pantomimes of Hippocrates are not conceived as
closely interdependent "demi-chemins d'action" suggesting
the successive images of a slow-motion film. Girodet did not
stress their transitory quality in the general emotional pro-
gression.

With the exception of Hippocrates' head and Girodet's
self-portrait at the extreme left of the composition, the phy-
sical types of the painting do not show any real individual

quality. Yet, Girodet's tendency to subdue the abstractions
of Horatius, a tendency which was already noted in the case
of Tatius and Joseph, is even more marked in his interpreta-
tion of the personages of Hippocrates. The age scale and the
social factor, though clearly indicated, are no longer the
most important elements of physical definition. There is a
new ethnic quality, marked by a "saffron"[1] coloration of the
skin, which, besides the garb, differentiates the Greeks from
the Persians. Moreover, within these ethnic groups, differ-
ences in the details of headdresses; shades of skin colora-
tion; and, to a lesser degree, suggestions of muscular strength
and changes of features, contribute to the definition of the
figures. One feels Girodet's concern with diversifying phy-
sically his personages within the limits of a general ideali-
zation. This method results in the creation of a great number
of physical types which are not individualized but varied.

The gestures and the facial expressions of the fig-
ures are still based on an analytical mechanism. Neverthe-
less, they are no longer conceived as completely impersonal
vehicles of "passions." The personages of Hippocrates show
the artist's definite interest in facial expression. This
quality is much more marked than in the previous paintings.
The facial expressions suggest with clarity various psycholo-
gical states, some of which, such as shrewdness, are of a

1. Polyscope, Quatrième lettre sur les ouvrages de peinture,
sculpture, etc. exposés dans le grand Salon du Museum, De-
loynes, op. cit., XVIII, 474, Ms., p. 589.

rather complicated nature. By coördinating this physiognomical play with the gestures of his figures, Girodet achieved in the expression of his pantomimes a greater coherence and intensity. Adapted to a particular physical type, the pantomime now provides further information for the understanding of this type. It has a descriptive quality reaching beyond the literal action or emotion of the personage. Following the principle of "suitability," it is particularized so as to contribute to the delineation of a definite "caractère." Girodet's new attitude may be illustrated in several instances. The pantomime of the satrap placed behind Hippocrates' left arm is not only that of any man engaged in persuasion. The carefully arranged blond curls of his headdress and the paleness of his face underline the fox-like expression of his smile and the mannered elegance of his self-assured attitude, so as to describe a courtly hypocrite. On the other hand, the tanned, rude features, the muscular neck, and the violent pantomime of the Persian placed in front of the door on the right describe the anger of a man of a less refined nature and marked by brutal, animal strength. Thus, elements of morality and temperament give a new color to these personages. Their personality is not, as it was in the previous paintings, the result of a more juxtaposition of "passions" or actions provoked by a dramatic moment. They are brought closer to revealing certain permanent qualities of the "disposition of their soul,"[1] as it was called by Montabert.

1. Montabert, op. cit., V, p. 363.

Characterization is also achieved in other figures
of the painting through the quality of "naïveté," which was
defined by Montabert as follows:

"Naïveté in the gestures exists every time that the
intentions of the actor do not take part in it, that is,
every time that the actions and the movements are exe-
cuted when the personage is not preoccupied with the way
in which he executes them."[1]

This may be illustrated in the figure of the Greek leaning on
the table at the left of Hippocrates and looking at the offer-
ings brought by the Persians. His face expresses an admiring
surprise, while his right hand nervously grasps the edge of
his cloak. This gesture has a subdued unconscious quality.
Though not specifically adapted to the physical type of this
personage, the very restraint and unconsciousness of his ex-
pression of greed gives an insight into his "caractère" and
delineates it more forcefully than conventional manifesta-
tions of remorse or respect do in Joseph.

In Hippocrates, the neutral personages are almost
completely eliminated. To various degrees, it is possible to
define the "caractères" of the great majority of the figures.
It may be said that the "variety in the expressions as well
as in the postures," which was considered by Coupin as mark-
ing the beginning of Girodet's "own feeling"[2] in Joseph,

1. Montabert, op. cit., V, p. 363.
2. Girodet, Oeuvres posthumes, op. cit., I, Notice his-
torique by Coupin, p. iv.

is much more completely realized in <u>Hippocrates</u>. Without any ambiguity, Girodet, in one of his letters to Dr. Trioson, stated his goal in the interpretation of the personages of this painting: "I have endeavored, as much as I could, to vary and characterize the expressions."[1]

These characterizations, often involving the elements of morality and temperament, give a certain cohesion to the personages, a quality which is further stressed by a psychological coördination of the facial expression and of the gestures. These factors make the analytical mechanism of the pantomime less conspicuous. Thus, in <u>Hippocrates</u>, the successive stages of the psychological progression are not marked by different "passions," but by different "caractères."

It may be seen that the consideration of the human figure in Girodet's historical paintings, from 1785 to 1792, shows a shift of emphasis from the concept of "passion" to that of "caractère." An attempt must be made to establish the causes and to interpret the meaning of this development. Simultaneously with the interest in the expression of "passions," at the end of the eighteenth century, indications point toward a growing importance of character study. This new interest was related to complex cultural developments. One of them was what Laprade called the "invasion of the individual character."[2] Beginning with J.-J. Rousseau, this

1. Girodet, <u>OEuvres posthumes</u>, <u>op. cit.</u>, II, <u>Correspondance</u>, Letter L, to Trioson, Rome, October 3, 1792, p. 418.

2. V. de Laprade, <u>Le sentiment de la nature chez les modernes</u>, 1868, p. 184, quoted in Monglond, <u>op. cit.</u>, II, p. 119.

rise of "égotisme"[1] resulted in a multiplication of autobiographies and Journals.[2] At the same time, one could note a growing fashion for English literature and particularly for Shakespeare, with his complex psychological types. More specifically, this interest in character study was related to the enthusiasm for mental science shown by the late Encyclopedists such as Camper and Cabanis. These trends culminated in another realm with the fashion for Gall's Phrenology and especially for Lavater's studies on Physiognomy, which strove to establish a series of permanent correspondences between the concept of character on the one hand, and the physical type, the physiognomical and pantomimic expression, on the other.[3] The growing importance of this concept at the turn of the century was typically reflected by Stendhal, who in 1804 wrote in his Journal: "Comedy has a great advantage over tragedy, it is to depict characters; tragedy only depicts passions."[4]

At the same time, this trend exerted a great influence in the development of ideas on art. In the late eighties, Prud'hon wrote in one of his letters from Italy:

> "I should say that we are too much occupied with what makes a painting and not enough with that which gives a soul and energy to what it must represent . . . We are

1. Monglond, op. cit., II, pp. 346-355.
2. As for instance those of Rouveau, Restif de la Bretonne, Madame Roland, Chabanon, etc.
4. Stendhal, Journal, Paris, Le Divan, 1937, I, June 6, 1804, p. 135.
3. As can be for instance illustrated by his passage on Socrates (Lavater, John Caspar, Essays on Physiognomy, T. Holcroft trans., 3rd ed., London, Blake, 1840, p. 115).

even occupied with the passions presented by the subject,
but that which we no longer think about, and which is the
principal goal of these sublime masters who wanted to im-
press our soul, is to depict forcefully the character of
each figure, which, being moved by the feeling of this
very character, carries in itself a life and a truth
which grasp and touch the spectator."[1]

Similarly, much later, around 1817, Girodet stated in his De
l'Ordonnance en peinture: "Poetical ordinance, basing itself
upon the data of history or mythology, will especially specify
the character, the age, the actual state of the personages."[2]
Comments referring to the concept of character frequently oc-
curred in the art criticism of the end of the eighteenth and
the beginning of the nineteenth century. The "ultra-ideal-
ists" recognized only the "characters consecrated by mythology"
and those "assigned to heroes in the art of the ancients.[3]
However, Vien, whom Girodet called the "Nestor of his art,"[4]
warned the young painters against using indiscriminately and
"too customarily the features worthy of being exclusively re-
served for the majestic representation of gods."[5] Moreover,
Landon, speaking about Meynier's Saint Vincent de Paul, wrote:
"One regrets that the artist did not have at his disposal the
portraits of some of his personages; their physiognomies would
have offered a more striking character."[6]

1. Quoted in Goncourt, L'Art du XVIII^e siècle, op. cit,
III, p. 377.
2. Girodet, OEuvres posthumes, op. cit., II, De l'Ordon-
nance en peinture, pp. 209-210.
3. Montabert, op. cit., V, pp. 537-542.
4. Girodet, OEuvres posthumes, op. cit., I, Le Peintre,
Chant VI, p. 195.
5. /Chaussard/, Le Pausanias français, op. cit., p. 68.
6. Landon, C. P., Salon de 1824, Annales du Musée, Paris,
Landon, p. 43.

In addition, contemporary art criticism showed evi-
dent signs of a direct influence of Lavater's ideas. In 1785,
a critic of the salon wrote: "the artists . . . do not study
enough . . . physiognomies and physical temperaments."[1] Be-
noit noted that Süe "ever since 1788 . . . was recommending
that the artists consult 'the famous Lavater.'"[2] In 1797,
Le Mercier had a lengthy discussion on Physiognomy with a
"disciple of Lavater."[3] Nothing can better illustrate La-
vater's influence on art criticism than the Pausanias fran-
çais, in which Chaussard wrote in 1806:

> "It is necessary . . . to express not only the char-
> acter but its different shades . . . Anatomical science
> comes to the artist's help and teaches him to move the
> parts of the body agitated by a passion. And first of
> all, the construction of a head reveals genius or stupid-
> ity; then the movement of the muscles is the complement
> of the expression: it is in this manner that the shape
> and the movement of the lips indicate carelessness or a
> firm will. Finally, it is in the actions . . . of men
> that the artist must look for the feature which completes
> their resemblance."[4]

There is no doubt that Girodet was well acquainted
with Lavater's ideas. Thus, in his Le Peintre, the artist
strongly advocated the example of the famous Swiss:

1. Réflexions impartiales sur les progrès de l'art en
France et sur les tableaux exposés au Louvre, Londres et
Paris, 1785, Deloynes, op. cit., XIV, 331, p. 25.
2. Benoit, op. cit., p. 217.
3. Réponse à cette observation de Le Mercier /par un/ dis-
ciple de Lavater, Deloynes, op. cit., XIX, 506, Ms.
4. /Chaussard/, Pausanias français, op. cit., p. 481.
Chaussard was evidently influenced by both Lavater and Gall.
Thus he criticized the figure of Ariosto in Bergeret's Death
of Raphael because "one does not find there this forehead of
the genius, this os magna sonaturum." (Idem., p. 97.)

"The painter, ingenious disciple of the learned Lavater,
Also observes with a curious eye,
The countenance, the color, the shape of the face;
He distinguishes a stupid man from a coxcomb, a fool from
a wise man."[1]

Earlier signs of Girodet's interest in Lavater may be
seen in a series of caricatures[2] (fig. 10) imitating certain
illustrations of Tome I of the 1781 French edition of Lavater's
studies.[3] Moreover, it seems that some figures of Hippocrates
(fig. 6) are related to Lavater's passage on temperaments,[4]
and more specifically to one illustration of the Essays on
Physiognomy. It is an engraving representing four person-
ages looking at the Farewell of Calas by Chodowiecki.[5] Each
figure stands for and acts according to one of the tempera-
ments. The choleric, "angular, contracted, and stamping,"
thinks of a "powerful revenge."[6] This description by Lavater
of the mood and the attitude of this personage who in the en-
graving is represented erect, his arm akimbo, and violently
turning his head, is strongly reminiscent of the figure of
the angry satrap standing before the door in Hippocrates.
The sanguine, shedding "ineffectual tears"[7] with a handkerchief

1. Girodet, OEuvres posthumes, op. cit., I, Le Peintre,
Chant II, p. 101.
2. Carnet de Rome, Bibliothèque Nationale, Cabinet des
Estampes, Paris.
3. Lavater, J. G., Essai sur la physiognomie destiné a faire
connoître l'homme et à le faire aimer, La Fite, Caillard, and
Reufner trans., La Haye, 1781-1803, I, p. 187.
4. Lavater, Holcroft trans., op. cit., p. 331.
5. Idem., Plate LIII, facing p. 331.
6. Lavater, Holcroft trans., op. cit., p. 331.
7. Idem.

held against his face, reminds one of the crying Persian on
the extreme right of Girodet's painting. Finally, the melan-
cholic, who "has no elasticity, exclaims not, but is oppressed,
bowed to the ground,"[1] seems to find his counterpart in the
satrap sadly standing in the extreme right foreground of Hip-
pocrates.

It may be noted that Lavater's concepts also influ-
enced Girodet from another point of view. The Swiss author,
far from describing only virtues, depicted a complex humanity
in which vices were given as much importance as good qualities.
Similarly, in his Hippocrates, Girodet, /in/stressing the moral
elements of his personages, juxtaposed virtuous and vile
"caractères."

The moral contrasts of Hippocrates may be understood
as conceived to emphasize the virtue of the hero. However,
it may be noted that this device was seldom if ever used
either by David or by his most orthodox followers. It would
be difficult to find in the entire historical production of
David one personage suggesting vulgarity or vice. Naturally,
outside the Davidian circle, painters still under the influ-
ence of the baroque tradition, like Barthélémy, did use oppo-
sitions of characters in their works.[2] Yet, most often, these
oppositions were limited to a contrast between noble and

1. Lavater, Holcroft trans., op. cit. p. 331.
2. The Prophet Eleasar Refusing to Eat the Forbidden Meat,
1789, Angers.

virtuous types on the one hand, and vulgar and brutal ones on
the other. The latter were not given serious consideration
and were conceived only as moral repoussoirs. It is, there-
fore, important to note that in Hippocrates Girodet gave at
least as much significance to vice as to virtue.

Thus, the didactic meaning of the school of David is
changed and complicated in Girodet's Hippocrates. The moral
lesson is no longer based on illustrious examples of virtue
alone, but, as in the poem La Conversation by Girodet's
friend Jacques Delille, on "the double example of good and
evil."[1]. Moreover, the evil of the personages of Hippocrates
is not of a pathetic and tragic kind. Each one of the im-
moral "caractères," such as the hypocritical satrap or the
greedy Greek, is conceived, like Delille's personages, as
"a comic scene."[2] These figures suggest vileness or ridicule
as much as evil, and belong to the realm of comedy or of genre
painting more than to the field of tragedy or heroic histori-
cal painting. Girodet's interest in the concept of "carac-
tère" by itself suggests his overstepping the recognized
borders of heroic painting. In French classical literature,
the study of "caractères" was traditionally the concern of
the comic mode,[3] while the play of "passions" was reserved

1. Delille, J., OEuvres, Paris, Lefèvre, 1844, II, La Con·ver-
sation, p. 196.
2. Idem., p. 197.
3. Le Sage wrote: "The authors want all the attention of the
spectators for the character." (Critique de Turcaret par le
Diable boiteux, quoted in Abry, Audic et Crouzet, Histoire il-
lustrée de la littérature française, Paris, Didier, 1931, p.292.)

for the tragic and the heroic genre.[1] From this difference
of emphasis was derived the tradition of a tragic circle of
"passions" and of a comic repertory of "caractères." These
ideas, and the accepted superiority of tragedy over comedy --
in other words, the play of "passions" over the description
of "caractères" -- were one of the bases for literary classi-
cism. This conception was transposed into Davidian painting.
Strong delineations of "caractères" were abandoned to genre,
while historical painting was chiefly concerned with the
"passions" of ideal personages. Girodet's historical paint-
ing started with Horatius, in the realm of classical heroic
tragedy, but ended, in Hippocrates, by infusing into the
classical drama elements of comedy and genre. This develop-
ment of Girodet's interpretation strikingly diverged from
that of David. It enriched but dangerously extended the tradi-
tional conception of historical painting.

In the late eighties and early nineties, historical
painting showed a tendency toward a general complication, a
multiplication of incidents, and a certain degree of psycho-
logical elaboration. Thus, very often historical themes were
criticized because of the "complicated, confused" quality of
their action.[2] This trend can be illustrated by a comparison

1. Racine wrote that the action of the tragedy "is only
sustained by the interests, the sentiments and the passions of
the personages." (Première préface de Britannicus, in OEuvres
complètes, Paris, Hachette, 1856, I, p. 195.)
2. Encore un coup de patte, pour le dernier, ou dialogue sur
le salon de 1787, Première partie, Deloynes, op. cit., XV, 378,
p. 14.

of such paintings as David's Oath of the Horatii or Drouais'
Canaanite Woman painted in 1784 with David's Death of Socra-
tes (1787), or Vincent's Zeuxis Choosing his Models among the
Most Beautiful Maidens of Cortona (1789). From this compari-
son, it can be seen that the painters were led to accumulate
inventions and ingenious details. This trend is fully paral-
leled in Girodet's development from the simplicity of Horatius
to what Baudelaire called the "witty details"[1] of Hippocrates.
However, Girodet's type of characterizations and his combina-
tion of elements of tragedy and comedy are, so far as I know,
only comparable to the conception of one other painting, by
his friend Gérard: Joseph Making Himself Known to his Broth-
ers.[2]

It is difficult to isolate Girodet's pictorial study
of vile "caractères" from his state of mind at the time of
the execution of Hippocrates. Before his Italian trip, he
wrote to Gérard: ". . . it is very hard . . . to learn to
know society only to despise it."[3] A little later, describ-
ing the French Academy at Rome, he wrote about the "secret
intrigues, the conflict of characters, more or less dishonesty
in the motives . . . Doctors, wit makers, shrewdly ambitious

1. Baudelaire, Charles, Curiosités esthétiques, Paris, Co-
nard, 1923, Le Musée classique du Bazar Bonne-Nouvelle, p. 210.
2. 1789, Angers. This work received the second place be-
hind the painting of Girodet.
3. Lettres adressées au baron François Gérard, op. cit., I,
Châtillon, December 30, 1789, p. 128.

people, horses, and especially many sheep."[1] He concluded by
saying that "if it is a summary of the school of the world,
it seems to me that the lessons here are very disgusting."[2]
These ideas are exactly applicable to the conception of Hip-
pocrates, in which even the disciples of the great Greek doc-
tor show greed.[3] Thus, the hero is misunderstood by his own
followers. It may be suggested that these signs of misan-
thropy only reflected the general fashion of the time. It
was good taste to have, like Rousseau, a pessimistic view of
civilized humanity. A man of some repute was often described
as surrounded by "the boredom, stupidity, and low malicious-
ness of people."[4]

Writing about Hippocrates Refusing the Presents of
Artaxerxes, exhibited in 1846 at the Musée classique, Charles
Baudelaire was struck by Girodet's "multiplicity of inten-
tions."[5] These words graphically describe the diversity of
the goals which the painter simultaneously aimed to reach in
his historical group. Girodet magnified the various contem-
porary concepts and attempted to fuse them without selection

1. Lettres adressées au baron François Gérard, op. cit.,
I, Rome, September 1790, p. 158.
2. Lettres adressées au baron François Gérard, op. cit.,
I, Rome, September 28, 1790, p. 102.
3. It is significant to note that, among the Greek follow-
ers of Hippocrates represented in the painting, only the fig-
ure of Girodet himself is depicted as being completely aloof
to the propositions of the Persians.
4. Sébastien Mercier, J.-J. Rousseau considéré comme un
des premiers auteurs de la Révolution, p. 250, quoted in
Monglond, op. cit., II, p. 178.
5. Baudelaire, op. cit., p. 210.

or emphasis. The realm of historical subject matter became too narrow for the artist's multiple aims. He had a choice between going back to a more orthodox Davidism or completely breaking the classical mold. Significantly, Hippocrates was the last historical painting of any importance before Girodet's late return to Davidism in the last years of his life.

CHAPTER II

EARLY RELIGIOUS PAINTING

CHAPTER II

EARLY RELIGIOUS PAINTING

In a general manner, this group corresponds to the
same phase of Girodet's productivity as his series of the
Prix de Rome. With the exception of two extant paintings,
it is chiefly composed of works known only by the titles
mentioned in the Catalogue of Pérignon.[1] However, these
two extant paintings (figs. 11 and 12), both based on the
theme of the Pietà,[2] have a unique importance in the opera
of the artist, as well as in the development of religious
painting at the end of the eighteenth century.

Religious painting, in spite of frequent statements
to the contrary,[3] still held an important place in the

1. Op. cit.
2. The first is a small oil sketch in the Fabre Museum (fig.
11); the second, signed and dated 1789, is a large painting in
the Church of Montesquieu-Volvestre (fig. 12).
3. As for instance Louis Gillet (La Peinture au Musée du
Louvre, I, Ecole française, XVIIIᵉ siècle, Paris, L'Illustra-
tion, 1929, p. 21).

eighteenth century.[1] This importance was particularly strik-
ing at the beginning of the second half of the century. Thus,
as noted by Locquin, the religious works of Natoire, Pierre,
and Parrocel formed "the most important pictorial ensemble
produced by the school since . . . the decoration of the
church of the Invalides and the chapel of Versailles."[2]
Moreover, some of the most significant paintings of the
period, as for instance Vien's Saint Denis Preaching in
France[3] or Doyen's Miracle des Ardents,[4] were based on reli-
gious subjects. As pointed out by Locquin,[5] it is undeniable
that the last quarter of the century corresponded to a cer-
tain decline in the production of religious paintings. How-
ever, they were far from having completely disappeared.
Thus, the ten years which preceded the Revolution were marked
by the execution of such important works as Suvée's Birth of
the Virgin,[6] David's Saint Roch,[7] and Regnault's Descent from
the Cross,[8] besides a considerable number of other religious
paintings.[9] As can be seen, Girodet's religious productions

1. Thus Alfred Leroy recalled the 68 paintings and the 125
drawings forming the religious production of Boucher (Histoire
de la peinture française au XVIII^e siècle, Paris, Albin Michel,
1934, p. 8).
2. Locquin, op. cit., p. 258.
3. 1767, Church of Saint Roch, Paris.
4. 1767, Church of Saint Roch, Paris.
5. Locquin, op. cit., p. 272.
6. 1779, Chapel of the Assumption, Paris.
7. 1780, Marseille.
8. Exhibited in the Salon of 1787.
9. From this point of view, it is sufficient to consult the
salon pamphlets of these years. The view of the Salon of 1787
represented in an engraving, reproduced in F. H. Taylor's The
Taste of Angels (Boston, Little, Brown & Co., 1948, facing
p. 512), gives a clear idea of the relative importance of con-
temporary religious painting.

were by no means isolated in the contemporary pictorial production.

Even a casual comparison between Joseph Making Himself Known to his Brothers (fig. 4) and the Pietà of Montesquieu-Volvestre (fig. 12), both executed in 1789, is sufficient to reveal how much Girodet's interpretation of religious subjects could diverge from Davidian rationalism when the painter was free from the ideals of the Prix de Rome. This impression becomes perhaps even more forceful when one compares the same Pietà to any one of the artist's early paintings based on classical history. The uniqueness of Girodet's interpretation of religious themes, when he was free from the Academic requirements must be evaluated in regard to three factors: the painter's attitude toward religion, his character, and the contemporary development of religious painting.

Girodet's attitude toward religion is difficult to define. There is little doubt that he came from a churchgoing, Catholic family. From this point of view, one can note that his aunts were nuns,[1] and one may recall that his maternal grandfather was expéditionnaire to the Papal Court.[2] As appears from a passage of Le Peintre, some of the artist's earliest aesthetic emotions seem to have been related to a religious atmosphere:

1. Girodet, OEuvres posthumes, op. cit., II, Correspondance, Letter XLIX, to Dr. Trioson, Rome, July 25, 1792, p. 416.
2. Supra, p.5, note 1.

> "The dark altar painting which, while listening to Mass,
> He incessantly contemplates, without seeing the officiant,
> The old woodcut in his Old Testament
> Plunge him into ecstasy and rapture."[1]

However, during the early years of the Revolution, which
roughly correspond to the execution of his religious paint-
ings, Girodet's opinions seem to have been very far from sug-
gesting an orthodox Catholicism. This appears in one of his
letters to Gérard, in which he frankly expressed his ironical
hostility toward the Papacy, as well as his complete indiffer-
ence to excommunication and to the possible schism between
the Gallican and the Roman church.[2]

However, neither of these factors played a determin-
ing role in the formation of Girodet's religious convictions.
His later writings are full of contrasting ideas ranging from
a fiery anti-clericalism[3] to a conformist piety.[4] Thus, it
is evident that these ideas should not be taken too seriously,
and it is doubtful whether Girodet had any coherent religious
beliefs. Most probably, like many of his contemporaries, he
was simultaneously influenced by a multitude of confused and
half-understood concepts derived from Rousseau's _Profession_
de foi d'un vicaire savoyard, orthodox Catholicism, and

1. Girodet, _OEuvres posthumes_, _op. cit._, I, _Le Peintre_,
Chant I, p. 53.
2. _Lettres adressées au baron François Gérard_, _op. cit._,
I, Rome, April 18, 1791, p. 166.
3. See for instance Girodet, _OEuvres posthumes_, _op. cit._,
I, _Le Peintre_, _Chant_ VI, p. 183.
4. See for instance _Idem._, p. 185.

Encyclopedic rationalism. These ideas permeated with the
current Illuminism, which Viatte described as a "taste for
voiled things, with a mystical and allegorical meaning,"[1]
resulted in the formation of a vaguely esoteric, often con-
tradictory, and primarily emotional deism. Girodet's emo-
tional attitude toward religion is vividly reflected in a
passage of his Veillées advising young artists to read the
Bible, "this immortal book" in which "everything is noble,
lofty, terrible, solemn":[2]

> "Read the seraphic odes of the Hebrew Pindar;
> Read the melancholy songs of the holy oracles."[3]

These feelings corresponded to the very essence of
Girodet's character. While intensely working for the Prix
de Rome, the painter appears to have been an ill-tempered and
highly emotional young man. Like the contemporary fashion-
able literary heroes such as Cleveland and Werther, he mani-
fested most of the symptoms of what Monglond called "l'homme
fatal,"[4] choking in the bonds of an artificial society,[5]
unique, and predestined to misfortune.[6] In his early letters,
he described himself as a naïve and trusting youth exploited

1. Viatte, op. cit., I, p. 180.
2. Girodet, OEuvres posthumes, op. cit., I, Veillées, I,
p. 354.
3. Idem.
4. Monglond, op. cit., I, p. 244.
5. Van Tieghem, Paul, Ossian en France, Paris, Rieder &
Cie., 1917, I, p. 213.
6. Monglond, op. cit., I, p. 244.

by his family.[1] Despising society, he considered himself
one of the very rare, ill-fated beings who are unable to
adapt themselves to foreign molds.[2] He believed that he was
fated to empty chalices,[3] cursed his unlucky star,[4] and de-
cided to choose an attitude of complete isolation and im-
penetrability.[5] This typically exaggerated sensitivity was
also manifested in Girodet's thirst for sincere affection and
in his desire to share his emotions. Thus, he wrote to Gérard:
". . . if I had no friend, I would imagine one, and I would
write to this imaginary being; I would believe myself loved
by him; I would write myself the answers."[6] While Girodet's
letters echo the characteristic epistolary lamentations of
the time, one cannot fail to perceive in them a few sincere
accents of despair. In this respect, it may be recalled that
the years which immediately preceded the Revolution corres-
ponded in the life of the painter to a period of deep sorrow
at the loss of his mother, to whom he was very devoted,[7] and
of bitter disappointment related to the competition for the
Prix de Rome.[8]

1. Lettres adressées au baron François Gérard, op. cit., I,
Letter of Girodet, Châtillon, December 30, 1789, p. 127.
2. Idem., p. 128.
3. Lettres adressées au baron François Gérard, op. cit., I,
Letter of Girodet, Orléans, March 21, 1788, p. 126.
4. Lettres adressées au baron François Gérard, op. cit., I,
Letter of Girodet, Châtillon, December 30, 1789, p. 127.
5. Idem., p. 128.
6. Lettres adressées au baron François Gérard, op. cit., I,
Letter of Girodet, Châtillon, December 30, 1789, p. 127.
7. Girodet, OEuvres posthumes, op. cit., I, Notice his-
torique by Coupin, p. xlvij.
8. Supra, pp. 6 and 7.

One can see that Girodet's emotional anxiety and his
sorrowfulness were very far from the calculated rationalism
shown in such paintings as Joseph Making Himself Known to his
Brothers (fig. 4) and Hippocrates Refusing the Presents of
Artaxerxes (fig. 6).

The trends of contemporary religious painting were much
more akin to the inner strivings of the artist. According to
Locquin, religious painting "After having evolved, until
1747, from seriousness to gracefulness," resumed "its evolu-
tion in an opposite direction."[1] There was a tendency toward
a noble style "more edifying, more really 'religious'."[2]
Thus, since 1760, religious painting had been "ready for re-
pentance,"[3] and the majority of the contemporary artists felt
the urge to "strongly speak to the soul."[4] This development
corresponded to a very strong current in the second half of
the eighteenth century, described by Monglond as the "reli-
gious essence of Pre-Romanticism."[5] However, during the
last years of the reign of Louis XVI, the critics, probably
under the influence of Winckelmann, seemed to agree that re-
ligious subjects "gave little span to the genius of the artist."[6]

1. Locquin, op. cit., p. 258.
2. Idem.
3. Idem., p. 264.
4. Idem., p. 268.
5. Monglond, op. cit., I, p. 7.
6. "Observations sur les peintures et sculptures exposées
au salon du Louvre" tirées de L'Année littéraire, nos. 35-40,
Deloynes, op. cit., XVI, 422, Ms., p. 355.

They thought that it was difficult for such themes to inspire the painters with the qualities of "warmth" and "expression" to the same degree as many profane subjects.[1] Yet, the artists could still hope "to glean in a field already harvested by the greatest masters."[2] This ambition could be fulfilled by reinterpreting the old religious themes, in other words, by giving them a "new composition,"[3] an "effet piquant,"[4] and an emphasized "expression."[5] Thus, the most admired paintings in the salons of the time, such as Delaistre's The Christ Child on the Globe Trampling the Serpent under his Feet[6] and Regnault's Descent from the Cross,[7] were those in which the critics found originality[8] or strong emotions.[9]

It can be noted that Girodet's restless sensitivity

1. Observations critiques sur les tableaux du sallon de l'année 1789, Paris, 1789, Deloynes, op. cit., XVI, 410, p. 16.
 2. "Observations sur les peintures et sculptures exposées au salon du Louvre" tirées de L'Année littéraire, nos. 35-40, Deloynes, op. cit., XVI, 422, Ms., p. 355.
 3. L'Ami des artistes au sallon, Supplément, précédé de quelques observations sur l'état des arts en Angleterre, Deloynes, op. cit., XV, 380, p. 10.
 4. "Observations sur les peintures et sculptures exposées au salon du Louvre" tirées de L'Année littéraire, nos. 35-40, Deloynes, op. cit., XVI, 422, Ms., p. 355.
 5. Idem.
 6. Salon of 1787.
 7. Salon of 1789.
 8. L'Ami des artistes au sallon, Supplément, précédé de quelques observations sur l'état des arts en Angleterre, Deloynes, op. cit., XV, 380, p. 10.
 9. Entretien entre un amateur et une admiratrice sur les tableaux exposés au Sallon du Louvre de l'année 1789, Deloynes, op. cit., XVI, 412, p. 21.

could hardly find a favorable outlet in the Davidian drama.
His disquieting moods could be much more naturally trans-
posed into subjects based on religion. These subjects, be-
cause of their elements of occult mystery, provided the
painter with an unhoped-for vehicle for his own emotions.
Moreover, according to the contemporary critics, these themes
necessitated a new interpretation, thus liberating the artist
from the Academic discipline and giving him a channel for the
expression of his self-assertion.

Among Girodet's religious works corresponding to the
early years of his life, a group of paintings, now lost, in-
cluding Nebuchadnezzar Ordering the Slaying of the Children
of Zedekiah,[1] Christ Expelling the Money Changers,[2] and the
Delivery of Saint Peter from Prison[3] was composed of projects
for the Prix de Rome, which most probably were interpreted in
the historical mode already exemplified by Joseph Making Him-
self Known to his Brothers (fig. 4).[4] Similarly, very little
can be said about Judith Cutting off the Head of Holophernes,
which was described in 1801 by Bruun Neergaard as "one of the
most beautiful productions of Girodet."[5] However, Girodet's

1. 1787; this was the subject of the painting of the first
concours in which Girodet took part and from which he was ex-
cluded (Girodet, OEuvres posthumes, op. cit., I, Liste des
principaux ouvrages de Girodet by Coupin, p. lv).
2. Sketch mentioned by Coupin (Idem., p. lxix).
3. Sketch mentioned by Coupin (Idem., p. lxix).
4. See supra, pp. 46 ff.
5. Bruun Neergaard, Sur la situation des beaux-arts en
France, ou lettres d'un Danois à son ami, Paris, Dupont, 1801,
pp. 157-158.

interpretation of two subjects, the Interior of the House of
Joachim and The Dead Christ Supported by the Virgin, are bet-
ter known and therefore must be given a particular importance.

Girodet's rendering of these two themes is known not
merely through titles. His oil sketch of the Interior of the
House of Joachim, now lost, was described by Pérignon[1] and
Coupin[2] in the following terms:

> "Sketch of a very striking effect, representing the in-
> terior of the house of Joachim. The principal group,
> illuminated by the light and reflected by the moon, is
> that of Saint Anne teaching the Virgin to read."[3]

In spite of its succinctness, this description gives an idea
of the mood of Girodet's interpretation and also indicates
that the subject of his sketch was derived from the tradi-
tional theme of the Education of the Virgin. Girodet's con-
ception of The Dead Christ Supported by the Virgin can be
studied in two extant works, a small preliminary sketch in
the Fabre Museum (fig. 11) and a large painting in the Church
of Montesquieu-Volvestre (fig. 12),[4] both based on the same
composition. The setting represents the interior of a dark,
spacious, rocky cavern. Through its opening one can see a
cross silhouetted against a sunset sky. Within the cavern,

1. Pérignon, op. cit., pp. 17-18, no. 61.
2. Girodet, OEuvres posthumes, op. cit., I, Liste des prin-
cipaux ouvrages de Girodet by Coupin, p. lxix.
3. Pérignon, op. cit., pp. 17-18, no. 61.
4. Haute-Garonne.

in the foreground of the composition, are depicted the fig-
ures of the Virgin and Christ. The Virgin is seated before a
sarcophagus, partially covered by a shroud; the body of the
dead Christ is placed on the ground, and is leaning against
the Virgin's knees. At the foot of this group lie various
instruments of the Passion such as nails and the crown of
thorns. It may be seen that the idea of this composition is
that of a Pietà.

The Pietà seems to have been originally painted for
a Capuchin convent in Touraine,[1] and the Education of the
Virgin was probably commissioned by a similar ecclesiastic
institution.[2] Thus, the chief interest of these works is
derived not so much from Girodet's selection of their sub-
jects as from his interpretation of them.

Girodet's interpretation of these two themes shows a
basic similarity. In contrast to the daylight treatment of
the subjects of the Prix de Rome series, his rendering of both
the Pietà and the Education of the Virgin shows a great de-
pendence upon a chiaroscuro effect. It is immediately per-
ceptible in the two extant paintings based on the first theme;

1. Girodet, Oeuvres posthumes, op. cit., I, Liste des prin-
cipaux ouvrages de Girodet by Coupin, p. lv. See also, Giro-
det's letter to Gérard written from Tours in 1789, quoted in
Adhémar, Jean, "L'Enseignement académique en 1820 -- Girodet
et son atelier," Bulletin de la société de l'histoire de l'art
français, IIe fascicule, 1934, p. 281.
2. The years immediately preceding the Revolution were
marked by a relatively important number of religious commis-
sions for the king and church congregations.

while for the second, it is suggested by Pérignon's description. As can be seen, Girodet chose the moment of sunset for the first subject and late evening or night for the second. In this respect, it may be noted that while both subjects had been often conceived as night themes,[1] they had not always been treated as such.[2]

Girodet's nocturnal effects have a definite significance which cannot be separated from the general predilection for night and moonlight in the contemporary literature. For writers under the influence of Young[3] and Macpherson,[4] night was the "mother of fright."[5] However, it also had more pleasant emotional connotations. It was considered "more touching than beautiful . . . more favorable to reverie than the day,"[6] full of "melancholy charm,"[7] and filling the heart with a mysterious anxiety.[8] Indeed, night was the most cherished time of the Pre-Romantic novels.[9]

1. As for instance Tiarini's Pietà in the Pinacoteca of Bologna and Georges de La Tour's Education of the Virgin in the Frick collection.
2. As can be seen in such examples as Guido Reni's Pietà in the Pinacoteca of Bologna and Rubens' Education of the Virgin in Antwerp.
3. Translated into French in 1769 by Letourneur.
4. Translated into French in 1776 by Letourneur.
5. Notaris, "La Nuit, imitation de l'anglais," Almanach des Muses, an III, pp. 129-130, quoted in Monglond, op. cit., I, p. 152.
6. Monglond, op. cit., I, p. 156.
7. Extraits du journal de Chênedollé, pp. 48 and 186, quoted in Monglond, op. cit., I, p. 158.
8. Monglond, op. cit., I, p. 158.
9. As can be seen in numerous passages of Rousseau's La Nouvelle Héloïse, Bernardin de Saint-Pierre's Paul et Virginie, Notaris' La Nuit, etc.

Directly related to this literary tendency, night and moonlight effects invaded the salon and eventually constituted a separate subject in themselves, as can be exemplified by the paintings of Sarrazin,[1] Eschard,[2] Coste,[3] Deperthes,[4] and many other artists of the time. More specifically, chiaroscuro treatment was frequently associated with religious themes, as can be illustrated by such works as Perrin's Death of the Virgin[5] or Lagrenée's The Christ Child Praying During the Night in a Solitary Spot.[6]

It may be suggested that Girodet's night effects can be traced to two separate trends in contemporary religious painting. The Education of the Virgin seems to have been related to the familiar, intimate current of the second half of the eighteenth century. This conception was influenced by the sentimental exaltation of the family often seen in Diderot and other exponents of the drame bourgeois, and was illustrated by such works as the Education of the Virgin of Fragonard[7] and the Birth of the Virgin of Suvée. Influenced to a certain degree by seventeenth-century Dutch painting, these works were characterized by warm, permeating but transparent

1. Moonlight, Salon of 1789.
2. Moonlight, Salon of 1791.
3. Moonlight, Salon of 1798.
4. The Moonrise, Salon of 1800.
5. Salon of 1789. The chiaroscuro effect was noted by one of the critics. (Vérités agréables ou le Salon vu en beau par l'auteur du Coup-de-patte, Paris, Knapen fils, 1789, p. 16.)
6. Salon of 1787.
7. Palace of the Legion of Honor, San Francisco.

shadows creating a somewhat smoky effect. On the other hand,
the Pietà was related to a not less typical current, that of
what Locquin described as the "atrocious and lugubrious paint-
ing satisfying the imagination of the painters saturated with
realism."[1] This mode, reflecting the influence of Caravaggio,
was exemplified in such paintings as Deshays' Resurrection of
Lazarus[2] or David's Saint Roch, and was characterized by
heavy, opaque shadows and dramatic contrasts of values.

Girodet, in both the Education of the Virgin and the
Pietà, shows a tendency to reinterpret the traditional icono-
graphy of these themes. While, as was noted, the theme of the
Education of the Virgin was occasionally conceived as a night
scene, its rendering within a moonlight effect was most rare,
and I have been personally unable to find an example of it.
In the Pietà, there is a more definite iconographical innova-
tion. Most of the Pietàs, Lamentations over the Body of
Christ, and Depositions comparable to Girodet's painting,
and involving a cavern-like tomb, usually show the principal
group of the Christ and the Virgin in the open air, in front
of the entrance to the tomb. This can be seen in such works
as the Deposition of Fontana[3] and that of Tiarini.[4] More
seldom, as in the eighteenth-century anonymous painting of

1. Locquin, op. cit., p. 274.
2. 1763.
3. Pinacoteca of Bologna.
4. Pinacoteca of Bologna.

the Cathedral of Saint-Jean at Besançon, the Christ is repre-
sented as being carried toward the entrance of the sepulcher.
Breaking with this tradition, Girodet depicted the dead
Christ and the Virgin already within the grotto-like tomb.

This iconographical change seems to be related to the
general vogue of the grotto and to the strange fascination
for the subterranean world which was frequently reflected in
contemporary literature and painting. Naturally, this theme
was an old one. It had been a part of the traditional garden
accessories since the Renaissance, and it often recurred in
baroque and rococo art, as for instance in Ribera's Saint
Paul[1] or Nattier's Mary Magdalen.[2] However, in the last quar-
ter of the eighteenth century, the grotto theme acquired a
hitherto unparalleled importance. In the salons of the period,
it appeared in a great variety of subjects ranging from clas-
sical literature[3] to genre.[4] Yet, it was most frequently
used for its suggestion of picturesque wilderness and remote-
ness, as can be seen in such subjects as Comte de Parois'
Robbers in a Cavern[5] and Lefebre's Cavern of Arab Thieves.[6]
For the contemporaries, the subterranean realm was also

1. Prado, Madrid.
2. Louvre.
3. As for instance, Valenciennes' Aeneas and Dido, Salon
of 1795.
4. As for instance, Cesar Wanloo's A Grotto in Which One
Can See Women and Children Bathing, Salon of 1787.
5. Engraving, Salon of 1787.
6. Salon of 1791.

associated with a feeling of awe and mystery. Writers exalted by Illuministic esoterism[1] described strange initiations, reminiscent of those of Cagliostro and of the Freemasons, during which the candidate was asked to "penetrate into the heart of the earth."[2] Delille devoted several pages of his poem L'Imagination to the description of the emotions of the painter Robert, lost in the catacombs:

"He sees only night and hears only silence,
And the silence still adds to his fright."[3]

This terror was not exempt from an element of morbid pleasure, for, having found the thread which was to lead him to safety, Robert

"Wants to enjoy this place and his terror.
At their lugubrious aspect, he feels in his heart
A pleasure mingled with a trace of fear."[4]

Finally, for the contemporaries, the grotto was also a refuge for the dreamer and the philosopher.[5] The Marquis of Pezay wrote in 1771:

"Twelve persons of different characters . . . and in different states of the soul will be able to meditate successively in the grotto where I rest. They will taste there the voluptuousness of retreat."[6]

1. Viatte, op. cit., I, pp. 184-185.
2. Robertson, op. cit., I, p. 157; also see Dupuis, Origine de tous les cultes ou Religion universelle, Paris, Rosier, 1835, VII, p. 98; and Noël, François, op. cit., II, p. 711.
3. Delille, op. cit., I, L'Imagination, Chant IV, p. 413.
4. Idem.
5. This idea seems to continue the conception of the saints and hermits as they are represented in baroque painting.
6. Monglond, op. cit., I, p. 182.

Thus, one's subjective self could be more easily felt in a grotto because it was considered one of the places "where silence and obscurity increase our solitude."[1] Some of these ideas are reflected in Girodet's use of the cavern in his Study of an Old Man (fig. 13), executed in Italy in 1791,[2] and in his Portrait of a Man Seated in a Catacomb,[3] which was perhaps inspired by Delille's account of Robert's adventures. As will be seen later, in such works as Atala,[4] (fig.49) or Anacreon[5] (fig.119), the grotto will remain an important iconographical element in Girodet's painting.

While echoing these contemporary moods, Girodet's Pietà (fig. 11), with its grotto setting conceived as a theme of solitary despair and mourning, suggests a more definite source of inspiration: Ossian, a source which will exert a great influence in Girodet's later works. Van Tieghem already noted the similarity between the character of the Ossianic landscape and the austere bareness of the paintings of the Davidians.[6] From this general point of view, the setting of Girodet's Pietà is strikingly close to the desolate, wild,

1. Monglond, opl.cit., I, p. 182.
2. Musée Fabre. It is probably related to the theme of Hippocrates Led to Democritus by the Abderitans (two sketches of Girodet mentioned by Pérignon, op. cit., p. 18, nos. 67-68). This is suggested by the fox skin often associated with Democritus, as for instance in A. Coypel's Democritus in the Louvre.
3. Oil sketch mentioned by Pérignon,op.cit.,p. 20, no. 79.
4. Infra, pp.257 ff.
5. Infra., p. 384.
6. Van Tieghem, P., op. cit.,I,p. 213.

rocky sites of Macpherson's poems. Moreover, the Ossianic
landscape, more than any other, abounds in caverns similar to
that of Girodet's Pietà, caverns which are very frequently
described as sites of tombs and scenes of mourning. Thus, a
grotto is the sepulcher of great warriors like Dermid[1] or
Cuthullin,[2] where the bards come to sing their "nocturnal
chants"[3] and "The virgins shed their tears."[4] The Ossianic
grotto is also conceived as the scene of paternal grief:

> "Fingal arrived at the cavern of Lubar where his young
> Fillan lay at rest . . . At this sight, grief deeply
> penetrated the soul of the king; overwhelmed by sorrow,
> he turns away . . . Then the king's tears flowed, and he
> remained for some time sunk in despair."[5]

It may be noted that Macpherson's description stresses the
turning away of the father from his son's body, a conception
which is reminiscent of the relative position of the Virgin
and Christ in Girodet's Pietà.

Nevertheless the particular arrangement of this group
seems to have been more directly influenced by another source.
Analogous oppositions of the attitude of the Virgin and /the that of
dead Christ can be fairly often found in the interpretation
of the theme of the Deposition. This may be illustrated by

1. Macpherson, Ossian, fils de Fingal, poésies galliques,
Letourneur trans., Paris, Dentu, 1810, I, p. 319.
2. Idem., II, p. 278.
3. Idem., I, p. 319.
5. Idem., II, p. 160 (this passage is illustrated by
Tardieu l'aîné).
4. Idem.

the examples of Raphael,[1] Sebastiano del Piombo,[2] Correggio,[3] or Annibal Carracci.[4] However, in all these cases, the group of the Virgin and Christ is accompanied by saints in whose arms Mary is swooning. It can be seen that Girodet isolated a typical group of the Deposition theme.[5] Moreover, in Girodet's painting, the individual figures of this group are strongly reminiscent of their counterparts in the traditional Depositions. It may be tentatively suggested that the closest possible models for the figures of Girodet's Pietà can be found in the Christ of Jean Goujon's Deposition[6] and in the Virgin of Sebastiano del Piombo's interpretation of the same subject.[7]

In Girodet's Pietà, the opposition of the attitudes of

1. Drawing reproduced in an engraving of Agricola.
2. Moscow.
3. Parma.
4. Castle Howard.
5. It is possible that Girodet's Pietà, reduced to the main group of two figures, was the result of the painter's simplification of his own earlier interpretation of the Deposition theme with several personages. An oil sketch, mentioned by Pérignon (op. cit., p. 18, no. 66) and Coupin (Girodet, Oeuvres posthumes, op. cit., I, Liste des principaux ouvrages de Girodet, p. lxxiv) under the title of Descent from the Cross, could reflect this earlier idea. From the descriptions of Pérignon and Coupin, it appears that this composition included at least one figure (that of Mary Magdalen) besides the principal group of the Virgin and Christ. Perhaps it was this painting which Bruun Neergaard (op. cit., p. 157) compared to Van Dyck during his visit to Girodet's atelier in 1801. However, it must be noted that there is nothing to suggest that this Descent from the Cross, which is now lost, was painted before 1789, date of the Pietà of Montesquieu-Volvestre.
6. Louvre, relief which originally belonged to the rood-screen of Saint-Germain-l'Auxerrois.
7. Moscow.

the Virgin and Christ effectively stresses the impression of
utter loneliness,[1] a feeling which is naturally also con-
veyed through the bareness, the darkness, and the immensity
of the cavern. This physical isolation dramatically under-
lines the Virgin's psychological solitude as well as her
hopeless sorrow. To intensify the emotional suggestiveness
of this conception, Girodet eliminated all traces of gesti-
culation, and emphasized the static quality of his group.
He even subdued his interest for facial expression, and fol-
lowed the famed example of Timanthes' Sacrifice of Iphigenia
by partially veiling the Virgin's face. Through these means,
he suggested a mysterious feeling of suspended time and ex-
pressed "the silence of grief" which the contemporary crit-
ics admired in Regnault's Descent from the Cross, exhibited
in the Salon of the same year.[2]

The Caravagglesque chiaroscuro and the monumentality
of Girodet's Pietà are still strongly suggestive of David.
However, the tragic despair of Girodet's conception is very
far from the heroic stoicism of his master and even further
from Winckelmann's ideal of unemotional beauty. Still work-
ing in the atelier of the master of the Horatii, Girodet for

1. In contemporary painting, the theme of loneliness was
almost as popular as that of the night, and it provided a
subject matter per se, as can be seen for instance in the
Solitude of Baltard, exhibited in the Salon of 1796.
2. Entretien entre un amateur et une admiratrice sur les
tableaux exposés au Sallon du Louvre de l'année 1789, De-
loynes, op. cit., XVI, 412, p. 21.

a moment stepped away from his teachings, and transposed into
a religious theme the deep emotional strivings which he was
unable to express in the subjects of the Prix de Rome. Al-
though Girodet's rendering of his Pietà could hardly be con-
sidered as devotional in an ecclesiastical sense, it is
nevertheless undoubtedly one of the most sincerely emotional
religious paintings of this period in France. The painter
will never again reach a degree of intense sincerity of feel-
ing comparable to that of his Pietà, in which he succeeded in
giving new life to an old subject, and which in David's opin-
ion could "sustain comparison with the productions of the
greatest masters."[1]

1. Pérignon, op. cit., p. 10, no. 13.

CHAPTER III

EARLY MYTHOLOGICAL PAINTING

CHAPTER III

EARLY MYTHOLOGICAL PAINTING

Girodet's mythological paintings represent a new and
perhaps the most important phase of his artistic development.
The five most important works of this group, between 1791[1]
and 1802, are:

The Sleep of Endymion[2] (fig. 14)

The Seasons[3] (figs. 16, 17, 18, 19, 20)

Danaö[4] (fig. 25)

The New Danaö[5] (fig. 26)

Ossian[6] (figs. 29, 30, 31, 32)

1. As can be seen, the dates of the classical historical
group and those of the mythological group are overlapping.
Hippocrates Refusing the Presents of Artaxerxes, the last
painting of the first group, was executed in 1792, one year
after The Sleep of Endymion, the earliest painting of the
second group.
2. 1791, Louvre.
3. 1801-1802 (?), Aranjuez.
4. 1798, Leipzig.
5. 1799, Wildenstein Gallery, New York
6. 1801-1802, Malmaison.

The study of these paintings can be divided into three major parts:

 I. The background influencing the conception and the execution of these paintings.

 II. The particular problems and the iconographical content of each individual painting considered separately.

 III. The common characteristics of the entire mythological group and its chronological development.

 I. The contrast between the hardships endured during Girodet's sojourn in Italy and the easy, fashionable life which he found on his return to France exerted a strong emotional influence on the painter. During this period, the artist tried to escape from the discipline of David's atelier and became intoxicated with a feeling of freedom experienced for the first time in Italy. Thus, instead of attempting to succeed in the Davidian medium, Girodet concentrated his efforts on finding his own path and expressing his own ideas. Yet, in his search for originality, the painter could not avoid the contemporary influence of complex cultural and literary trends, such as Illuminism and preciosity, trends which can be strongly felt in the general conception of his mythological works of these years.

 II. The heterogeneous character of Girodet's mythological group and the extreme complexity of the individual problems suggested by each painting necessitate a separate study of each of the major productions. These works were no longer

executed as academic projects for the Prix de Rome. A show-
piece like Endymion, a personal satire like The New Danaë, or
a private commission like Ossian were rooted in actuality and
were determined by different individual conditions. While some
of the aspects of these paintings continue previous tendencies,
many of their basic elements differ essentially from those of
the historical works such as Hippocrates. Thus, the details,
instead of being considered as elements of an archaeological
local color, or parts of a coherent allusive system, became
the ideograms of various secret symbolical meanings. Giro-
det's aims changed with each individual theme, and, as a result,
each work acquired its own specific allegorical complexity.

III. Moreover, Girodet's mythological paintings show a
restless and anguished emotionalism which replaced the logic
and the clarity of the historical works. The setting, far
from being conceived as a neutral background, now directly
takes part in the mystery and ambiguity of the general at-
mosphere. The human figure is still an important vehicle
for the "expression of the sentiments of the soul." Yet,
Girodet was no longer concerned with rationalized "passions"
or "caractères," and the disquieting emotionalism of his
mythological paintings takes its source in distorted atti-
tudes and equivocal gestures, the very elements that the
painter was trying to avoid in his historical productions.
These various trends led Girodet to betray the traditional
Academic rules and to break the Davidian classical mold.

I.

BACKGROUND

The study of the background influencing the conception
and the execution of Girodet's mythological paintings can be
divided into two parts: the first considering the artist's
life and the second giving a brief sketch of the contemporary
cultural trends.

Girodet's Life during the Revolutionary Period

This period of the painter's life was full of tensions
and contrasts. The events of these restless years created a
particularly intense atmosphere which strongly influenced the
conception of Girodet's works during this period.

The artist spent the most crucial phase of the French
Revolution in Italy.[1] This foreign sojourn forced him to
some involuntary sacrifices in France, where Dr. Trioson was
compelled to yield Girodet's feudal rights.[2] Nevertheless,
the young man was spared from the persecutions to which his
foster-father was subjected. The latter, who had only re-
cently occupied an important position in the circle of the
king's family, was particularly suspected by the Jacobins of

1. 1790-1795.
2. Girodet, OEuvres posthumes, op. cit., II, Correspondance,
Letter LVI, to Trioson, Naples, November 3, 1793, p. 442.

Montargis.[1] However, Girodet's residence in Italy gave him little safety or tranquility. He was exposed to the attacks directed against all Frenchmen not officially classified as *émigrés*. From this period date the most venturesome episodes of the artist's life. While he was suspected by the municipal authorities of Châtillon, in France, of prolonging his foreign stay for political reasons,[2] he was, at the same time, trying very hard to avoid being labeled a Revolutionary in Italy. He changed his usual manner of wearing his hair, "short hair being the sign of Jacobin opinions."[3] He avoided the society of persons known for their radical ideas, and he never attempted to fight the opinions of the Italians.[4] In spite of this cautious behavior, he was often visited by the Italian police,[5] and was arrested several times. While facing danger, Girodet always showed a resolute attitude. He did not hesitate to fight bare-handed the soldiers who apprehended him on the Bridge of Sant' Angelo.[6] He also displayed his courage on the occasion of his arrest while he was drawing

1. Dr. Trioson incurred losses (Girodet, OEuvres posthumes, op. cit., II, Correspondance, Letter XXXIX, to Trioson, Rome, February 1, 1791, p. 380) and was at one time arrested (Girodet, OEuvres posthumes, op. cit., II, Correspondance, Letter LVI, to Trioson, Naples, November 3, 1793, pp. 439-440).
2. Girodet, OEuvres posthumes, op. cit., II, Correspondance, Letter LV, to Trioson, Naples, July 25, 1793, p. 436.
3. Girodet, OEuvres posthumes, op. cit., II, Correspondance, Letter XLVIII, to Trioson, Rome, March 27, 1792, p. 413.
4. Girodet, OEuvres posthumes, op. cit., II, Correspondance, Letter L, to Trioson, Rome, October 3, 1792, p. 419.
5. Lettres adressées au baron François Gérard, op. cit., I, Letter of Dr. Trioson, 20 pluviôse (February) 1793, p. 182.
6. Lettres adressées au baron François Gérard, op. cit., I, Letter of Girodet, Rome, August 11, 1790, pp. 153-155.

a landscape near Venice. Daru gave a colorful account of
this episode in his Histoire de Venise:

> ". . . after having stripped, tied, infamously mistreated
> him, one of those rascals asks him if they still celebrate
> any holidays in France. 'More than ever,' answered Giro-
> det: 'the holiday of Victory comes back every month'."[1]

Moreover, during mob violences in Rome, Girodet volunteered,
with his friend Péquignot, to remain in the city to paint
the new escutcheons of the French Republic, which were to re-
place the monarchic fleurs de lys at the Academy.[2] On this
occasion and in several other instances, his life was di-
rectly threatened.[3]

For the painter, these Italian years, besides being a
period of instability and danger, were at the same time a
phase of economic hardship and illness. Almost all of Giro-
det's letters to Dr. Trioson reflect a difficult and some-
times desperate financial situation. He had to interrupt his
collecting of antique medals,[4] his purchase of books,[5] and,
occasionally, his use of models.[6] The scarcity of his

1. Daru, Histoire de Venise, V, p. 410, quoted in Girodet, OEuv-
res posthumes, op. cit., I, Notice historique by Coupin, p. xij.
2. Girodet, OEuvres posthumes, op. cit., II, Correspondance,
Letter LII, to Trioson, Naples, January 19, 1793, pp. 424-425.
Girodet's description of these disturbances which resulted in
the assassination of the French envoy Basseville is the most
famous passage of his correspondence.
3. Idem., p. 425 and also p. 426.
4. Girodet, OEuvres posthumes, op. cit., II, Correspondance,
Letter XLVI, to Trioson, Rome, January 3, 1792, p. 405.
5. Idem., p. 406.
6. Girodet, OEuvres posthumes, op. cit., II, Correspondance,
Letter XLVII, to Trioson, Rome, February 28, 1792, p. 408.

resources deprived him of the pleasure of the Comedy, and at
times prevented him from visiting art galleries.[1] He was
permanently in debt, borrowing money from friends, and re-
ceiving assistance from the French officials.[2] Girodet
recalled this period in a letter to Julie Candeille: "I have
lived two months on black bread and water, firmly believing
that my fate would be limited to this and that I would never
see my fatherland again."[3] At the same time, he was in very
poor health, and was continually visiting doctors[4] because
of a pulmonary disease[5] and paludism.[6] He philosophized on
his fleeting youth, bad health, brevity of life,[7] and was
haunted by the idea of death.[8] At the end of his Italian so-
journ, he felt matured and aged.[9]

These sufferings psychologically prepared Girodet, on

1. Girodet, OEuvres posthumes, op. cit., II, Correspondance,
Letter XLI, to Trioson, Rome, May 15, 1791, p. 389.
2. Girodet, OEuvres posthumes, op. cit., II, Correspondance,
Letter LVII, to Trioson, Venice, September 1794, p. 446.
3. Lettres de Girodet-Trioson à Madama Simons-Candeille,
Bibliothèque d'Orléans, Ms., Montargis, January 21, 1809 (?).
4. Cirillo in Naples (Girodet, OEuvres posthumes, op. cit.,
II, Correspondance, Letter LVI, to Trioson, Naples, November
3, 1793, p. 440), Malvet in Genoa (Girodet, OEuvres posthumes,
op. cit., II, Correspondance, Letter LX, to Trioson, Genoa,
June 16, 1795, p. 457).
5. Girodet, OEuvres posthumes, op. cit., II, Correspondance,
Letter LVI, to Trioson, Naples, November 3, 1793, p. 440.
6. Girodet, OEuvres posthumes, op. cit., II, Correspondance,
to Trioson, May 24 /1795/, p. 454; Letter LX, to Trioson,
Genoa, June 16, 1795, p. 457.
7. Idem., p. 455.
8. Idem.; also Girodet, OEuvres posthumes, op. cit., II,
Correspondance, Letter LVI, to Trioson, Naples, November 3,
1793, p. 444.
9. Girodet, OEuvres posthumes, op. cit., II, Correspondance,
to Madame Trioson, October 27, 1794, p. 450.

his return to France, to participate in the general reaction which followed the years of the Terror. He strove for social recognition, professional celebrity, and financial success, sharing the disquieting lust for life, compared by Lucien Descaves to that of the "roaring twenties,"[1] which characterized the period of the Directory.

Progressively, competition isolated Girodet from his former friends like Gérard and Gros.[2] Similarly, in spite of the artist's exterior manifestations of respect for David, his already cool relations with his teacher were further strained. His animosity was related to a question of one hundred écus, a sum which was or was not sent by David to Girodet at the moment of the latter's financial difficulties in Italy.[3] This state of affairs was given an even more unpleasant character by David's demand to be repaid a loss (questioned by Girodet) which he claimed to have undergone in shipping one of Girodet's paintings.[4] The painter was in closer contact with minor figures like Isabey and Boilly.[5]

1. Goncourt, E. & J. de, Histoire de la société française pendant le Directoire, Edition définitive, Paris, Flammarion/Fasquelle, 1928, pp. 441-442.

2. Lettres adressées au baron François Gérard, op. cit., I, p. 125, Note 1.

3. Girodet, OEuvres posthumes, op. cit., II, Correspondance, Letter LVII, to Trioson, Venice, September 1794, pp. 445-446.

4. Girodet, OEuvres posthumes, op. cit., II, Correspondance, Letter LIII, to Trioson, Naples, p. 429. For David's justification see J. L. Jules David, op. cit.

5. See Boilly's Réunion d'artistes dans l'atelier d'Isabey, 1798, Louvre.

He was surrounded by actors like Chénard,[1] musicians like
Boucher,[2] and literati like De Valori,[3] Saint-Victor,[4] Ma-
dame de Salm,[5] and Julie Candeille.[6] At the same time, prob-
ably through Dr. Trioson, Girodet seems to have been ac-
quainted with some of the most famous physicians and scient-
ists of this period, such as the surgeon Larrey[7] and the
physiologist Cabanis.[8] He acquired an overbearing attitude
which was reflected in the cool reception he gave to Prud'hon,
returning from Italy,[9] and in his disdain for Bruun Neergaard's
visits to his atelier.[10] Thus, his contemporaries frequently

1. Girodet gave him the sketches of the Education of the
Virgin and the Descent from the Cross (Bruun Neergaard, op.
cit., p. 157).
 2. First violinist of the King of Spain.
 3. He dedicated to Girodet his poem La Peinture (Van Tieg-
hem, op. cit., II, p. 151). In return, the painter illustrated
De Valori's translation of The Gnat (Girodet, OEuvres post-
humes, op. cit., I, Liste des principaux ouvrages de Girodet
by Coupin, p. lxxxij).
 4. Saint-Victor "sends to the artist stanzas where he ex-
tols his genius and his work" (Nouvel Almanach des Muses,
1803, p. 103; also OEuvres de Saint-Victor, p. 325, quoted by
Van Tieghem, op. cit., II, p. 151).
 5. In her poem A mes amis, Madame de Salm gave an especially
important place to Girodet (OEuvres complètes de Madame la
Princesse Constance de Salm, Paris, Didot, 1842, II, pp. 214-
215). In the frontispiece of the same volume, Girodet appears
in the very center of the engraving representing the most fam-
ous habitués of Madame de Salm's salon.
 6. With whom the painter had a well-known liaison. See let-
ters of Julie Candeille to Girodet, Ms., collection of the Com-
mandant Pilleuil, and also letters of Girodet to Madame Simons-
Candeille, op. cit.
 7. Girodet, OEuvres posthumes, op. cit., I, Notice histo-
rique by Coupin, p. xxj.
 8. Girodet, OEuvres posthumes, op. cit., II, Correspondance,
Letter XXI, to Montagut, Paris, May 9, 1808, pp. 324-325; also
Girodet, OEuvres posthumes, op. cit., II, Correspondance, Let-
ter X, to Madame Cabanis, Paris, April 2, 1823, p. 303.
 9. Goncourt, L'Art du XVIIIème siècle, op. cit., III, p.
391, Note 1.
 10. Bruun Neergaard, op. cit., p. 157.

criticized his atelier for being a rendez-vous of rich snobs
rather than a center of study.[1]

Girodet obstinately tried to come to the surface of
the social chaos of his period. He made himself the spokes-
man of the artists who had suffered losses during the Italian
disturbances.[2] He adulated Bonaparte, to whom he suggested a
new type of artistic jury for public competitions.[3] He begged
for honors,[4] and skillfully used his influential friends and
acquaintances to obtain commissions. Already in his Italian
letters, he had boasted of meeting "a very wealthy English-
man",[5] or "Polish princes."[6] His friend Noël probably helped
him to be put in charge of the decoration of the palace of
the French envoy in Venice,[7] and he succeeded in working for
the Commissaire Général Gaudin,[8] the king of Spain,[9] and the

1. Girodet, OEuvres posthumes, op. cit., I, Notice his-
torique by Coupin, p. xxxviiJ.
2. Pommier, op. cit., pp. 356-358. Girodet led two demands
of reparations: July 14, 1797 and August 6, 1797.
3. Girodet, OEuvres posthumes, op. cit., II, Correspondance,
Letter IV, to Bonaparte, pp. 284-287.
4. Girodet received 12,000 francs for his Ossian. Yet he
wrote: "I shall dare to insist on the other kind of reward
which I have especially hoped for" (Girodet, OEuvres posthumes,
op. cit., II, Correspondance, Letter VI, to Bonaparte, p. 290).
5. Girodet, OEuvres posthumes, op. cit., II, Correspondance,
Letter LVI, to Trioson, Naples, November 3, 1793, p. 443.
6. Girodet, OEuvres posthumes, op. cit., II, Correspondance,
Letter XLV, Rome, November 25, 1791, p. 401.
7. Girodet, OEuvres posthumes, op. cit., II, Correspondance,
Letter LVIII, to Trioson, Venice, 5 Pluviôse, An III, p. 451.
8. Girodet, OEuvres posthumes, op. cit., I, Notice his-
torique by Coupin, p. xlv.
9. To be discussed in relation to the Seasons.

Bonaparte family.[1] His receiving the official commission to paint the Assassination of the French Envoys at Rasdadt created jealousy and raised a storm of protest.[2] Girodet's successful opportunism and arrogance gave him enemies and made him an object of calumnies. One of the most striking was the rumor suggesting that he had provoked the arrest of Boilly.[3] One may already note that these activities and intrigues placing the painter in the center of actuality, played an important part in the conception of his contemporary works. Another significantly influential element can be seen in Girodet's new scholarly and literary ambitions. The painter began to show these tendencies around 1800. He actively collaborated in the Dictionnaire de la fable of his friend François Noël[4] and started writing the Veillées ou Promenades

1. To be discussed in relation to Ossian.
2. Chaussard, mentioning the official commission of Girodet, added in a note: "Several artists have wished that I insert their complaint: they are asking 1) why this national subject has not been submitted to the concours, 2) why about 3000 francs have been appropriated for this one work, 3) why a part of this sum is, they say, already paid and even paid in advance, when sums of money owed for completed works are not yet paid." (C. Chaussard, "Exposition des ouvrages de peinture, sculpture, architecture, gravure, dessins, modèles composés par les artistes vivans et exposés dans le Salon du Musée central des Arts," Journal de la Décade, 1799, Deloynes, op. cit., XXI, 580, Ms., pp. 451-452.)
3. Reynart, Catalogue du Musée de Lille, 1872, article "Boilly," quoted in Marmottan, Paul, Le Peintre Louis Boilly, Paris, Gateau, 1913, p. 52, note 1.
4. During the Revolution, Noël was the "ministre de la République" in Venice (Girodet, OEuvres posthumes, op. cit., II, Correspondance, Letter IX, to Trioson, Genoa, June 16, 1795, p. 459). In 1795, Girodet saved him from Robespierre's indictment (Girodet, OEuvres posthumes, op. cit., I, Notice historique by Coupin, p. xij). On his return to France, Noël, through his relations, provided Girodet with an atelier in the Louvre (Idem., p. xiij; also Girodet, OEuvres posthumes, op.

du peintre d'histoire avec ses élèves, which was the first
version of his better-known poem Le Peintre.[1]

Undoubtedly, one of the most determining factors in
Girodet's artistic development may be found in the rise of
his concept of originality. The painter seems to have
nursed unorthodox ideas on art even before his departure to
Italy. Thus, in 1790, he wrote to Gérard:

> "/David/ will tell you that a skillful man finds it re-
> warding to copy Etruscan vases; you will say /to him/
> that I don't want to believe any of it, and that I do
> not like the Antique, that I am stubborn, that I have
> pride."[2]

However, these half-humorous statements are not comparable
to the exalted feeling of freedom which he manifested in his
very first Italian letters. Thus he wrote to Dr. Trioson:

> "I am extremely bored by our Academic administration,
> and I confess that it displeases me greatly. It is not
> that our director /Ménageot/ bothers us, for we, or at
> least I, hardly see him except in the street or on the
> stairs. When I first came, though, he wanted to force
> me to draw at the Academy; I asked him to excuse me, and

4. (footnote continued from preceding page).
cit., II, Correspondance, Letter LX, to Trioson, Genoa, June 16,
1795, p. 459). In his Préface to the Dictionnaire de la fable,
Noël wrote: "I owe a great deal, in this new edition, to the
friendship of the Citoyen Girodet, who has graciously consented
to contribute a great number of notes related to this interest-
ing research." (Noël, op. cit., I, pp. xxvij-xxviij, Note 2.)
 1. Girodet, OEuvres posthumes, op. cit., I, Le Peintre, Dis-
cours préliminaire, p. 21.
 2. Lettres adressées au baron François Gérard, op. cit., I,
Letter of Girodet, Châtillon, January 17, 1790, p. 133.

when he insisted I insisted too, answering that such an occupation was not at all to my taste, and that I urgently requested him to allow me to direct my own course of study, which he did, and he did well."[1]

Girodet disapproved of the very system of Academic education, because it erased the individuality of the students:

"What I do not like is the way we are all forced to live together, and so, forced to follow approximately the same studies . . . each scholar should be sent to foreign countries . . . and be free to go to Rome, Bologna, Florence, Venice, to the mountains, Flanders, Switzerland, wherever he pleases, on condition that he give each year proof that he is studying in these countries . . . This would be the only way of getting men of genius and new productions."[2]

During this period, Girodet's opinions had occasionally a genuine revolutionary quality, as can be seen in the following passage of one of his letters to Gérard: "Italy is a superb country and much more valuable in itself and for its monuments than for its paintings, none of which, without exception, has impressed me as much as the Gallery of Rubens."[3]

However, Girodet's main concern was to be different from David and to assert his independence: "I am trying to move away from his /David's/ type of work as much as possible, and I am sparing neither work, nor study, nor models, nor casts."[4] Triumphantly, he exulted at his first success in

1. Girodet, OEuvres posthumes, op. cit., II, Correspondance, Letter XLV, to Trioson, Rome, November 25, 1791, p. 399.
 2. Idem., pp. 399-400.
 3. Lettres adressées au baron François Gérard, op. cit., I, Letter of Girodet, Rome, August 11, 1790, p. 151.
 4. Girodet, OEuvres posthumes, op. cit., II, Correspondance, Letter XLII, to Trioson, Rome, June 23, 1791, p. 392.

Italy, because "everyone agreed that I do not resemble in any way M. David."[1] This passion for originality was to be one of the most characteristic features of Girodet's art during the period of 1791 to 1802. Writing about his Ossian to Bernardin de Saint-Pierre, he said:

"It is this painting which . . . has given me the most confidence in my small talents, because it is altogether, in all its parts, my own creation . . . Why should not one be allowed to try to extend even further the effects and the limits that these great men /Raphael and Poussin/ have known? But one is lost in space, one does not follow any longer routes that are safe. -- Well! even if one should fail, it is beautiful to fall from the skies. Icarus could not sustain himself there, but he gave his name to the Icarian sea, and his fall was almost a triumph."[2]

It must be stressed that Girodet's striving for originality was not the manifestation of a new doctrine. The theories which he formulated in his essay on Originality[3] were only post factum statements written at the end of his life. In the early period, corresponding to the execution of his mythological paintings, Girodet's search for independence was basically manifested in a generally negative attitude, a compelling but vague revolt against the prevailing Academic and Davidian ideas.

1. Girodet, OEuvres posthumes, op. cit., II, Correspondance, Letter XLIV, to Trioson, Rome, October 24, 1791, p. 396.
2. Girodet, OEuvres posthumes, op. cit., II, Correspondance, Letter III, to Bernardin de Saint-Pierre, pp. 277-279.
3. Girodet, OEuvres posthumes, op. cit., II, De l'Originalité dans les arts du dessin,*speech read by Girodet on April 24, 1817 at the annual and public meeting of the four academies.
*pp. 187-204.

Contemporary Cultural Trends

In 1803, Francois Noël wrote in the second edition of
his Dictionnaire de la fable: ". . . the C. Girodet . . .
has already shown more than once how a fresh and gay imagina-
tion can revive the subjects of antique mythology and outdo
the allegories of the ancients."[1] It is clear that the
painter, following his striving for originality, was attempt-
ing to renew the traditional mythological themes. For this
purpose, although often failing to be "fresh and gay," Giro-
det emphasized in his interpretation esoteric and symbolic
elements. However, his refinements in this direction fre-
quently resulted in conceptions which were difficult to de-
cipher for even his contemporaries. Thus in 1802, the Arle-
quin au Museum, criticizing the obscure elaboration of the
allegory of Girodet's Ossian, wrote: ". . . it is in vain
that Girodet takes the defense of this kind of painting . . .

> And each allegorical painter,
> As soon as he has left his brushes,
> Must use his rhetoric
> To explain his paintings to us."[2]

Girodet was not the only target of such criticisms. Allegori-
cal obscurity and iconographical oddity were the two main
themes of derision in the salon pamphlets, at the turn of the

1. Noël, op. cit., II, p. 500. This is the particular
edition which received the collaboration of Girodet.
2. Arlequin au Museum ou critique des tableaux en Vaude-
villes, Paris, Marchant, 1802, no. 3, p. 4.

century. Thus, the critic of the Journal de Paris wrote in
1799: ". . . all allegorical compositions are formed of the
same elements, and often they can be understood only through
an oral explanation."[1] A typical example can be seen in the
attacks directed against the painter Caraffe, who was ridi-
culed because "he has exhibited . . . an allegorical sketch
the smallest defect of which is to be undecipherable."[2] Sim-
ilarly, the Journal des Débats criticized the young painters
because

> "most of them have especially tried to distinguish them-
> selves by this bizarreness of composition, which the per-
> sons who wish to know more than the persons who have
> learned a great deal find convenient to take as a sign of
> genius and the secret of art."[3]

In general, allegory held an important place in the
painting of the second half of the eighteenth century. Loc-
quin described how, progressively, "Allegory has followed the
natural law of its development, it has become over-loaded with
ideas . . . so complicated as to constitute impenetrable enig-
mas."[4] This tendency toward elaboration can be seen in the
evolution of the allegories of such a representative artist
as Cochin. Rocheblave, the author of a monograph devoted to

1. "Exposition des peintures, sculptures, dessins, architec-
ture et gravures exposés au salon du Louvre," Journal de Paris,
1799, Deloynes, op. cit., XXI, 581, Ms., p. 542.
2. Revue de Salon de l'an X ou examen critique de tous les
tableaux qui ont été exposés au Museum, Paris, Surosne, An X,
1802, p. 10.
3. "Salon de 1802," Journal des Débats, Deloynes, op. cit.,
XXVIII, 778, Ms., p. 693.
4. Locquin, op. cit., p. 277.

this artist, illustrated this trend by comparing Cochin's already complicated 1765 Frontispiece of the Encyclopédie with the frequently incomprehensible figures of his Iconologie, published in 1791.[1] Applied to modern historical subjects, allegories, as pointed out by Locquin, "respond . . . to a social need. They reflect the more or less sincere élans of public opinion."[2] At the same time, as noted by Rocheblave:

"The 'philosophy' of the period officially adopts allegory. The latter becomes, from then on, a kind of déesse Raison of the Fine Arts. Rebus and bombast have become credos."[3]

Significantly, Marmontel, writing in the introduction of Cochin's Iconologie, remarked: "Allegory is one of the most beautiful inventions of the human spirit."[4]

These earlier concepts undoubtedly culminated in the esoteric and symbolic elaboration of the Directory, and Girodet's mythological paintings represent a typical instance of this current trend. Yet, these paintings were also directly influenced by three characteristic contemporary cultural developments marked by literary preciosity, the predilection for a metaphorical approach of the classical theorists, and Illuminism.

1. Rocheblave, S., Charles-Nicolas Cochin, Paris et Bruxelles, G. Vanoest, 1927, pp. 81-83.
2. Locquin, op. cit., p. 281.
3. Rocheblave, op. cit., pp. 81-82.
4. Marmontel, discours préliminaire to Iconologie ou Traité de la science des allégories d'après Gravelot et Cochin, Paris, Lattre, quoted in Rocheblave, op. cit., p. 83.

In considering the poetry of the most celebrated author
of this period, Girodet's friend Jacques Delille,[1] one is im-
pressed by the extraordinary complication of his style. The
writer painstakingly avoided naming or describing a thing in
clearly understandable, direct, or usual terms. He indulged
in an orgy of periphrases, circumlocutions, and allusions.[2]
It is not too difficult to identify "vile animals fattened in
mire"[3] as pigs, or "the lover of Cephalus"[4] as Aurora. How-
ever, what contemporaries thought to be ingenious stylistic
tours de force and delightful manifestations of wit frequently
become genuine riddles for an untrained reader. Thus, in De-
lille's poetry the truffle is described as:

> ". . . hidden in the earth, where its fate keeps it,
> Waits to be picked by the wealth of a gourmand."[5]

Lime becomes:

> ". . . a daughter of the water,
> And fruitful source of various marbles,
> . . . born from the old remains of the inhabitants of
> the water."[6]

1. Girodet spoke of the "affectionate friendship" of De-
lille and of the latter's advice in the writing of his Le
Peintre (Girodet, OEuvres posthumes, op. cit., I, Le Peintre,
Discours préliminaire, p. 37).
 2. Petit de Julleville, L., Histoire de la Langue et de la
littérature française des origines à 1900, Paris, Armand Colin,
1899, VII, p. 132.
 3. Delille, quoted in Abry, Audic, Crouzet, op. cit., p. 425.
 4. Rousseau, J.-B., Odes, II, 11, quoted in Abry, Audic,
Crouzet, op. cit., p. 424.
 5. Delille, op. cit., II, Les Trois Règnes, p. 99.
 6. Idem., p. 60.

Outside the literary realm, at a more popular level, this preciosity was manifested in an extraordinary vogue for enigmas, logogriphs, charades, and puns. They can be found in almost all the contemporary newspapers. Some of the most serious literary periodicals, such as the Mercure de France, did not hesitate to publish them in every issue and to encourage contributions from the readers. In certain cases, these logogriphs kept the Parisians in suspense during a whole month.[1] The social vogue for this type of amusement is often reflected in Stendhal's Journal, in which the writer described how he tried to find new words for charades[2] and brought thirty rebuses to a social gathering.[3]

The literary preciosity of Delille emphasized periphrasis, metaphor, and allusion. In the field of aesthetics, the classical theorists attempted to influence the visual arts in the same direction: "This is the time of . . . the Delilles of form."[4] Allegorical preciosity was thought of as a traditional device of classical antiquity. Thus, it was very important for the artist to "deepen the knowledge of 'attributes,' and make of . . . the so-called 'emblems' of the ancients the 'code of the artists in all fields'."[5] Winckelmann and his disciples particularly stressed the significance of this

1. For instance the issues of the years 1798-1802.
2. Stendhal, Journal, op. cit., IV, August 11, 1811, p. 193.
3. Idem., June 14, 1811, p. 159.
4. Rocheblave, op. cit., p. 82.
5. Cochin, Iconologie, quoted in idem., p. 83.

question. In his De l'Imitation dans les beaux-arts, Quatre-mère de Quincy wrote of "the necessity /for the artist/ to call upon these metaphorical conventions,"[1] and he repeatedly preached the extensive use of allegory[2] and symbols.[3]

The influence of literary preciosity and of classiciz-ing allegory was strongly felt throughout the last quarter of the eighteenth century. Girodet's esoteric mythological in-terpretations must also be related to the Illuministic trend, which was one of the major currents of Pre-Romanticism. Though already in evidence in the last years of the monarchic era, it was particularly strongly expressed during the last decade of the century, and was at its height during the exe-cution of Girodet's mythological paintings. Auguste Viatte, one of the most important scholars of Illuminism, wrote in his Sources occultes du Romantisme: "Toward 1780, a complete reversal takes place in the minds" of the contemporaries.[4] While until this date, it was fashionable to affect a cynical attitude, now "one will be compelled to consider seriously even the strangest myths."[5] During the last years of the reign of Louis XVI, this "taste for veiled things with a mys-tical, allegorical meaning, becomes general in Paris and

1. Quatremère de Quincy, Essai sur la nature, le but et les moyens de l'imitation dans les beaux-arts, op. cit., p. 361.
2. Idem., Paragr. XI, XII, XIII.
3. Idem., Paragr. XIV, XV.
4. Viatte, op. cit., p. 184.
5. Idem., pp. 184-185.

preoccupies all the wealthy people."[1] It is the golden age
of secret mystical sects such as the Rosicrucians,[2] the Il-
luminés d'Avignon,[3] and the Martinists.[4] Their adepts wanted
the "re-establishment of the antique patriarchal faith,"[5]
believed that the end of the world was at hand,[6] and attempted
to make direct communications with the world of spirits.[7]
During this period appeared a multitude of esoteric doctrines
like the theory of numbers,[8] metempsychosis,[9] or the arcana
of Egyptian science.[10] This trend culminated in the tremen-
dous success of Cagliostro's magic.[11] One must note that
each one of these various sects developed a complicated para-
phernalia of esoteric symbols.

This first wave of Illuminism, at its peak around 1789,
was followed by a second one, reaching its greatest height at
the turn of the century. However, this second movement had a
somewhat different character. In contrast to the Illuminism
of the reign of Louis XVI, centered around an intellectual and
aristocratic elite, the esoteric and occult tendencies of the
Directory and Consulate had a more wide-spread and popular

1. Idem, pp. 180-181.
2. Idem, pp. 34-37.
3. Idem, p. 89.
4. Idem, Chapter II, pp. 45-71.
5. Idem, p. 207.
6. Idem, pp. 98-99.
7. Idem, pp. 108-109.
8. Idem, p. 264.
9. Idem.
10. Idem, p. 221.
11. Idem, Chapter V, pp. 200-231.

quality. Now, some of the esoteric sects, like the Théophilanthropes, had numerous avowed followers, public cults, and temples.[1] At a lower level, chiromancy and palmistry had never had a larger group of adherents.[2] These "high sciences"[3] were dominated by the famous Mademoiselle Lenormand, who was particularly gifted in imitating the language of the Illuminists, and combined with the usual practices of her arts the specific terms, symbols, and reminiscences of the esoteric mystics.[4] The popular dissemination of the terminology and the concepts of occult sects was also continued by Robertson. In his Fantasmagories, this versatile adventurer claimed to unveil the secrets of the Illuminists.[5] His programs, published in almost every issue of the Journal de Paris, displayed such characteristic items as the "Evocation of spirits such as the ones imagined by the Illuminists," "the fertile Egg,"[6] and "the priests of Memphis in the mysteries of initiation."[7] The Fantasmagories were the most popular entertainments of Paris; newspapers published detailed accounts of Robertson's séances, and the public reacted with an almost hysterical enthusiasm.[8]

1. Challamel, Augustin, Histoire-Musée de la République française, Paris, Challamel, 1842, II, pp. 117-126.
2. Viatte, op. cit., I, pp. 220-221.
3. Mademoiselle Lenormand, Souvenirs prophétiques d'une sibylle, Paris, 1815, p. 119, quoted in Viatte, op. cit., II, p.18.
4. Viatte, op. cit., II, p. 18.
5. Robertson, op. cit., I, p. 284.
6. Journal de Paris, 2 Germinal, An VIII.
7. Idem, 18 Nivôse, An VII.
8. Robertson, op. cit., I, p. 206 and pp. 216-217.

This invasion of cryptic preciosity and esoteric concepts into various levels of society and culture corresponded to a progressive abandonment in art of the system of symbols based on the baroque tradition and on C. Ripa's Iconologia.[1] In 1828, Houdon still had a traditional Iconology in his possession.[2] Yet, this type of book came to be generally neglected by artists at the end of the eighteenth century.[3] Pérignon listed only two repertories of symbols among the books belonging to Girodet: Symbola divina et humana pontificum, imperatorum, regum, etc.[4] and Symbola varia diversorum principum.[5] Judging from these titles, these works do not appear to have been genuine Iconologies but rather repertories of emblazonments and heraldry. Considering the importance of the artist's library, the lack of a traditional book on symbols may be taken to suggest that the painter tended to neglect the consultation of usual Iconologies. Thus, following the general trend at the turn of the century, Girodet often based his inventions of symbols on different sources, and, as is to be seen in the consideration of his works, tended to combine the baroque allegorical paraphernalia with a new system of symbols.

1. Mâle, Emile, L'Art religieux de la fin du XVIᵉ siècle, du XVIIᵉ siècle et du XVIIIᵉ siècle, Paris, A. Colin, 1951, p. 428.
2. Idem.
3. Idem.
4. Pérignon, op. cit., p. 94, No. 782.
5. Idem, p. 95, No. 793.

II

CONSIDERATION OF THE INDIVIDUAL PAINTINGS: PARTICULAR PROBLEMS AND ICONOGRAPHICAL CONTENT

Girodet's mythological paintings may be divided into two groups: the first including the traditional classical themes and the second concerning a new type of subjects.

Traditional Classical Mythological Themes

The discussion of this group can be based on its three most important subjects: The Sleep of Endymion, The Seasons, and the first Danaë. In each of these examples, Girodet attempted to give a new interpretation of a traditional mythological theme.

The Sleep of Endymion[1] (fig. 14)

This painting, more than any other work, was responsible for Girodet's early success. Executed in Rome in 1791 and exhibited at the Salon of 1793, it "made all Paris run" to see it.[2] In 1801, Bruun Neergaard, writing about the artist, said: "His Endymion gave him, at an early age, the honor of

1. 1791, Louvre.
2. Delécluze, E. J., Louis David, son école et son temps, Paris, Didier, 1855, p. 254.

being classified among the painters of this century the most
gifted with poetic genius."[1] Facing such a considerable suc-
cess, Girodet persistently refused to sell the painting,
either to Polish princes for large sums of money[2] or to the
king of Holland, in spite of the honor involved.[3] _Endymion_
received the first prize in the _Concours_ of _l'An_ VII,[4] and
the artist exhibited the painting in practically all the salons
throughout his life, using it almost like a commercial sign.
Girodet's name became so intimately associated with this work
that he did not hesitate to sign as _Endymion_ in a letter ad-
dressed to Gérard.[5]

Girodet's _Endymion_ inspired one of the first of the
calumnies to which the artist was so often subjected. In 1806,
Chaussard wrote in his _Pausanias français:_

1. Bruun Neergaard, _op. cit._, p. 157. Similarly, Valen-
ciennes wrote about _Endymion:_ ". . . here is the poetry of
painting; here is what pleases the scientists, the artists,
and all people of good taste." (Valenciennes, P. H., _Élémens
de perspective pratique à l'usage des artistes, suivis de ré-
flexions et conseils à un élève sur la peinture et particuli-
èrement sur le genre du paysage, 2ème ed., Paris, Payen, 1820,
p. 307.)
2. Girodet, OEuvres posthumes, _op. cit._, II, _Correspondance,_
Letter XLV, to Trioson, Rome, November 25, 1791, p. 401.
3. Stein, Henri, "Girodet-Trioson peintre officiel de Napo-
léon," _Annales de la société historique et archéologique du
Gâtinais,_ Fontainebleau, 1907, XXV, Girodet's letter to Mirbel,
p. 357. In refusing the king's offer, the artist proposed to
paint a "repetition" with "some improvements" of _Endymion,_
(1808) (_Idem._)
4. Benoît, _op. cit._, p. 322.
5. _Lettres adressées au baron François Gérard, op. cit._,
I, Letter of Girodet, Paris, May 13, 1800, p. 180.

"Who does not know the Endymion of M. Girodet? It is said that originally it was a figure of académie, and that the artist's comrades advised him to introduce the scene of love into it."[1]

Undoubtedly, the painting was initially executed as a study or académie. This type of work, exemplified by David's Hector[2] or Fabre's Abel,[3] was required of the pupils of the Academy of France in Rome to be sent to Paris as a proof of their activity and progress. This original purpose of Endymion was often stated by Girodet in his letters to Dr. Trioson.[4]

However, the undeniable fact that the painting was originally meant as an académie does not necessarily imply that it was not conceived from the beginning as Endymion. The pupils of the Academy of France in Rome, in view of the future exhibition of their works in Paris, often composed their académies, from the start, as historical or mythological subjects. Moreover, Chaussard's denial of Girodet's personal invention of the theme does not seem to be sustained by the facts. Girodet, in his very first letter, dated April 19, 1791, mentioning the actual execution of the painting, gave Dr. Trioson a detailed description of the subject of Endymion.[5]

1. /Chaussard/, Le Pausanias français, op. cit., p. 170.
2. Fabre Museum, Montpellier.
3. Fabre Museum, Montpellier.
4. For instance in his letter No. XXXIX, February 1, 1791 (Girodet, OEuvres posthumes, op. cit., II, Correspondance, p. 384).
5. Girodet, OEuvres posthumes, op. cit., II, Correspondance, Letter XL, to Trioson, Rome, April 19, 1791, p. 387.

Considering the fact that the work was finished five months later, on September 18, it is safe to infer that the painter selected his theme practically from the beginning.[1] At any rate, it is difficult to accept Chaussard's derogatory implications from what is known of Girodet's method of work. Delécluze, though usually unfriendly to the artist, wrote: "This painter has always had the defect of abstaining from consulting anyone and of listening to neither advice nor criticisms during the execution of his works."[2]

Chaussard's calumny probably originated from the mystery with which Girodet liked to surround the execution of his works. Thus, describing his subject to Dr. Trioson, the painter wrote: "I should indeed be very pleased if no one knew about it."[3] Similarly, he wrote to Gérard: "I am asking you . . . not to speak about it, and to say that you do not know what I am doing."[4] Planning an ultimate effect of surprise, the painter worked in deep secret, puzzling his impatient friends and providing his enemies with an occasion for gossip.

1. Girodet, OEuvres posthumes, op. cit., II, Correspondance, Letter XLIV, to Trioson, Rome, October 24, 1791, p. 396. Girodet's earliest comment related to the painting as an académie, without mentioning the subject, dates from February 1st, 1791 (OEuvres posthumes, op. cit., II, Correspondance, Letter XXXIX, to Trioson, Rome, February 1, 1791, p. 384). In this letter he said that he was planning to start his work in a month.
2. Delécluze, op. cit., p. 262.
3. Girodet, OEuvres posthumes, op. cit., II, Correspondance, Letter XL, to Trioson, Rome, April 19, 1791, p. 387.
4. Lettres adressées au baron François Gérard, op. cit., I, Letter of Girodet, Rome, May 1791, p. 169.

It will be seen that this love of drama will remain the characteristic approach of Girodet to his public.

The theme of Endymion is a very old one. It was described by many classical authors such as Lucian, Apollonius, Ovid, Propertius, and others. There are several variations of the legend. The best known, which provided the basis for Girodet's painting, was narrated in Noël's _Dictionnaire de la fable_:[1]

> "Endymion . . . grandson of Jupiter . . . having been disrespectful to Juno . . . was condemned to a perpetual sleep . . . Other writers relate that Jupiter having given him the choice of asking for what he wished most, he asked to sleep forever, without being subjected either to old age or to death. It is supposed that it is during this sleep that the Moon, charmed by his beauty, came to visit him every night in a cave of Mount Latmos. The goddess had fifty daughters and one son by him . . . after this, Endymion was recalled to Olympus."[2]

The painting was described by Girodet himself in one of his letters to Dr. Trioson:

> "I am painting a sleeping Endymion. Eros pulls aside the branches of the trees near which he is lying so that the rays of the moon may light him through this opening, and the rest of his body is in the shade."[3]

A more lyrical account of the work, most probably also written by the artist, can be found in the _Dictionnaire de la fable_:

1. Because of Girodet's active collaboration in this book (_supra_, pp. 104-5, note 4), it must be considered the most dependable source of information in relation to the painter's mythological themes.
2. Noël, _op. cit._, I, pp. 475-476.
3. Girodet, _OEuvres posthumes, op. cit._, II, _Correspondance_, Letter XL, to Trioson, April 19, 1791, p. 387.

"Endymion, almost naked and ideally beautiful, is sleeping in a grove. Eros, disguised as Zephyrus, but recognizable by his vulture wings and his sly expression, is pulling aside the foliage. And through this open gap, a ray of moonlight, in which all the warmth of passion is breathing, comes to rest on the mouth of the beautiful sleeper. The reflection of the moon and the tint of the objects and of Endymion's body itself do not leave any doubt as to the hour of the night when the action takes place, and as to the presence of the goddess."[1]

To these descriptions it may be added that in Girodet's painting Endymion is represented reclining under a plane tree, on a drapery and a leopard-skin spread on a rock, with his dog sleeping by his side.

Girodet, writing to Bernardin de Saint-Pierre, was surprisingly modest on the subject of his sources of inspiration for Endymion:

"Endymion has been too much praised in my opinion . . . I must admit that the subject is not badly felt. However, genius does not take part in its creation. It owes much of its effect to a more or less skillful manual execution. As to the distribution of light and shade, I have seen it in nature, I did not invent it. As to the forms, I have similarly seen them in living models and in the antique which I had before my eyes, I have not created them. They are heads of a Greek type, and, therefore, known for a long time. There is here only the merit of an almost servile and almost always easy imitation."[2]

However, when he wrote to Pastoret, who was in charge of making a report to the Emperor on the situation of the arts in France,[3] Girodet showed a more affirmative attitude in respect

1. Noël, op. cit., I, p. 476.
2. Girodet, OEuvres posthumes, op. cit., II, Correspondance, Letter III, to Bernardin de Saint-Pierre, pp. 274-275.
3. Girodet, OEuvres posthumes, op. cit., II, Correspondance, Letter XXVII, p. 338, note of Coupin.

to his part in the invention of the theme:

> "Its invention was inspired by a relief of the Villa
> Borghese. I have even almost copied the antique Endymion.
> However, I preferred not to represent the figure of Diana.
> It seemed unfitting to me to paint a goddess renowned for
> her chastity, even in a moment of a mere amorous contem-
> plation. The idea of the ray /of moonlight/ seemed to me
> more delicate and more poetic, besides the fact that it
> was new at the time. This thought belongs entirely to
> me, as well as the idea of the figure of the young Eros,
> represented as Zephyrus, who is smiling while pulling
> aside the foliage. Thus, this painting is not, as some
> people have called it, Diana and Endymion, but rather The
> Sleep of Endymion."[1]

Girodet's indications of the sources for his interpre-
tation of Endymion are far from being complete. In this re-
spect, several problems are suggested by a consideration of
the painting. These problems are related, on the one hand,
to the origin of the accessories and of the figures; and, on
the other, to the significance of the absence of Diana and
of her replacement by a ray of light.

Several sketches of the Carnet de Rome may be asso-
ciated with the accessories of the painting. Such are a study
of a dog of the same breed as the one in the painting, and
lying in approximately the same position; a sketch of a tree
on which lean a quiver and a bow, and on which hangs a wreath;[2]
and finally, a preliminary drawing for Endymion's sandals and
for the vegetation seen in the lower right corner of the paint-
ing, below the left arm of the principal figure. These

1. Idem, pp. 339-340.
2. Both of the sketches are on the same page of the Carnet
de Rome.

sketches, in spite of their fragmentary character, seem to con-
firm Girodet's claim, stated in his letter to Bernardin de
Saint-Pierre, of having worked, at least partially, from na-
ture. The most important accessories of Endymion, that is,
the tree above his head, the stone on which he reclines, and
the dog beside him, are almost the traditional elements of
the classical treatment of the theme. Thus, all of them
simultaneously appear in such examples as the reliefs of the
sarcophagi in the Rospigliosi palace,[1] the Campo Santo of
Pisa,[2] or one of the paintings in Herculaneum.[3] Separately,
they can be seen in practically all the classical interpreta-
tions of the subject of Endymion.[4] The meaning of some of
these accessories, as it was understood during the period
approximately contemporary to the execution of Girodet's
Endymion, is revealed in Maréchal's Antiquités d'Herculanum,
published in 1780:

> ". . . according to some authors, Endymion's bed was
> placed under an oak, near the grotto of the nymphs, in a
> spot where could be seen stones so white that, from a dis-
> tance, one thought that the milk of the cows of Endymion
> was spilled on the earth."[5]

1. Reproduced in Reinach, S., Répertoire de reliefs grecs
et romains, Paris, E. Leroux, 1912, III, p. 317, no. 2.
 2. Idem, III, p. 110, no. 2.
 3. Maréchal, P. S., Antiquités d'Herculanum, Paris, F. A.
David, 1780, IV, p. 58, fig. 38.
 4. As for instance in the reliefs of the Capitoline collec-
tion, the Farnese Palace, San Paolo fuori le mura, another
painting in Herculaneum, and numerous other examples.
 5. Maréchal, op. cit., III, p. 11.

As in Girodet's painting, a great number of representations of the myth of Endymion show one or more flying cupids. They can be seen in the reliefs of many classical sarcophagi[1] as well as in much later works, such as the paintings of Jean Van Loo[2] and of Gabriel Blanchard.[3] Most often, these cupids play an introductory role between Diana and Endymion. The gesture of Girodet's Eros pulling aside the foliage is, so far as I know, unique for the theme, justifying the painter's claim of originality. Yet, a close parallel to this action can be found in the traditional gesture of cupids pulling aside the drapery of Endymion, in such classical works as the reliefs of the Lateran Museum,[4] the Doria-Pamphili Gallery,[5] the Capitoline Collection,[6] and of San Cosimato.[7] The general attitude of Girodet's Eros recalls these examples and is also reminiscent of such other typical classical representations of cupids and genii as can be seen in the sarcophagus with a medallion in the Giustiniani Collection[8] or in the Torlonia Museum.[9] Moreover, Girodet's interpretation of the youthful Eros undoubtedly shows the influence of Correggio. The latter was greatly admired by the artist, who called him:

1. Reinach, Répertoire de reliefs, op. cit., II, pp. 182, 446, 539, III, pp. 19, 50, etc.
2. Louvre.
3. Salon of Diana at Versailles.
4. Reinach, Répertoire de reliefs, op. cit., III, p. 273, no. 5.
5. Idem, p. 244, no. 1.
6. Idem, p. 184, no. 2.
7. Idem, p. 319, no. 3.
8. Idem, p. 254, no. 1.
9. Idem, p. 339, no. 1.

"the happy painter who discovered grace,"[1] and who wrote:

> "When I left for Italy, I had seen only Correggio's
> Danaë in Paris. But it is in Parma that I saw his master-
> piece, the famous St. Jerome /The Holy Family with St.
> Jerome usually referred to as The Day/. . . I could not
> detach myself from it . . . A grace, voluptuous and chaste
> at the same time, flows from his brush, the most suave
> and the most mellow that was ever entrusted by Painting
> to her most cherished favorites."[2]

This passage explains the Correggiesque quality of Girodet's
Eros, in which the artist combined the youthful, sensuous
forms of the Cupid in Danaë with the sly smile of the angel
in The Day.[3]

In Girodet's painting, the attitude of the figure of
Endymion himself seems to correspond to a passage of Lucian's
Dialogues of the Gods, in which Selene, speaking about Endy-
mion, says to Aphrodite:

> ". . . you should see him when he has spread out his cloak
> on the rock and is asleep; his javelins in his left hand,
> just slipping from his grasp, the right arm bent upwards,
> making a bright frame to the face, and he breathing softly
> in helpless slumber."[4]

In his representation, Girodet seems to have followed the text
of Lucian even in respect to the spear which, lying immediately

1. Girodet, OEuvres posthumes, op. cit., I, Le Peintre,
Chant I, p. 60.
2. Idem, Notes du Chant I, pp. 215-216.
3. Danaë is now in the Borghese, and The Day is in the
Pinacoteca of Parma.
4. The Works of Lucian of Samosata, Oxford, Clarendon
Press, 1905, I, Dialogues of the Gods, XI, p. 70.

below the left hand of Endymion, seems to have escaped from his grasp.[1]

The most original and the most praised[2] quality of Girodet's interpretation of the myth lies in the fact that the painter eliminated from his composition the figure of Diana.

The usual treatment of the subject of Endymion in Renaissance and baroque art, as exemplified by Gabriel Blanchard[3] or Jean Van Loo,[4] included the representation of both Diana and Endymion. I know of only two paintings, in this general period, in which the figure of Diana is suppressed. Both are by Guercino; one is in the Doria,[5] the other in the Uffizi.[6] These productions differ very little from each other. Endymion is represented alone, asleep in a seated attitude, at the entrance of a grotto. He is leaning on his arm, with a telescope placed on his lap. The presence of

1. It is possible that Girodet borrowed this attitude directly from classical reliefs in which it frequently appears, as for instance in the sarcophagi in the Capitoline Collection (Reinach, Répertoire de reliefs, op. cit., III, p. 184, no. 2), the Doria-Pamphili Gallery (Idem, p. 242, no. 3), the Farnese Palace (Idem, p. 248, no. 1), the Giustiniani Collection (Idem, p. 252, no. 1) or in the Lateran Museum (Idem, p. 273, no. 5).

2. Girodet's interpretation was often admired by his contemporaries for its "original" and "poetic" "invention," as for instance in: Explication par ordre des numéros et jugement motivé des ouvrages de Peinture, Architecture et Gravure, exposés au Palais National des Arts, Paris, Jansen, Deloynes, op. cit., XVIII, 458, p. 42.

3. Salon of Diana, Versailles.

4. Louvre.

5. Michel, Histoire de l'Art, op. cit., 1921 VI, 1ère Partie, p. 87, fig. 57.

6. Engraved by Morghen.

this optical instrument indicates that Guercino was following a less known version of the myth, relating that:

"Endymion . . . was the twelfth king of Elis. Driven out of his kingdom, he retired to Mount Latmos, where his study of celestial bodies gave rise to the myth of his loves with Diana."[1]

There is nothing in Girodet's Endymion to indicate that the absence of Diana may be explained by this particular astronomical interpretation of the legend.

The classical interpretation of the myth most frequently included the representation of both Diana and Endymion with numerous secondary personages like Somnus, cupids, and a personification of Mount Latmos. Yet, fairly often, one can find classical examples of Endymion without Diana. While some of them show Endymion completely alone,[2] others, more numerous, suggest the proximity of the moon goddess by allusion, through the reactions of animals accompanying Endymion. This can be illustrated by the goats, in the painting in a columbarium of the Villa Pamphili,[3] and in the relief of the Albani,[4] or by the dogs, showing excitement or barking at the sky, in the famous relief of the Capitoline Collection,[5] and in a

1. Noël, op. cit., I, p. 476.
2. For instance the sculpture of Stockholm (Reinach, Répertoire de la statuaire grecque et romaine, Paris, Leroux, 1897, I, p. 314, Pl. 580) and that of the British Museum (Idem, p. 540, Pl. 882).
3. Reinach, Répertoire de peintures grecques et romaines, Paris, Leroux, 1922, p. 53, no. 3.
4. Reinach, Répertoire de reliefs, op.cit., III, p.137, no.3.
5. Idem, p. 185, no. 4.

painting at Herculaneum.[1] However, no interpretation of
Endymion, known to me, uses, as in Girodet's painting, the
device of a moonlight ray to suggest the presence of Diana.

Yet, it is unfortunately difficult to give to the art-
ist the full credit for the invention of this so often cele-
brated idea. It seems to have been derived from Raphael, as
appears through a comparison of the composition of Jacob's
Ladder in the Loggia[2] (fig. 15) with that of Girodet's Endy-
mion (fig. 14). The two paintings bear a very close resem-
blance to each other. In both cases, a young man is repre-
sented asleep on his mantle stretched on a rock, with light
breaking the darkness and streaming toward him. Jacob's fig-
ure does not exactly correspond to that of Endymion. His
right arm is not placed so as to frame his head. Yet, the
position of his head and his facial expression are almost
identical to those of Girodet's figure.[3] The resemblance be-
tween the two conceptions becomes striking when one realizes

1. Maréchal, op. cit., IV, p. 58, Pl. 38.
2. Frescoes of the ceiling (arch VI), probably by G. F.
Penni from drawings attributed to Raphael.
3. Moreover, Jacob's right arm is stretched out horizon-
tally in a position almost identical to that of Endymion's
left arm. In classical representations of Endymion, the arm
which is not framing the head is usually bent in an angular
fashion (as in the Capitoline sarcophagus, Reinach, Répertoire
de reliefs, op. cit., III, p. 184, no. 2). When, in classical
interpretations, this arm is not bent but stretched out, it
is not horizontal but hangs vertically toward the ground (as
in the painting in the columbarium of the Villa Pamphili,
Reinach, Répertoire de peintures, op. cit., p. 53, no. 3).
Thus, at least from this point of view, the figure of Raphael's
Jacob is the closest approximation to that of Girodet's Endy-
mion.

that Girodet repeated in reverse the composition of Raphael.
While in Jacob's Ladder, the stone on which the figure is re-
clining is placed in the lower left corner, its counterpart
in Endymion is in the lower right corner. While in the former
the figure is represented in an oblique position directed from
the upper left to the lower right, in the latter it is in-
clined from the upper right to the lower left. Finally, while
in Raphael the source of light comes from the upper right, in
Girodet it originates from the upper left. The fact that the
composition of Endymion repeats that of Jacob in reverse is
particularly significant as a factor confirming the relation-
ship between the two works. Girodet used a similar camouflage
device for his Joseph Making Himself Known to his Brothers
(fig. 4) in order to hide his imitation of the composition of
Raphael's Solomon Meeting the Queen of Sheba.[1]

Naturally, Girodet's borrowing from Raphael's Jacob
may have been the result of a straightforward pictorial eclec-
ticism inspired by the presence of a moon crescent in the
upper left corner of the fresco in the Loggia. It must be
also recognized that the idea of suggesting Diana by a ray of
moonlight is strongly reminiscent of a poetic metaphor, a
literary preciosity à la Delille, and that it may have been
selected by the painter for precisely this very quality. Yet,
the resemblance between Girodet's interpretation of a classical

1. A drawing in Montargis (fig. 5) shows the composition of
Joseph before its reversal.

myth and Raphael's rendering of a Biblical passage suggests
still another characteristic contemporary cultural trend. It
seems to reflect the semi-scholarly, semi-esoteric interest
for daring parallels between various myths and religions of
different times and civilizations. In Raphael's interpreta-
tion of the passage from Genesis,[1] God appears on the top of a
supernatural luminous ladder descending through the night
toward the sleeping Jacob. Girodet, in his rendering of the
classical myth, chose the moment of Diana's contemplation of
Endymion,[2] which is suggested by means of a ray of moonlight
breaking through the darkness and streaming toward the sleep-
ing hunter. In both cases, light is used as a supernatural
prolongation of divinity, its occult communication with the
sleeper. By taking over this idea, Girodet, in a Neo-Platonic
fashion, seems to have transfused the expression of the
supernatural of a Biblical theme into a classical myth.[3] This

1. Gen. 28, 11-15.
2. Girodet described it as such in his letter to Pastoret,
(see supra, p. 123). The idea of contemplation seems to de-
rive from Lucian: "What is this I hear about you, Selene?
When your car is over Caria, you stop it to gaze at Endymion
sleeping hunter-fashion in the open" (Dialogues of the Gods,
op. cit., XI).
3. It is interesting to note that Dupuis, in his Origine
de tous les Cultes, almost contemporary to the execution of
Girodet's Endymion, explained the story of Jacob's Ladder as
well as that of Endymion's myth as both being typical examples
of Sabéisme or the cult of the stars. (Dupuis, op. cit., III,
p. 229, and IV, p. 80.) Noël in his Dictionnaire de la fable
compared the legend of Endymion to a supposed Egyptian ritual
involving an Isis with a crescent and a sleeping Horus, enact-
ing the idea of the rest and the security of humanity at the
beginning of Time (Noël, op. cit., I, p. 476).
 The tendency of making such parallels was one of the
typical trends of Illuministic esoteric thinking. It was

spiritualized conception, accentuated by a chiaroscuro effect, gives to the conventional subject of Endymion a genuine feeling of supernatural mystery, having an almost mystical suggestion.

In his letter to Pastoret, Girodet found it necessary to assert that the title of his painting was not, "as some people have called it, Diana and Endymion, but rather The Sleep of Endymion."[1] It must be remembered that the work was contemporary to the horrors of the Terror and that it was executed at a time of great personal insecurity for the painter, during the Roman disturbances.[2] Considering these conditions, the particular emphasis on sleep in the conception of

3. (continued from preceding page).
especially accepted because of its necessarily scholarly and pedantic aspect, relating it to the Encyclopedic tradition. Madame de Staël, in her Essai sur les fictions, and Benjamin Constant, in his De la Religion considérée dans sa source, ses formes et ses développement studied the allegorical origin of mythologies. (Viatte, op. cit., II, p. 101.) Dupuis, in his Origine de tous les cultes, attempted to explain the origin of the various religious myths from a common astrological, primitive cult. Thus, he made elaborate comparisons between the myths of Mithra, Bacchus, and the life of Christ. At the same time, Werner was playing with the idea of a universal religion (Viatte, op. cit., II, p. 122). He imagined a complicated pantheon, combining various myths with the Christian religion (Idem), and hoped that the works of art would contribute to the creation of this universal church (Idem, pp. 122-123).

These ideas found an echo among certain groups of artists, like the followers of Maurice Quay. They can also be seen in the first idea of Gérard for his Ossian, in which he wanted to create a pantheon combining several mythologies. Girodet himself reflected this particular tendency in his frontispiece to the 1803 edition of the Dictionnaire de la fable. This drawing, engraved by Roger, represents Philosophy in the midst of "a pantheon of all the gods that human superstition has liked to invent" (Noël, op. cit., I, frontispiece).

1. Supra, p. 123.
2. Supra, pp. 97 - 99.

Endymion suggests an escapist implication. This idea is some-
what reminiscent of the feeling expressed, a little later, by
Parny in his poem A la Nuit, in which the author, attempting
through sleep to evade the "treacherous humans," exclaimed:
"O gods, delay my awakening."[1]

Girodet's Endymion played an important role in the evo-
lution of non-heroic mythology at the end of the eighteenth
century. It was one of the first instances of an important
divergence of the contemporary mythological iconography from
the baroque tradition. Girodet in his conception broke away
from eighteenth-century interpretations of the Endymion theme,
as exemplified by the works of Blanchard or Van Loo, emphasiz-
ing a playful, decorative content, and using a traditional
iconography. Thus, it may be said that in spite of his borrow-
ings, Girodet, even before Prud'hon, renewed the conception
of a classical subject. The artist was very much aware of
this fact as he wrote to Pastoret commenting on his concep-
tion of Endymion: ". . . it was new at the time. This
thought belongs entirely to me."[2]

In conclusion, it may be said that Girodet derived
many elements of his conception from the classical icono-
graphical tradition of Endymion. Nevertheless, through an
approach reminiscent of the literary preciosity of his time

1. Parny, A la Nuit, published in the Journal de Paris, 16
Vendémiaire, An XII (October 9, 1803).
2. Supra, p. 123.

and the introduction of an esoteric idea echoing contemporary
Illuminism, the painter succeeded in infusing a conventional
subject with a new atmosphere and a new meaning. Girodet's
Endymion remained the recognized prototype of non-heroic
mythology even during the fame of Prud'hon and was imitated
even as late as 1822, as can be seen in the painting of
Langlois in the Fogg Museum.[1]

The Seasons

This theme, consisting of four compositions, is illus-
trated in Girodet's production by three analogous yet some-
what different versions. The earliest example, now lost and
known only through the engravings of Lingée (figs. 16, 17, 18,
19) published in Landon's Salon de 1808,[2] consisted of prelim-
inary studies for the second version.[3] The latter, composed

1. Diana and Endymion, reproduced in Landon's Salon de 1822,
Annales du Musée, Paris, Landon , II, Pl. 1. This painting,
tentatively attributed to Girodet in the Fogg, is definitely
identified as a work of Langlois by the reproduction and the
text of Landon (Idem, pp. 5-7).
 It is interesting to note that Langlois, though ridiculed
by Landon for copying Girodet and spoiling the latter's concep-
tion by the introduction of too litural details, attempted to
imitate more closely the classical antique interpretations. This
may be seen in such characteristic details as the cupid pulling
aside Endymion's drapery or the dog raising his head. One may
also note that Endymion is represented in an almost sitting po-
sition, still holding his spear, which is leaning on his arm.
 In the field of the decorative arts, Girodet's work in-
spired a motif for a bronze clock of Jeneest (reproduced by an
engraving of J. B. Arnout).
 2. Landon, Salon de 1808, Annales du Musée, op. cit.,IPls.
10, 11, 12, 13.
 3. Idem, p. 46. Landon wrote that E. Lingée's engravings
reproduced the "painted sketches and studies" of the paintings
(sent to Spain), now "lost for France."

of four paintings (fig. 20) in the Casita del Labrador at Aranjuez in Spain, was executed around 1801-1802.[1] Finally, the third set, consisting of four paintings (figs. 21, 22, 23, 24), in the Château de Compiègne, which can be dated 1817,[2] represents a late repetition of the subject.

One of the most important aspects of Girodet's Seasons can be found in the fact that they were originally conceived as part of a commission given to Percier and Fontaine by the king of Spain. The treaty of Lunéville (February 9, 1801), following Bonaparte's victory at Marengo, by giving the Duchy of Tuscany to a Spanish prince, created very friendly relations between France and Spain. Before taking possession of his newly acquired throne, the Spanish prince of Parma, travelling under the name of Count of Livorno, made a visit to Paris. The French government received him with great pomp and organized in his honor numerous feasts and celebrations.[3] The friendship between France and Spain gave the occasion for an exchange of gifts. Thus, the Spanish ambassador Azzara offered to Bonaparte a bust of Alexander the Great,[4] and Charles IV asked for a copy of David's Bonaparte at the Saint Bernard.[5]

1. Noël, op. cit., II, p. 500. Noël mentioned "l'an X" (1801-1802).
2. Girodet, OEuvres posthumes, op. cit., I, Liste des principaux ouvrages de Girodet by Coupin, p. lvij.
3. Mercure de France, An IX, 16 Prairial, 1er Messidor.
4. Elias Tormo y Monzo, Aranjuez, Madrid, p. 37.
5. Mercure de France, 16 Ventôse, An IX.

This political atmosphere perhaps explains the commission given to Percier and Fontaine, the official architects of the Malmaison,[1] by the king of Spain. These two artists were asked to execute a small cabinet, now known as the Gabinete de Platina[2] (fig. 20), for the Casita del Labrador which was being built at Aranjuez during the same period, and which was finished in 1803.[3] Girodet's part in this commission can perhaps be explained by his contemporary collaboration with Percier and Fontaine in the Malmaison[4] and by his great friendship with Boucher, the first violinist of Charles IV.[5]

In their Recueil de décorations intérieures, Percier and Fontaine described the Gabinete de Platina in the following terms:

"This cabinet . . . was entirely executed in Paris and transported to the palace of Aranjuez in Spain . . . The large paintings, filling the intervals between the pilasters and representing the Seasons, as well as the medallions showing children's games are by M. Girodet. The small paintings, depicting the views of the most famous beautiful sites, are by MM. Bidault and Thibault. The ensemble of this room . . . shows an extraordinary sumptuousness."[6]

1. The Count of Livorno visited the "monuments of the Malmaison" as was reported in the Mercure de France, 16 Prairial, An IX.
2. Elias Tormo y Monzo, op. cit., pp. 38-39.
3. Idem, p. 34.
4. Girodet painted his Ossian as part of the decorative scheme of the Salon de Musique of Josephine.
5. Leroy, A., Girodet-Trioson peintre d'histoire, op. cit.
6. Percier et Fontaine, Recueil de décorations intérieures, Paris, Les Auteurs, 1812, text explaining plate 61.

All around the barrel-vaulted cabinet, immediately above the
decorative dado, one may see eight landscapes. The views of
Florence and Venice, above which are placed two of Girodet's
allegorical medallions, appear on either side of one door.
On either side of the other door are placed the views of
Naples and of the Louvre, above which are situated two other
small allegorical medallions of the painter. Finally, ar-
ranged so as to flank the two windows, appear four countryside
scenes, above which are placed the four compositions of Giro-
det's Seasons.[1]

The old theme of the seasons was one of the most fash-
ionable subjects in France, at the end of the eighteenth cen-
tury. Coinciding with the currents of classicism and Anglophilia, it

1. Unquestionably, this decorative scheme is reminiscent of
similar arrangements, typical of the early style Empire, exem-
plified in the Malmaison or at Fontainebleau. Yet, one must
note the considerable importance given to landscape in the
Gabinete de Platina. It is represented by eight rather real-
istic views, four of which are precise reproductions of known
cities. It may be recalled that landscape was the most deni-
grated genre in French painting during the last years of the
eighteenth century. At any rate, it was almost completely
eliminated from French neo-classical interior decorative ar-
rangements. (For instance, Charles de Boisfrémond did not
introduce any landscape below his Seasons in the Salon des
Saisons of the Hôtel de Beauharnais in 1803. Similarly, Giro-
det eliminated the landscapes of Aranjuez in his repetition
at Compiègne.) However, at Aranjuez, landscape was a parti-
cularly favored type of painting, and is numerously exempli-
fied in almost every room of the Casita del Labrador (Salón
de Baile, Salón de María Luisa, Galería Pompeyana, etc.).
Thus, it can be suggested that the introduction of landscape
into the decorative scheme of the Gabinete de Platina was
the direct result of a program or suggestions which came from
Spain.

acquired a new vogue with Delille's famous translation of the
Georgics[1] and that of the much celebrated Seasons of Thomson
by Madame Bontemps.[2] The subject was taken over by a great
number of minor literary figures like Bernis,[3] Saint-Lambert,[4]
Roucher,[5] and Bernard.[6] Naturally, the visual arts, since
classical antiquity, have shown the continuous popularity of
this theme, which was often used as a standard motif for the
decoration of interiors. Thus, around 1800, the literary
predilection for the seasons merely gave a new impulse to a
traditional idea of decorative arrangement.[7]

Often associated with such themes as the Months, the
Hours, or the Four Ages of Man, the subject of the Seasons al-
ludes to the cyclic aspect of nature and humanity. Thus, Pous-
sin chose Adam and Eve to illustrate his Spring and the Deluge
to depict his Winter. The same idea was expressed in 1801 by
Valenciennes in his Elémens de perspective:

1. 1769.
2. 1756.
3. Les quatre saisons, 1779.
4. Les Saisons, 1769.
5. Les Mois, 1779.
6. Saisons, quoted in Valenciennes, op. cit., pp. 394-395.
7. Thus, it was represented in a salon of the Hotel Saint-
Julien (Bruun-Neergaard, op. cit., p. 128) and in the Salon
des Saisons of the Hôtel de Beauharnais decorated by Boisfré-
mond (Fare, Michel, "L'Hôtel de Beauharnais," Art et Industrie,
III, April 1946, pp. 5-9). Repeated by Girodet in 1817 at
Compiègne, it still inspired Dejuine as late as 1818. This
fashion is reflected at Aranjuez where, in the Casita del La-
brador, the theme of the seasons is exemplified twice by
Maella and Japelli, besides the paintings of Girodet (Elias
Tormo y Monzo, op. cit.).

". . . the periodical renewal of seasons has given them
[the philosopher and the artist] every year physical and
moral satisfactions which have made them enjoy the happiness
of existence through the contrast of the oppositions of
all the successive moments of life. They have seen the
birth of Nature in Spring, its youth and strength in Summer . . .
its greatest vigor [in Autumn] . . . its decrepitude [in
Winter]."[1]

In his conception, Girodet personified the four seasons by four
corresponding human figures, isolated against the background of a dark
and cloudy sky. This effect explains the painter's assertion of having
taken his source of inspiration from the figures "known under the name
of dancers of Herculaneum."[2] Thus, the effect of Girodet's compositions
is reminiscent, in a general manner, of the engravings reproduced under
this title in Maréchal's Antiquités d'Herculanum.[3]

The painter's own lengthy descriptions[4] provide, in spite of their
lyrical confusion, the basic elements necessary for the understanding
of the artist's conceptions.

Spring, personified by a young feminine figure, shows the
features "of the youngest of the Graces . . . One of her
hands is fluttering on the lyre of Cupid . . . the other,
armed with one of his arrows, is gently touching the cords."
On the left of the picture, approaching the lyre, "two souls"
represented by two diminutive human figures having the forms
of "Psyche and Cupid," "attracted by each other," seem to
"become fused." Yet, "everything

1. Valenciennes, op. cit., p. 387.
2. Girodet, OEuvres posthumes, op. cit., II, Correspondance,
Letter XXVII, to Pastoret, p. 342.
3. Maréchal, op. cit., III, Pl. 63; I, Pl. 64, 65, 67, etc.
4. Published several times with minor variations in Noël,
Dictionnaire de la fable, op. cit., and in his Leçons françaises de
littérature et de morale; also in Landon, Salon de 1808, Annales du
Musée et école moderne des Beaux-Arts, Paris, Impr. des Annales du
Musée, 1808, I, and Girodet, op. cit.

that breathes has assured rights" to Spring's love. "In
the shadow of her floating robe . . . two white doves,
moved by the sounds of the magic lyre, tenderly kiss each
other." Spring, listening to her own music, "bends down
her beautiful head, where a thousand different flowers are
blooming and renewing themselves unceasingly. They take
the place of wavy hair for her. They alone form her . . .
headdress . . . A smile of happiness is on her red lips
. . . her aim is fulfilled: everything is satisfied,
everything is happy through her good deeds, and the face
of Nature is renewed."[1]

Summer, personified by a young masculine figure, is look-
ing down toward the earth. "His head and his robust chest,
center of the igneous elements, propagate their emanations
in all directions. Tongues of fire form his radiant hair.
With one hand, he holds back Sirius blowing off . . . his
malignant exhalations. With the other, he pours fecundat-
ing waters from an urn. From the mixture of the two prin-
ciples of warmth and humidity, he creates stormy clouds
which he pushes down ·by pressing with his powerful foot."
These clouds are the source of lightning, hail, as well as
of "beneficial rain." Over the right shoulder of the fig-
ure of Summer, in the folds of his cloak, "a dangerous
reptile, originating from the lands under the yoke of the
burning equator, proudly displays his many coils. Raising
his bold head toward that of the god, he seems to light
from the rays of the latter's hair the black venom which
is swelling him . . . However, the beneficial Summer has
produced his effect. From the rich cloak covering him, he
generously drops the golden harvests, sweet reward . . .
of the sweat of the untiring ploughman."[2]

Autumn, personified by a goddess, bends her head and smiles
to the earth. "With her right hand, she shakes her golden
hair from which pours an inexhaustible rain of a thousand
various fruits. With her left hand, she lovingly presses
her fecund breast from which spouts a sweet and red liquid,
which will be drunk by the happy children of Cybele . . .
A light scarf, the color of which recalls the tender green-
ness of Spring, surrounds her waist and gently sways,
blown by Zephyrus. This is the allegorical image of the
second sap of the year which seems to defy the coming win-
ter. . . With her bare feet . . . she presses the purple
and golden grapes . . . thus, she prepares herself the
liquor of Bacchus . . . Besides these gifts, Autumn also

1. Noël, op. cit., II, p. 501. This is the earliest pub-
lished version (1803).
 2. Noël, op. cit., II, pp. 501-502.

provides to man . . . the riches and the pleasures of the
hunt." "It is in vain" that the hare attempts to hide
under the folds of her robe from its "agile enemy." Soon,
it is to become "the prey of the hunter."[1]

Winter is personified by an old yet vigorous masculine fig-
ure. "He turns over toward his feet the torch from which
emanates creative warmth, and restrains its fire without
extinguishing it. From the urn of bronze, which he holds
under his arm, he pours the treasures of frost, and he
presses with his foot the gathered flakes of the sparkling
snow . . . Aquatic birds rapidly fly through the glacial
atmosphere . . . Winter's robust arms, his bare and ner-
vous thighs and legs show his invincible force. His hair,
his beard, and his eyebrows, resembling the summits of
the eternal ices of the Alps . . . stress his fierce as-
pect. Fogs and black storms are created in his threatening
head. They originate from his brow sadly bent toward the
earth . . . however the powerful laws of nature do not al-
low Winter to injure all its productions."[2]

These passages of Girodet's description, quoted from
the 1803 edition of the Dictionnaire de la fable, are closely
paralleled by the painter's earliest interpretation of The
Seasons reproduced by Lingée's engravings (figs. 16, 17, 18,
19).

In classical antiquity, the seasons were usually con-
ceived, when personified by isolated human figures, as poetic
entities which could be given a great variety of interpretations.
Nevertheless, they were more often associated with a certain
pattern of ideas, symbols, and accessories. This traditional
order of associations is reflected in many elements of Giro-
det's interpretation of the seasons, reproduced in Lingée's
engravings. Thus, the painter stressed flowers and the idea

1. Noël, op. cit., p. 502.
2. Idem.

of renewal and love in his figure of Spring (fig. 16); wheat,
heat and its beneficial influence on agriculture in his figure
of Summer (fig. 17); fruits, the hunt, and fecundity in his
figure of Autumn (fig. 18); and finally, aquatic birds, cold,
and barrenness of nature in his figure of Winter (fig. 19).
The artist was also influenced by classical mythological typo-
logy. Thus, the physical characteristics of the figure of
Summer (fig. 17) and the emphasis placed on the "dangerous
reptile" suggest a resemblance to the Apollo type.[1] Similarly
the muscles, the "invincible force," and the attitude of the
figure of Winter (fig. 19) leaning on his torch are reminis-
cent of the Farnese Hercules leaning on his club. The mean-
ing of those associations was given by Noël who noted, in his
Dictionnaire de la fable, the occasional classical characteriza-
tion of Summer by Apollo and of Winter by Hercules.[2] In this
classical system of associations, Spring and Autumn were re-
spectively personified by Mercury and Bacchus.[3] Girodet, using
feminine figures in his conception of Spring and Autumn, (figs.
16, 18) was unable to follow it and had to revert to the more
familiar associations of these seasons with Flora and Pomona.

Girodet, while using many traditional elements in his
earliest version of The Seasons reproduced in Lingée's engrav-
ings, painstakingly attempted to give a new interpretation to

1. This suggestion is confirmed by the figure of Summer in
Compiègne (fig. 22), which shows the typical Apollo-knot in its
hair.
2. Noël, op. cit., II, p. 499.
3. Idem.

his subject. On the one hand, he complicated the usual meaning of the theme by pseudo-philosophical implications. On the other, he exaggerated to the extreme the use of visual images derived from literary preciosity.

In his Spring (fig. 16), Girodet eliminated the figure of the "little Cupid testing his arrows" which Noël described as the most common allusion to love used by the "moderns" in this particular subject.[1] In Girodet's conception, it was replaced by "creative harmony"[2] symbolized by the music of "Cupid's lyre" which manifests its effects at two different levels. In the highest realm, it is the cause of the union of the two souls under the forms of "Psyche and Eros," which "become fused" in an "ineffable felicity."[3] At a lower level, this "creative harmony" inspires the love of the two white doves which "tenderly kiss each other. Their half-spread wings voluptuously flutter. Each feather seems to shiver with pleasure."[4] Thus, the painter suggested the two extremes of a Neo-Platonic scale of love.[5] The spiritual fusion of the human souls is opposed to the physical voluptuousness of the

1. Noël, op. cit., II, p. 418.
2. Girodet's description of his Seasons in Noël, op. cit., II, p. 501.
3. Idem.
4. Idem.
5. The amorous effects of Spring on men and animals were often suggested in genre interpretations of Spring, involving landscape and personages. Yet, the carrying over of this idea into an isolated personification of Spring, as well as the concept of a contrast between the spiritual and physical elements, belong to Girodet's inventiveness.

animal world. This conception not only reflects a pseudo-philosophical or a literary affectation. It also echoes the very sincere Neo-Platonic feelings of the painter, which appear, for instance, in one of his letters to Julie Candeille, written after the break of their liaison:

> "Our souls have met when your soul promised to remain inviolably attached to me, independently of the illusions of the senses . . . I shall never keep such a sweet memory of any other love, it will replace for me all the satisfactions of the senses which I am abandoning for a very long time, perhaps forever."[1]

In his interpretation of Summer (fig. 17), Girodet was not content to suggest only the traditional beneficial aspect of this season. His conception, stressing both the hostile and favorable elements, is based on the idea of opposition. Thus, the "malignant exhalations" of Sirius, the dog symbolizing the much-dreaded star of the constellation Canis Major[2] is contrasted with the "fecundating waters" poured from the urn. Similarly, lightning and hail are opposed to the "beneficial rain." Finally, the "dangerous reptile" filled with "black venom" is contrasted with the "golden harvest, sweet reward . . . of the ploughman." This interpretation, emphasizing the naïvely optimistic idea of compensation, is reminiscent of some of the ideas of Bernardin de Saint-Pierre. Thus, Girodet created a paraphernalia of heterogeneous images influenced by classical mythology as well as by the contemporary

1. Girodet, Lettres à Madame Simons-Candeille, op. cit.
2. Noël, op. cit., II, p. 565.

which can be seen in the paintings of Aranjuez. Yet in the
latter (fig. 20), Girodet introduced certain changes and
simplified his composition. The painter's new rendering of
Spring and Summer illustrates this transformation. The two
figures stand alone. The diminutive Psyche and Eros, as well
as the white doves, are eliminated from the interpretation of
Spring. Similarly, the bunch of wheat and the serpent disap-
pear from the composition of Summer, while the dog Sirius is
replaced by a more traditional burning torch.[1] Moreover, the
two personifications of the seasons are now given real hair.
It replaces the flowers growing on the head of Spring and the
tongues of fire originating from the head of Summer. In the
latter figure, the flames are coming from behind so as to
form a kind of halo.

These simplifications and changes can perhaps be ex-
plained in relation to the Aranjuez commission. It is impos-
sible to understand fully Girodet's conceptions without his
own description. Thus, it is not too difficult to imagine
that the painter's complicated paraphernalia of accessories
and his daring visual metaphors were found too obscure or
bizarre, and were not judged suitable by Percier and Fontaine
for a foreign commission. From another point of view, it may
be suggested that the four landscapes placed below Girodet's
four Seasons in the Gabinete de Platina were intended to

1. Noël, op. cit., I, pp. 510-511. Noël mentioned its
frequent association with Summer.

which can be seen in the paintings of Aranjuez. Yet in the latter (fig. 20), Girodet introduced certain changes and simplified his composition. The painter's new rendering of Spring and Summer illustrates this transformation. The two figures stand alone. The diminutive Psyche and Eros, as well as the white doves, are eliminated from the interpretation of Spring. Similarly, the bunch of wheat and the serpent disappear from the composition of Summer, while the dog Sirius is replaced by a more traditional burning torch.[1] Moreover, the two personifications of the seasons are now given real hair. It replaces the flowers growing on the head of Spring and the tongues of fire originating from the head of Summer. In the latter figure, the flames are coming from behind so as to form a kind of halo.

These simplifications and changes can perhaps be explained in relation to the Aranjuez commission. It is impossible to understand fully Girodet's conceptions without his own description. Thus, it is not too difficult to imagine that the painter's complicated paraphernalia of accessories and his daring visual metaphors were found too obscure or bizarre, and were not judged suitable by Percier and Fontaine for a foreign commission. From another point of view, it may be suggested that the four landscapes placed below Girodet's four Seasons in the Gabinete de Platina were intended to

1. Noël, op. cit., I, pp. 510-511. Noël mentioned its frequent association with Summer.

supplement them and thus eliminated the necessity for such an
elaborate allegorical conception. Moreover, the complication
of Girodet's first interpretation was difficult to harmonize
with the classical simplicity of the decorative scheme of Per-
cier and Fontaine. Most probably, as in the case of the Salon
de Musique in the Malmaison,[1] the architects asked the painter
to produce a simpler version of his Seasons, which can now be
seen in the Casita del Labrador at Aranjuez. The further
transformation of this theme in Girodet's late repetition of
the Seasons at Compiègne (figs. 21, 22, 23, 24) will be studied
in the chapter considering the late classical works of the
painter.[2]

The First Danaë[3] (fig. 25)

This painting was executed in 1798[4] for the decoration
of the salon of a little hôtel, rue du Mont-Blanc, built by
Percier for the Commissaire Général Gaudin.[5] It was one of
the numerous works commissioned by the representatives of the
new financial aristocracy of the Directory, who formed a

1. As to be seen in relation to Ossian, infra, p. 173 ff.
2. Infra, p. 385.
3. 1798, Leipzig, lithographed by Aubry-le-Comte. One must
be careful not to confuse this first Danaë with the second or
New Danaë related to Mademoiselle Lange.
4. Dated 1798 by Coupin and 1797 in Aubry-le-Comte's litho-
graph of 1849.
5. Girodet, OEuvres posthumes, op. cit., I, Notice histo-
rique by Coupin, p. xiv. Gaudin was to become Minister of
Finances.

typical class of nouveaux riches who had acquired their
wealth and power through the speculations of agiotage.[1] This
kind of decorative painting was fairly common during this
period. Thus, around 1800, Prud'hon executed for De Lenois,
a rich contractor, a series of panels in his salon of the Hô-
tel Saint-Julien, rue Cerutti.[2] Similarly, in 1803, his pupil
Charles de Boisfrémont decorated, in collaboration with the
architect Bataille, the Hôtel de Beauharnais, 78 rue de Lille.[3]
Characteristic of the sad situation of the arts during the
Directory,[4] these decorative works were very poorly remunera-
ted. Thus, Girodet received for his first Danaë the very mod-
est sum of six hundred francs.[5]

The subject of Danaë was as common in painting as that
of the seasons. It is almost impossible to list all the pro-
ductions based on this theme, which is illustrated by the well-
known examples of Titian, Correggio, Rembrandt, and many
others. In the Renaissance and in baroque art, this subject
followed a definite tradition. In the majority of the Danaës
of these periods, the scene was set in a room with a large

1. Goncourt, Histoire de la société française pendant le
Directoire, op. cit., pp. 159-160.
2. Bruun Neergaard, op. cit., p. 120.
3. Fare, Michel, "L'Hôtel de Beauharnais," Art et Indus-
trie, III, April 1946, pp. 5-9.
4. Goncourt, Histoire de la société française pendant le
Directoire, op. cit., pp. 268 ff.
5. Girodet, OEuvres posthumes, op. cit., I, Notice histo-
rique by Coupin, p. xiv. M. Rilliet, in 1829, estimated the
painting at 25,000 francs.

open window. The figure of Danaë was usually represented re-
clining on a bed with heavy curtains, and she received the
shower of gold with the help of a servant or of cupids. This
interpretation could be given minor changes, but the basic
elements remained constant. In his Dictionnaire de la fable,
Noël wrote: "This subject /Danaë/, used as it is in poetry
and in painting, has given new ideas to a young artist of
great promise, the citoyen Girodet."[1] The most complete de-
scription of the artist's painting can be found in the Notice
historique of Coupin:

> ". . . while keeping to the principal circumstances of
> Ovid's story, he /Girodet/ has been able to give to this
> legend a particular character. In order to enjoy, at the
> same time, the freshness of the night and the beauty of
> the sky, Danaë has ordered her bed to be placed on the top
> of the tower where she is held. This tower is guarded,
> for one can see spear-points, and, in order to show that
> the guards are asleep, the painter has entwined their
> spears with poppies. Suddenly, flowers scatter on Danaë's
> bed: she rises in surprise. At the same time, Eros gives
> her a mirror in which she admires herself with a naïve
> satisfaction, and in which she sees jewels attaching them-
> selves to her neck and to her arms. While she intoxicates
> herself with the odor of the flowers and with the knowl-
> edge of her own beauty, Eros directs to her heart his all-
> powerful torch: the god can appear. In the agitation
> which overcomes Danaë, it will not be difficult for him to
> subjugate her."[2]

Other details may be derived from the description of Noël:

> "Jewels, flowers, adornments of all kinds emerge from the
> clouds and float in the air. A beautiful necklace magi-
> cally entwines around her alabaster throat, and a mirror,

1. Noël, op. cit., I, p. 386.
2. Girodet, OEuvres posthumes, op. cit., I, Notice histo-
rique by Coupin, p. xiij.

in which she complacently views the radiance that this
ornament adds to her charms, achieves her surrender. The
lack of space in the painting does not allow the guards
to be seen, but the points of their spears, which seem to
bend down, show a voluntary sleep caused by the same
means of seduction."[1]

One may see that Girodet's interpretation diverges from
the traditional conception of the theme. Thus, the nocturnal
element is particularly emphasized by the painter, and the
scene is situated in open air, against the night sky. More-
over, Danaë is standing; Eros is burning her heart with a
flaming torch; there is a suggestion of guards; and the cus-
tomary shower of gold is replaced by flowers and various fem-
inine ornaments. These variations are not particularly im-
portant unless they are understood from the point of view of
Girodet's new conception of the subject. The spears of the
sleeping guards crowned with poppies, and the Eros burning
Danaë's heart with a flaming torch, exemplify the painter's
predilection for Quatremère's metaphors[2] and have the obvious-
ness of worn-out literary clichés. Nevertheless, as in Endy-
mion, Girodet stressed the magic-like mystery of the theme.
This is underlined in the description, most probably written
by Girodet himself,[3] of the painting in the Dictionnaire de la

1. Noël, op. cit., I, pp. 386-387.
2. Quatremère de Quincy, Essai sur la nature, le but et les
moyens de l'imitation dans les beaux-arts, op. cit., p. 361.
3. As was already noted, Girodet participated actively in
the writing of the Dictionnaire de la fable. Upon comparing
Girodet's description of The Seasons and of Ossian published
in his OEuvres posthumes to the corresponding articles of the
Dictionnaire de la fable, it becomes evident that Girodet him-
self wrote the descriptions of his own paintings.

<u>fable</u>. As was seen, the text emphasizes such miraculous images as the jewels floating in the air and the necklace which, by itself, comes around Danaë's neck. In the painting, the mystery of the night sky which fills the greatest area of the background further stresses this mood.

Perhaps more important is the peculiar morality of Girodet's interpretation. Coupin wrote that, in this painting, the artist "has wanted to remove all the connotations that might be shameful for Danaë."[1] However, this pious comment cannot be accepted from the evidence provided by the painter's treatment of the theme. Zeus does not come to Danaë in the form of a shower of gold. Instead, before his arrival, he took the precaution to send gifts and to inebriate her with the perfume of flowers. The great god even went so far as to humiliate himself by bribing the guards to simulate slumber. This method of seduction resembles the behavior of an <u>agioteur</u> of the Directory attempting to win the favors of a minor Laïs. Girodet's conception might perhaps be explained by the actual purpose of M. Gaudin's financing the building of his <u>hôtel</u>, rue du Mont-Blanc. Thus, the already immoral content of the classical myth is tinted with a <u>nouveau riche</u>, tasteless cynicism, reminiscent of the words of Molière's Trissotin: "Love has so dearly sold me its bonds."[2] It must

1. Girodet, <u>OEuvres posthumes</u>, <u>op. cit.</u>, I, <u>Notice histo-rique</u> by Coupin, p. xiij.
2. Molière, <u>OEuvres</u>, Paris, F. Didot, 1860, II, <u>Les Femmes Savantes</u>, Acte III, Scene II, <u>Sur un carosse de couleur amarante donné à une dame de mes amies</u>, p. 545.

be noted that Girodet's interpretation was by no means unique
from this point of view. For instance, Prud'hon, in the salon
of the contractor De Lonois, represented the personifications
of the Pleasures and of Wealth beside those of Philosophy and
the Arts and gave to all of them an equally honorable place.
Bruun Neergaard, describing Prud'hon's paintings, signifi-
cantly wrote that the figure of Wealth, wearing the green man-
tle of Plutus, holds a "necklace with which she seems to call
pleasure."[1] As may be seen, Prud'hon's idea is very close to
that of Girodet's Danaë. They both reflect the extraordinary
venality and immorality of the Directory.

New Mythological Subjects

Girodet, in the two most important paintings of this
group, The New Danaë and Ossian, was no longer merely re-in-
terpreting traditional themes. In these works, the painter,
though referring to classical and Ossianic mythologies, was
essentially inventing new subjects.

The New Danaë[2] (fig. 26)

The execution of this painting was related to the most
famous salon scandal of the last decade of the eighteenth cen-
tury. No other work of the artist inspired equal controversy,

1. Bruun Neergaard, op. cit., pp. 120-122.
2. 1799, Wildenstein, New York.

which gave rise to unlimited gossip, rumors, doggerel rhymes, and pamphlet writings. Through this incident, Girodet's name acquired prominence and notoriety in the social life of the time.

In spite of the many contradictory accounts of the incidents leading to the painting of The New Danaë, one may determine certain fairly reliable facts. The controversy arose with Girodet's execution of a portrait of Mademoiselle Lange. This lady, reputed to have had her portrait painted every year,[1] was one of the most celebrated actresses of the Directory, famous for her beauty and the number of her liaisons. Girodet's painting, exhibited in the Salon of 1799,[2] received fairly favorable comments from the critics.[3] Nevertheless, this portrait was derided and ridiculed in the entourage of Mademoiselle Lange for its lack of resemblance,[4]

1. "Beaux-Arts, Musée central des Arts," Mercure de France, Deloynes, op. cit., XXI, 565, p. 267. "The portrait of the Citoyenne Lange in the role which she is playing in the play L'Isle déserte" by Colson, exhibited in the Salon of 1793, is the only other example known to me (Description des ouvrages de peinture, sculpture, architecture et gravures, exposés au Sallon du Louvre le 10 Août 1793, Paris, Hérissant, Supplement, p. 9, no. 721).
2. "Portrait de la Ce M. Simons, née Lange," Explication des ouvrages de peinture et dessins, sculpture, architecture et gravure des artistes vivans, exposés au Museum central des Arts le 1er Fructidor, an VII, Paris, Impr. des Sciences et Arts, An VII, p. 28, no. 148.
3. Chaussard, "Exposition des ouvrages de peinture, sculpture, architecture, gravure, dessins, modèles, composés par les artistes vivans et exposés dans le Salon du Musée central des Arts," Journal de la Décade, 1799, Deloynes, op. cit., XXI, 580, Ms., p. 452.
4. Girodet, OEuvres posthumes, op. cit., I, Notice historique by Coupin, p. xiv.

or more probably because it was thought not to be sufficiently flattering.[1] Hubert Robert, "who calls himself the friend of our painter," hastened to repeat these disparaging remarks to Girodet.[2] Moreover, the actress insultingly offered to pay only twenty-five of the fifty *louis* agreed upon for the portrait.[3] The painter, perhaps in love with Mademoiselle Lange[4] and still remembering the great amount of work and care he had put into the execution of the portrait,[5] was bitterly offended and hurt. Under the pretext of retouching the painting, he took it back, tore it up, and had the pieces brought back in a *serviette*[6] to the actress by a guardian of the *Muséum*.[7] To complete his revenge, the artist spent forty days[8] in painting his *New Danaë*, a biting satire based on the notorious private life of Mademoiselle Lange. Girodet did not hesitate to send his work, in the original frame of the first portrait,[9] to the same Salon of 1799. In spite of the fact that it was exhibited only two days,[10] as

1. François peintre, "Exposition du salon de peinture," Journal du Mois, Deloynes, op. cit., XXI, 581, Ms., p. 513.
2. Girodet, OEuvres posthumes, op. cit., I, Notice historique by Coupin, p. xiv.
3. "Second précis historique au sujet du portrait de Madame Simons," Journal des Arts, 1799, Deloynes, op. cit., XXI, 585, Ms., p. 592.
4. Goncourt, Histoire de la société française pendant le Directoire, op. cit., p. 346.
5. Girodet, OEuvres posthumes, op. cit., I, Notice historique by Coupin, p. xiv.
6. "Beaux-Arts, Musée central des Arts," Mercure de France, Deloynes, op. cit., XXI, 565, p. 267.
7. "Précis historique de ce qui s'est passé au sujet du portrait de la Citoyenne Lange, femme Simons" tiré du Journal des Arts, Marant, 1799, Deloynes, op. cit., XXI, 584, Ms., p. 584.
8. Idem, p. 588.
9. François peintre, "Exposition du salon de peinture," Journal du Mois, Deloynes, op. cit., XXI, 581, Ms., p. 512.
10. Idem, p. 513.

wrote Coupin, it aroused "the curiosity and the maliciousness
of the public to the highest degree."[1] A contemporary en-
graving by Naudet represents the hanging of The New Danaë in
the Salon before the eyes of the gaping onlookers and the
angry figure of Girodet himself.[2]

Above all, it must be stressed that The New Danaë was
iconographically conceived like a roman à clef. The diffi-
culty of deciphering its cryptic content is reflected in the
fact that even contemporary critics disagreed on the signi-
ficance of some of the allegorical aspects of the painting.
Naturally, one must admit that certain elements of The New
Danaë were derived from the corresponding classical myth.
Thus, it is possible to recognize the familiar feminine fig-
ure seated on a bed, holding a mirror, and receiving the
shower of gold with the assistance of a Cupid-like child. How-
ever, this resemblance is only superficial and cannot account
for the accumulation of various personages, animals, and ob-
jects crowded into the picture.

A contemporary pamphlet suggests a possible approach
to the study of the painting. Its writer, speaking of The New
Danaë, said that in this picture Mademoiselle Lange "is

1. Girodet, OEuvres posthumes, op. cit., I, Notice histo-
rique by Coupin, p. xv.
2. Reproduced by Arnauldet, T., in "Estampes satiriques
relatives à l'art et aux artistes français pendant les XVIIᵉ
et XVIIIᵉ s.," Gazette des Beaux-Arts, 1859, IV, pp. 111 ff.

expiating her past and her present behavior."[1] It is evident
that Girodet's work was conceived as a contemporary, personal
satire. Thus, the meaning of its heterogeneous paraphernalia
can be understood only in the light of certain incidents re-
lated to the private life of the actress. In the period ap-
proximately contemporary to the execution of The New Danaë,
four names stood out among the friends and protectors of
Mademoiselle Lange. They were Antoine, her faithful theatri-
cal adviser; Leuthrop Beauregard, a rich winegrower of Cor-
bigny; Hoppé, a successful speculator from Hamburg; and
Michel-Jean Simons, the son of a wealthy coach-maker from
Brussels. Antoine held a modest but constant place in the
affection of the actress. Beauregard, having lost his for-
tune and in difficulty with the police, was rejected by Made-
moiselle Lange. He was replaced by Hoppé, the father of her
daughter Palmyre. Upon his separation from the actress,
Hoppé gave her two hundred thousand livres for the education
of their child, on the condition that the mother abandon the
stage. Yet, unmindful of her promise, the actress went back
to the theatre and kept the money. Whereupon, Hoppé brought
the case to court and claimed the guardianship of Palmyre.
Meanwhile, Mademoiselle Lange's life became further complicated
by her prospective marriage with Michel-Jean Simons. The lat-
ter's father, Jean Simons, was opposed to his son's giving his
name to a comédienne, and he purposely came from Brussels to

1. François peintre, "Exposition du salon de peinture,"
Journal du Mois, Deloynes, op. cit., XXI, 581, Ms., p. 515.

Paris in order to prevent this wedding. However, once in France, he fell in love with Mademoiselle Lange's colleague, the actress Julie Candeille.[1] Under these circumstances, the previous objection was forgotten, and father and son married Candeille and Lange, respectively. All these incidents, widely publicized through the gossip of the pamphlet literature, became the laughing-stock of Paris.[2]

This vaudeville-like background provides a key to the understanding of some of the otherwise mysterious iconographical elements of the painting. First one must consider Girodet's conception from the point of view of the chronology of the events of Mademoiselle Lange's life.

Unquestionably, the principal figure of The New Danaë represents the actress herself. All the contemporary critics agreed that the resemblance was striking.[3] One may note that Mademoiselle Lange is seated on a coarse blanket spread over an "ignoble pallet,"[4] which is steadied by a brick.[5] According to Brinquant, one of the earliest possessors of the

1. The future friend of Girodet.
2. These details concerning Mademoiselle Lange's life are derived from Goncourt, Histoire de la société française pendant le Directoire, op. cit., pp. 343-346, and from Michaud, Biographie universelle, ancienne et moderne, Nouvelle Edition, Paris, Ch. Delagrave, XXIII, pp. 171-172, and VI, p. 537.
3. For instance, Coupin in his Notice historique in Girodet, OEuvres posthumes, op. cit., I, p. xv.
4. "Précis historique de ce qui s'est passé au sujet du portrait de la Citoyenne Lange femme Simons," Journal des Arts, Marant, 1799, Deloynes, op. cit., XXI, 584, Ms., p. 586.
5. Brinquant spoke of tiles (Stenger, op. cit., p. 112).

painting, these elements allude to the low birth of the ac-
tress.[1]

In the lower part of the picture, near the frame, one
can see a head, which I believe to be that of Leuthrop Beau-
regard. The vine-leaves crowning the head seem to refer to
his occupation of winegrower. The coin, introduced behind the
lower eyelid and hiding the eye, suggests a play on words, so
typical of the time.[2] Girodet ironically alluded to the mean-
ing of the name Leuthrop Beauregard ("le trop beau regard,"
"the too beautiful glance"). The greediness, indicated by
the coin, and the satyr-like, almost obscene expression of the
head, suggest the well-known character of the personage.[3] The
oversized horns have an obvious connotation related to Made-
moiselle Lange's unfaithfulness. The ruinous effect of the
actress' disloyal love is intimated by the snail, with erected
horns, feeding on the vine-leaves, Beauregard's original
source of wealth. Finally, his misfortune and his ultimate
rejection by Mademoiselle Lange are stressed by the modest
location of the head, relegated to the shadow of the pallet,

1. Brinquant, quoted in idem. According to the Biographie
Michaud, nothing was known of Mademoiselle Lange's parents nor
of her early youth (op. cit., XXIII, p. 171).
2. Supra, p. 112.
3. Beauregard increased his fortune through shameless agio-
tage. It was rumored that he paid ten thousand livres per
twelve hours of Mademoiselle Lange's affection (Goncourt, His-
toire de la société française pendant le Directoire, op. cit.,
p. 160).

almost like a discarded hunting trophy.[1]

The Cupid-like figure helping Danaë-Lange to gather the coins falling into the drapery can be identified as the actress' daughter, Palmyre. This is suggested by the fact that the painter replaced the traditional boyish Cupid helping Danaë by a girl who wears the same earrings, the same headdress, the same turban, with the same peacock-feathers, as Mademoiselle Lange. The protective, motherly gesture of the actress, as well as the action of the child helping her to receive the coins, seem to be a direct reference to the two hundred thousand livres given by Hoppé to Mademoiselle Lange for the education of Palmyre.

The turkey cock, on the left of the picture, was often identified by contemporary critics as representing the husband of the actress.[2] They even spoke of the actual resemblance of the bird to Michel-Jean Simons.[3]

1. It must be said that this head may also be interpreted, though less convincingly, as that of Antoine. In following this identification, the vine-leaves stand for friendship (Noël, op. cit., I, p. 76), on which feeds the parasitism of Antoine (the snail). The coin closing the eye may signify the paid discretion of this constant and modest friend. The particularly long horns may suggest more intimate relations with Mademoiselle Lange, undisturbed by the long series of successive unfaithfulnesses. Finally the location of the head may indicate the social obscurity of the personage.

The main criticism of this interpretation lies in the fact that these features of Antoine's character, about whom almost nothing is known, can only be inferred from a very short and elusive description of the Goncourts (Goncourt, Histoire de la société française pendant le Directoire, op. cit., p. 344).

2. Brinquant is the only source interpreting the turkey as Talleyrand and the head under the pallet as Simons. However, what is known of Talleyrand's character and of Simons' wealth make their respective position in the painting most doubtful. Brinquant's theory is also improbable because of its late date: early twentieth century (Stenger, op. cit., p. 112). Also Arnault, A.-V., Souvenirs d'un sexagénaire, nouv. ed., Paris, Garnier, II, p. 54, note 1 (by Dietrich).

3. Goncourt, Histoire de la société française pendant le Directoire, op. cit., p. 347.

This identification is confirmed by the ring which can be seen on the foot of the bird.[1] In his conception, Girodet emphasized the usual association of the turkey with stupidity and vanity.[2] The painter elaborated this idea through the action of a Cupid-like boyish figure[3] who, seen behind the bird, is plucking its tail and replacing its feathers by those of a peacock.[4] The ludicrous character of the beguiled, plucked, and flattered turkey-Simons is further stressed by his air of pomposity and happy complacency.

Turkey-Simons, the husband and the principal source of income of Danaë-Lange, enacts the role of Jupiter in the Danaë theme.[5] He is represented as letting fall his flaming thunderbolt,[6] most probably referring to his attacks and criticisms of Girodet's first portrait of Mademoiselle Lange.[7] However, amorously looking at his wife, he does not realize

1. Suggesting marriage.
2. "Précis historique de ce qui s'est passé au sujet du portrait de la Citoyenne Lange femme Simons," Journal des Arts, Marant, 1799, Deloynes, op. cit., XXI, 584, Ms., p. 586.
3. Strongly resembling his counterpart in Lotto's Marriage Yoke.
4. This interpretation is mentioned by François peintre, "Exposition du salon de peinture," Journal du Mois, Deloynes, op. cit., XXI, 581, Ms., p. 512.
5. "Précis historique de ce qui s'est passé au sujet du portrait de la Citoyenne Lange femme Simons," Journal des Arts, Marant, 1799, Deloynes, op. cit., XXI, 584, Ms., p. 586.
6. Idem.
7. The French word for thunderbolt (foudre) can have a figurative meaning of anger and of spirited attack.

that the flame of this thunderbolt is igniting the scroll of
the manuscript of Plautus' Asinaria.[1] This classical comedy
tells of a young man asking his father to finance his love
for a courtesan. The father agrees, with the disgraceful
stipulation of himself spending one day with her. It may be
seen that Girodet used the theme suggested by the scroll of
Asinaria as a particularly degrading allusion to the relation-
ship of Michel-Jean Simons and Jean Simons, the son and the
father, with Mademoiselle Lange.[2] Thus, by showing the thun-
derbolt of the unjust criticisms of Simons igniting the manu-
script of Plautus, the painter inferred that the actress'
husband was himself responsible for enkindling the satire of
Mademoiselle Lange's private life. In the painting, the smoke
of the burning Asinaria invades the room, and its heat is
already felt by Danaë-Lange, who seems to draw back her right
foot.[3] Still another allusion to the marriage of the actress

1. One can read: MACCII.PLAVTI.
 - ASINARIA -
 COMOEDIA
 2. The same idea suggesting an amorous relationship of the
two Simons to Mademoiselle Lange was expressed in Stratonice
et son peintre, conte qui n'en est pas un by De Guerle, men-
tioned in Brainne, C., Debarbouiller, J., Lapierre, Ch.-F.,
Les Hommes illustres de l'Orléanais, Biographie générale des
trois Départements Loiret, Eure-et-Loir et Loir-et-Cher, Or-
léans, A. Gatinau, 1852, I, pp. 63-70.
 3. Because of the extreme preciosity of the scheme, I do
not pretend to state a definitive, final interpretation. Sev-
eral other solutions are possible. Thus, one may suggest the
influence of the procedure used during the fantasmagories of
Robertson. The latter, in order to evoke his apparitions,
burned a series of objects related to the character and the
life of the persons about to appear. For instance, Marat was
evoked by burning two copies of his newspaper, the Journal des
Hommes-Libres (Robertson, op. cit., I, p. 217).

is suggested by a yoke, lying beside her on the pallet. One
white dove, with a broken wing, lies dead, killed by a coin
from the shower of gold. This dove is attached to the yoke
by a collar on which one can read the inscription fidelitas.
Another dove, with the inscription constantia, tears its
bond and flies away from the yoke. Thus Girodet once more
intimated the lack of faithfulness and constancy in Mademoi-
selle Lange's union with her husband.

The remaining elements of the painting, while not di-
rectly referring to the marital life of the actress, further
elaborate certain particular aspects of her character. On the
right side of the picture, above the left arm of Danaä, one
can see a small statue of Venus, placed on top of a colonnette.
Venus is here conceived as the tutelary goddess of Mademoiselle
Lange, a household divinity. Thus, a small votive flame burns
before the statue, on the base of which one can read:

BONAE SPEI.
ET LARIBUS.
SACRUM

This meaning is reinforced by an anchor (hope[1]), which is hang-
ing from the colonnette. Mademoiselle Lange's hope placed in
Venus is not deceived, and numerous butterflies and mice, ob-
viously representing the admirers of the actress, attracted by
the flame, come to burn themselves at the sacred fire[2] of the

1. Noël, op. cit., I, p. 508.
2. Mentioned by François peintre, "Exposition du salon de pein-
ture," Journal du Mois, Deloynes, op. cit., XXI, 581, Ms., p. 512.

courtesan's home. This theme of ensnaring is repeated in the
upper part of the picture, where a spider is catching flies
in its web, as well as in the lower part, where a rat is shown
caught in a trap. One can note that Mademoiselle Lange's vic-
tims are alluded to by a low category of animals, such as
night butterflies, flies, mice, and rats. The heads of stags
with prominent horns delineated on the coins of the shower of
gold[1] make Girodet's message unmistakable.

Finally, Mademoiselle Lange's vanity, her inability to
see herself as she really is, and therefore her finding Giro-
det's first portrait not flattering enough, is suggested by
the broken mirror held in Danaë's hand.

By placing his New Danaë in the frame intended for his
first portrait of Mademoiselle Lange, Girodet followed a
definite purpose. He replaced the four allegorical medallions
"inspired by the talent and the beauty of the model"[2] by other
medallions "which seem to be the account of her amorous an-
nals."[3] The medallion on the upper left of the frame shows
an inscription quoted from Horace's De Arte Poetica:

<div style="text-align:center">

DESINIT IN PISCEM
MULIER FORMOSA
SUPERNE [4]

</div>

1. Steins, in Brainne, Debarbouiller, Lapierre, op. cit.,
spoke of silver and copper coins (pp. 63-70).
2. Girodet, OEuvres posthumes, op. cit., I, Notice histo-
rique by Coupin, p. XIV.
3. François peintre, "Exposition du salon de peinture," Jour-
nal du Mois, Deloynes, op. cit., XXI, 581, Ms., p. 512.
4. Horace, De Arte Poetica, verse 5.

One may note that Girodet changed Horace's "Desinat," the
present of the subjunctive, into "Desinit," the present of
the indicative. Thus, the painter actualized Horace's quota-
tion and gave to it a meaning applicable to his satire of
Mademoiselle Lange.[1] This inscription is illustrated by a
woman with a bifurcated fish tail, looking into a mirror, an
obvious allusion to the duplicity and the vanity of the ac-
tress.

The medallion on the upper right continues the same
quotation from the De Arte Poetica:

"RISUM TENEATIS
AMICI?"[2]

Above the inscription one can see a strange creature having
the head and the neck of an ostrich, the tail of a turkey, the
palmate feet of an aquatic bird, and the breast of a woman.
The upper part of this strange being is supplemented by two
Janus-like, opposed masculine heads, one of them adorned with
the horns of a ram. This composite monster is ridden by a
squirrel driving it with a whip. In a general manner, this
figure seems to have been inspired by the very beginning of
the De Arte Poetica.[3] It repeats once more the now familiar

1. Naturally, the meaning of the quotation in its context
is not aiming at any kind of social satire.
2. Horace, De Arte Poetica, verse 5.
3. ". . . a man's head upon a horse's neck,
 Or limbs of beasts of the most different kinds,
 Cover'd with feathers of all sorts of birds,"
(Horace, The Complete Works, Rhys ed., London, Dent & Sons,
New York, Putton & Co., The Art of Poetry, p. 133).

satirical themes derived from Mademoiselle Lange's life.
Thus, the head of the ostrich alludes to the actress' vora-
city;[1] the tail of the turkey signifies her stupidity; the
palmate feet refer to her marshy origins; and the woman's
breast definitely identifies the beast as a female. The
head with the ram-horns probably alludes to Mademoiselle
Lange's husband, while the other head, which seems to be
that of an older man, presumably represents the father Si-
mons. Finally, the squirrel driving the beast suggests the
agility with which the actress dominated the two Simons.

The medallion on the lower left represents butter-
flies, some of which are attracted by flowers and others by
gold. This image, referring once more to the cupidity of
Mademoiselle Lange, is a free interpretation of a quotation
from Virgil's Eclogues inscribed in the lower part of the
medallion:

> "TRAHIT SUA QUEMQUE
> VOLUPTAS"[2]

The last medallion on the lower right ridicules the
arrogance and the unjustified pretension to fame of the ac-
tress. Girodet based his satire on the illustration of La

1. Noël, op. cit., II, p. 767.
2. Virgil, The Loeb Classical Library ed., H. R. Fair-
clough trans., London, Heinemann, New York, Putnam's Sons,
I, Eclogues, II, 65, p. 14.

Fontaine's fable: La Grenouille qui veut se faire aussi
grosse que le boeuf, ironically contrasted with the motto of
Louis XIV:

NEC PLURIBUS
IMPAR.

In his New Danaë, Girodet based his iconographical
interpretation on both the old, traditional repertory and new,
contemporary concepts.

Needless to say, the satirical implications of the
theme of Danaë had already been underlined by the classical
authors.[1] Moreover, it can be pointed out that the bitter,
caustic spirit of Girodet's conception is similarly strongly
reminiscent of the writings of Latin satirists like Juvenal
or Martial.[2] Undoubtedly, many of the individual iconographi-
cal elements of Girodet's painting are of the most traditional
kind. One can note such evident derivations from classical
sources as the yoke, Jupiter's thunderbolt, the scroll, or
the statuette of Venus. Other images were inspired by baroque
iconography, widely popularized through various monuments and
Iconologies. Such are the anchor, the turkey, the peacock
feathers, or the ostrich. Finally, several other ideas were

1. For instance, Martial, Epigrams, London, Bell & Sons,
1890, Book XIV, Epigram No. CLXXV, p. 626.
2. Girodet frequently indulged in literary imitations of
classical satirists (Girodet, OEuvres posthumes, op. cit.,
II, pp. 77-87).

taken from popular or proverbial backgrounds. This can be
exemplified by the numerous allusions to cuckoldry, the spider
web, the mousetrap, or the butterflies attracted by the flames
which are burning them.[1]

However, Girodet's most important source of inspira-
tion for the general conception of his New Danaë can be seen
in certain late eighteenth century caricatures. Typical ex-
amples of the latter, ranging from the last years of the
monarchic regime throughout the Revolutionary period, show in
their conception a striking resemblance to Girodet's paint-
ing.[2] Thus, it is possible to note in these caricatures as
well as in The New Danaë a trend toward preciosity, the use
of puns, the formation of composite creatures from various
animals, and a general cryptic quality. Moreover, /both/these
caricatures and Girodet's painting show a similar accumula-
tion of humerous accessories alluding to the satirized per-
sonage, yet having no apparent logical relation to each other.

Yet, Girodet was not satisfied with mere borrowings
or imitations from traditional and common sources. Attempt-
ing to renovate the satirical iconographical repertory, the
painter painstakingly tried to find new images. However, his

1. It seems to have been a rather popular theme, reflected in
an engraving in Lavater (La Fite, Caillard, and Reufner trans.,
op. cit., I, p. 213), and in a poem of Andrieux: Les Nouveaux
papillons (in OEuvres, Paris, Nepveu, 1818, III, p. 323).
2. For instance, Erostrate moderne écrivant sur les Arts,
caricature of Sébastien Mercier, reproduced in Monglond, op.
cit., I, Pl. IV, facing p. 48.

efforts were not often rewarded by a creation of genuinely
new concepts. Most frequently his method was based on the
principles of addition and elaboration of already existing
concepts. Thus, Girodet's idea of Simons' thunderbolt set-
ting afire the satire of _Asinaria_, which goes up in smoke to
envelop Mademoiselle Lange, equals or outdoes the most re-
fined and daring preciosities of the contemporary allegories
and caricatures.[1] Similarly, in combining the visual constitu-
ents of the play on words, such as the one on the name of Leu-
throp Beauregard, the artist showed a keenness and an ingenu-
ity which excel the frequently dull caricatural _calembours_ of
the time.[2] His general approach is characterized by the com-
posite beast of the upper right medallion of The New Danaë.
While many allegories and caricatures combined several ani-
mals into one being,[3] few of them united as many as seven.

However, the painter succeeded in transforming some of
the ideas found in contemporary caricature so as to give them
a completely different accent. An interesting instance can
be seen in Girodet's combination of animal and human forms.
The contemporary caricatures frequently characterized famous

1. See for instance, _Le dégel de la Nation_, 1792, repro-
duced in Challamel, _op. cit._, I, facing p. 230.
2. See for instance, _Condé riding Austria_ (Ostrich), re-
produced in _idem_, I, p. 175.
3. Usually two, as for instance: Bailly-coco in _idem_, p.
68. (The closest parallel to Girodet's conception can be seen
in a classical combination of a man, a horse, and a rooster,
reproduced in Gorlaeus, Abraham, _Dactyliothecae_, Lugduni Bata-
vorum, Petrus Vander Bibliop., 1695, I, Pl. 186, and II, Pl.
316.)

personages by means of animals. For this purpose, most often, the caricaturists combined the human head of the personage with the body of the animal involved.[1] Girodet, exploiting the success of the 1777 exhibition of Lebrun's drawings on the comparison of the physiognomy of men and of animals[2] as well as the general fashionable interest in Lavater,[3] transposed their concepts into the field of caricature. Thus, the ram-horned and sheep-faced head of Mademoiselle Lange's husband, in the composite creature in the upper right medallion of the painting, was definitely inspired by one of Lebrun's animalized humans.[4] The same Michel-Jean Simons was recognized by contemporaries in the successfully humanized and psychologically convincing expression of the turkey cock.[5] It can be seen that the painter succeeded in identifying the personality of Mademoiselle Lange's husband with two different

1. For instance M.'. L'Ane comme il n'y en a point, caricature against Sébastien Mercier, reproduced in Monglond, op. cit., II, Pl. VII, facing p. 176.
2. Notice des dessins originaux, carton, gouaches, pastels, émaux et aussi miniatures au musée central des arts, 1ère partie, Paris, Imp. des Sciences et des Arts, An V (1797), p. 84. The success of this exhibition is suggested by Le Mercier, who wrote in his Observation sur cette exposition de dessins: "after this study /of Lebrun's drawings/, some furtively run toward the large mirrors at the end of the gallery to verify in the mirror if their faces resemble the turkey cock or the eagle, the dromedary or the lion, the monkey or the pig"(Deloynes, op. cit., XIX, 505, Ms., p. 131).
3. Le Mercier (in idem) showed that the renewal of the fashion for Lebrun's drawings was related to the fame of Lavater.
4. As for instance by The Donkeys or The Rams engraved by A. Le Grand. Girodet borrowed from both and combined them with some individual features of Simons.
5. Supra, pp. 159-60, note 1.

animals, in the first case animalizing a human and in the
second, humanizing an animal. One must recognize that this
approach is much more subtle than the simple juxtapositions of
the contemporary caricaturists.

All these elements led Girodet to create a series of
cryptic images which were the visual counterparts of the cur-
rently fashionable logogriphs and enigmas. The riddle-like
complexity of his preciosity, play on words, or composite
creatures is difficult, if not impossible, to understand with-
out a key. Thus, The New Danaë was originally conceived for
the persons familiar with Mademoiselle Lange's life. Yet,
this individualized character of Girodet's satire is not the
only explanation of the cryptic quality of the painting. This
cryptic quality also derives from what seems to have been the
painter's willful concealment of certain iconographical ele-
ments within his composition, leaving them to be discovered by
the spectator.[1] It is only after a prolonged study that the
uninformed onlooker can notice such details as the rat caught
in the trap, in the shadow of the pallet, or the mouse climb-
ing the colonnette, in the smoke of the burning Asinaria. The
general cryptic appearance of The New Danaë is also the result

1. In a different manner, this tendency toward concealment
is reflected in the lost-and-found type of popular engravings
such as the one satirizing the Duc d'Aiguillon reproduced in
Challamel, op. cit., I, p. 63, the landscape which becomes a
profile, or the man on a horse who becomes a woman's head
(Facéties, Pls. 26 and 29, Bibliothèque Nationale, Cabinet
des Estampes, Paris).

of the accumulation of accessories suggesting no apparent
rational relation to each other. Thus, Girodet's additive
method created a mystifying complexity which goes far beyond
that of contemporary allegories and caricatures.

The intriguing charm of The New Danaë is especially
brought out by a particular quality which is seldom found in
the caricatural productions of the time. While the refine-
ments and the preciosity of the latter were based on uncon-
vincing, conventionalized elements, the esoteric and cryptic
effects of Girodet's work are expressed through realistic,
almost illusionistic images. Far from being a mere accumula-
tion of semi-abstract ideograms, Mademoiselle Lange's satire
gives the impression of a fascinating and paradoxical con-
trast between extreme irrationality and a most convincing
realism.

The New Danaë seems to have inspired a number of con-
temporary popular caricatures such as Qui se ressemble s'as-
semble, Les Inséparables (fig. 27), and La moderne Danaë ou
La Maîtresse à la mode (fig. 28). However, Girodet's satire
also gave rise to a great number of attacks directed against
the personality of the artist. The most typical criticisms
blamed the artist for his lack of taste and pretended to be-
lieve that the painter's reason for painting such a satire
was based solely on a question of money. Thus, the author
of an anonymous pamphlet circulated among Mademoiselle Lange's
friends wrote:

"In vain, as a result of a vile resentment,
The painter has pretended to take vengeance for an offense.
He has, for a little gold, degraded his talent,
Outraged good morals, taste, feeling,
Betrayed the secret of Beauty to abuses,
 And completely proved
That it is much easier to be miserly and mean
Than to paint a faithful portrait of an angel."[1]

From the time of the Lange incident, Girodet acquired the lasting reputation of being a miser. In his poem, Le Peintre, the artist justified and regretted his satire:

"Has only the poet the right to satire?
.
The artist . . .
Laughs at the anger and the discourses of fools.
.
Yes! the painter has the right to punish stupidity
Seated on a coarse cloth or on purple;
 . . . his irritated brushes
Will revenge his insulted honor and fame.
The artist, . . .
When he is insulted, doubly feels the insult.
.
Hatred follows love
Could the poet and the painter, alas! too irascible,
Have talent, if they were insensible?
Learn, then, to forgive the offended genius,
For throwing back the arrow which has wounded him."[2]

Girodet's satire had very serious consequences for Mademoiselle Lange, who was forced to renounce the stage permanently.[3] Moreover, as was reported in the Biographie Michaud: "She was overcome with grief, and as a result contracted an illness, for

1. Stenger, op. cit., p. 112, note 2.
2. Girodet, OEuvres posthumes, op. cit., I, Le Peintre, Chant II, pp. 99-100.
3. Biographie Michaud, op. cit., XXIII, p. 172.

which was prescribed a trip to Italy; but her condition grew
worse, and she died in Tuscany around 1825."[1] The painter,
somewhat ashamed, hid his New Danaë and refused to show it to
even his most intimate friends.[2]

Ossian or Ossian and His Warriors Welcoming in Their Aerial Realm the Shades of the French Heroes[3] (fig. 29)

In this painting Girodet combined elements of political
actuality with his interest in esoteric preciosity, now real-
ized on a large scale. Completely abandoning the tradition
of Davidian rationalism, this work marked the beginning of
the decrease of Girodet's fame as a painter.

Around 1800, Percier and Fontaine, in charge of the
restoration and decoration of the Malmaison, asked Gérard and
Girodet to each execute a painting for the Grand salon de ré-
ception.[4] In spite of the fact that Girodet was commissioned
to paint a "tableau d'agrément"[5] (of a pleasant and not serious

1. Biographie Michaud, op. cit., XXIII, p. 172.
2. Girodet, OEuvres posthumes, op. cit., I, Notice histo-
rique by Coupin, p. xv.
3. 1801-1802, La Malmaison. Girodet, OEuvres posthumes,
op. cit., I, Liste des principaux ouvrages de Girodet by Cou-
pin, p. lvij. The painting is referred to by several other
titles, the simplest of which is the Apotheosis of the Heroes
(Girodet, OEuvres posthumes, op. cit., II, Correspondance,
Letter V, to Napoleon, 6 Messidor, an X (June 1802), p. 287.
4. Delécluze, Souvenirs de soixante années, 1862, p. 48,
quoted by Van Tieghem, op. cit., II, p. 142.
5. Girodet, OEuvres posthumes, op. cit., II, Correspondance,
Letter V, to Napoleon, 6 Messidor, an X (June 1802), p. 288.

nature), his first idea was based on political actuality.
This first project, described by Coupin as an "allegorical
subject inspired by the event of the third of Nivôse,"[1] was
an obvious allusion to the unsuccessful plot against the life
of Napoleon (3 Nivôse, An IX: December 22, 1800).[2] This oil
sketch, mentioned by Coupin, is now lost. It represented
Bonaparte as Hercules crushing a monster spitting fire,[3] a
reference to the machine infernale, a powerful explosive de-
vice used by the conspirators against the life of the First
Consul. Girodet was advised by Percier to abandon this sub-
ject. Yet, its political inspiration remained an important
factor in the conception of the painter's final contribution
to the Malmaison.

Coupin reported that Girodet, compelled to choose an-
other theme, asked Gérard about the subject of his work for
the Malmaison and learned that he was painting The Bard Ossian
Evoking Ghosts on the Shores of the Lora. Gérard's selection
of an Ossianic theme probably determined the choice of Girodet,
who was perhaps stimulated by a desire to compete with a rival.[4]
It may also be suggested that the painter's decision to choose

1. Girodet, OEuvres posthumes, op. cit., I, Liste des prin-
cipaux ouvrages de Girodet by Coupin, p. lxx.
2. Napoleon's escape from death inspired a great number of
popular poems and songs (Challamel, op. cit., II, pp. 177-
178).
3. It is perhaps the oil sketch called by Pérignon "Her-
cules crushing Cacus" (Pérignon, op. cit., p. 17, no. 60).
4. Girodet, OEuvres posthumes, op. cit., I, Notice histo-
rique by Coupin, p. xv.

an Ossianic subject was influenced by the tremendous vogue of
Macpherson's Ossian. It was the favorite book of Bonaparte,
and the height of its popularity coincided with the latter's
coming to power around 1800. Its fame was reflected in new
translations,[1] imitations,[2] plays,[3] as well as in the poems
glorifying the First Consul through Ossianic mythology.[4]

By combining the information provided by Girodet's
descriptions of his own work,[5] which is now in the Malmaison,
with those contained in the legends of Aubry-Lecomte's litho-
graphs of the painting,[6] one can arrive at a fairly complete
identification of the elements of Girodet's Ossian.

The personages of the painting are divided into two
major groups: the French soldiers and the Ossianic warriors.

In the center of the composition one can see Ossian
and General Desaix,[7] in the act of embracing each other. Be-
hind Desaix, in the right half of the picture, one can iden-
tify a group of French generals composed of: Kléber,[8]

1. In 1801 there appeared a new edition of Letourneur's
translation as well as a new, very popular translation by
Baour-Lormian.
2. See Van Tieghem, op. cit., II, pp. 85-109.
3. The most famous was Les Bardes, an opera by Le Sueur.
See idem, Chapter IV, Ossian au théâtre, pp. 115 ff.
4. For instance Vers sur la mythologie d'Ossian by Creuze,
quoted in Noël, op. cit., I, pp. xix-xxij; see also Van Tieg-
hem, op. cit., II, pp. 13-21.
5. The most detailed descriptions can be found in Noël, op.
cit., I, pp. 502-503, and in Girodet, OEuvres posthumes, op.
cit., II, Correspondance, pp. 289-295.
6. 1822, E. Engelmann.
7. His name is inscribed on the sheath of his sword.
8. Immediately to the right of and behind Desaix. With his
left hand, he holds a trophy also held by Desaix. His name is
inscribed on the sheath of his sword.

Caffarelli-Dufalga,[1] Marceau,[2] Hoche,[3] Dugommier,[4] Joubert,[5] Dampierre,[6] Championnet,[7] Kilmaine,[8] Marbot,[9] and Duphot.[10] Moreover, it is possible to recognize two other famous military figures: the first grenadier of the Republic, Latour-d'Auvergne,[11] and the drummer Bara.[12] The remaining French soldiers, such as the grenadiers,[13] sappers,[14] dragoons,[15] chasseurs,[16] hussars,[17] and cannoneers,[18] can be identified only by their uniforms. The victories of the French arms are suggested by the flag taken from the Turks, held by Caffarelli-

1. Looking to the right and holding a flag with his left hand. He is placed immediately to the right of and behind Kléber. His name is inscribed on the sheath of his sword.
2. Wearing the high, cylindrical hat of the hussars on which is inscribed his name. He is placed immediately to the left of and behind Desaix and Kléber.
3. Between Marceau and Ossian, immediately to the right of the latter.
4. Between Hoche and Marceau.
5. Wearing a bicorn hat on which is inscribed his name, and appearing above the heads of Hoche and Dugommier.
6. His head appears between the heads of Marceau and Kléber.
7. His head appears between the heads of Kléber and Caffarelli-Dufalga.
8. On the extreme right of the picture, the third head to the left of the frame, below the flag held by Caffarelli-Dufalga.
9. His head appears immediately to the right of that of Kilmaine.
10. His head appears between the head of Marbot and the frame.
11. Behind the flag held by Caffarelli-Dufalga, between the latter and Kilmaine, his back turned to the spectator.
12. Represented in the act of drumming, immediately below Latour-d'Auvergne. This identification does not appear in Girodet's description and is only tentative.
13. Seen immediately to the right of the head of Caffarelli-Dufalga.
14. Seen between the heads of the grenadiers and of Latour-d'Auvergne.
15. His helmet, half hidden by the trophy held by Desaix and Kléber, appears immediately above the head of the latter.
16. His head appears slightly above and between the heads of Kléber and Championnet.
17. Dimly appearing in the upper right of the picture.
18. His head appears between the feet of Marceau and Ossian.

Dufalga; the trophies conquered from the Mamelukes, held by
Desaix and Kléber; and the flag won from the Austrians, float-
ing in the background above the heads of the French generals.
The figure of Victory flies above the group. With her left
hand, she presents to the Ossianic warriors a caduceus, sym-
bol of peace. With her right hand, she is holding aloft a
sheaf of palm, laurel, and olive leaves, symbolizing the
"profitable and glorious conquests" of the French armies.[1]
This sheaf is surmounted by a cock, the symbol of France. The
main body of the French troops is marching toward the Ossianic
warriors, from right to left. Yet other soldiers are engaged
in drinking,[2] riding,[3] hunting,[4] or courting the Ossianic
ladies.[5]

The Ossianic personages can be divided into two classes
from the point of view of their ethnic origin and of the man-
ner in which they react to the arrival of the French.

The first class consists of the former inhabitants of
Morven.[6] Headed by the blind bard Ossian,[7] they are welcoming

1. Noël, op. cit., I, p. 502.
2. Appearing between the legs of Ossian and Desaix as well
as below Bara.
3. In the right part of the background, above the figure of
Victory.
4. In the upper right corner of the picture.
5. Immediately to the right of the sheaf held by Victory.
6. "Ancient name of the part of Scotland, which is on the
seashore in the northwest" (Macpherson, op. cit., Letourneur
trans., I, Explication des nomsgalliques, p. xlvj).
7. The mythical author of the Ossianic poems, who was de-
scribed as the last descendant of the ruling family of Morven.

the arriving Frenchmen. Ossian, embracing Desaix with his
right hand, is leaning on his reversed spear. He is accompan-
ied by his faithful dogs which greet Desaix' greyhound.[1] Be-
hind and to the left of Ossian, it is possible to identify
his son, Oscar;[2] his father, Fingal,[3] clasping Kléber's hand;
and his ancestors Comhal[4] and Trenmor.[5] Moreover, one can see
some of the most famous warriors, followers or allies of Fin-
gal: Cuthullin, the king of Dunscaith,[6] holding a spear with
a broken point; Morar,[7] blowing his horn; and Crugal,[8] whist-
ling a "bellicose tune."[9] Finally, one can recognize Ossian's
wife, Everallin,[10] and Oscar's wife, Malvina,[11] both playing
harps. Other ladies and maidens of Morven greet the arrival
of the French by playing musical instruments,[12] singing,[13]

1. On its collar one can read: I belong to the General.
It is probably the famous greyhound-bitch of Desaix.
2. Wearing a semi-antique helmet with a large crest, his
head appears between Ossian and Fingal.
3. Wearing a semi-medieval helmet ornamented with a large
wing, he is placed immediately to the left of and behind Ossian.
4. The grandfather of Ossian. He is placed to the left of
the wing of Fingal's helmet. He is represented with white hair
floating around his bare head.
5. In the upper left corner of the painting. He is wearing
a crown and is leaning on his scepter.
6. He is placed between Comhal and Fingal. He is wearing a
conical helmet with a crown, half-hidden by Fingal's helmet.
He is described as the ruler of the castle of Dunscaith, on
the island of Tura in Ireland.
7. His head appears immediately above the head of Comhal.
8. A hero of Ireland, his head appears immediately to the
left of the head of Comhal.
9. Girodet, OEuvres posthumes, op. cit., II, Correspondance,
p. 293.
10. Immediately below Fingal.
11. Immediately to the left of Everallin.
12. Comala, one of Fingal's beloveds,is playing a lute-like in-
strument, below Trenmor; Aina, playing a double flute, appears on
the right of Trenmor, above the head of Comala;Minona, one of the mu-
sicians of Fingal's palace of Selma,is represented holding a flute
and is the third feminine figure from the right in the lower
right corner of the picture.
13. Girodet, OEuvres posthumes, op. cit., II, Correspondance,
p. 293.

throwing flowers under their feet,[1] presenting them with wreaths,[2] and offering them drinks in shell-shaped cups. Eager to prove their valor to the French, the heroes of Morven are showing them the spoils of their victories over the Romans:[3] a helmet, a standard, and an eagle.[4]

The second class of Ossianic personages is composed of former inhabitants of Lochlin.[5] They are the traditional enemies of the land of Morven[6] and react with great anger and displeasure to the arrival of the French soldiers. The warriors of Lochlin, Cormac,[7] Foldath,[8] and Clothal,[9] are headed by Starno, the king of Lochlin,[10] and by his son Swaran.[11] Two of the ladies of the land of Lochlin, Lorma[12] and Agandecca,

1. Moma and Dina, immediately to the left of Minona.
2. Bosmina, Ossian's sister, on the right of Minona.
3. The warriors of Morven were described as having fought the invading Roman legions of Caracalla (Macpherson, op. cit., Letourneur trans., I, Discours préliminaire, pp. 1 ff.)
4. Seen above the figure of Ossian.
5. "It was the Gaelic name for Scandinavia in general and for Jutland in particular." (Macpherson, op. cit., Letourneur trans., I, Explication des noms galliques, p. xlv.)
6. The great majority of the combats described in the poems of Ossian were concerned with the wars between Morven and Lochlin.
7. On the extreme left of the picture. He is placed between the frame and the shield. He holds a sword in his right hand. His head is the second head below Comala.
8. His head is visible below that of Cormac. He is the king of Moma, in Belgium, and an ally of Starno.
9. Immediately below Foldath.
10. In the lower left corner of the picture, wearing a helmet adorned with a crown. A skull is hanging from his belt.
11. He is placed between Fingal and the group of Cormac, Foldath, and Clothal, above the figure of Malvina.
12. Her head and her hand appear in the lower right corner of the picture. She is the wife of the king of Sora, in Scandinavia, an enemy of Fingal.

daughter of Starno and beloved of his enemy Fingal,[1] join the maidens of Morven in welcoming the French. Enraged by his daughter's attitude, Starno seizes Agandecca by the hair and is about to kill her, when she is saved by a French dragoon,[2] who pierces Starno with his sword. Meanwhile, Swaran, holding his broken sword, angrily looks at the French soldiers; Foldath seems to be yelling; Cormar strikes the shield of one of the warriors of Morven with the hilt of his sword; and another follower of Starno[3] "whistles seditiously."[4]

The eagle of the Austrian Empire,[5] represented above the Ossianic personages, is fleeing at the sight of the cock, the symbol of France. The latter spreads a protecting wing over a small bird rescued from the eagle. The remaining area of the picture is filled by numerous, unidentifiable personages,[6] and is traversed by meteors,[7] which are the only source of light of the scene.

Girodet's Ossian is very different from the contemporary

1. Agandecca is placed below the figure of Malvina, to the right of Starno.
2. His head appears below Malvina, between Starno and Agandecca.
3. His head appears at the feet of Comala.
4. Noël, op. cit., I, p. 502.
5. Idem, p. 503.
6. It is impossible to identify all the figures of Girodet's painting. This becomes evident from the fact that Aubry-Lecomte's lithographs, executed under the supervision of Girodet himself, show many contradictory identifications, misspell certain names, and introduce others which cannot be found in the Ossianic mythology.
7. Some of them seem to be localized above certain figures, such as, for instance, those of Victory, Trenmor, Malvina, or Everallin.

pictorial interpretations of Ossianic subjects as exemplified
by Gérard's The Bard Ossian Evoking Ghosts on the Shores of
the Lora, Gros' Malvina,[1] or Forbin's Ossian.[2] While the
themes of these paintings are based solely on the content of
the Ossianic poems, Girodet's conception combines Ossianic
sources with various heterogeneous elements. Thus, it is
necessary, in the study of Girodet's Ossian, to make a dis-
tinction between the purely Ossianic sources and the other
factors introduced by the artist.

The typical contemporary Ossianic painters usually
conceived their scene as taking place before the death of the
bard Ossian, who was represented alive, evoking the shades of
his ancestors. In contrast to this idea, Girodet represented
all his Ossianic personages, including Ossian himself, after
their death, and transposed them into their after-life sojourn.
The general idea of representing the shades of the Ossianic
personages as transparent, fading figures, yet armed and
capable of action and emotion, in a cloudy, aerial realm trav-
ersed by meteors, was directly inspired by numerous passages
of the Ossianic poems.[3] However, the clothes and the arms of
these "Caledonians of the third century"[4] offered a difficult

1. Painted around 1801.
2. Salon of 1806.
3. Girodet summarized all this information in his description
of the painting (Girodet, OEuvres posthumes, op. cit., II, Cor-
respondance, pp. 289-291).
4. Van Tieghem, op. cit., II, p. 162.

problem to Girodet. Macpherson's text is extremely vague on
this subject. Naturally, the ever scholarly Girodet was not
willing to adopt the solution of the popular contemporary
Ossianic illustrations, showing classical, baroque, Tyrolean,
or Scotch attire.[1] Thus, the painter wrote: "I have been
forced to invent even the costumes, of which no monument of
antiquity gives any trace. I could be guided only by analo-
gies."[2] Consequently, the artist dressed Ossian in the gar-
ments of the barbarians, as they appear in Roman monuments,
like the Column of Trajan. While the helmet of Oscar has a
classical character, those of Fingal and Cuthullin are almost
completely medieval. Yet they, as well as the helmet of Starno,
show elements derived from Roman medals depicting the kings of
Caucasia and of Mesopotamia.[3] Only the shield behind Fingal
was directly inspired by Ossianic descriptions.[4]

One can note that Girodet's conception is not related
to any particular incident of the Ossianic after-life, as de-
scribed in the poems. While all the Ossianic personages of
the painting are prominent characters of Macpherson's work,

1. Van Tieghem, op. cit., II, pp. 162-164.
2. Girodet, OEuvres posthumes, op. cit., II, Correspondance,
Letter III, to Bernardin de Saint Pierre, pp. 277-278.
3. As for instance those represented in Cenini, Iconografia,
Rome, 1669 (listed by Pérignon as belonging to Girodet), p.
110, Pl. 80; p. 114, Pl. 84; p. 118, Pl. 88; or Pl. 113.
4. The famous shield with many embossments (Macpherson,
op. cit., Letourneur trans., I, Discours préliminaire, p.
xv).

they are never all gathered together in any one scene of the
poems. Girodet seems to have selected his Ossianic person-
ages so as to show the genealogy and the alliances of the
two most famous warring families of Morven and of Lochlin.
He further stressed this basic opposition by contrasting the
different reactions of the two clans at the arrival of the
French.

The most striking factor of Girodet's conception, in-
dependently of its Ossianic sources, is undoubtedly the pres-
ence of the French soldiers in the Ossianic after-life sojourn.
In general, the idea of evoking the shades of the French mili-
tary heroes of the Revolution was a common device in the con-
temporary patriotic poems, as for instance in the Chant du
premier Vendémiaire by Esménard and Lesueur.[1] Other poems
even directly compared the after-life activities of the
French soldiers slain on the battlefield with those of the
shades of the Ossianic heroes. Thus, Esménard, in 1801,
wrote in his Stances, speaking of the "warriors lost by the
Fatherland on the fields of honor":

"... in the midst of the skies battered by the storms,
Like the shades of the heroes depicted by Ossian,
Their bellicose spirits fly on the clouds,
And follow our flags."[2]

1. Published in the Mercure de France, 1er Vendémiaire, An
IX (September 23, 1800), words by Esménard, music by Lesueur.
2. Esménard, Stances, "Presented to the First Consul during
the celebration given on the twenty-eighty of Pluviôse by the
Minister of Foreign Affairs, on the occasion of the Peace Treaty
concluded in Lunéville by the French Republic, the Emperor, and
the Empire," Mercure de France, 1er Ventôse, An IX.

Girodet, while claiming the full authorship of his conception, nevertheless significantly wrote: ". . . these ideas, or rather their application, is, I dare say, new and poetical."[1] Thus, the painter implicitly suggested that his uniting of the Ossianic and the French heroes was not a completely new idea. While it is possible that Girodet only elaborated on the thoughts expressed by such poems as that of Esménard, an even more direct source of inspiration is suggested by the writings of the artist's friend Delille. The latter, describing the paradise of Odin, usually associated with Ossian by the contemporaries, wrote in his poem L'Imagination:

> "Odin, the great Odin to the valorous souls
> Will show the happy habitations of the houris.
> .
> The brilliant exploits and the sweet sound of arms,
> Show them the charms of the warriors' paradise;
> . . . exempt from death,
> Are they leaving all bloody the scene of combat?
> A selected group of the freshest beauties
> Comes . . . to offer them ambrosia;
> Then each one takes his spear and successively goes
> From pleasure to combat, from combat to love.
> I seem to see the grace and the courage of the French."[2]

Thus Girodet seems to have derived from the contemporary patriotic poems and from Delille the general conception of his Ossian, as well as such episodes as the drinking and the love-making of the French soldiers. Yet, the painter's

1. Girodet, OEuvres posthumes, op. cit., II, Correspondance, Letter III, to Bernardin de Saint-Pierre, p. 278.
2. Delille, OEuvres, op. cit., I, L'Imagination, Chant VIII, p. 507, written between 1785 and 1794.

blunt frankness in the rendering of these scenes is not to
be found in the literary sources, and it greatly shocked some
of the contemporary critics. They objected to the "guard-
house hero entering this Olympus, . . . smoking his pipe";[1]
to the "intoxicating drinks which some soldiers directly
poured into their mouths, while others vomited with burlesque
and caricatural attitudes and facial expressions";[2] and finally
to the vulgar manner in which the French warriors were court-
ing the Ossianic ladies.[3] These critics concluded by saying
that Girodet's conception was more reminiscent of "the tavern
of Tenare" than of the Elysian fields.[4] It must be noted, as
Girodet himself stated, that according to the Ossianic mythol-
ogy, the shades of the heroes preserve the same tastes and
indulge in the same pleasures in their aerial sojourn as
during their earthly life.[5] Thus, the French soldiers of Os-
sian are allowed, in the Ossianic paradise, to participate in
activities which were traditionally associated with the French
trooper. It must be stressed that these activities were popu-
larly viewed with a benevolent good humor as a manifestation
of esprit gaulois, by no means offensive to the French army.

1. The figure described as Bara.
2. Soldiers located at the feet of Ossian and Desaix as
well as at the feet of Caffarelli-Dufalga and Bara.
3. In the upper right corner of the picture, to the right
of the cock. All these criticisms are quoted from the Publi-
ciste by Stenger, op. cit., p. 112.
4. Stenger, op. cit., p. 112.
5. Girodet, Oeuvres posthumes, op. cit., II, Correspondance,
p. 289.

The particular case of the misbehavior of the French soldier
in Paradise was related to a series of songs and anecdotes,
some of which were enacted on the stage of the time.[1] One
can note that Girodet's soldiers, with their scars, their
greyish mustaches, and their jocose buoyancy, are among the
earliest examples of the typical characterization of the
Napoleonic grognard to be later so often used by Charlet and
Raffet. On a different level, the representation of men smok-
ing, heavily drinking, or engaged in vulgar courtship, re-
flects the contemporary popularity of Flemish and Dutch
painting.[2] This popularity was echoed by Girodet himself,
who wrote in his Veillées:

"Thus, when I am tired of admiring the Antique,
Teniers' smokers and their bacchic interiors
Relax my mind and rest my eyes.
For me all the genres are good except the boring genre."[3]

1. On the occasion of a dinner given by Talma in honor of
the English actor Kemble, Girodet, together with many other ar-
tistically prominent people, attended a representation given by
the actor Beaupré. The latter enacted the role of a grenadier
of the Imperial Guard who, after having been killed on the bat-
tlefield, was chased from Paradise for his bad manners and gen-
eral misbehavior. Bouilly, who related this performance,
wrote: "One had never heard a more curious and bizarre mix-
ture of the sacred and profane." (Bouilly, J. N., Mes Récapi-
tulations, Paris, Louis Janet, III, p. 90.)
2. It can be seen in the success of the exhibition of Gé-
rard Dou's Dropsical Woman, which was brought to Paris in 1798
(Annonce de l'arrivée à Paris de la femme hydropique de Gérard
Dou, Deloynes, op. cit., XX, 551, Ms.). A great number of Dutch
paintings had been taken to France, as trophies, by the trium-
phant armies of the Republic. Notice des Tableaux des écoles
françaises et flamandes exposés dans la grande gallerie du musée
central des Arts, Paris, Impr. des Sciences et Arts, An VII(1799)
The vogue of northern art is reflected in such works as the Imi-
tation of a Flemish Painting by Girodet's pupil Chatillon (exhi-
bited in the Salon of 1790).
3. Girodet, OEuvres posthumes, op. cit., I, Veillées, IV,
p. 401.

Girodet's purpose in introducing in his _Ossian_ the
representatives of the various branches of the French Army,
as well as the most famous generals recently killed during
the Republican campaigns, is explained in his letter to
Bonaparte:

> "I have erected, I dare say, a national monument to the
> memory of the generals whom your example has inspired. I
> have offered to the admiration of posterity venerated
> shades gathered together, and under the emblem of Victory
> and under the figure of the brilliant symbol of France,
> /I have shown/ the image of her protecting genius."[1]

Thus, Girodet dedicated his work to the glory of the French
armies and of Napoleon. In his selection of generals and of
trophies, the painter emphasized the Egyptian campaign and
the victory of Marengo, which had both been under the leader-
ship of Bonaparte.[2] Moreover, unable to introduce in the
Ossianic after-life the still living First Consul, the artist
suggested his occult presence, among the heroes, by repre-
senting his head on the pipe of one of the soldiers.[3]

However, certain elements of the painting suggest a
more complex political content. Thus, several iconographical

1. Girodet, OEuvres posthumes, op. cit., II, Correspondance,
Letter VI, to Bonaparte, p. 297.
2. The most conspicuous of the generals are Desaix and Klé-
ber, the first killed at Marengo, the second in Egypt. Learn-
ing of the death of Desaix during the battle of Marengo, Napo-
leon is said to have exclaimed: "Why don't I have time to
mourn him!" (Mercure de France, 1er Ventôse, An IX).
3. The pipe is represented immediately below the clasped
hands of Desaix and Ossian.

factors cannot be explained from the point of view of a
simple glorification of the French heroes and of Bonaparte.
Such is for instance the strongly marked opposition between
the bellicose and triumphant attitude of the French, the dig-
nified sadness of the warriors of Morven, and the infuriated
anger of the soldiers of Lochlin. Similarly, it is difficult
to understand why the cock symbolizing France, placed above
the French, is balanced by the eagle, emblem of the Austrian
Empire, placed above the warriors of Morven to whom it is so
conspicuously related.

The key to the complex political meaning of Girodet's
conception lies in a passage of his description of the paint-
ing, in which he wrote that the warriors of Lochlin "vainly
try to impede the celebration of peace."[1]

This celebration of peace in Girodet's Ossianic realm
is undoubtedly a direct allusion to the numerous festivities
organized throughout France on the occasion of the peace treaty
signed on February 9, 1801 at Lunéville by France, Austria,
and other continental powers. The continental peace estab-
lished by this treaty was hailed with great manifestations of
joy and was considered a personal achievement of Bonaparte.
The contemporary patriotic poems, celebrating him as the hero
who established peace through his victories, spoke of the

1. Girodet, OEuvres posthumes, op. cit., II, Correspondance,
p. 294.

thankfulness of Europe and of the nations, which:

". . . forgive your /Napoleon's/ glory,
And /are/ successively vanquished without being humiliated."[1]

This background explains the relationship between the French
soldiers and the warriors of Morven in Girodet's Ossian, the
execution of which is exactly contemporary to the treaty of
Lunéville. Thus the French are triumphantly marching under
the figure of Victory,[2] which seems to be supported by the
saber of one of the soldiers. Laurel and olive leaves are
generously scattered among them. The figure of Victory offers
the caduceus of peace[3] to the warriors of Morven. The latter
undoubtedly personify the continental nations vanquished by
Bonaparte, among which the Austrian Empire, alluded to by the
eagle, was the most powerful.[4] They show the sad dignity of
those who are "vanquished without being humiliated." Their
defeat is further suggested by the fact that their principal
personages (Ossian, Fingal, Comhal) hold their spears pointing

1. Esménard, Stances, op. cit.
2. Girodet described this figure as a "wingless victory,"
a term explained by Coupin as referring to the Nike Apteros
of Athens -- in other words, associating the French heroes
with these of Greece (Girodet, OEuvres posthumes, op. cit.,
II, Correspondance, p. 291).
3. In all his official writings, Bonaparte emphasized the
fact that he was the first to offer peace to his enemies.
4. One must note that the eagle-wing of Fingal's helmet
directly touches the eagle of Austria. This detail, as well
as the fact that Fingal is clasping the hand of Kléber, "the
Bayard of the eighteenth century" (Noël, op. cit., I, p. 503),
seems to suggest the possible identification of Fingal with
the famous Austrian general Melas.

downward as a sign of peace and friendship.[1] Cuthullin car-
ries his spear in an upright position, but its point is
broken, symbolizing weakness and failure.[2] The significance
of these details is suggested by the care with which Girodet
noted them in the description of his painting.[3]

However, at the time of the execution of Ossian, Eng-
land was still at war with France, and had not signed the
treaty of Lunéville. She was frequently attacked, in the
contemporary newspapers, for attempting to arm the enemies of
France and to impede the peace negotiations. Bonaparte him-
self wrote in the Message des Consuls:

"Europe knows all the attempts of the British govern-
ment to cause the failure of the negotiations at Luné-
ville."[4]

Thus, the enraged followers of Starno most probably represent
the English.[5] It is significant that, besides shouting, "se-
ditiously whistling," and brandishing broken weapons,[6] one of

1. Macpherson, op. cit., Letourneur trans., I, Discours
préliminaire, p. xviij.
2. Idem.
3. Girodet, OEuvres posthumes, op. cit., II, Correspondance,
pp. 291-292.
4. Bonaparte, Message des Consuls au Corps législatif et au
Tribunat, published in the Mercure de France, 1ᵉʳ Ventôse, An 9.
5. Starno's helmet (fig. 31) shows certain elements which
seem to allude to England. Thus, its frontal part is decorated
with an ocean-like face, while its crest suggests the shape of
sea-waves.
6. Swaran is holding a broken sword symbolizing weakness
and failure; yet, he looks back with anger.

the soldiers of Lochlin, Cormac, strikes with the hilt of his sword the shield of one of the warriors (representing the continental powers) of Morven (fig. 30). This action, underlined by Girodet in his description of the painting,[1] refers to the traditional call to war in Ossianic mythology.[2] In this manner, the painter suggested that the British were trying to impede the peace negotiations of Lunéville and to incite the continental powers to war against the French.

Interpreted from this political point of view, the women of Morven welcoming the French soldiers probably personify the populations of the continent rejoicing at the peace.[3] The small bird rescued from the eagle by the cock undoubtedly alludes to the territories liberated from Austria by France.[4] Finally, Agandecca, saved from her father Starno by a French dragoon, perhaps symbolizes the small nations attacked by England and protected by France.[5]

It is interesting to trace the development of Girodet's

1. Girodet, OEuvres posthumes, op. cit., II, Correspondance, p. 294.
2. Macpherson, op. cit., Letourneur trans., I, Discours préliminaire, p. xv.
3. This idea is reminiscent of Esménard's Stances, a resemblance which is stressed by the throwing of flowers also emphasized in the poem.
4. Through the Treaty of Lunéville Austria lost several states which became recognized as Republics.
5. The fact that Agandecca was described in Macpherson's poem as being at the same time the daughter of Starno (England) and the beloved of Fingal (Austria) suggests that she personifies, in Girodet's painting, the Northern countries threatened by England and given an assurance of help by Bonaparte in his Message des Consuls, op. cit.

conception by considering his earlier projects for the Mal-
maison. After abandoning his classical allegory alluding to
the plot of the machine infernale,[1] Girodet executed a small
oil sketch of Ossian, which is now in the Louvre[2] (fig. 32).
This composition still preserved certain allusions to the
conspiracy against Napoleon.[3] Moreover, while being very
close to the conception of the final painting in the Mal-
maison (fig. 29), it differs from it in some important de-
tails. There is no figure of Victory above the French sol-
diers. The animal[4] captured by the Austrian eagle has not
yet been rescued by the French cock. With the exception of
Ossian, all the male Ossianic figures show the same hostile
attitude toward the arrival of the French. Finally, the war-
riors of Morven and of Lochlin are not individually charac-
terized -- they are all unpleasant and do not show any heroic
figures comparable to Fingal or Cuthullin in the final paint-
ing. It can also be noted that in a drawing at Angers,[5]
Girodet represented the figure of Ossian holding a spear
with its point upward and unbroken. All these indications
suggest that the painter, in these preliminary works, was

1. Supra, p. 174.
2. Incorrectly dated 1802 by Coupin (Girodet, OEuvres
posthumes, op. cit., I, Liste des principaux ouvrages de
Girodet by Coupin, p. lxx).
3. In the upper right corner of the oil sketch, one can see
a figure firing a pistol at another figure, which seems to
fall.
4. A hare instead of a bird.
5. Musée Pinel.

inspired by an earlier political situation, perhaps before
the treaty of Lunéville, when the continental powers were not
yet considered with the same friendliness and respect as at
the moment of the final Ossian. Thus Girodet seems to have
followed political actuality.[1] Nevertheless, his final con-
ception also became outdated by the signature of the treaty
of Amiens (March 25, 1802), which proclaimed the general
peace with all the powers including England.[2]

It is almost unnecessary to point out that Girodet,
in his Ossian, continued his trend of literary allegorical
preciosity. This can be seen in such visual metaphors as
the figure of Victory actually supported by the saber of one
of the French soldiers. Yet, the painter also added poetic
images derived from Macpherson's Ossian, such as the broken
spears and the frogs hidden in the folds of the Austrian
flag, thus indicating its marshy origin.[3] The large scale of
the painting and the very great number of personages and of
various accessories influenced Girodet, already inclined
toward a rebus-like conception, to create a baffling, seem-
ingly chaotic, and at first glance undecipherable composition.

1. Girodet even took back his painting after its completion
in order to make some changes ("Salon de l'an X," Journal des
Débats, October 1, 1802).
2. Thus the political actuality implied in the composition
was soon forgotten. Moreover, during the Restoration, the de-
scriptions of the painting, such as that of Coupin or those im-
plied in Aubry-Lecomte's lithographs, eliminated certain elements
which might have indicated the Bonapartist leanings of the paint-
ing. Thus, Coupin did not mention the eagle as the symbol of Austria.
3. Girodet, OEuvres posthumes, op. cit., II, Correspondance,
p. 290.

It can be seen that Girodet's Ossian, while still fol-
lowing the development of the baroque allegories celebrating
the glories of a particular regime, shows decisively new
factors. The latter can be seen in the painter's surprising
combination of the mysterious, eerie Ossianic atmosphere with
a classical heroic mood, current political actuality, and
low-life scenes. This juxtaposition of tragic, heroic, and
comic elements was the greatest sin which could be committed
by a painter against the traditional principle of the unity
of genre expressed in Horace's De Arte Poetica and in the so-
called rules of Aristotle. Thus, in his Ossian, Girodet
broke the rationalistic mold of Davidism.

The political content as well as the general unortho-
doxy of the painting inspired many criticisms.[1] Among the
most typical, one may note the remark of the Journal des Arts
which ridiculed Girodet for having represented Republicans in
Paradise,[2] and the reaction of David, who was reported by De-
lécluze to have exclaimed after having seen Ossian:

"Girodet is mad! . . . He painted personages of crystal
. . . What a pity! in spite of his fine talent, this
man will never do anything but foolish things . . . he
has no common sense."[3]

1. Some of which were already mentioned.
2. Journal des Arts, 1802, Deloynes, op. cit., XXVIII,
761, p. 303.
3. Delécluze, op. cit., p. 266.

For his defense, Girodet, helped by his friend Boutard, propagated the rumor that, for patriotic reasons, he refused to sell his _Ossian_ to wealthy foreigners.[1] Moreover, he kept the public informed about the fate of his painting through articles published in the _Journal des Débats_. Thus, one could learn that "crowds of amateurs besieged his atelier for three months" to see _Ossian_,[2] or that the painting, "now in the _Salle du Conseil_ of the Malmaison," was about to be "transferred to Saint-Cloud or the Tuileries."[3] Finally, Girodet indefatigably called to witness the prestige of Bonaparte himself, whom he reported to have said to him: "You have had a great idea; the figures of this painting are real shades: I recognize the generals."[4]

1. "Salon de l'an X," _Journal des Débats_, October 1, 1802.
2. _Idem._ Boutard, one of the editors of the _Journal des Débats_, was often ridiculed by the contemporary critics for his too obviously biased attitude in favor of Girodet.
3. _Journal des Débats_, October 17, 1802. Significantly, this announcement was published among the news of the day and not in the art _feuilleton_.
4. _Idem._ Girodet also frequently repeated words which he attributed to David: ". . . this production /Ossian/ did not resemble that of any master of any school: that he /David/ had never seen a painting to which it could be compared and that it /Ossian/ sould be given justice after my /Girodet's/ death" (Girodet, OEuvres posthumes, op. cit., II, _Correspondance_, Letter III, to Bernardin de Saint-Pierre, p. 278).

III.

COMMON CHARACTERISTICS

The study of the common characteristics of Girodet's mythological paintings can be divided into two sections: the first considering the artist's manner of rendering the setting of the scene and the second concerning his interpretation of the human figure.

The Setting

The setting of many of Girodet's mythological paintings, between 1791 and 1802, is characterized by a vaporous darkness suggesting a general vagueness and a feeling of mystery. The painter's predilection for cloudy, nocturnal effects was paralleled, during the years of the Directory, by a corresponding fashion for the sfumato. While, as it was seen, beginning much earlier,[1] this trend reached its culmination during the period immediately following the Revolution. It acquired a wide-spread character, by no means limited to the works of Girodet or to those of Prud'hon. Thus, in 1799, one critic noted the fashion of "black drawings"

1. Supra, pp. 85 ff. Fragonard's works provide several examples of the chiaroscuro conception applied to mythology, as can be seen in such paintings as Plutarch's Dream and the Dream of Love (Rouen Museum and Louvre, respectively).

among "our young draftsmen" during the past "two or three
years."[1] Similarly, one finds numerous references to "vapor-
ous sketches,"[2] and the Arlequin au Museum, ridiculing Hanne-
quin's conception of Orestes, made this painter say:

> "Always in dark vapors
> One could perceive my personages."[3]

The dark sfumato permeating Girodet's mythological
scenes stresses the vagueness of their setting. It creates
a spatial ambiguity, a lack of any definite depth, and a fre-
quent melting of forms.[4] The general feeling of ambiguity also
derives from the lack of localization of the scene, which
seems to take place in a cloudy nowhere. Naturally, this im-
pression is particularly striking in The Seasons (figs. 16,

1. Arlequin au Museum ou des tableaux en vaudevilles, Pa-
ris, Clairvoyant, Deloynes, op. cit., XXI, 561, p. 40. The
author also mentioned the vogue of "dotting."
2. Arlequin au Museum ou critique des tableaux en vaude-
villes, no. 1, Paris, Marchant, 1802, Deloynes, op. cit.,
XXVIII, p. 12 (p. 368). A few years later, Vien "deplores the
error of the draftsmen who use unfruitfully much time and many
pencils in order to imitate English prints" /Chaussard/, Le
Pausanias français, op. cit., p. 49).
3. Arlequin au Museum ou critique des tableaux en Vaude-
villes, no. 1, Paris, Marchant, 1802, p. 10.
4. The stylistic analysis of Girodet's paintings does not
fall within the scope of this study. Yet, it is interesting
to note briefly the development of the artist's conception of
space. The space of the mythological paintings of this period
is remarkable for its vagueness, and its lack of definition,
with the personages and the objects more or less compressed
against the picture plane. Girodet achieved this conception
after having successively evolved from an almost Poussinesque,
well-articulated rendering of space, as exemplified in Hora-
tius Killing his Sister (fig. 2), to the Davidian mode of
classical relief illustrated in Joseph Making Himself Known
to his Brothers (fig. 4).

17, 18, 19) and in Ossian,[1] (fig. 29). However, the same ef-
fect is suggested in the paintings the action of which occurs
on earth. Thus, the leaves and the flowers appearing through
the vapors of Endymion (fig. 14) do not convey the idea of a
convincing landscape. They are depicted as isolated, still
life-like objects, independent from the setting which they
identify. Naturally, in The New Danaë (fig. 26), Mademoiselle
Lange's paraphernalia is too heterogeneous and paradoxical to
define any particular location. Finally, in the case of the
first Danaë (fig. 25), Girodet represented his figure against
a cloudy night sky which covers the greatest area of the pic-
ture, while the specific accessories are relegated to a sec-
ondary place.

Girodet's accentuation of the feeling of vagueness in
his rendering of the setting seems to be related to some of
his ideas. In the opinion of the painter, vagueness possesses
a particularly stimulating poetic virtue and can be used as a
springboard for the imagination. For this reason, Girodet was
attracted by almost any irregular and ambiguous shape.[2] He

1. Speaking about Ossian, Noël wrote: ". . . the artist
has ingeniously placed a star in one of the corners of the paint-
ing in order to indicate to the spectator that it /the scene/
takes place in a higher region" (Noël, op. cit., I, p. 503).
2. Girodet wrote in Le Peintre:
 "The painter also observes all these old monuments,
 Which show the interesting marks left by the hand of Time;
 The broken surfaces of rocks, the veined heart of marble,
 The firebrands of the hearth, the gnarled trunks of trees"
(Girodet, OEuvres posthumes, op. cit., I, Le Peintre, Chant II,
p. 104).

was especially fascinated by the ever-changing, melting forms
of clouds, which were for him one of the most inspiring sour-
ces of images:

> ". . . these immense clouds /are/
> .
> Variously transformed by the winds into innumerable shapes,
>
> In their vague outlines and their uncertain planes,
> They appear erected as rocks, raised as mountains,
> They lean as hills . . .
>
> Imagination, this generating sense,
>
> . . . creates prodigies to the eyes of the painter.
> Then, in the midst of the air, inhabited for him alone,
> he sees enchanted beings,
> Riders, chariots, imaginary ghosts of armies,
>
> Fabulous monsters, seas, and forests.
>
> The artist, another Ixion, loses himself in the clouds."[1]

Originally, these ideas were obviously inspired by Leonardo.
Yet, Girodet, unlike the Renaissance artist, did not consider
clouds only as a possible source of pictorial inspiration.
Like Romain Rolland's Jean Christophe, he dreamingly "loses
himself in the clouds." In the literature of the time, this
attitude is reminiscent of Burke's fascination for "confused,
obscure, uncertain images."[2] It is difficult to separate

1. Girodet, OEuvres posthumes, op.cit., I, Le Peintre, Chant II, pp.102-
2. Burke's ideas were made known in France through a trans- 104.
lation in 1789: "Confused, obscure, uncertain images have on
the imagination more of the force which produces great passions
than clearer and more determined images . . . to see distinctly
an object is the same thing as to perceive its limits . . . In
other words, a clear idea is only a thin and weak idea." (Quoted
in Gilpin, Voyage en différentes parties de l'Angleterre, trans-
lated in 1789 by Guédon de Berchère, I, pp. 339-340, quoted by
Monglond, op. cit., I, p. 130.)

Girodet's ideas from the effect created in his mythological
works, an effect combining the cloudy ambiguity of the set-
ting with the esoteric and cryptic character of the content.
In his De l'Ordonnance en pointure, the painter, after having
stressed the necessity of a rational approach in art, signi-
ficantly added:

> "There are however a few special subjects in which the
> incoherence of ideas, the vagueness of images, the strange
> shapes of objects leave a wider field to the imagination
> and necessitate, even demand, a confused composition.
> Such are fairy-like themes, or subjects of magic, dreams,
> apparitions, the fantastic scenes of which belong to the
> realm of the mind."[1]

Thus, it may be suggested that in his mythological paintings,
Girodet, by a psychological transposition, seems to have in-
vited the spectator's imagination to lose itself in the mys-
terious atmosphere of the painting, the "chaos from which will
spring out worlds."[2]

The Human Figure

Girodet's interpretation of the human figure in his
mythological works suggests a strongly marked irrational ten-
dency. This tendency can be felt in the particular relation-
ship of the personages to the setting, in their appearance,
and in their psychological rendition.

1. Girodet, OEuvres posthumes, op. cit., II, De l'Ordon-
nance en peinture, pp. 219-220.
2. Girodet, OEuvres posthumes, op. cit., I, Le Peintre,
Chant II, p. 103.

Girodet's figures do not suggest a logical relation to the setting. They appear like polished, smooth forms emerging from the smoky vagueness and having little dependence on the laws of gravity. This quality is particularly evident in the floating personages of The Seasons (figs. 16, 17, 18, 19) or of Ossian (fig. 29). Yet, it can also be felt in the figures which are visually related to the ground. Thus, the personages of Endymion (fig. 14), the first Danaë (fig. 25), and of The New Danaë (fig. 26) do not seem to be firmly pressing upon the objects on which they are placed. They are conceived as almost weightless volumes, having very little physical relation to the setting and giving the impression of being suspended in the air.[1] This illogical relationship between the human figure and the setting was paralleled in the last years of the eighteenth century by Girodet's avowed interest in the paintings of Herculaneum.[2] It may be seen that

1. The same effect can be noted in Girodet's minor contemporary works such as the 1792 Abandoned Ariadne (fig. 33) (A. Dreyfus Collection, Paris). Typically, in this work as well as in some of his sketches, the painter showed a tendency to schematize the feet of his figures more than any other part of the body. This can be illustrated in numerous drawings of the Carnet de Rome or in one of the preliminary drawings for Joseph Making Himself Known to his Brothers*(Montargis). The personages of all these sketches do not seem to be provided with a sufficient means of physical support. *(fig. 5)

2. Noël, op. cit., II, p. 500. It is significant to see Noverre, one of the most ardent exponents of the rationalized conception of the human body in pantomime, protest, in the 1807 edition of his Lettres (Lettres sur les arts imitateurs en général et sur la danse en particulier, Paris, Collin, La Haie, Immerzeel, 1807), against this new illogical representation of the human figure hanging in mid-air, without any visible support or definite background.

the artist's conception completely diverged from the Davidian
emphasis upon the laws of gravity and upon the rational de-
pendence of the figure on the setting.

The unreal quality of Girodet's figures resulting from
this conception is further stressed by the painter's artifi-
cial use of color, a factor which particularly shocked the
contemporary critics. Speaking about Endymion (fig. 14), a
correspondent of the Petites Affiches de Paris wrote: ". . .
because of the lunar color of his painting, one can see no-
where the local color of the flesh, the tint is blue every-
where, not real enough."[1] Chaussard, though in 1799 favor-
ably inclined toward Girodet, could not hide his astonishment
when, commenting upon the portrait of Mademoiselle Lange torn
by the artist, he wrote: "This portrait! it was actually
purple."[2] Beginning with the mythological paintings of this
period and throughout his career, Girodet was criticized for

1. "Exposition au salon du palais national des ouvrages de
peinture, sculpture et gravure," Petites Affiches de Paris,
Deloynes, op. cit., XVIII, 459, Ms., p. 187. There were sev-
eral similar criticisms of Endymion; for instance in 1793,
one read: ". . . this painting is dominated by a bluish tint
which is not real enough" (Explication par ordre des numéros
et jugement motivé des ouvrages de peinture, sculpture, archi-
tecture et gravure, exposés au Palais National des Arts, Paris,
Jansen, Deloynes, op. cit., XVIII, 458, p. 43).

2. Chaussard, "Exposition des ouvrages de peinture, sculp-
ture, architecture, gravures, dessins, modèles composés par les
artistes vivans et exposés dans le Salon du Musée central des
arts," Journal de la Décade, 1799, Deloynes, op. cit., XXI,
580, Ms., p. 452. The same author also criticized Girodet's
Bathing Nymph*(Jules Chéret Museum, Nice) which he found "of
an artificial color . . . and purplish" (idem).
*(fig. 34)

the artificiality of the bluish, purplish, or blackish tonal-
ity of his figures. Thus, Landon wrote in his Salon de 1824
that "a purplish tint" was typical of Girodet's school.[1] Per-
haps as a result of a darkening caused by an extensive use of
bitumen, Girodet's paintings no longer appear blue or purple.
Yet, the critics' excitement about the painter's peculiar
color scheme can perhaps find its reason in a phenomenon
analogous to the one described in Reutersvard's "The 'Violet-
tomania" of the Impressionists."[2] Girodet's contemporaries
were still accustomed to certain baroque coloristic devices,
which can be noted in the most classical paintings of the
time. Thus, David, in the Oath of the Horatii or in the Sa-
bines, still preserved the habit of marking certain areas of
his figures, such as the articulations, the knees, the toes,
or the ear lobes, with a reddish tonality. This approach was
completely abandoned by Girodet, who emphasized a monochrome,
gray uniformity, which baffled his contemporaries. Undoubt-
edly, the figures of the Oath of the Horatii appear realis-
tically warm and high in color in comparison with those of Endy-
mion, which by contrast suggest an artificial bluish tonality.[3]

1. Landon, C. P., Salon de 1824, Paris, Ballard, 1824, I, p.
38. The same year, Stendhal wrote: "He /Girodet/ exaggerates
the chiaroscuro to such a point that the portrait of M. de Bon-
champs (fig.67) seems to be an old painting blackened by the
years" (Stendhal, Mélanges d'art et de littérature, Paris,
Calmann-Lévy, 1927, "Salon de 1824," p. 206).
 2. Reutersvard, Oscar, "The 'Violettomania' of the Impres-
sionists," The Journal of Aesthetics and Art Criticism, Vol.
IX, no. 2, December 1950, pp. 106-110.
 3. A major exception to this tendency can be seen in the
warm, reddish tonality of The New Danaë.

The psychological conception of Girodet's personages suggests an irrational character paralleling the quality observed in relation to setting and color. In his mythological paintings of the last decade of the eighteenth century, Girodet's interpretation of the human body as a vehicle for the "expression of the sentiments of the soul" reveals a new trend. The artist showed a definite reaction against the analytical rationalism and the character study typical in his works of the earlier historical group. Instead of conceiving the human figure as a "caractère" or as a compound of well-defined "passions," Girodet infused it with a more ambiguous, though more intense, emotionalism, achieved through exaggerations, distortions, and equivocal gestures. It is possible to study the artist's new concept of the human figure by considering its two most striking aspects: a tendency toward eroticism and toward a neurotic quality.

The most marked manifestations of the erotic trend can be seen in Girodet's rendering of the figures of the young woman and the young man.

The painter's interpretation of the feminine type, as for instance exemplified by Agandecca[1] (fig. 29), shows several characteristic qualities which can be seen in practically all of Girodet's feminine figures of this period.[2] The

1. Lower left corner of Ossian.
2. For instance, Mademoiselle Lange in The New Danaë (fig. 26, the first Danaë (fig. 25), the figure of Spring (fig. 17), and the Ossianic ladies (fig. 29).

rendering of the texture and of the consistency of the flesh
suggests an amorphous softness which almost completely hides
the anatomical structure. The visible parts of the body do
not convey the idea of a convincing organization or a feel-
ing of solidity. The typically feminine aspects of the fig-
ure are sensuously exaggerated. Moreover, the erotic feeling
is further stressed by the heaviness and the unnatural round-
ness of the body.

The youthful masculine type, exemplified for instance
by Endymion[1] (fig. 14), shows a very strong sensual and ef-
feminate character. The proportions of the figure are marked
by an exaggerated, Praxitelean elongation. The rendering of
the very small head and of the rounded, swelled throat does
not show any difference from that of the feminine figure.
The hips are well marked and the attitude suggests an effem-
inate, affected gracefulness. The androgynous impression of
this type is also underlined by the smooth, polished texture
of the body and the very slightly indicated muscles.[2]

1. The principal figure of Endymion. The type can be also
exemplified in Girodet's contemporary illustrations of Didot's
Virgil, such as The Death of Pallas, The First Exploit of As-
canius (fig. 35), The Arrival of Aeneas and his Companions at
Latium (fig. 36), and The Manes of Aeneas Appearing to Him Dur-
ing his Sleep (fig. 37) (Publius Virgilius Maro, Opera, P. Di-
dot, Paris, 1798).

2. The androgynous youth had already appeared in 1789 in
Joseph Making Himself Known to his Brothers (fig. 4). In this
painting, Girodet clothed the figure of Benjamin in a thin,
light, seemingly wet drapery. In places it clings closely to the
body which it reveals, decoratively floats, or drops, exposing
the boy's rounded, feminine shoulder. The painter applied to his
effeminate youth the erotic devices used by Greuze in his femin-
ine figures.

These anatomical exaggerations emphasizing the erotic character of the feminine and of the youthful masculine types are combined, in many cases, with classicizing stylizations and distortions, reminiscent of some of Picasso's figures of the nineteen-twenties. The head makes one think of a quasi-caricatural interpretation of the classical type, with an extremely low forehead prolonged in a straight line by the nose; very large eyes set far apart; and a diminutive mouth, with the upper lip beginning immediately below the nose and protruding over the lower lip. The classicizing stylization is further stressed by an extremely long neck, as well as by ribbon-like fingers. Thus, the general impression given by Girodet's interpretation of the feminine and of the youthful masculine types is that of an almost mocking, abstract classical stylization infused with a strong erotic feeling.

In opposition to these two types, the mature masculine figure, as for instance exemplified by Starno[1] (figs. 29, 31), is characterized by sturdy proportions, well-developed muscles, and a generally virile appearance. Girodet frequently used this type for the sake of an erotic contrast, opposing it to the voluptuous softness of the feminine figure[2] or to the sensual effeminacy of the youth.[3]

1. Lower left corner of Ossian.
2. As can be seen in Ossian (Starno-Agandecca) (fig. 29).
3. As can be seen in The First Exploit of Ascanius (fig. 35), (Didot's edition of Virgil, op. cit.)

These tendencies toward eroticism were paralleled by
certain social manifestations of the time. The period of
the Directory was characterized by a crisis of morality and
a wave of loose sensuality which had been equalled only by
the depravity of the Regency. Some of the aspects of this
trend have already been noted in relation to Girodet's life
and in the study of the first _Danaë_ and of Mademoiselle
Lange's allegory.[1] The Goncourts, in their _Histoire de la_
société française pendant le Directoire, gave a vivid and de-
tailed account of the various manifestations of this immoral
current, which even went so far as to influence contemporary
fashions.[2] From a general point of view, this tendency ex-
plains the eroticism of Girodet's interpretation of the human
figure. This quality was broadly reflected in contemporary
art,[3] and may be interpreted as continuing and intensifying
a typical element of the spirit of the eighteenth century.
Yet, the great emphasis placed on effeminacy during the

1. _Supra_, pp. 101, 151-152, 156 ff.
2. Goncourt, _Histoire de la société française pendant le_
Directoire, op. cit., pp. 411 ff.
3. This trend can be illustrated by numerous examples among
the works of Gérard, Prud'hon, etc. Even before the Directory,
the feminine figures of the _Oath of the Horatii_, in spite of
their classical dignity, were far from being exempt from sen-
suousness, a quality which was stressed by their opposition to
the muscular virile figures. The development toward a more
effeminate conception of youth was similarly indicated in
such works as _Mars and Venus_ (Louvre, 1789), or _Bara_ (Avignon,
1794). Like Girodet, though to a lesser degree, David op-
posed the effeminate youthful type to the mature masculine
figure, as can be seen, for instance, in the case of Romulus
and Tatius in the _Sabines_.

Directory was a new and unusual factor. For this reason, as
well as because of its great importance in Girodet's work,
it must be given a particular consideration.

The androgynous character of many of Girodet's mascu-
line figures did not escape the suspicious imagination of
his contemporaries. Speaking about the painter, Delécluze
wrote in his Louis David, son école et son temps: "It is
known that he /Girodet/ was hit by cruel arrows shot by the
god of love in his moments of passing fantasy."[1] Balzac,
though a great admirer of Girodet, possibly echoed in Sarra-
sine similar atelier rumors,[2] which were also reflected in
one of the artist's letters to Julie Candeille.[3] However,
these allusions seem to have been based only on rumors, and
there is no serious reason to believe that the effeminate ten-
dencies of Girodet's youthful masculine type can be traced to
a peculiar aspect of the painter's personality. The sources

1. Delécluze, op. cit., p. 272.
2. In this novel, the author of the Comédie humaine wrote
that Girodet's Endymion was inspired by Vien's Adonis, which
was derived from a statue representing Zambinella, an androgy-
nous favorite of the Cardinal Cigognara (Balzac, Sarrasine,
1830, in L'OEuvre de Balzac, Les éditions du Vert-Logis, p.
63).
3. These rumors seem to have been the cause of Girodet's
break with Julie Candeille. In his letter, the painter spoke
about "the misfortune and the fault which you /Julie Candeille/
have imputed to me . . . a thing which, on the one hand, made
me vile in your eyes . . . and which, on the other, compro-
mised my existence." Julie Candeille mockingly sent a lantern
to Girodet, which she interpreted as an allusion to Diogenes'
search for a man, and which he refused to accept. (Lettres
de Girodet-Trioson à Madame Simons-Candeille, op. cit.)

of this trend are difficult to ascertain. Perhaps it was
partially the result, as in certain phases of the Italian
Renaissance, of an indiscriminate admiration for all the as-
pects of classical antiquity. This idea was suggested in the
art of the late eighteenth century by the recurrence of the
theme of friendship, as it was often conceived in classical
literature.[1] At any rate, this current was paralleled by
certain social manifestations of the Directory. In the nine-
ties, one could note the simultaneous expressions of an exag-
gerated masculinity and of an affected effeminacy. Thus, on
the one hand, as remarked by the Goncourts, "This world . . .
has begun to adore and to cultivate the body,"[2] "Everyone
strives to be an athlete,"[3] the Jeux Gymniques become very
popular,[4] and young men dramatically indulge in athletic con-
tests.[5] On the other hand, in spite of this virile display
of force, the fashionable dandy of the Directory, the Merveil-
leux, the Incroyable, or the Muscadin, walks with a "skipping

1. Thus, Gérard, in his drawings for Didot's edition of
Virgil, chose to illustrate the theme of Corydon; and Girodet,
in his Anacreon series, interpreted the subject of Bathylus'
portrait. In his Considérations sur le génie particulier à
la peinture et à la poésie, Girodet selected an analogous in-
stance of this type of friendship to exemplify Virgil's sensi-
bility (Girodet, OEuvres posthumes, op. cit., II, p. 98). The
idea of this theme was echoed in the painter's predilection
for placing side by side muscular mature men and effeminate
youths (supra, p. 206).
2. Goncourt, Histoire de la société française pendant le
Directoire, op. cit., pp. 185-186.
3. Idem, p. 186.
4. Idem.
5. Idem.

gait . . . sways . . . takes such little steps."[1] Moreover,
". . . these bullies . . . have adopted an effeminate voice
. . . They have muscles strong enough to kill a bull; they
simulate a throat so delicate as to be bruised by a strong
sound!"[2] Thus, it became fashionable to affect a strange
lisping which completely eliminated the letter R.[3] The ef-
feminate manners of Garat, the most celebrated singer of the
time, contributed to the vogue and the popularization of this
tendency.[4] As was already seen, Girodet was by no means the
unique exponent of this trend in art. Renouvier, commenting
on Bosio's drawings, wrote that they showed "how our David-
ians succeeded in drawing the Greek with the same affection
that the Merveilleuses spoke French."[5] Thus, in his usual
manner, Girodet over-emphasized a characteristic current of
the Directory, and conceived a type which, though disturbingly
androgynous to the modern eye, only reflects the fashion of
the time.

The eroticism of Girodet's interpretation of the human
figure is frequently combined with a strongly marked neurotic
element. Instead of being concerned, as in his earlier his-
torical works, with clear delineation of the "caractères" and

1. Polyscope, Décade philosophique, Fructidor, An II,
quoted by Jules Renouvier (Histoire de l'art pendant la Révo-
lution considérée principalement dans les estampes, Paris,
Vve Jules Renouard, 1863, p. 470).
2. Goncourt, Histoire de la société française pendant le
Directoire, op. cit., p. 418.
3. Idem, pp. 418-419.
4. Idem, pp. 368-369.
5. Renouvier, op. cit., p. 207.

the "passions" of his personages, the painter, in his mytho-
logical works, was striving toward a maximum of emotional
intensity, often achieved at the expense of logic. The
"sentiments of the soul," as expressed by the human figure,
now tend toward two extreme emotional maxima: an almost con-
vulsive violence and an atonic languidness. The study of
this new psychological conception of the painter can be based
on two examples illustrating the extreme manifestations of
this emotional polarity: the figures of Starno and of Endy-
mion.

The figure of Starno[1] (figs. 29, 31) can be taken as an
illustration of the more violent of these two emotional modes.
The dying Starno, pierced by the sword of a French dragoon,
seems to fall in the air, clutching the hair of his daughter
Agandecca and biting his own weapon in a fit of rage.[2] This
latter action, as well as the violence of the attitude of
this personage, suggest an emotional intensity which goes far
beyond that of the restless dying figures found in contempor-
ary paintings. However, this emotionalism is also derived
from the painter's interpretation of the figure itself, inde-
pendently of its action. The artist's rendering of Starno's
heavy muscular body shows a tendency toward elaboration,
exaggeration, and distortion. The visible elements of the

1. Lower left corner of Ossian.
2. "The barbarian falls, biting with rage the weapon which
badly served his fury" (Girodet, OEuvres posthumes, op. cit.,
II, Correspondance, pp. 294-295).

anatomical map, such as the muscles and the veins of the arms,
are defined with a strong relief and a great multiplicity of
details. Yet, the appearance of the figure does not suggest
the normal play of the anatomical mechanism. The articula-
tions seem to be distorted, and there is little concern for
a logical connection between the body and the various segments
of the limbs. All the muscles, independently of their respec-
tive role in the action, seem to be contracted to an impos-
sible paroxysm. In this hypertrophic exaggeration, the em-
phasis is placed on each anatomical detail separately, with-
out expressing the over-all organic relationship. Thus, while
suggesting an extreme intensity of muscular effort, Starno's
pantomime shows a definite lack of coördination. Far from
indicating an action resulting from the will of the personage,
this interpretation of the human figure gives the impression
of a pathological convulsion, a feeling which is further
stressed by the distorted features and the gnashing teeth of
Starno.[1]

1. This type of convulsive violence is not found only in the
masculine type, exemplified by Starno. It can also be observed
in Girodet's interpretation of the feminine type, as for in-
stance in the case of the figure of Phèdre (Girodet's drawings
for Didot's edition of Racine's Phèdre, (OEuvres de Jean Racine,
Paris, P. Didot l'aîné, An IX, 3 vols.) Acte II, Scene V, en-
graved by Massard (fig. 38). It may be suggested that the ori-
gin of the idea of emotionalism achieved through intense muscu-
lar contraction can be traced back to David. The latter, in the
masculine figures of the Oath of the Horatii, "tightens and stif-
fens the muscles under the skin" (Rosenthal, op. cit., p. 9).
This exaggerated muscular tension is one of the main sources of
the emotional power of David's figures. Girodet, as early as
1791, in his figure of Hippocrates, showed a tendency to over-
state David's conception. Thus, while being derived from Drou-
ais' Marius, Hippocrates was interpreted in a much more emotional

It can be seen that the emotionalism suggested by the figure of Starno is largely derived from the irrational violence of its attitude and its anatomical distortions. These qualities, as well as the general appearance of the personage, are reminiscent of some of Giulio Romano's giants in the Palazzo del Tè or of Michelangelo's figures in The Last Judgment. The idea of a possible influence of Michelangelo on Girodet is confirmed by a consideration of the group of Starno's followers crowded in the left part of Ossian[1] (fig. 29). Thus, the soldier of Lochlin, whistling with his fingers in his mouth,[2] repeats the action of one of the demons of The Last Judgment.[3] Similarly, the faces of Cormac[4] and Clothal[5] (fig. 30), showing contracted, muscular foreheads and exophthalmic, convulsed eyes, seem to have been directly inspired by a type found in Michelangelo's fresco.[6] At the time of the execution of Ossian, Michelangelo's influence was not exceptional, and certain young

1 (continued from preceding page).
manner. In Hippocrates, the David-like muscular tenseness of Drouais was given a tetanus-like rigidity. Thus, it can be seen that Starno's frenzy was the culmination of an earlier development.

 1. This crowding by itself recalls similar groupings in The Last Judgment.

 2. This figure appears between the shield and the frame, below Comala and above Cormac.

 3. This demon can be seen in the lower right corner of Michelangelo's fresco, to the left of the figure entwined by a serpent.

 4. Below the whistling soldier.

 5. Below Foldath, the latter being placed below Cormac.

 6. As for instance the figure of one of the damned, hiding his left eye with his hand, placed slightly above Charon's boat. It must be noted that Macpherson, in his Ossian, frequently described somber, rolling eyes (op. cit., Letourneur trans., I, p. 263) and whistling soldiers (idem., p. 103).

French painters in Rome had already begun, as early as in 1791, to show an interest in this master.[1] However, even before this date, in 1790, Girodet wrote to Trioson: "I have just obtained permission to draw from Michelangelo in the Sistine Chapel, and I am planning to work there during mornings and afternoons."[2] Thus, striving to stress the emotional intensity of his figures, Girodet took his inspiration from Michelangelo. This artist, as well as Giulio Romano, provided him with numerous and forceful illustrations of the use of exaggeration and distortion for the sake of emotion.[3]

Contrasting with this convulsive violence, the figure

1. Thus, Girodet wrote to Gérard: "Lebrun is becoming Michelangelized" (Lettres adressées au baron François Gérard, op. cit., I, Rome, July 13, 1791, p. 179). This Lebrun is J. B. Topino-Lebrun, a pupil of David.

2. Girodet, OEuvres posthumes, op. cit., II, Correspondance, Letter XXXVII, to Trioson, Rome, September 28, 1790, p. 373. Direct evidence of these studies can be seen in one of Girodet's drawings executed in Rome: Head of One of the Damned from Hell, lithographed under the painter's direction by Negelen (Achémar, Jean, "L'Enseignement académique en 1820 -- Girodet et son atelier," op. cit., p. 281). Pérignon mentioned three drawings based on heads from Michelangelo's Last Judgment (op. cit., pp. 33-34, no. 214).

3. Coupin spoke of Girodet's enthusiasm for Michelangelo and Giulio Romano (Girodet, OEuvres posthumes, op. cit., I, Notice historique by Coupin, p. xlv). Girodet believed that such great painters as Giulio Romano and Michelangelo, marked by a particular type of genius, had the right to follow their fiery inspiration without concern for logic. For Girodet, the productions of these artists were "striking examples of this type of proud and impetuous originality which . . . does not calculate but acts with the imperious urge of following only its own inspiration, almost without concern for established rules. Only such masters /Michelangelo, Giulio Romano, or Rubens/ succeed in arousing our admiration not only for the beauty of their works but sometimes also for the brilliant errors of their genius." (Girodet, OEuvres posthumes, op. cit., II, De l'Originalité dans les arts du dessin, p. 191.)

of Endymion (fig. 14) exemplifies the other extreme of neuro-
tic emotionalism. Endymion's attitude as well as the anatomi-
cal treatment of his body, with its lightly and unconvincingly
indicated muscles, suggest a general torpor. Yet, this fig-
ure is far from showing a complete relaxation. While following
the antique convention for the attitude of sleep, the position
of the limbs is reminiscent of a dance movement.[1] The throat
is exaggeratedly swelled, and the head is thrown back, affect-
ing a movement which seems to have been inspired by the
trachelismus described by Maréchal in his Antiquités d'Her-
culanum.[2] This attitude gives the impression of a spasmodic
and ecstatic state which is further stressed by the enrap-
tured facial expression, with its half-open mouth and a faint
indication of a smile. Thus, this figure paradoxically com-
bines the anatomical appearance of muscular atony with an
expression suggestive of an ecstatic spasm. Girodet's con-
ception of this type gives the impression of a languid neuro-
sis; and his figure of Endymion, far from suggesting a will-
ful action, seems to be, like a puppet, subjected to its own
movement.[3]

1. It has already been noted that this attitude can be seen
in many antique examples of Endymion. It can also be observed
in numerous other classical works, such as the Ariadne of the
Vatican.
2. Maréchal, op. cit., III, p. 87.
3. This particular neurotic mode is exemplified in many
masculine and feminine figures of Girodet, as can be seen in
his Manes of Aeneas Appearing to Him During his Sleep (fig.
37) (Didot's edition of Virgil, op. cit.) or in his Abandoned
Ariadne (Carnet de Rome).

The neurotic character of Girodet's interpretation of the human figure, as well as its tendency toward either convulsive violence or ecstatic languor, corresponded to parallel manifestations in the contemporary cultural background.

The neurotic tendency in the social and the literary realms took its source from what Monglond called the "epidemic of sensibility," one of the most characteristic prevailing trends during the reign of Louis XVI.[1] Popularized in literature by such writers as Diderot[2] and Rousseau,[3] this current was diffused in everyday life.[4] It was based on the concept of the sensitive soul, shown in exaggeratedly tender manifestations of love for humanity, admiration for family virtues, and in tears shed on the least occasion. The sensitive soul became one of the most indispensable qualities of literary heroes, like Saint-Preux or Alexis, in whom it was usually fused with a feeling of melancholy.[5] Progressively, during the years of the Revolution and of the Directory, the melancholy of the sensitive soul acquired a strongly marked neurotic and morbid character. Many facts suggest this

1. Monglond, op. cit., II, p. 372.
2. Père de Famille, 1758.
3. Nouvelle Héloïse, 1761.
4. Monglond, op. cit., II, pp. 388-389.
5. "This sweet melancholy which delights so much sensitive hearts . . . Sensitivity, melancholy, these old-fashioned words inflame a French knight in the 18th century" (L'Ami des artistes au sallon, Supplément, précédé de quelques observations sur l'état des arts en Angleterre, Deloynes, op. cit., XV, 380, p. 4).

particular mood. Such are the Ball of the victims,[1] the
vogue for posthumous portraits,[2] the appearance of "inconsol-
able widows" who decorated their apartments in imitation of
funerary chapels,[3] or that of women who eagerly bought the
hair of guillotined young men for their adornment.[4] Robert-
son's Fantasmagories became the most popular entertainment
of Paris.[5] Contemporary newspapers reflected the morbid in-
tensity of this atmosphere by relating a very real epidemic
of suicides.[6] These neurotic social manifestations were
paralleled by a current interest in abnormal states of mind.
Thus, in various ways and to different degrees, practically
everyone was concerned with such questions as dreams,[7]

1. Goncourt, Histoire de la société française pendant le
Directoire, op. cit., p. 146.
2. A typical illustration of this vogue can be seen in an
article published in the Journal des Débats (1er Ventôse, An
VIII) to advertise the painter Bourgeois who specialized in
painting posthumous portraits, under the guidance of the family
of the deceased. The article added that Hogarth "painted the
portrait of a deceased, enacted by Garrick." Girodet himself
was praised for his posthumous portrait of Charles Bonaparte
(fig. 75), the father of Napoleon, which was described as "a
precious example of the manner in which posthumous portraits
should be interpreted" (Journal des Débats, November 15, 1804).
3. Monglond, op. cit., II, p. 445.
4. Goncourt, Histoire de la société française pendant le
Directoire, op. cit., p. 409.
5. See for instance: Journal des Débats, 1er Ventôse, An VIII.
6. For instance: Mercure de France, 16 Nivôse, An IX. It was
echoed in art in such works as Gros' Sappho Throwing Herself from
Leucadia (1801); Girodet's Sappho (mentioned by the Princesse
Constance de Salm, Quelques lettres extraites de la correspon-
dance générale, de 1805 à 1810, F. Didot, 1841, p. 38, March
16, 1809, answer to Girodet); and his drawing representing the
Suicide of Hero (Louvre).
7. One may note the frequent recurrence of the theme of
sleep in Girodet's works, as for instance: Endymion, the Manes
of Aeneas Appearing to Him During his Sleep, Ariadne, etc.
Interpretation of dreams played a considerable role in Illumin-
ism. On the other hand, Cabanis believed that there are "con-
stant and determined relations between dreams and delirium"
(Cabanis, OEuvres complètes, Paris, F. Didot, 1824, III, p.453).

somnambulism,[1] mesmeric hypnosis,[2] or manias. During the
years following the Revolution, this influence was reflected
in practically all the levels of cultural life. Thus, it
was echoed in such widely diverging realms as the French
language,[3] art criticism,[4] the theater,[5] or satirical prints.[6]

1. Illuminists associated somnambulism with supernatural
clairvoyance (Matter, M. J., Saint-Martin le philosophe in-
connu, Paris, Didier, 1862, pp. 377-379).
 2. Mesmer's experiments were also attracting an esoteric
interest (idem, p. 376).
 3. The French vocabulary was invaded by new terms based on
the word manie, such as anglomanie (Babié de Bercenay, quoted
by Robertson, op. cit., I, p. 210; Renouvier, op. cit., p. 401;
this term inspired L'Anglomane of Vernet); anticomanie (Renou-
vier, op. cit., p. 401); or dansomanie (idem, p. 186; the au-
thor mentioned it as the title of an engraving of Debucourt).
The expressions related to the sphere of fashion and to that
of the theater reflected a similar influence, as can be seen
in such names or titles as La Folie du jour (idem, pp. 229 and
366); Bonnet à la folle (Goncourt, Histoire de la société fran-
caise pendant le Directoire, op. cit., p. 405); Le Délire (play
mentioned by Renouvier, op. cit., p. 363); or Dansomanie (played
in the Théâtre français) (Journal de Paris, 28 Brumaire, An VII).
 4. Among the most frequent expressions found in the art
criticism of the end of the eighteenth and the beginning of
the nineteenth century one can note: "imagination in a state
of delirium" (Revue du Salon de l'an X ou examen critique de
tous les tableaux qui ont été exposés au Museum, Paris, Su-
rosne, 1802, IIe Supplément, Deloynes, op. cit., XXVII, 769, p.
184); and especially "convulsive movements" (Explication des
ouvrages de peinture, sculpture, architecture, gravures, des-
sins, modèles, etc. exposés dans le grand sallon du Museum au
mois de Vendémiaire, An IV, Paris, Hérissant, p. 39). The
writers of the Salon were unusually fond of this latter term,
which acquired the quality of a cliché.
 5. Geoffroy writing about Talma's acting in Ducis' Othello,
commented upon the "portrayal of passion worked up to delirium,
to insanity" (quoted by Mantzius, op. cit., VI, p. 167). The
same critic found that in Voltaire's Orestes, the actor "Rep-
resents with great accuracy an unhappy human being who has
gone out of his mind; he reproduces with great truth all the
symptoms of common madness" (idem, p. 165).
 6. La Folie prêchant dans la Cathédrale de Paris by Brion
de la Tour (mentioned by Renouvier, op. cit., p. 236).

The scientists of the time showed a similar concern with abnormality. Pinel, the best-known psychiatrist of the end of the eighteenth century, wrote in his Nosographie philosophique, published in 1797-1798:

"It is only in the latter half of this century that we have most frequently observed what is called nervous illnesses, vapors, nervous melancholia, and that we have seen numerous authors . . . describe these diseases."[1]

Pinel noted a definite intensification of these illnesses after the excesses of the Revolution: the "events of the Revolution, either because of deep regrets for the old regime or because of the extreme exaltation of a fiery patriotism" are among "the most common sources of mania."[2] Without attempting to analyze the period of the Directory from a medical point of view, one may suggest that its peculiar fascination for abnormality can be compared to the twentieth century interest in psychoanalysis and Freudian concepts. Girodet's writings strongly reflect the morbid curiosity of his time. He was fascinated by the no man's land of abnormality, Horace's "sick men's dreams,"[3] these "regions of profound darkness in

1. Pinel, P., Nosographie philosophique ou la méthode de l'analyse appliquée à la médecine, Paris, Maradan, An VI, II, p. 7. As early as 1789, doctors considered melancholy "'as a new plague' so common has it become" (Bressy, Recherches sur les vapeurs, 1789, pp. II-III, quoted by Monglond, op. cit., p. 253).
2. Pinel, op. cit., II, p. 11.
3. The Art of Poetry, in op. cit., p. 133. Girodet obviously took his inspiration from Horace when he spoke of "the dreams of a sick man" (Girodet, OEuvres posthumes, op. cit., II, De l'Originalité, p. 191).

which monsters are generated."[1] Thus, he wondered about the
"brilliant works" conceived in a state of sleep, somnambul-
ism, illness, or mental disequilibrium by people who would
not be able to rise to such heights in a normal condition.[2]
Girodet's awareness of the morbid current of the Directory,
as well as what has been said about the painter's character,[3]
make it possible to understand why he, more than any other
artist of his time, emphasized the neurotic elements in his
interpretation of the human figure. However, it must be

1. Girodet, OEuvres posthumes, op. cit., II, De l'Origi-
nalité, p. 202.
2. . . . how shall we explain these prodigies conceived
by somnambulists and by sick people . . . students compos-
ing, in these two peculiar states, brilliant works which they
would not have been able to produce while being awake or in a
state of perfect health, and returning after their crisis to
their usual mediocrity? What must we then think of this kind
of nocturnal genius, which manifests itself only when the
springs of thought are relaxed, or of the kind which only
appears at the moment when the vital organism has lost its
equilibrium?' (Girodet, OEuvres posthumes, op. cit., II, Con-
sidérations sur le génie particulier à la peinture et à la
poésie, pp. 115-116). Nowhere does one find as frequently as
in Girodet's writings such terms as "delirium" (Girodet, OEuv-
res posthumes, op. cit., II, De l'Originalité, p. 200), "ma-
nia" (Idem, p. 197), "convulsive spasms" (Idem, p. 189), or
"lethargic vapors" (Idem). For Girodet, genius, beauty, and
virtue occupy the center of a series of concentric circles,
the last of which "touches the regions of profound darkness."
Passing these limits, a "too venturesome art . . . only shows
absurd ideas and incoherent images, similar to the dreams of
a sick man." Yet, the painter was obviously fascinated by
this abnormal realm. Thus, speaking about artistic genius,
Girodet wrote that if the intensity of creation "goes beyond
certain limits, and if the moderating harmony . . . no longer
regulates its course; similar in his convulsions to a ship
the pilot of which has lost control of the helm. . . now
thrown on the summit of the abyss, now hurled in its depths,
the genius, abandoned to his ardor and to his blind impetuo-
sity, is nothing but a brilliant delirium, in which sublimity
and extravagance unceasingly clash." (OEuvres posthumes, op.cit.,
II, Considérations sur le génie particulier à la peinture et à
la poésie, p. 118.)
3. Supra, pp. 97 ff.

stressed that, far from being intentional, this quality was most probably an indirect, unconscious result of a transposition from the contemporary psychological climate.

It is interesting to note that, more specifically, the contrasting tendencies of Girodet's personages, toward either an ecstatic torpor or a convulsive violence, corresponded to a definite psychological attitude of the time. This attitude is particularly evident in the contemporary literary interpretation of the typical melancholy hero with a sensitive soul. The behavior of this literary type shows a definite pattern, marked by successive shifts from complete prostration to extreme agitation. On the one hand, "The paleness, the attitudes, a willowy figure /of the hero/ must suggest an almost morbid languidness"[1] or even a strange "stupor."[2] On the other hand, when moved by great stress, the same hero indulges in "scenes of delirium and frenzy," which sometimes reach an emotional violence causing him to faint.[3] This type of conduct was not limited to art or literature. It was widely echoed in the scientific realm[4] and in the social life

1. Madame de Staël, Delphine, OEuvres, V, p. 114, quoted in Monglond, op. cit., I, p. 253.
2. Ducray-Duminil, Alexis, ou la maisonnette dans les bois, Grenoble et Paris, 1789, I, pp. vi-vii, quoted in Monglond, op. cit., II, p. 292.
3. Monglond, op. cit., I, p. 254.
4. It is interesting to note that the behavior of the literary hero permeated the medical writings. Thus, it influenced Cabanis' and Pinel's descriptions of the pathological melancholy maniac. The conduct of the latter was depicted as being only a slight exaggeration of the behavior of the literary hero. On the one hand, the influences of morbid melancholia "oppress and stupefy the nervous system" (Cabanis, op.cit. III, p. 462); "the pulse is slowOne has a marked inclination for inactivity" (Pinel, op. cit., II, p. 27). On the other hand, the same influences can create "dementia and fierceness" (Cabanis.

of the time. Monglond made an extensive study of these con-
trasting shifts from a "languid tenderness to violence,"
characterizing the behavior of the contemporaries.[1]

It may be said that the phase represented by Girodet's
mythological paintings between 1791 and 1802 was unique in
the development of the artist. Through its esoterism, ir-
rationality, and neurotic emotionalism, Girodet's art com-
pletely diverged from David. This evolution was partially
the result of the painter's striving for originality. How-
ever, in attempting to escape the influence of David and to
create a new, individual art, Girodet paradoxically succeeded
in becoming only the most representative artist of the vari-
ous cultural and social currents of the Directory.

[1] (continued from preceding page).
op. cit., III, p. 462); "The emotions of the soul are suscep-
tible of the greatest violence, love is worked up to delirium,
piety to fanaticism, anger to a frantic fury, desire for re-
venge to the most barbaric cruelty" (Pinel, op. cit., II, p.
27). The resemblance between the maniac and the literary hero
is not accidental, for both were artifically evolved from the
concept of the same predisposing melancholy temperament, of
which they were the successive stages (Pinel, op. cit., II,
p. 16). One must note the contemporary fashion for the mel-
ancholy temperament, which was considered as an almost neces-
sary condition for genius (Pinel, op. cit., II, p. 16).
 1. Monglond, op. cit., II, pp. 411-423.

CHAPTER IV

LA GRANDE MANIERE

CHAPTER IV

LA GRANDE MANIERE

The paintings of this group represent the culminating effort of Girodet's productivity. The four major works of this phase, between 1806 and 1810, are:

Scene of a Deluge[1] (fig. 42)

The Entombment of Atala[2] (fig. 49)

Napoleon Receiving the Keys of Vienna[3] (fig. 55)

The Rebellion of Cairo[4] (fig. 56)

The consideration of these paintings can be divided into three main parts:

I. The background.

II. The particular problems related to each painting.

III. The common characteristics of the group.

I. This period was marked by the artist's most intense and continuous effort which was to end with a complete shattering of his health. Moreover, the painter's work was

1. 1806, Louvre.
2. 1808, Louvre.
3. 1808, Versailles.
4. 1810, Versailles.

impeded by the increasing pressure of the Imperial discipline
which forced him to restrain his striving for originality.

II. In his selection of subjects, Girodet abandoned, to a
great degree, the classical historical or mythological sour-
ces. At the same time, he eliminated from his conceptions
the esoteric symbolism and the irrational emotionalism which
characterized the previous period. He now attempted to ex-
ploit new sources of emotion, more traditionally related to
the concept of nineteenth century Romanticism. Thus, he
based his Deluge on the idea of a catastrophe and experimented
with such factors as exotic atmosphere (Atala), local color
(Napoleon Receiving the Keys of Vienna), and orientalism (The
Rebellion of Cairo).

III. The paintings of this period are characterized by a
new heroic scale and a grande manière. They show a general
return to a rationalized concept of drama, in which the set-
ting and the action are given a new important role.

I.

BACKGROUND

Deeply hurt by the criticisms directed against Ossian, and bitterly aware of the passing years,[1] Girodet, during this period, concentrated all his energy on re-establishing his reputation. In 1803, he moved from the Louvre, where he was a neighbor of Prud'hon, to the isolation of the Capucines, Place Vendôme.[2] This new atelier became the scene of the most intense and continuous efforts of the artist. "Seldom satisfied with what he was doing . . . he was constantly thinking of possible improvements"[3] and was endlessly re-touching and correcting his paintings.[4] Finding the days too short for what he wanted to accomplish,[5] he took the habit of working until midnight,[6] and sometimes, "seized by a kind of

1. "I must hurry . . . for the years are passing quickly, especially for me who am no longer young." (Girodet, OEuvres posthumes, op. cit., II, Correspondance, Letter XII, to Coupin de la Couprie, Montargis, February 17, 1811, p. 310.)
2. Letter of Prud'hon to Denon, September 30, 1803, quoted by Goncourt in L'Art du XVIIIᵉ Siècle, op. cit., III, pp. 404-405. According to Prud'hon, Girodet's moving was due to the noise and disturbances caused by Madame Prud'hon.
3. Mademoiselle Ducrest, Mémoires sur Joséphine, II, p. 205, quoted in Stenger, op. cit., p. 111.
4. Delécluze, op. cit., p. 271.
5. Girodet wished he had "days of 96 hours" (Lettre de M. Boher, peintre et statuaire et la réponse de M. Girodet, peintre d'histoire, et membre de l'Institut, Perpignan, Alzine, Paris, December 20, 1819, p. 4).
6. Lettres de Girodet Trioson à Madame Simons-Candeille, op. cit., 1808 (?).

inspirational fever," he even rose from his bed in the middle
of the night in order to paint.[1] These nocturnal labors were
made possible by his pupil Pannetier who invented for the
artist a special lighting apparatus, consisting of a lamp
and candles attached to a hat which Girodet wore while paint-
ing.[2] Delécluze wrote that the artist became so accustomed to
this method of work that having "begun by saying that artifi-
cial light was as satisfactory for painting as daylight, . . .
he ended by affirming that it was even better."[3] Though work-
ing as hard as a "Trappist"[4] or a "galley slave,"[5] Girodet
spent a surprising length of time on certain paintings, as for
instance four years in the case of the _Deluge_.[6] Yet, during
these years, he was eagerly reading all the new literary

1. Mademoiselle Ducrest, _Mémoires sur Joséphine_, II, p.
205, quoted in Stenger, _op. cit._, p. 111.
2. It is the famous "lamp with three wicks" (_Lettres de
Girodet-Trioson à Madame Simons Candeille, op. cit._), (1808)(?).
Contemporaries liked to ridicule this "comical attire" (Made-
moiselle Ducrest, _Mémoires sur Joséphine_, II, p. 205, quoted
by Stenger, _op. cit._, p. 111). A painting of Dejuine shows
Girodet painting at night in the presence of Sommariva and
Bréguet (_Archives de l'art français_, 1879, p. 309). While
the _Deluge_ seems to have been executed by the light of candles
held by Girodet's pupils Coupin and Chatillon (Girodet, _OEuv-
res posthumes, op. cit._, II, _Correspondance_, Letter XXII, to
Pannetier, Paris, September 16, 1806, p. 328), _Atala_ was
painted with the help of the "lamp with three wicks" (_Lettres
de Girodet-Trioson à Madame Simons Candeille, op. cit._, note
presumably written by Madame Simons Candeille).
3. Delécluze, _op. cit._, p. 270.
4. _Lettres de Girodet-Trioson à Madame Simons Candeille,
op. cit._
5. _Lettres de Girodet'Trioson à Madame Simons Candeille,
op. cit._
6. Girodet, _OEuvres posthumes, op. cit._, I, _Notice histo-
rique_ by Coupin, p. xvj.

productions,[1] he began to work on his poem _Le Peintre_,[2] and published verses in the contemporary periodicals.[3] This intense artistic and literary activity, as well as a tiring management of complicated financial affairs,[4] completely shattered Girodet's health.[5] The artist was never again to be capable of a similar effort.

At first glance, Girodet's exertions seem to have been rewarded by his winning the _Prix décennal_ over David in 1810.[6] Yet, the judgment of the jury of the _Institut_ was far from corresponding to the opinion of the majority of the critics and to the feeling of the public.[7] It must be noted that the painter acquired, during the period of the Empire, a few faithful supporters, as for instance the Marquis Boutard, one of the editors of the influential Journal de l'Empire.[8]

1. Girodet, OEuvres posthumes, op. cit., I, Le Peintre, Discours préliminaire, p. 22.
2. At the publication of Millevoye's Les Plaisirs du poète, Girodet abandoned the Veillées and began Le Peintre (idem,pp.21-22).
3. On September 24, 1804, the Journal des Débats published Girodet's verses read at the occasion of the dinner celebrating the crowning of Gros' Jaffa (reprinted in Delestre, J. B., Gros et ses ouvrages, Paris, Labitte, 1845, pp. 92-94); in 1806, F. Didot published Girodet's La Critique des critiques du Salon de l'an 1806; and on August 29, 1807, the Mercure de France published a fragment of an Essai poétique sur l'école française.
4. Lettres de Girodet-Trioson à Madame Simons Candeille, op. cit., February 6, 1810.
5. Idem. From this period on, practically all of Girodet's letters reflected his concern for his health and business difficulties.
6. Girodet's Deluge was selected over David's Sabines (David, J. L. Jules, op. cit., I, pp. 460 ff.).
7. See Depenne's Stances à David, Peyranne's Ages de la peinture, or L. de Lamothe's Injustice (mentioned by J. L. Jules David, idem, p. 475).
8. Known before Napoleon's coronation as the Journal des Débats. Girodet wrote to Boutard to thank him for his continuously favorable criticisms (Girodet, OEuvres posthumes, op.

However, Boutard's obvious partiality to Girodet's paintings
became a source of standard jokes among the writers on art.[1]
David went so far as to say that his former pupil's fame
was based on his friends' "pen strokes" and on the writings
of venal newspapermen.[2] In spite of these statements, it
can be said that, in general, the great majority of the crit-
ics were, to various degrees, hostile to Girodet's produc-
tions and indifferent to his almost pathetic efforts.
Constantly attacked, the artist himself entered the field
of polemics by writing his Critique des critiques, in which,
imitating the style of Boileau and La Bruyère, he anonymously
satirized his enemies.[3] Girodet was particularly sensitive

3 (Continued from preceding page).
cit., II, Correspondance, Letter IX, to Boutard, Bourgoin, May
7, 1821, p. 301; also Girodet, OEuvres posthumes, op. cit., II,
Correspondance, Letter VIII, to Boutard, Paris, September 28,
1806, p. 300).

 1. For instance in Observations sur le Salon de l'an 1808,
no. 12, Tableaux d'histoire, Paris, Vve Gueffier et Delaunay,
1808, Deloynes, op. cit., XLIII, 1139, p. 671; or in Première
journée d'Cadet Buteux au Salon de 1808, Paris, Aubry, 1808,
pp. 3 ff.

 2. Notes of David on his major pupils, quoted in J. L.
Jules David, op. cit., I, pp. 502-503.

 3. La Critique des critiques du Salon de l'an 1806, étrennes
aux connaisseurs, Paris, F. Didot, 1806. In a letter to Madame
Simons Candeille, Girodet admitted himself to be the author of
this writing which was published anonymously (Lettres de Giro-
det-Trioson à Madame Simons Candeille, op. cit.) This anony-
mity was used by Girodet to suggest that he had impartial sup-
porters, as can be seen in his letter to Pastoret (Girodet,
OEuvres posthumes, op. cit., II, Correspondance, Letter XXVII,
to Pastoret, p. 344). Girodet was probably also the author of
a caricature entitled Le Grand chiffonier -- critique du Salon
de 1806 (fig. 41). This is suggested by the content of the
caricature referring to the Critique des critiques as well as
by the fact that the authors of the caricature are indicated
in the following terms: Verus pinxt.; Momus-Justus excudt.;
Fidelis sculpt.

to the opinion of one of the critics[1] who, in spite of the
painter's mature age, paradoxically considered him as a young
artist of great promise, and praised him for his potential
talent rather than for his actual works. This judgment was
mockingly quoted in Girodet's satire:

> "'Possibly, the author /Girodet/ is not without talent,
> Be it so . . . I think so . . . perhaps . . . some day . . .
> with time,
> He could become an artist above mediocrity;
> However, to achieve this goal, he has to work a great deal.'"[2]

It can be understood why the attitude of the critics should
have embittered the painter who had worked even at night, who
had spent four years on the Deluge, and who was acutely aware
of his passing years. Thus, Girodet rapidly acquired the
reputation of being a misanthrope unable to bear criticism.[3]
While this was undoubtedly true, the artist began to consider
himself more and more as a misunderstood genius who would be
appreciated only by future generations.[4]

Besides the awarding of the Prix décennal,[5] Girodet
received little encouragement from the Imperial officialdom.

1. In Le Publiciste.
2. La Critique des critiques, op. cit., p. 18.
3. As for instance is suggested in Madame de Salm's poem
Sur la mort de Girodet (OEuvres complètes, op. cit., II, p.
188; see also idem, note 1, pp. 295-297).
4. This idea recurs very frequently in Girodet's writings,
as for instance in Le Peintre, Chant V (Girodet, OEuvres post-
humes, op. cit., I, p. 165).
5. The ten thousand francs of the Prix were never paid to
Girodet (Girodet, OEuvres posthumes, op. cit., I, Notice his-
torique by Coupin, p. xix).

Although decorated by Napoleon,[1] he was pursued by the hostility of Vivant Denon and did not succeed, during the Empire, in becoming a member of the _Institut_, an honor which was one of his most cherished ambitions.[2] In contrast to the numerous Imperial commissions received by Gérard, Gros, and David, Girodet was granted only three important ones, the last of which, consisting of thirty-six identical portraits of Napoleon for all the Courts of Appeal of France, proved to be as tedious as it was unprofitable.[3] Moreover, Coupin wrote that Girodet felt ill at ease in interpreting themes which were imposed on him by official commissions.[4] In general, the artist resented the highhandedness of the Imperial artistic officialdom, the compulsory exhibitions of paintings at the salon,[5] and the fixed limits of time for the execution of works commissioned by the government.[6] Writing to Julie Candeille, he expressed the feelings of many artists by saying:

1. A painting by Gros in Versailles represents Napoleon distributing decorations to a group of artists among whom is Girodet, at the Salon of 1808.

2. _Lettres de Girodet-Trioson à Madame Simons Candeille_, _op. cit._, Paris, June 11, 1815.

3. Stein, Henri, _op. cit._, pp. 355 ff.

4. Girodet, _OEuvres posthumes_, _op. cit._, I, _Notice historique_ by Coupin, p. xvij.

5. Girodet was also forced to abandon his habit of exhibiting his works almost at the closing of the salon to attract a greater interest (Boutard in the _Journal des Débats_, September 5, 1802.

6. _Lettres de Girodet-Trioson à Madame Simons Candeille_, _op. cit._

"We /painters/ are very regimented although we are not wearing uniforms: painting brush to the right, pencil to the left, forward march -- and we march."[1]

Thus, longing for recognition, Girodet, working under the pressure of the critics and under the influence of the disciplinarian atmosphere of the Empire, was forced to compromise between his striving for originality and the taste of Napoleon.

1. Lettres de Girodet-Trioson à Madame Simons Candeille, 2. cit.

II.

CONSIDERATION OF INDIVIDUAL PAINTINGS: PARTICULAR PROBLEMS AND ICONOGRAPHICAL CONTENT

The study of this group of paintings, inspired by literature or contemporary history, can be based on the consideration of four major works: Scene of a Deluge, The Entombment of Atala, Napoleon Receiving the Keys of Vienna, and The Rebellion of Cairo.

Scene of a Deluge[1] (fig. 42)

Girodet, aware of the lack of genuine success of Ossian,[2] isolated himself in the Capucines where, from the end of 1802 to the end of 1806, he worked on the Deluge.[3] Coupin described the artist in his new atelier, which was located immediately below the roof, painting relentlessly during the

1. 1806, Louvre.
2. Delécluze, op. cit., p. 266.
3. Since Ossian was exhibited in the Salon of 1802, it may be safe to presume that the Deluge was begun immediately afterwards. We know unquestionnably that on September 16, 1806, the Deluge was finished and was already hanging in the Salon (Girodet, OEuvres posthumes, op. cit., II, Correspondance, Letter XXII, to Pannetier, Paris, September 16, 1806, p. 325). Thus, one may account for the four years mentioned by various authors (as for instance Delécluze, op. cit., p. 266; or Coupin, see p. 226, note 6).

most intense heat of the summer, completely soaked with per-
spiration.[1] After much work and many difficulties,[2] the
exhausted Girodet triumphantly wrote to his friend Pannetier:

> "Yes, my dear friend, my painting is actually finished
> and hanging /in the salon/ . . . I have finished in time,
> but so nearly in time that I was still working at it the
> eve of the day before it left my atelier . . . I have lost
> much weight, which you will find hard to believe, for al-
> ready when you left I had not much to lose. However, I
> have suffered this fatigue without succumbing to it, but
> it was really time that it ended."[3]

The Deluge as well as Gros' Aboukir were the two paintings
which attracted the most attention in the Salon of 1806.[4]
Girodet's work, inspiring the numerous critical writings
which forced the painter to publish his Critique des critiques,[5]
was the last production which placed him in the midst of an
important artistic controversy, and in the center of public
attention. It is interesting to note that the Deluge was
conceived independently of any commission, and that, in spite
of the minor explosion it created, it did not find any acquirer

1. Girodet, OEuvres posthumes, op. cit., I, Notice histo-
rique by Coupin, pp. xlj-xlij.
2. Such as the incident of the greasy oil which ran over
the paint (Girodet, OEuvres posthumes, op. cit., II, Corres-
pondance, Letter XXII, to Pannetier, Paris, September 16,
1806, p. 326).
3. Girodet, OEuvres posthumes, op. cit., II, Correspondance,
Letter XXII, to Pannetier, Paris, September 16, 1806, pp. 325-
326.
4. Idem, p. 327. Girodet seemed to be aware of a possible
competition offered by Gros' Aboukir: "We cannot harm each
other: neither the subject, nor the effect, nor the execution
have anything in common.
5. In which he defended the Deluge as well as Gros' Abou-
kir.

before the Restoration, at which time it was bought by the
government.[1]

It is possible to obtain a fairly complete description
of the Scene of a Deluge from the text published by Boutard
in the Journal des Débats:

"The mountain lake, swelled by rains . . . has suddenly
broken its dikes . . . its waters are streaming down tor-
rentially . . . they have filled the valley and are still
rising; the storm has not ceased. In this danger, a
man has placed his old father on his shoulders; and /is
walking/ followed by his wife, whom he is leading by the
hand, and by his two children, one in his mother's arms
and the other walking behind her. They were fleeing to-
gether before the rising flood, by making their way from
rock to rock, when the accident chosen by the painter for
the moment of his action occurred.

"This man, on whose strength rests the salvation of
his entire family and who provides the point of support
for this chain of personages whom we have just described,
has seized the branch of a tree in order to sustain him-
self on a slippery rock. This branch bends under his
effort; the unfortunate stiffens in vain on his feet and
tries to lighten the upper part of his body, in order to
maintain the equilibrium which is being destroyed. The
old man, who is attempting to hold on to the broken tree,
quickens the danger. The impulse is propagated to the
other personages. The mother, having fainted, falls
backward under the child whom she is holding in her arms.
The other child, pushed by the shock from the narrow top
of the rock where he had just arrived behind his mother,
is grasping her hair and remains suspended above the abyss.
Meanwhile the tree breaks and bends more and more; nothing
can any longer delay the loss of this family."[2]

1. Girodet, OEuvres posthumes, op. cit., I, Notice histo-
rique by Coupin, p. 11j.
2. "Salon de l'an 1806-no. III," Journal des Débats, Sep-
tember 27, 1806. The same description, probably by Girodet
himself, was quoted by Chaussard in his Pausanias français,
op. cit., p. 116.

Completing this description, the Critique des critiques added
that the action of the painting takes place at night, illumi-
nated by lightning, and that the provident old man is holding
the fortune of the family.[1] Finally, Landon, in his Annales
du Musée, mentioned the body of a dying young girl floating
in the water.[2]

Needless to say, the general idea of the theme of the
deluge was a very old one, and the Biblical Flood inspired
innumerable paintings, such as those of Raphael, Michel-
angelo, and Poussin. At the end of the eighteenth century,
one can note a definite interest not so much for the Bibli-
cal Deluge for rather for catastrophes in general, such as
floods, shipwrecks, volcanic eruptions, earthquakes, or
fires. In their striving for esoteric parallels between
myths of various ages and cultures,[3] scholars enumerated and
compared the floods of classical antiquity, such as the five
deluges mentioned by Xenophon,[4] the one described by Diodorus
Siculus,[5] and the various floods of the mythologies of the
Brazilian, African, and Mohammedan cultures.[6] Writers of the

1. La Critique des critiques, op. cit., p. 17.
2. Landon, Annales du Musée et de l'école moderne des
Beaux-Arts, Paris, Landon, XIII, 1807, p. 17.
3. Supra, p. 131 , note 3 .
4. At the time of (a) Ogyges, (b) Hercules, (c) another
Ogyges, (d) Deucalion, (e) the Trojan war (Noël, op. cit.,
I, p. 403).
5. Idem.
6. Idem.

time referred to the death of Pliny the Elder and to the
famous eruptions of Vesuvius and Etna, at the least occa-
sion.[1] Catastrophes also played a very important role in the
fictional literature of the end of the eighteenth century.
Thus, such different writers as Macpherson,[2] Gessner,[3] De-
lille,[4] Bernardin de Saint Pierre,[5] and Chateaubriand[6] fre-
quently introduced disasters caused by nature in their works.
It may be suggested that this fascination for catastrophes,
while showing a typically Pre-Romantic predilection for
sources of strong emotion, also reflected the anxiety of the
Illuministic expectation of the cataclysmic disaster, which
was to bring about the end of the world.[7]

This literary tendency was widely echoed in the artis-
tic realm. Besides the countless representations of ship-
wrecks or storms at sea,[8] one can see, at the end of the

1. For instance, Girodet himself in Le Peintre, Chant III
(Girodet, OEuvres posthumes, op. cit., I, pp. 116-119, 121,
132, etc.); also Coupin (in Girodet, OEuvres posthumes, op.
cit., Le Peintre, Notes du Chant III, pp. 286-287); or De-
lille (op. cit., I, L'Homme des champs, pp. 166-167).
2. Ossian.
3. Gessner, Solomon, La Tempête, Tableau du déluge.
4. Delille, op. cit., I, L'Homme des champs, III, pp.
164-166.
5. Bernardin de Saint-Pierre, Paul et Virginie.
6. Chateaubriand, Atala, Le Génie du Christianisme, Les
Martyrs.
7. Viatte, op. cit., I, pp. 98-99, 216, 233, 236, 237-238;
II, pp. 17, 56, 84; also supra, p. 114.
8. For instance, in the same salon in which Girodet's De-
luge was exhibited (1806), there were three works representing
shipwrecks: Crépin's Shipwreck of Lapeyrouse, Sautoire-Va-
renne's Shipwreck, and Marlet's Shipwreck of La Père.

eighteenth century, a multiplication of subjects inspired by
the theme of the flood. Thus, looking at random in the li-
vrets of the salons of the last twenty years of the century,
one finds: the Deluge by Bounieu, 1783;[1] the Scene of the
Deluge by Regnault, 1789;[2] another larger version of the sub-
ject by the same artist, 1791[3] (fig. 47); The Deluge by Nai-
geon, 1793;[4] The Deluge by Lagrenée the Elder, 1796;[5] A Scene
of the Deluge Taken from a Fragment of Gessner by P. M. Dela-
fontaine, 1798;[6] The Deluge by P. Wallaert, 1800;[7] and the
Scene of the Deluge, a sculpture by M. Clodion, 1801[8] (fig. 48).

1. Engraved by Bounieu. The date is given by Locquin, op.
cit., p. 275, note 2.
2. Observations critiques sur les tableaux du Sallon de
l'année 1789, Paris, 1789, Deloynes, op. cit., XVI, 410, p.
21, no. 91.
3. Explication des peintures, sculptures et gravures, de
messieurs de l'académie royale, Paris, 1791, Deloynes, op. cit.,
XVII, 432, p. 18, no. 93.
4. Description des ouvrages de peinture, sculpture, archi-
tecture et gravures, exposés au Sallon du Louvre le 10 Août
1793, Paris, Hérissant, p. 59, no. 617.
5. Explication des ouvrages de peinture, sculpture, archi-
tecture, gravures, dessins, modèles, etc. exposés dans le grand
Salon du Musée central des Arts, Paris, Impr. des Sciences et
Arts, An V (1796), p. 47, no. 229 bis.
6. Explication des ouvrages de peinture et dessins, sculp-
ture, architecture et gravures, exposés au Musée central des
Arts, Paris, Impr. des Sciences et Arts, An VI (1798), p. 19,
no. 106. Gessner also inspired a drawing of Monnet, engraved
by Letellier, which illustrates the Tableau du déluge (OEuvres
de Gessner, Paris, Dufart, II, facing p. 412).
7. Explication des ouvrages de peinture et de dessins, sculp-
ture, architecture et gravure des artistes vivans, exposés au
Musée central des Arts, Paris, Impr. des Sciences et Arts, An
VIII (1800), p. 67, no. 383.
8. Explication des ouvrages de peinture et dessins, sculp-
ture, architecture et gravure des artistes vivans exposés au
Museum central des Arts, Paris, Impr. des Sciences et Arts,
An IX (1801), p. 68, no. 413.

It can be seen that Girodet's Deluge was preceded by a long series of similar themes.

A letter of Girodet, published in the Journal de Paris, reveals the artist's particular approach to the subject:

> ". . . it is by mistake that, in the livret of the salon, my painting has been announced under the title of A scene of the Deluge. I have wanted to give neither the idea of the Deluge of Noah nor of that of Deucalion. I have taken the word deluge in the sense of a sudden and partial inundation produced by a convulsion of nature, such as, for instance, the picture which could be seen during the disaster which recently occurred in Switzerland. It is A scene of a deluge."[1]

Moreover, the artist wrote to Pastoret:

> "/This painting is not the/ universal Deluge, but, as I have already stated, A scene of a deluge; or, if you reject this qualification as too vague, perhaps you would prefer: a family, surprised during the night by an inundation, is about to be engulfed by the waters? It seems to me that this description better explains my painting."[2]

Thus, Girodet implied that his subject was inspired by a cataclysm of nature. However, the disaster referred to in his letter to the Journal de Paris, identified by J. L. Jules David as that which took place at Goldau on September 2, 1806,[3]

1. Girodet, "Lettre aux rédacteurs," Journal de Paris, September 21, 1806.
2. Girodet, OEuvres posthumes, op. cit., II, Correspondance, Letter XXVII, to Pastoret, pp. 343-344. The artist frequently reiterated this idea, as, for instance, in the Journal des Débats, September 27, 1806. See also Le Breton, op. cit., pp. 62-63.
3. David, J. L. Jules, op. cit., I, p. 438, note 1.

could not possibly have been, because of its date,[1] the
specific source of the painting. Therefore, Girodet's Deluge
seems to be devoid of any specific religious, mythological,
or literary connotation, as well as of any definite relation
to a contemporary event. From this point of view, the pain-
ter's concept of a fictional catastrophe followed the example
of earlier interpretations of the theme, such as those of
Bounieu and Regnault, who also invented their own cataclysms.[2]
Yet, it is evident that Girodet, as well as his predecessors,
could not possibly have been completely immune to the influ-
ence of the Illuministic ideas on the end of the world, or
to the literary diffusion of the catastrophe theme. Thus, in
spite of the painter's affirmation, it may be suggested that,
in a general manner, these influences are echoed in the

1. From Girodet's letter to Pannetier (supra, p. 233,
note 3), it is known that the Deluge was already hanging
in the salon on September 16, 1806, only fourteen days af-
ter the disaster of Goldau.
2. It is interesting to note that, with the exception
of the paintings of Naigeon, Lagrenée, and Wallaert, which
are lost and unknown to me, none of the previously men-
tioned deluges was based on the Biblical Flood. The paint-
ing of Delafontaine was directly inspired by Gessner, and
the sculpture of Clodion seems to represent one of the
classical deluges (Landon, C. P., Annales du Musée et de
l'école moderne des Beaux-Arts, op. cit., I, 1801, p. 100).
Yet, the works of Bounieu and Regnault appear to have been
conceived independently of any definite source. (For Bou-
nieu, see Locquin, op. cit., p. 275, note 2; for Regnault,
see Landon, Annales du Musée et de l'école moderne des
Beaux-Arts, op. cit., III, 1802, p. 49).

artist's painting.[1]

Having recognized the importance of the cultural atmosphere in the artist's selection of the subject, one must attempt to consider the specific significance of Girodet's interpretation of the theme by analyzing the individual iconographical elements of the painting.

Girodet's description of the Deluge suggests that the depicted action takes place in a mountainous region similar to Switzerland.[2] However, the setting of the painting (fig. 42) seems to be devoid of any precise localization and appears to be based on a well-established iconographical repertory of the subject. Broken, battered trees rising on barren, rocky elevations surrounded by water are the essential elements of the landscape of many well-known examples of the theme, as can be seen, for instance, in the works of Michelangelo[3] and Poussin.[4] Yet, instead of conceiving the

1. It is difficult to agree with Benoit,(op. cit., p. 383) who explained the multiplication of the deluge themes by a revival of religious feeling and by a particular interest in Gessner. The religious revival, referred to be Benoit, began to show its influence only after the Concordat of 1801, and fails to explain the great number of deluges which had been painted prior to this date. Similarly, considering the widespread importance of flood themes in the contemporary literature (supra, p. 236), it is difficult to give to Gessner the sole responsibility for the diffusion of the subject. The same can be said about Antal's suggestion that Chateaubriand was the predominant source of Girodet's Deluge (Antal, op. cit., p. 137).
2. Supra, pp. 234 and 238.
3. Sistine Chapel.
4. Louvre.

scene, like his great predecessors, as seen from a certain distance, Girodet selected a close-up view. In choosing this approach, the painter was perhaps influenced by some of the late eighteenth century deluges, like those of Regnault. But in following their example, Girodet also applied one of his own favorite ideas on landscape, considering a close-up view as conveying stronger emotions than a distant panorama.[1] It can be seen that in his _Deluge_, the painter surpassed Regnault (fig. 47) both in the austerity and in the dramatic feeling of the setting. By eliminating all the accessory details, with the exception of one tortured tree and one steep, jagged cliff, Girodet abstracted the essential elements of the traditional deluge site.[2] Moreover, by representing the scene as occurring at night, with stormy clouds pierced by flashes of lightning,[3] the artist made all the elements of nature concur to express a maximum of dramatic intensity.

Instead of representing a large number of figures, as

1. Girodet, _OEuvres posthumes_, op. cit., I, _Le Peintre, Notes du Chant_ I, p. 210, note 8.
2. Regnault's landscape (fig. 47) is much more complex and shows several mountains, houses, grass, and the traditional serpent derived from Poussin. In his striving to represent the bare essentials of the setting, Girodet avoided too realistic a treatment and was criticized for representing the rocks too shiny and the water too clean (/Chaussard/, _Le Pausanias français_, op. cit., p. 126).
3. Girodet's painting is one of the very rare renditions of the theme as taking place during the night.

in the traditional interpretations of the Deluge,[1] Girodet
limited the enactment of his drama to one small group of
personages. Just as he represented only the basic constitu-
ents of the flood landscape, so he depicted only the essen-
tial representatives of humanity, the fundamental sociologi-
cal unit formed by the members of a family. This conception,
illustrated by many of the deluges of the late eighteenth
century, like those of Regnault,[2] corresponds to some of
the most famous examples of classical tragedy, such as the
Laocoön or the Niobids. This idea is also related to the
eighteenth century emphasis on the family, diffused through-
out the writings of Rousseau and Diderot and continued in
the early nineteenth century by Bernardin de Saint-Pierre
and Delille. Moreover, Girodet, by introducing the family
concept in his painting, was provided with an occasion to
depict personages of different sexes and ages, related to
each other by deep bonds. This idea, because of its possi-
bilities for displaying détails touchants and interesting
passions, was particularly praised by the jury of the Prix
décennal.[3]

1. Poussin's Deluge, which is one of the least crowded
versions of the subject prior to the eighteenth century,
shows ten figures.
2. The same conception can be seen in the versions of
Bounieu and Clodion.
3. Report of the jury of the Prix décennal, quoted in J.
L. Jules David, op. cit., I, p. 403; also in Girodet, OEuv-
res posthumes, op. cit., I, Notice historique by Coupin, p.
xix.

The arrangement of the figures of Girodet's Deluge
(fig. 42) reflects some of the ideas found in the late
eighteenth century versions of the theme. Thus, one can see
in Girodet's painting, as in the works of Regnault (fig. 47)
and Clodion (fig. 48), on the one hand the group of the mother
holding her child and, on the other, that of the son carrying
his father.[1] However, instead of isolating these groups,
Girodet united all the members of the family into one con-
tinuous chain. One can agree with the painter's critics
that this idea was most probably inspired by some of the
human garlands of The Last Judgment in the Sistine Chapel.[2]

[1]. In the Deluge of Clodion (fig. 48) the father is carry-
ing his son.
The idea of a group formed by a man carrying another
was so frequently exemplified in art that it is impossible
to find the specific source of its application in Girodet's
painting. Classical literature provided the artists with two
famous examples of such a theme: Menelaus carrying the body
of Patroclus and Aeneas fleeing Troy with his father Anchises
on his shoulders. These subjects, and particularly the lat-
ter, which is more directly related to Girodet's conception,
were repeated ad infinitum by various sculptors and painters,
as for instance Bernini and, in the period contemporary to
Girodet, Antonio De Moron (1786, Borghese) or Blondel (1803,
reproduced in Landon, Annales du Musée et de l'école moderne
des Beaux-Arts, op. cit., V, 1803, p. 143, Pl. 68). Moreover,
similar groups are exemplified in such famous paintings as
Michelangelo's Deluge, in the Sistine, and Raphael's The Fire
in the Borgo.
Some of the remaining figures of Girodet's group were
also derived from earlier prototypes. Thus, the young boy
seems to have been inspired by the climbing warrior on the
upper left of David's Leonidas, and the mother is almost a
repetition of Agandecca in Girodet's Ossian (fig. 29).
[2]. Chaussard wrote that the large size of The Last Judg-
ment allowed to Michelangelo's genius "all the developments
and even extravagances," qualities which were not excusable
in the conception of Girodet's Deluge (/Chaussard/, Le Pau-
sanias français, op. cit., pp. 125-126).

Yet, in contrast to the figures of Michelangelo, the person-
ages of Girodet are far from being fantastically interwoven
without any visible element of support. The human chain of
the Deluge is composed of clearly defined, interlocked links,
and it is secured by a dramatically emphasized point of sus-
pension. In stressing the logic of the points of linkage of
this chain, Girodet also underlined their weakness. The
spectator is left no doubt as to the fact that the young boy
will not be able to grasp much longer his mother's hair;
that the father will soon have to release his hold on his
wife's hand; and, finally, that at any moment the breaking
of the tree will precipitate the dislocated group into the
water. Moreover, Girodet stressed the imminence of the catas-
trophe by conceiving his chain as a chronological sequence,
reminiscent of his earlier historical paintings of the late
eighties.[1] The figures of the Deluge are placed at various
levels of height, thus suggesting the successive stages of
the impending fall. At the very top of the cliff, the father,
"by the simultaneous stiffening of all his muscles,"[2] still
succeeds in standing on the slippery rock. Below him, his
wife, having lost her strength, "has first fainted, as can
be seen by the position of her feet, legs, and thighs; then
her body fell backwards . . .; finally, her head was pulled

1. As for instance Joseph Making Himself Known to his
Brothers (supra, p. 47).
2. "Salon de l'an 1806, - no. III," Journal des Débats,
September 27, 1806.

down by the boy hanging on to her hair."[1] At the lowest
level, the boy, barely touching the cliff with only one
foot, cannot find any stronger point of support than "the
hair of a swooning woman."[2] Finally, in the lower left
corner of the painting, the figure of a drowning young girl
alludes to the imminent fate of the family.

Girodet's adoption of the final arrangement of his
figures was arrived at after a long series of experiments.
His preliminary studies (figs. 43, 44, 45, 46) show how he
came to choose the completely desperate situation of the per-
sonages of the Deluge, after having progressively eliminated
any element that might have suggested a possible hopeful out-
come of the drama.[3] Girodet's conception differs from earlier

1. This description, most probably by Girodet himself or
by his friend Boutard under the inspiration of the artist, is,
if further proof is necessary, the best evidence of the pain-
ter's intention to conceive his group in a chronological se-
quence.("Salon de l'an 1806-No.III,"Journal des Débats,September 27,
 2. "Salon de l'an 1806 no. III, Journal des Débats, 1806).
September 27, 1806.
 3. Two of the earliest drawings related to the theme,
found in the Carnet de Rome, were most probably executed in
1795 in Genoa, where, according to Coupin (Girodet, OEuvres
posthumes, op. cit., I, Notice historique, p. xvj), the pain-
ter conceived for the first time the idea of the Deluge. One
of these drawings (fig. 43) is too sketchy for a definite
identification of all the figures. Yet, its conception seems
to be reminiscent of the Deluge of Poussin, as can be seen in
the arrangement of the group of figures placed on the right
in the latter's painting. In Girodet's drawing, as in Pous-
sin's painting, one can see the figure of a man crouching on
a rock. He is holding his right hand down toward the water,
in which appear a woman holding a child and two(?) figures
stretching their arms toward him. In this interpretation, at
least one of the personages is definitely safe, and there seems
to be no hope for the others.
 On the same page of the Carnet de Rome appears another
drawing (fig. 44) which already shows the main elements of the
final Deluge. However, the group of the man carrying his

eighteenth century interpretations of the deluge theme. Thus,
the feeling of an imminent catastrophe suggested in the work
of Girodet contrasts with the allusion, in Bounieu's painting,
to the slow death of the family about to be engulfed by the
rising waters.[1] Similarly, the studied hopelessness of

3 (Continued from preceding page).
father conveys the idea of a firm equilibrium. This man does
not need the support of a tree. He stands solidly on the ground
with both feet on the same level. His father is securely placed
on his shoulders, as can be seen from the position of his feet
appearing between the legs of his son. The mother, weakly hold-
ing her child, is the only person in danger (the older boy is
not introduced at this stage by Girodet). It seems that the
painter was experimenting in this drawing with the idea of rep-
resenting the man releasing his hold on his wife's arm and let-
ting her fall into the water. Thus, one can distinguish two
possible positions of the hands linking these two figures, one
of which leaves a definite gap, thus breaking the human chain.
At any rate, in this drawing, the safety of the man carrying
his father seems to be assured.
 An undated painting (fig. 45) in the Delamarre Collection
seems to represent the next stage of Girodet's conception. All
the personages of the family of the final Deluge are now repre-
sented. The equilibrium of the man carrying his father has become
more precarious. He is forced to hold on to a branch of a tree,
which now appears in the composition. His feet are placed at
different levels, and his position is imperilled by the weight
of his father, whose feet are hanging at the side of the man's
body. Yet, his fate is not completely hopeless. The tree does
not show any definite signs of breaking, and his wife, whom he
is holding by only three(?) fingers, is about to save his life
by slipping out of his grasp. Finally, instead of representing
a drowning figure as in the final version, the artist depicted
a personage clutching the side of the cliff. Thus, there seems
to be a possible hope for three personages, among them two mem-
bers of the family.
 A drawing (fig. 46) in the Fabre Museum suggests one of
the ultimate stages before the final painting. The general ar-
rangement of the figures is practically the same as in the final
version. The only difference can be seen in the fact that the
boy, hanging on to the hair of his mother, is still provided with
a possible solid support under his feet. However, as in the final
version, there is no doubt that the entire family is doomed.
 1. Locquin gave the following description of the painting: "A
naked man and a woman clasping a child to her breast have taken
refuge on a mound. Around them the water is rising, and one can
foresee, by their expression of despair, that they will be en-
gulfed before long." (Op. cit., p. 275, note 2.) Chaussard, in

Girodet's interpretation differs from the moral choice offered, in Regnault's conception (fig. 47), to the man who must decide between saving his father or his wife and child.[1] It can be seen that Girodet selected for depicting the _passions_ of his personages an ideally perfect catastrophic situation, in which all the members of a family, vainly fighting for survival, sense the imminency of an inevitable disaster and are about to witness each other's inexorable fate.

The _passions_ displayed by Girodet's personages faced with this complete disaster inspired a series of bitter discussions in the contemporary periodicals. It is difficult to penetrate to the original intentions of the painter amidst this flow of polemic statements, many of which were obviously qualified either by animosity or by a desire to secure the

1 (Continued from preceding page).
his _Pausanias français_, compared the work of Bounieu to that of Girodet and preferred the former to the latter, because: "Bounieu . . . with less effects succeeded in obtaining a greater one" (_op. cit._, pp. 126-127).

1. The small and the large versions of Regnault's _Deluge_ were among the most successful paintings exhibited in the Salons of 1789 and 1791. The Corneillan choice given by Regnault to his principal personage was particularly remarked and admired. One critic praised Regnault for the final decision of this personage whom he believed to have decided to save the life of his father at the expense of those of his wife and child: "I have felt with you that one can find a hundred wives, that one can become a father again, but that the loss of the author of our days can never be repaired. Oh no, never, never!" (_Lettres analytiques, critiques et philosophiques sur les tableaux du sallon_, Paris, 1791, Deloynes, _op. cit._, XVII, 441, pp. 67-68).

public success of the <u>Deluge</u>.[1] Many writers found the purse
held by the old man, which they understood as symbolizing
his avarice, out of place at such a tragic moment.[2] Girodet
was blamed for having represented the young man with all his
muscles unnaturally contracted at the same time, his fea-
tures distorted by a grimace, and looking at the spectator,
like an "acrobat" at his public, instead of being concerned
with the fate of his family.[3] The spectacle of the young boy
holding on to his mother's hair, interpreted by the critics
as "a child attempting to save his life at the expense of his
mother's," was found "horrible, unheard of, immoral."[4] Finally,
Girodet was criticized for having depicted the infant held by
the mother awake and crying, instead of asleep and unaware of
the danger.[5] The artist and his faithful supporters gave
rather awkward answers to these criticisms. They said that
the old man's purse, far from showing his avarice, was a sign

1. The biased character of this polemic can be seen in the
fact that Chaussard, hostile to Girodet, found it convenient
to disregard, in his discussion of the <u>Deluge</u>, Girodet's as-
sertion that the painting was not meant to represent the Uni-
versal Deluge. Chaussard took this point of view in spite of
the fact that he reproduced this assertion in the beginning
of his article (<u>Le Pausanias français, op. cit.</u>, pp. 116 ff.).
On the other hand, it has been seen that Girodet pretended
that his <u>Critique des critiques</u> was written by an unknown sup-
porter (<u>supra</u>, p. 228, note 3).
2. <u>Le Publiciste</u>, <u>Feuilleton</u>, October 14, 1806.
3. /Chaussard/, <u>Le Pausanias français, op. cit.</u>, pp. 124-125;
also <u>Le Publiciste</u>, <u>Feuilleton</u>, October 14, 1806.
4. /Chaussard/, <u>Le Pausanias français, op. cit.</u>, p. 126.
5. Boutard referred to this criticism in the <u>Journal des
Débats</u>, September 27, 1806.

of his foresight.[1] The simultaneous contraction of all the muscles of the man was due to his efforts to maintain a difficult equilibrium on a slippery rock; while his grimacing expression was "the most frightful and at the same time the most real image of the alterations which terror, or more exactly fear, can bring to a physiognomy."[2] An attempt was made to minimize the action of the young boy pulling at his mother's hair by referring to the "lightness which is characteristic of his age."[3] Finally, Girodet's friends claimed that the appropriateness of the infant crying in the arms of his mother was a matter for debate.[4]

In general, the painter's critics found that his interpretation emphasized human selfishness,[5] while his supporters considered that his conception created one of the situations in which man could "display all the physical and

1. Girodet, "Lettre aux rédacteurs," Journal de Paris, September 21, 1806. To reinforce this reasoning, the painter recalled the example of the remains of some of the inhabitants of Pompeii, whom no one considered miserly, although they were found still clutching their most precious possessions in their hands (idem). However, in Le Peintre, Girodet, describing the eruption of Vesuvius, seems to have contradicted this assertion by writing: ". . ./lying/ his gold, his friend from whom nothing can separate him, The storm/of lava/ surprises and destroys the miser." (Girodet, OEuvres posthumes, op. cit., I, Le Peintre, Chant III, p. 117.)
2. "Salon de l'an 1806," Journal des Débats, September 27, 1806.
3. Idem.
4. Idem.
5. Le Publiciste, Feuilleton, October 14, 1806.

moral strength with which he is endowed."[1] Without attempting
to pronounce a final judgment on the moral appropriateness of
the individual passions expressed in the Deluge, one cannot
deny to Girodet's conception a strong element of pessimism.[2]
However, this feeling is not so much based on the passions of
the personages as on the general idea of the painting. This
interpretation is confirmed by considering two passages from
Girodet's writings. In the third Chant of Le Peintre, the
artist, describing the plight of the inhabitants of Pompeii
surprised by the eruption of Vesuvius, contrasted the vile
behavior of the thief, the selfish man, and of the miser
with the virtuous conduct of the good man:

"Pulling his young sons together with their mother,
The pious man flees, bent under the weight of his old
father.
. .
Fear freezes the heart, fear confuses the eye;
Despair, death are painted on the faces."[3]

This description, obviously reminiscent of the Deluge, sug-
gests that the family depicted by Girodet is the family of

1. Landon, Annales du Musée et de l'école des Beaux-Arts,
op. cit., XIII, 1807, p. 17.
2. It may also be said that Girodet's idea is suggestive
of a latent misogyny. In the Deluge the woman's weakness is
one of the chief causes of doom. In contrast to this concep-
tion, Gérard's Three Ages, painted in 1808, stressed "the role
of the woman, the support of man at the various phases of life"
(Lettres adressées au baron François Gérard, op. cit., I, No-
tice biographique, p. 10). One might perhaps also say that Giro-
det's misogyny is suggested in his concern with the theme of Pan-
dora. Girodet's interest in this subject is reflected in studies
from nature (Pérignon, op. cit., p. 30, no. 237), drawings (one of
them in the Museum of Montargis), and two preliminary oil sket-
ches (Pérignon, op. cit., p. 12, nos. 24, 25).
3. Girodet, OEuvres posthumes, op. cit., I, Le Peintre, Chant
III, pp. 117-118. This passage is somewhat reminiscent of Gessner's
Tableau du déluge (in op. cit., II, p. 412).

the just, surprised and stunned by the hostility of nature.
Moreover, the philosophical symbolism of this situation in
the painting was stressed by the artist in his letter to the
editors of the Journal de Paris. Explaining the meaning of
the group barely sustained by a branch of a tree "of an old
and fragile wood which by breaking betrays their hope,"[1] he
wrote:

> "I thought to find in this concept the idea of a parallel,
> which seemed significant to me, between physical and moral
> nature. How many people who, placed on the reefs of the
> world and in the midst of social storms, entrust, like
> this family, their salvation and their fortune only to
> rotten supports!"[2]

This awkwardly expressed idea was to receive, a few years
later, its poetic and romantic culmination in the verses of
one of the greatest French poets. Alfred de Vigny, inspired
by Girodet's painting, wrote a poem, Le Déluge, in which he
described the fate of a man and his wife betrayed by God and
his angel.[3]

Besides this pseudo-philosophical pessimistic symbolism,
Girodet, in his Deluge, was also greatly concerned with another
aspect of the subject matter. In stressing the horror of the
catastrophe by a particularly dramatic landscape, a pathetic

1. Girodet, "Lettre aux rédacteurs," Journal de Paris, September 21, 1806.
2. Idem.
3. Vigny's poem Le Déluge composed in 1823 became a part of his Poèmes antiques et modernes (Paris, Bourdilliat et Cie, 1859, Le Déluge, pp. 63-83).

human situation, an emphasized crucial moment, and intensi-
fied expressions of the personages, the artist was obviously
attempting to exploit to the maximum the emotional possibili-
ties of the theme. From the historical point of view, Giro-
det's attempt to intensify the emotional content of his
painting through a feeling of horror gave rise to the most
significant controversy related to the Deluge.

The basic arguments of Girodet's critics can be found
in Chaussard's Pausanias francais:

"Whoever has never been sensitive to the frightful beau-
ties, to the horrible charm of some passages of Aeschylus,
Dante, Shakespeare, Milton, Klopstock, Schiller, will
never appreciate the compositions of Michelangelo, nor
this one /Girodet's Deluge/ in which Mr. Girodet seems to
have sought and accumulated dramatic effects, stressing
them even beyond the limits of terror.

"Perhaps he, more than anyone else, should religiously
preserve principles, that is, he should not push the
genres beyond their boundaries . . . Terror must never be
exaggerated. The Medusa, The Niobids, the Laocoön are the
best models. Disregarding them, one meets the Moses or
The Last Judgment of Michelangelo . . .

". . . it seems that the paralyzed brains /of the spec-
tators/ can /in our time/ only be moved by electrical and
violent shocks. Are the sweet tears of sensitivity dis-
appearing from /our/ dried hearts? Are we condemned to
shed tears of blood? . . . This disastrous tendency re-
sembles a Gothic invasion; all the limits of the arts
seem to be shaken . . .

". . . Painting itself, or at least a certain school,
has multiplied tragic and even horrible representations.
It is probably a means to forcefully impress vulgar people
. . . but then this merit will have to be shared with the
makers of drama /and/ with the author of the Judge Played
by Order of Cambyses . . .

.

". . . Let us agree that if Poussin is indeed the
Virgil of Painting, Mr. Girodet can be considered in a
certain respect as the Milton of this art."[1]

Thus, Girodet was criticized for not having followed, in his
Deluge, the dramatic solutions of classical antiquity or of
Poussin; for having, like Michelangelo, exaggerated the emo-
tional intensity of his scene to a point of horror; and
finally, for having overstepped the boundaries of the realm
of painting.

Most of Girodet's answers can be found in his Critique
des critiques. In replying to the first criticism, the
painter pointed out that the examples invoked by his censors,
such as the Laocoön and Poussin's Massacre of the Innocents,
as well as such great works of art as Le Sueur's Martyrdom of
Saint Gervais, Domenichino's Martyrdom of Saint Agnes, or
Raphael's Martyrdom of Saint Felicitas, were far from being
exempt from horror.[2] Ridiculing the paradoxical opinions of
his critics, the painter let one of them describe his reac-
tions while contemplating the above mentioned works:

"/I feel7 . . . a happy calm, a pure ravishment,
A deep joy, a sweet rapture,
A beneficial and lasting admiration;
.
I have seen them /the paintings7; never have they offended
my heart.

1. /Chaussard7, Le Pausanias français, op. cit., pp. 118-
123.
 2. /Girodet7, La Critique des critiques, op. cit., pp. 15-
16 and p. 35, note to p. 16.

Each one of them, however, represents only crimes,
Only instruments of death, only torturers and victims,
Fanaticism, folly, errors, wars, battles,
In other words, man guilty of the blackest crimes."[1]

The reason for this paradoxical opinion was evident to Giro-
det, and his fictional critic went on to say:

"These painters, if they were alive, would, in my opinion,
be subject to criticism;
They are dead, therefore they are, in all respects,
admirable."[2]

Thus:

"Today Poussin is a much greater man
Than the late Monsieur Poussin when he lived in Rome.
His Deluge, today praised by clever people,
Might, during his lifetime, have failed in Paris."[3]

Replying to the second criticism, Girodet denied that
his conception of the Deluge was as terrifying as was, in
his opinion, exaggeratedly claimed by his censors. He under-
lined the fact that his painting did not show any crime,
torture, or bloodshed comparable to those depicted, for in-
stance, in Poussin's Massacre of the Innocents. Girodet
pointed out that in his Deluge:

1. /Girodet/, La Critique des critiques, op. cit., pp.
15-16.
 2. Idem, p. 16.
 3. Idem, p. 9.

"Only the troubled elements of nature are the cause of their /the personages'/ misfortune."[1]

Moreover, the painter stated that it was better to sin by an excess rather than by a lack of vigor and emotion,[2] and ridiculed the critics who considered the manner of Michelangelo to be too austere and too proud.[3] It is interesting to note that, far from denying his eclectic interest in the master of the Sistine, Girodet frankly admitted that Michelangelo's influence had been an important factor in his conception of the Deluge.[4]

Finally, the painter's answer to the accusation of having overstepped the limits of the genre of painting can be found in his letter to Bernardin de Saint-Pierre, written shortly before the completion of the Deluge. In this letter, the artist stated that the boundaries of painting "without

1. /Girodet/, La Critique des critiques, op. cit., p. 17. Girodet ridiculed the exaggerated horror simulated by his critics in a manner reminiscent of the caricatures satirizing the exhibitions of the Impressionists in the late nineteenth century:
 "Vraiment ce Girodet a l'âme par trop dure!
 Exposer en public une telle peinture!
 C'est vouloir, sans égard pour leur complexion
 Faire accoucher de peur les femmes au Salon." (Idem, p.19.)
2. Idem, p. 13. Girodet ridiculed a statement to the contrary published in the Feuilleton of the Publiciste, October 22, 1806.
3. La Critique des critiques, op. cit., p. 14.
4. Idem, p. 35, note to p. 18. Girodet made this admission after having quoted the following criticism of the Publiciste: (Feuilleton, October 27, 1806): "It is a Michelangelo that M. Girodet has wanted to paint . . . It is not the paintings of Michelangelo but the paintings of Girodet that we are asking for."

being infinite like those of poetry, are however more ex-
tensive than is thought."[1] Moreover:

> "Painting, which can so well speak to the heart, through
> the brushes of Raphael and Poussin, can also speak to
> the mind and to the imagination; these masters have
> proved it. Why should it not be allowed to try to ex-
> tend even further..the boundaries which these great men
> have known?"[2]

In conclusion, it may be admitted that Girodet's Del-
uge was, from a certain point of view, a tour de force.
While continuing the traditional iconography of the late
eighteenth-century flood themes, the painter succeeded,
through a series of eliminations and selections, in conceiv-
ing an ideal catastrophe which, in spite of its basic clas-
sicism, reached an emotional intensity seldom paralleled in
contemporary art. In his Deluge, Girodet embodied an idea
at which he had arrived in his mature years, the concept

1. Girodet, OEuvres posthumes, op. cit., II, Correspondance,
Letter III, to Bernardin de Saint-Pierre, p. 278.
2. Idem, pp. 278-279. In this connection, it is interest-
ing to note the attitude of David. He publicly praised the
Deluge: "It is Michelangelo's pride combined with Raphael's
grace. Let them now dare to say that painters are not poets!"
(Girodet, OEuvres posthumes, op. cit., I, Notice historique
by Coupin, p. xvj; also Girodet, OEuvres posthumes, op. cit.,
II, Correspondance, Letter XXII, to Pannetier, Paris, Septem-
ber 16, 1806, p. 326). However, he privately wrote in his
notes: ". . . if one opens the door to such subjects /as the
Deluge/, there is no longer any reason to stop in such a won-
derful path. Good-bye to dignity of art, good-bye to ideal
beauty, the only goals toward which must aim the true histori-
cal painter . . . this genre /historical painting/ is falling
into the ridicule which is found in melodramas" (David, J.
L. Jules, op. cit., I, p. 503).

that the only aim of heroic painting was to create emotion.[1]

The Entombment of Atala[2] (fig. 49)

Girodet could hardly have found a more popular subject
than Atala to redeem his reputation, imperilled by the contro-
versies over Ossian and the Deluge. Chateaubriand's short
novel Atala, published for the first time in 1801, had met
with an extraordinary public success, as can be seen by the
twelve editions which appeared between 1801 and 1805.[3] Expect-
ing for his painting a part of the fame attached to Chateaubri-
and's book, Girodet, in choosing his subject, could also hope to
satisfy the contemporary taste for the exotic scenes of the New
World as well as the newly awakened religious interest.[4] A

1. Girodet, OEuvres posthumes, op. cit., II, Considéra-
tions sur le génie, p. 103. It is amusing to note the naïve
happiness of Girodet in observing the emotional effectiveness
of his painting on some of the unsophisticated salon specta-
tors. He quoted the words of a soldier, contemplating the
Deluge, to another: "Tonnerre de D..., la f... position! Ah!
cette pauvre mère! . . . Tiens, viens-t'en, ça me fait mal."
(La Critique des critiques, op. cit., p. 37, note to p. 13.)
2. 1808, Louvre.
3. Lemonnier, Henry, "L'Atala de Chateaubriand et l'Atala
de Girodet," Gazette des Beaux-Arts, 4e période, II, May 1914,
p. 363.
4. The interest in exotic, distant lands had already
started a long time before Chateaubriand's novel, the first
literary masterpiece of this trend having been Bernardin de
Saint-Pierre's Paul et Virginie (1788). On the other hand,
the revival of religious feeling coincided with the signing
of the Concordat, in 1801, between Bonaparte and the Pope,
as well as with the publication of Chateaubriand's Génie du
Christianisme in 1802.

considerable number of artists[1] had already had the idea of taking Chateaubriand's novel as a source for their works. However, because of his friendship with the writer, Girodet came to be considered, at the exhibition of his _Entombment of Atala_ in the Salon of 1808, almost the official painter of Chateaubriand.

It is certain that Girodet's friendship with Chateaubriand reached a high point in the years 1807-1809 when the writer, who had just returned from his trip to the Orient, was composing his _Martyrs_. In this book, published in 1809, Chateaubriand modestly spoke of Girodet's embellishment of his conceptions, and thanked the artist for "the admirable painting of _The Entombment of Atala_."[2] The writer went so far, in his display of admiration for the art of Girodet, as to admit his direct borrowing of the idea of _The Sleep of Endymion_ for his own description of the sleep of Eudore in the first book of _Les Martyrs_.[3] At the same time, Girodet

1. Such as the painters: Mademoiselle Lorimier (_A Young Girl by a Window Crying over a Page of Atala_, Salon of 1802); Gautherot (_The Funeral Procession of Atala_ (fig. 53), Salon of 1802); Hersent (_Atala Poisoning Herself in the Arms of Chactas_, 1806); Lordon (_The Last Communion of Atala_ (fig. 54), Salon of 1808, _Father Aubry Finding Atala and Chactas, Chactas and Lopez_); Millet; Dufourc; and the illustrators: Mallet (_Chactas at the Feet of Atala, The Last Communion of Atala_); Dugoure (_Atala and Chactas Descending the River, The Death of Atala_); and Garnier (_Chactas and Father Aubry Mourning over the Body of Atala_, 1805).
2. Chateaubriand, _Les Martyrs_, in _OEuvres complètes_, Paris, Garnier, IV, p. 347, remarque 39 to p. 22.
3. Idem; see also _OEuvres complètes_, op. cit., XII, _Table analytique et raisonnée_, p. 585.

was making great efforts to equal the flattering enthusiasm
of the "bard of Chactas."[1] He did not hesitate to quote
directly, in an inscription appearing on the wall of the
cave of his Atala, a passage from Chateaubriand's novel.[2]
Moreover, in his portrait of the writer (fig. 66), Girodet
made an allusion to Les Martyrs, then about to be published,
by representing the Colosseum in the background of his paint-
ing.[3] As can be seen, the friendship between the writer and
the painter, reflected in their productions, worked to their
mutual advantage by attracting the attention of the public.

The action of Chateaubriand's Atala takes place in
Louisiana in the eighteenth century. During a battle, the
Indian Chactas is captured by his enemies. However, he is
freed by Atala, a Christian Indian maiden, who has fallen in
love with him. Both escape and find refuge in the cave of
the hermit Father Aubry. Remembering her dead mother's vow
consecrating her to God, Atala poisons herself when she feels
that she is about to yield to Chactas' love. She has a Chris-
tian death witnessed by Father Aubry and Chactas, who promises
her that he will become a Christian.

1. Girodet, OEuvres posthumes, op. cit., I, Le Peintre,
Chant IV, p. 152.
2. Infra, p. 262.
3. This identification of the building seen in the back-
ground of Girodet's portrait of Chateaubriand in the Louvre
was confirmed by Coupin (Girodet, OEuvres posthumes, op. cit.,
I, Liste des principaux ouvrages de Girodet, p. lx). There
cannot be any doubt as to the fact that the Colosseum was an
allusion to Les Martyrs. Chateaubriand was opposed to anti-
quity and was the chief exponent of Christian themes in art.

Girodet, like several other artists inspired by Chateaubriand's <u>Atala</u>,[1] was particularly attracted by the last and most dramatic phase of the novel. At first, the painter wanted to represent the moment of the extreme unction administered to Atala. This early conception is reflected in a drawing (fig. 50) in the Museum of Besançon, in which Girodet closely followed the corresponding passage of Chateaubriand's novel.[2] However, the painter finally decided to select the theme of Atala's entombment, which had not hitherto been illustrated by the contemporary artists.

As was already noted by Henry Lemonnier,[3] Girodet's interpretation of Atala's entombment did not entirely follow

1. Such as Gautherot (fig. 53), Hersent, Lordon (fig. 54), Mallet, Dugoure, and Garnier (<u>supra</u>, p. 258, note 1).
2. Museum of Besançon, drawing no. D.2796. In a general manner, the composition of this drawing is a reversal of that of the final painting in the Louvre. On the left can be seen Atala, who is reclining on a bed, with the upper part of her body leaning against a pillow. In the middle of the composition appears Father Aubry, who is holding the Ciborium and is leaning toward Atala. On the right, near the entrance to the cave, it is possible to see Chactas kneeling at the foot of the bed, with his head bent over Atala's feet. The disposition and the attitude of the personages correspond exactly to Chateaubriand's description of the last rites of Atala, starting with the passage: "a supernatural force compels me /Chactas/ to fall on my knees and bends my head at the foot of Atala's bed." (Chateaubriand, <u>Atala</u>, in <u>op. cit.</u>, III, p. 60.) In the upper corner of the drawing of Besançon, one can also see a larger, and more finished, representation of the head of Atala, with an expression corresponding to the same passage of Chateaubriand: "This saint had her eyes ecstatically raised to the sky . . . her lips slightly opened" (<u>idem</u>).
3. Lemonnier, <u>op. cit.</u>, p. 370. This author wrote that Girodet "transposed the admirable description of the enshrouding to the burial scene."

Chateaubriand's description of this particular moment. The
iconographical elements of the painting combine three impor-
tant passages of the novel: the burial, the nocturnal mourn-
ing over the body of Atala, and the extreme unction.

The definite moment chosen by Girodet, that is, the
descent of the body of Atala into her tomb, was only briefly
referred to by Chateaubriand in one sentence: ". . . we car-
ried the beauty into her bed of clay."[1] However, the painter,
in his rendering of the setting (fig. 49), used the writer's
description of the location of the burial, which can be
found in another passage of the novel. Thus, the grotto in
which are placed the personages of the painting must be iden-
tified as what Chateaubriand described as the "arch of a
bridge made by nature."[2] Through its opening, one can see
the "cemetery of the Indians of the Mission or the Boskets
of death" identifiable by the cross which had been placed
there by Father Aubry.[3]

With the elements derived from the burial scene in the
novel, Girodet combined some of the details included in Cha-
teaubriand's lengthy description of the nocturnal mourning
of Chactas and Aubry over the body of Atala. Thus, Girodet
represented the heroine partially wrapped in a "European
linen cloth," woven by Aubry's mother.[4] The painter's depiction

1. Chateaubriand, Atala, in op. cit., III, p. 63.
2. Idem, p. 61.
3. Idem, p. 46.
4. Idem, p. 62.

of Atala corresponds to the same passage of Chateaubriand's
text: "Her lips . . . seemed to languish and to smile . . .
Her beautiful eyes were closed . . . and her alabaster hands
pressed to her heart a crucifix of ebony."[1] Around the grave
one can see "sensitive plants of the mountains,"[2] which in
Chateaubriand's novel are growing at the entrance to Aubry's
cave and not under the "arch of the bridge made by nature" of
the grave. Finally, the description of the nocturnal mourn-
ing over the body of Atala is also alluded to by the inscrip-
tion, seemingly incised in the rocky wall, to the left of
Father Aubry's head:

> J'AI PASSÉ COMME
> LA FLEUR
> J'AI SECHÉ COMME L'HERBE
> DES CHAMPS

This passage from the Book of Job is recited by Father Aubry
during the mourning scene in the novel.[3]

Girodet's inspiration from Chateaubriand's passage on
the extreme unction is suggested only by the attitude of
Chactas. The position of this personage is reminiscent of
the following passage of the novel: ". . . a supernatural
force compels me /Chactas7 to fall on my knees and bends my
head at the foot of Atala's bed."[4] The description was more
literally followed by the painter in his drawing of Besançon[5]

1. Chateaubriand, Atala, in op. cit., III, p. 62.
2. Idem.
3. Idem.
4. Idem, p. 60.
5. Supra, p. 260, note 2.

(fig. 50); however, he did not have to transform the attitude
of Chactas too much in order to adapt it to the action of the
entombment. Finally, Girodet took the liberty of enriching
his conception with his own interpretation of the garments
worn by Father Aubry and Chactas, and with such details as
ivy[1] and lianas[2]. Considering the freedom with which the
painter combined various passages of Chateaubriand's novel,
it can be said that Lemonnier's criticism of Girodet's omis-
sion of such details as the magnolia flower or the scapular[3]
is not well justified.

One can see that in his interpretation, Girodet, by
combining different passages of Chateaubriand's Atala, came
to depict a scene which does not exist in the novel. The
dramatic climax invented by the painter is based on the idea
that while the body of Atala is lowered into her grave, Chac-
tas, "broken by pain"[4] and unable to restrain his intense
grief, sits on the edge of the grave and clasps his beloved
for the last time in his arms. Commenting on this action,
Antal justly remarked that Girodet depicted the scene "as a
combination of the two themes of Christ's Lamentation and

1. In the novel ivy is growing at the entrance to Aubry's
cave (Chateaubriand, Atala, in op. cit., III, p. 43).
2. In the novel, liana plants grow in the forest through
which Atala and Chactas are fleeing from their enemies (idem,
p. 41).
3. Lemonnier, op. cit., p. 371. The magnolia flower and the
scapular would have corresponded to Chateaubriand's description
of the nocturnal mourning (Chateaubriand, Atala, in op. cit.,
III, p. 62).
4. Brainne, Debarbouiller, Lapierre, op. cit., pp. 63 ff.

Entombment."[1] However, one may note that the artist did not
have to invent this particular combination which already
existed in such paintings as Le Sueur's Descent from the
Cross.[2] At any rate, one must agree with Antal that Giro-
det's Atala "is in essence a mere variation of the Pietà"[3]
(fig. 12). Thus, one recognizes in the painting of 1808, the
grotto setting,[4] the cross, and something of the feeling of
mournful sadness which characterized Girodet's Pietà of 1789.
However, the painter, in his Atala, is far from having
achieved the austere solemnity and the desolate grandeur of
his Pietà. It is interesting to note that, while in the
Pietà Girodet infused a traditionally religious subject with
an emotion derived from Ossianic literature,[5] in Atala, he
did the opposite, by introducing into a literary theme ele-
ments taken from religious iconography. Thus, paradoxically,
the sentimentalism of Atala is permeated with a much more ec-
cleastical atmosphere than the tragic emotion of the Pietà.[6]

1. Antal, op. cit., p. 138.
2. Louvre. The attitudes of Mary Magdalen and of Joseph of
Arimathaea in Le Sueur's composition are almost identical to
those of Chactas and Aubry.
3. Antal, op. cit., p. 138.
4. It may be suggested that Girodet transformed Chateaubri-
and's "arch of a bridge made by nature" into a complete grotto.
The writer placed his "arch" to the east of the cemetery marked
by the cross (Chateaubriand, Atala, in op. cit., III, p. 46).
Considering the fact that the entombment takes place at dawn
(idem, p. 63), the source of light in Girodet's scene should have
come from the east and not from the west, if the setting were a
free arch, open on both sides.
5. Supra, p.89ff.
6. The 1789 Pietà still echoed the emotionality of Catholic
baroque art, while the 1808 Atala, though a literary subject,
was already permeated with the nineteenth century religious
sentimentalism which was to culminate, somewhat later, in the
paintings of Flandrin.

Considered from another point of view, Goridet's _Atala_
is one of the latest, as well as one of the most important
French examples of an attempt to suggest an exotic atmos-
phere based on American scenery.[1] The artist showed his
interest in this particular source of inspiration when he
wrote in his poem _Le Peintre_:

> "Let us turn our glances toward these new lands
> Which neither man nor time have dishonored;
> Where, without artifice, nature proudly displays
> Both its savage luxuriance and its virgin beauty;
> Where
> The savannah . . . unfolds to the eye
> Its carpets of verdure and its waves of flowers;
> Where the dark depths of endless forests
> Have never felt the insult of the axe,
> And, raising to the sky their domes of foliage,
> Are hiding the happy love of the wandering Indian.
> See him display his vigorous limbs,
>
> Cut through the rapid waves of the great Meschacebe
> And embellish with gracefulness his free movements:
> He is cruel in combat, heroic when tortured,
> And if banished to foreign lands,
> He takes with him only the remains of his fathers!
>
> What a lesson for you, civilized peoples!
> And you receive it from a savage horde!"[2]

It can be seen that, in these verses, Girodet combined a
Rousseau-like idealization of the primitive man with exotic
details derived from Chateaubriand. However, in his painting,

1. This fascination for America, already marked in the
eighteenth century (Monglond, _op. cit._, I, pp. 67 ff.),
will be progressively replaced, in the nineteenth century,
by a longing for Oriental lands, which will become the main
source of exotic inspiration.
 2. Girodet, OEuvres posthumes, _op. cit._, I, _Le Peintre_,
Chant IV, pp. 151-152.

the artist did not achieve the lyrical exotic feeling of Chateaubriand's novel.[1] Girodet's preliminary studies show how the artist, in the final painting, eliminated or attenuated various outlandish elements. From Chateaubriand's complicated, almost botanical description of American flora, the painter preserved only the ivy, the sensitive plants, and the lianas.[2] Similarly, Chactas' tattoos appearing in one of the early drawings[3] (fig. 51) were eliminated, and his bizarre hair-knot[4] was replaced, in the final painting, by braids, partially hidden in the general looseness of his hair.[5]

1. It may be noted that Girodet gave a more lyrically exotic interpretation of the landscape of Mauritius Island in his illustration for Bernardin de Saint-Pierre's Paul et Virginie (fig. 52) (engraved by B. Roger, included in Bernardin de Saint-Pierre, OEuvres complètes, Paris, Mequignon-Marvis, 1818, VI, facing p. 70).

2. It is difficult to believe that this vegetation, with the exception of the lianas, could have suggested a very exotic atmosphere to the painter's contemporaries. Some of the engravings illustrating travelers' accounts had a more more markedly outlandish character (as for instance the Sacrifice des dévoués au chef chez les Natchez in Lafitau, Moeurs des sauvages Amériquains, reproduced in Monglond, op. cit., I, Pl. V). Nevertheless, Girodet showed a great concern for exactness, and it is known that he went to the Botanical Garden of Paris to study American flora (Lettres de Girodet-Trioson à Madame Simons Candeille, op. cit.).

3. As for instance in the drawing (fig. 51) in the Museum Turpin de Crissé at Angers (Recouvreur, A., Musée Turpin de Crissé, Catalogue-Guide, Angers, Impr. centrale, 1933, p. 154, no 249; reproduced in Recouvreur, A., Nos dessins, quelques dessins et deux lettres inédites de Girodet-Trioson, Angers, Editions de l'Ouest, 1935, p. 9).

4. Recouvreur, Nos dessins, quelques dessins et deux lettres inédites de Girodet-Trioson, op. cit., p. 9.

5. However, Girodet kept in his final version Chactas' earrings, a traditional Indian adornment described in travelers' accounts.

Girodet's _Atala_ appears to have been an attempt to combine a
dramatic display of _passions_ with a Neo-Catholic sentimentalized piety,
and an exotic atmosphere. This mild, softened interpretation of
Chateaubriand, eliminating the writer's sensual suggestions[1] and fusing
elements from various current trends, was most probably one of the
reasons for the success of the painting. With the exception of the
figure of Atala which, though much admired, was criticized for
seeming too alive,[2] Girodet's work was generally praised by

1. The restraint of Girodet's conception in contrast to
Chateaubriand's sensuality was already noted by Lemonnier (_op.
cit._, p. 370). The painter eliminated the erotic suggestiveness
of a particularly sensual passage in Chateaubriand's description
of the burial: ". . . her [Atala's] breast rose for some time from
the blackened earth, like a white lily" (Chateaubriand, _Atala_, in
op. cit., III, p. 63).

2. Practically all the authors stressed this particular criticism,
as for instance can be seen in _Observations sur le Salon de l'an 1808_,
no. 12; _Tableaux d'histoire_, Paris, Vve Gueffier et Delauney, 1808,
Deloynes, _op. cit._, XLIII, 1139, p. 671; _Première journée d'Cadet
Buteux au Salon de 1808_, Paris, Aubry, 1808, p. 3; _Exposition des
tableaux en 1808 -- A.P._, Deloynes, _op. cit._, XLIV, 1144, Ms., p. 34;
etc. The most severe version of this criticism was exemplified by
David himself: "The head, the color of Atala are truly those of a dead
woman. Why, shall I ask, are her hands not dead? Do not answer me
that it is so as to express the last moment of her piety, of her fervor:
death surprised her when she was clasping the crucifix. -- I wanted to
suggest the feeling that she is clasping it even in . . . -- You were
mistaken, nature does not act in this manner. It would have been
better to show the hands still in the position of holding, but no
longer clasping; the crucifix, without support, slowly sliding on her
bosom." (David, J. L. Jules, _op. cit._, I, p. 503.)

As has already been noted, Girodet's idea of representing Atala
still clasping the crucifix in death was directly inspired by
Chateaubriand's text (_supra_, p. 262). Moreover, in this respect,
Girodet was faithful to the spirit of the novel in depicting the dead
Atala as a "statue of sleeping Virginity" (Chateaubriand, _Atala_,
in _op. cit._, III, p. 62).

the great majority of the critics.[1]

Napoleon Receiving the Keys of Vienna[2] (fig. 55)

This painting was Girodet's first important attempt at interpreting a contemporary historical event.[3] It was

1. The praise was quasi-unanimous. One of the most favorable comments can be found in the "Salon de 1808," Journal de l'architecture, des arts libéraux et mécaniques, des sciences et de l'industrie, Deloynes, op. cit., XLV, 1157, p. 601: "Monsieur Girodet has just convinced us that with very simple means and some genius it was possible to produce great effects." It is difficult to agree with Jean Adhémar in considering Boilly's caricature The Death of Flora as a convincing proof of the general rejection of Girodet's painting. (Adhémar, J., "Girodet un fou," Arts, J I 3, 1936, p. 3.) This caricature, in which the scene of Atala's entombment is enacted by dogs, is only one of the typical parodies of the famous paintings of the time.
2. 1808, Versailles.
3. It is known that Girodet tried on several occasions to obtain from the government a commission to paint a subject depicting a contemporary historical event. Thus, during the Directory, Girodet wrote in 1797 to Talleyrand, then Minister of Foreign Affairs, requesting the commission to paint the presentation of the Turkish ambassador to the members of the Directory (Letter of Girodet to Talleyrand, July 28, 1797, Collection Dubrunfaut, quoted in Leroy, Girodet-Trioson, peintre d'histoire, op. cit., p. 45). A little later, in 1799, Girodet seems to have been asked to paint the subject of the assassination of the French ministers at Rastadt (Chaussard, "Exposition des ouvrages de peinture, sculpture, architecture, gravure, dessins, modèles composés par les artistes vivans et exposés dans le Salon du Musée Central des Arts," Journal de la Décade, 1799, Deloynes, op. cit., XXI, 580, Ms., pp. 451-452). Moreover, in 1811, the director of the Travaux Publics asked Girodet to paint the subject of the reintegration of the statues and monuments of the kings in the Church of Saint-Denis, for the sacristy of this church (Leroy, Girodet-Trioson, peintre d'histoire, op. cit., p. 59). However, probably because of the financial difficulties of the Directory and later because of the hostility of Denon, these commissions seem never to have been executed, and Girodet was generally overlooked for governmental projects.

part of an Imperial commission which was announced in the
Journal de l'Empire in the following terms:

> "The Emperor has just ordered a series of paintings eight
> of which, of a dimension of 5 meters by 3 meters, 3 deci-
> meters with figures of natural proportion, are entrusted
> by the choice of His Majesty to Messieurs Gérard, Le-
> thière, Gautherot, Guérin, Hennequin, Girodet, Meynier,
> and Gros. These paintings destined for the Gallery of
> the Tuilleries will have to be finished for the public
> exhibition of the Salon of 1808 and will retrace the most
> memorable events of the campaign of Germany."[1]

From some of the titles of the paintings included in this
commission,[2] it appears that the artists were required to
illustrate the various phases of the campaign leading to
Napoleon's great victory of Austerlitz, on December 2, 1805.
Girodet received the task of depicting an event related to
the capture of Vienna on November 13, 1805, a few days before
the famous battle.

The scene represented in Girodet's *Keys of Vienna* takes
place outside the city, in the vicinity of the castle of
Schoenbrunn, which appears in the background of the painting.[3]

1. "Tableaux commandés pour le gouvernement," *Journal de
l'Empire*, Deloynes, op. cit., XLIII, 1126, Ms., pp. 539-540.
The same article mentioned a series of smaller paintings
entrusted to Lejeune, Ménageot, Berthélémy, Perrin, Bachère,
Peyron, Hue, Tauney, Demarne, Dunoy, and Monsiau.
2. For instance: Gérard's *Battle of Austerlitz* (Ver-
sailles), Lejeune's *Bivouac at Austerlitz* (Versailles), and
Meynier's *The Day Following Austerlitz* (Versailles).
3. Identified in Mauricheau-Beaupré, C., *Versailles, l'his-
toire et l'art, guide officiel*, Paris, Editions des Musées
Nationaux, 1949, p. 100.

In the center of the composition can be seen Napoleon and the burgomaster
of Vienna.[1] The latter is approaching the French Emperor and is presenting
him with the key to the city, which Napoleon is about to take. Between
these two figures appears the Emperor's horse held by a Mameluke,[2]
behind whom can be seen some Austrian citizens and soldiers.[3] On
either side of the burgomaster and Napoleon are represented groups of
Austrians and French, arranged on the left and on the right of the
painting, respectively. On the Austrian side, following the burgomaster,
appear the Archbishop of Vienna,[4] a representative of the Chapter,[5] two
generals commanding the garrison,[6] soldiers and "simple citizens
attracted by this extraordinary spectacle."[7] Among the latter one
can notice the much admired[8] Austrian peasant family, composed of the
father, the mother, and the little girl,

1. Identified in, for instance, Examen critique et raisonné
des tableaux des peintres vivans formant l'exposition de 1808,
Paris, Hocquart, 1808, p. 12.
2. Identified in, for instance, idem, p. 13.
3. The Austrian soldiers are recognizable by the initials F II
(Francis II) appearing on their uniforms.
4. Identified in, for instance, Observations sur le Salon de
l'an 1808, no. 12, Tableaux d'histoire, Paris, Vve Gueffier et Delauney,
1808, Deloynes, op. cit., XLIII, 1139, p. 670.
5. Identified in, for instance, Examen critique et raisonné
des tableaux des peintres vivans formant l'exposition de 1808,
Paris, Hocquart, 1808, p. 12.
6. Identified in, for instance, Landon, C. P., Salon de 1808,
Annales du Musée, Paris, Landon, p. 7.
7. Idem.
8. As for instance in Exposition des ouvrages de peinture,
sculpture, architecture et gravure des artistes vivans (A...Z),
Deloynes, op. cit., XLIV, 1146, Ms., p. 207.

appearing on the very left of the painting; the two young
boys climbing the large tree; and the three Arcadian-like
youths who can be seen between this tree and Napoleon's
horse. On the French side, to the right of the Emperor, ap-
pear several high-ranking officers among whom it is possible
to recognize Murat, Marshal Bessières, and the Prince of
Neufchâtel.[1]

This scene, somewhat reminiscent of Velasquez' Sur-
render of Breda,[2] does not seem to have been an exact depic-
tion of the actual historical event. Shortly before the
capture of Vienna, a deputation of inhabitants came to

1. These three officers are, for instance, identified in
Landon, C. P., Salon de 1808, Annales du Musée, Paris, Landon,
p. 7.
2. Besides the general resemblance of the two compositions,
one can note a definite similarity of certain details. The
attitudes of Napoleon and of the burgomaster are almost iden-
tical with those of Spignola and the Flemish commander. Sim-
ilarly, the attitude of the father of the Austrian family, on
the left of the Keys, seems to repeat that of the Fleming
placed in the corresponding position in Las Lanzas. Moreover,
the opposition of the vertical and the oblique, formed by the
spears and the flag of the Spaniards, seems to be echoed by a
similar contrast created by the plumes of the grenadiers and
the saber of the equestrian figure on the right of Girodet's
painting. Finally, the movement of the column of smoke ris-
ing from the left background of Velasquez' painting seems to
be repeated by the branch of the large tree seen in the cor-
responding area of the Keys. Without conclusively proving
Girodet's borrowing from Velasquez, these similarities sug-
gest its possibility. In this respect, it can be noted that
the date of Girodet's work (1808) corresponded to the end of
Napoleon's Spanish campaign, the coming to France of Charles
IV, and the return of French troops with a rich booty of ob-
jects of art. Girodet could have seen a copy or an engrav-
ing of Velasquez' painting.

implore Napoleon's clemency at Schoenbrunn.[1] However, the city was
not formally surrendered to the French but was captured by surprise,
through a stratagem of Murat.[2] Thus, Girodet combined in his painting
the historical incident of the Viennese deputation with the theme of
the key, symbolical of the ultimate capture of the city.

Speaking about Girodet's Keys of Vienna, Landon wrote:

> "The surrender of a city like Vienna, is a great event
> for two rival nations. For the historian it is the subject
> of an important account. However, one must admit that as
> a subject for painting this historical event does not present
> the same degree of interest to an artist whose genius,
> impatient to create, is satisfied only with strong ideas
> and terrible or touching expressions."[3]

This passage paralleled Girodet's own lack of enthusiasm for subjects of
"apparat,"[4] like the Keys of Vienna, which combined "modern history"
with "contemporary pomp."[5] The painter, in an article written for the dictionary
of the Académie des Beaux-Arts,[6] underlined the limitations of such themes. In

1. Thiers, L. A., History of the Consulate and the Empire of
France, D. Forbes Campbell and J. Stebbing trans., London, Chatto &
Windus, 1893, IV, p. 42.
2. Idem, IV, pp. 43-44.
3. Landon, C. P., Salon de 1808, Annales du Musée, Paris,
Landon, p. 7.
4. Girodet, OEuvres posthumes, op. cit., II, De l'Ordonnance en
peinture, p. 222.
5. Idem, p. 207, note by Coupin.
6. In this article (De l'Ordonnance en peinture), Girodet
classified these paintings of apparat in a special category among
the various genres of subjects. The painter's invention was the cause
of an animated debate at the Académie des Beaux-Arts. The intensity
of this discussion was such that, as a result, Girodet withdrew his
article and ceased to collaborate in the dictionary (idem, p. 207,
note of Coupin).

composing a painting of "apparat," the artist, according to
Girodet, is compelled to introduce artificially great crowds
of historically important personages. He is forced to repre-
sent with great realism and minuteness of detail the "too
often bizarre"[1] attire of modern officials. He is also
paralyzed by the "tyranny of etiquette"[2] and is deprived of
the "beauty always resulting from a happy use of the nude."[3]
The disadvantages of the subjects of apparat were also fre-
quently discussed by the contemporary critics:

> ". . . they [the artists] are not allowed to freely use
> their imagination . . . The costumes, the facial resem-
> blance, the color of the garments are practically pre-
> scribed to them. Even the attitudes are forced on them
> by certain conventions."[4]

Commenting on Girodet's Keys of Vienna, Landon pointed
out that the subjects of apparat did not necessarily deprive
the artists of the possibility of depicting passions. Thus:
"Many an artist would have perhaps rendered, or even exagger-
ated, the joy of the conquerors, the suffering and the humi-
liation of the vanquished."[5] However, the writer praised

1. Girodet, OEuvres posthumes, op. cit., II, De l'Ordon-
nance en peinture, p. 223.
2. Idem.
3. Idem.
4. Exposition des ouvrages de peinture, sculpture, architec-
ture, et gravure des artistes vivans (A...Z), Deloynes, op. cit.,
LXIV 1146, Ms., pp. 204-205. Another critic, commenting upon
the difficulties of the subjects of apparat, wrote that David
. . . was far below his usual excellence when he had to inter-
pret the subject of the coronation." (Exposition des tableaux
en 1808 -- A.P., Deloynes, op. cit., XLIV, 1144, Ms., p. 33.)
5. Landon, /., Annales du Musée, Paris, Landon, p. 7.
Salon de 1808,

Girodet for having avoided such an interpretation and for having "preferred to preserve in his principal personages the calm and the dignity which characterize men elevated by their rank or by the importance of their functions."[1] The personages of Girodet's Keys of Vienna justify Landon's comments by their lack of emotion and their static, somewhat frozen attitudes.

While striving to achieve the exactness of detail and to suggest the dignity required by a subject of apparat and so appreciated by the critics,[2] Girodet had nevertheless to partially disregard these factors in order to solve certain unavoidable problems. Thus, although introducing in his painting the genuine portraits of the French officers,[3] the artist was unable to render the members of the Austrian deputation in the same manner. However, according to Landon:

> ". . . in order to avoid idealized figures which would
> have created a shocking disparity with those of the op-
> posed group, the artist substituted for the Austrians the
> portraits of some of his friends. The great masters,
> among them Raphael and Paolo Veronese, have done the same
> in their most important works."[4]

1. Landon, C. P., Salon de 1808, Annales du Musée, Paris, Landon, p. 7.
2. Idem, pp. 7-8.
3. Idem, p. 7.
4. Idem, p. 8; Leroy wrote that Girodet used his pupils as models for the Austrians in the painting (Leroy, Girodet-Trioson, peintre d'histoire, op. cit., p. 48). However, this idea does not seem to be confirmed by the apparent age of the personages. There seems to have been a certain confusion in the identification of the figures. Thus, the Archbishop of Vienna was sometimes identified as Cardinal Fesch (Museum of Châteauroux), which is most improbable. The deputy of the Chapter shows a certain resemblance to Girodet's friend, the publisher Firmin

Moreover, Girodet, wanting to maintain the appearance of
historical accuracy, was compelled to specify the location
of the scene by depicting the castle of Schoenbrunn and in-
troducing Austrian peasants. The artist was evidently at-
tracted by the picturesque character of their national cos-
tume, which he depicted with a great amount of detail.[1]
Besides showing a certain interest in local color, the
painter, in his interpretation of the Austrian peasants, was
influenced by prevailing ideas about the Germanic people,
which were propagated by Madame de Staël and Girodet's
friend, the Princess of Salm.[2] Thus, in his Keys of Vienna,
the artist depicted idyllically pastoral Austrian peasants,
showing a complete lack of patriotic sorrow at the surrender
of their capital. The members of the family on the left of
the painting seem to manifest only a respectful curiosity,

4 (Continued from preceding page).
Didot (drawing in the Louvre, No. 13123). Yet, it is impos-
sible to make any definite identification of this figure as
well as of the other Austrians of the painting.
 1. Girodet's detailed rendition of the national Austrian
costume was not much appreciated by certain critics. One of
them, admiring the Austrian family on the left of the paint-
ing, wrote that the personages were "drawn with the utmost
good taste, although dressed in the national costumes of their
country" (Exposition des ouvrages de peinture, sculpture, ar-
chitecture et gravure des artistes vivans (A...Z), Deloynes,
op. cit., XLIV, 1146, Ms., p. 207).
 2. Although Madame de Staël's De l'Allemagne was published
only in 1810 and the Princess of Salm's Des Allemands com-
parés aux Français appeared only in 1826, these ideas were
already widespread much earlier and were already partially
formulated in Madame de Staël's De la Littérature in
1800.

while the two youths and the young girl, in the background, who seem to be incidentally passing by, are preoccupied with their own Arcadian dreams, and only casually glance at the historical scene.[1] Finally, Girodet, ill at ease in the formal etiquette of his subject of apparat, did not hesitate to enliven his conception. He introduced an emotional element in the dramatically heroic attitude of the officer on horseback[2] and in the colorful group of the Mameluke[3] restraining Napoleon's prancing horse. It is interesting to note that these two types of dramatized conception were to become part of the traditional repertory of Géricault and Delacroix.

The Keys of Vienna, with the exception of minor criticisms,[4] was received with a succès d'estime in the Salon. However, the praises had a political character and were caused rather by the theme of the glorification of Napoleon than by the quality of the painting itself. Thus, commenting upon Girodet's work, one of the critics significantly wrote:

> "Here the truth is so glorious and so interesting that it is much more important than all the charms and the devices of art."[5]

1. Among the most striking characteristics of the Germans mentioned by Madame de Staël are a lack of patriotism, and a tendency toward sentimentality and dreaming.
 2. He can be identified by his uniform as an officer of the chasseurs à cheval of the Imperial Guard.
 3. This personage is probably the famous Mameluke brought by Napoleon from the Egyptian campaign.
 4. The critics found the composition too crowded (Exposition des tableaux en 1808 -- A.P., Deloynes, op. cit., XLIV, 1144, Ms., p. 33); and said that the legs of the Mameluke did not seem to belong to his body (Exposition des ouvrages de peinture, sculpture, architecture et gravure des artistes vivans (A...Z), Deloynes, op. cit., XLIV, 1146, Ms. p. 210.
 5. Exposition des ouvrages de peinture, sculpture, architecture et gravure des artistes vivans (A...Z), Deloynes, op. cit., XLIV, 1146, Ms., p. 205.

The Rebellion of Cairo[1] (fig 56)

In this painting, Girodet, for the first time, simultaneously developed three major themes: contemporary history, exotic orientalism, and war. The Rebellion of Cairo was one of the numerous paintings based on Bonaparte's Egyptian campaign, commissioned in the first decade of the nineteenth century.[2] Girodet and Guérin were asked to depict two episodes of a rather minor incident of this campaign during the French occupation of Egypt: the insurrection which broke out in Cairo on the 21st of October, 1798.[3] Guérin painted the subject of Napoleon's pardon of the rebels,[4] while Girodet represented a scene of the uprising prior to this forgiveness.

Girodet's painting shows the last crucial moments of the rebellion. The French soldiers, pursuing the fleeing Moslems, are fighting them in the Mosque of El Azhar, the very headquarters of the insurrection.[5] On the left, beyond

1. 1810, Versailles.
2. For instance Gros' Battle of Aboukir (1806), Hennequin's Battle of the Pyramids (1808), Gros' Battle of the Pyramids (1810), or Colson's Bonaparte Entering Alexandria (1812).
3. Bourienne, L. A. F. de, Memoirs of Napoleon Bonaparte, R. W. Phipps ed., New York, Scribner, 1891, I, p. 175.
4. The Emperor Forgiving the Rebels of Cairo in the Square of El Kebir (David, J. L. Jules, op. cit., I, p. 464).
5. Leroy, Girodet-Trioson, peintre d'histoire, op. cit., p. 48.

the entrance to the mosque, can be seen one of the minarets
from which spread the call for the uprising.[1] Coming from
the left, the French, among whom it is possible to recog-
nize grenadiers,[2] dragoons,[3] and hussars,[4] are attacking
the Moslems who are pushed back, on the right, into the
very heart of the mosque. The great majority of the Arabs
are retreating to the upper story of the building. Yet, a
few Moslems, grouped behind the warrior supporting the fig-
ure of a dying pasha,[5] are still desperately fighting the
French. In the remaining areas of the painting, one can see
various incidents of the battle amidst smoke and flashes of
gunfire.

Coupin, writing about Girodet's Rebellion of Cairo,
stressed the painter's enthusiasm for this subject:

"He /Girodet/ showed a great admiration for the paintings
of Gros which were inspired by the Egyptian campaign. He
often said that he also wished to paint Arabs. The re-
bellion of Cairo gave him the occasion to realize this
project . . .

". . . Girodet executed no other painting with a simi-
lar verve, rapidity, and assurance. His mood was cheerful.
He was surrounded by Mamelukes, who were practically liv-
ing in his house and whose beauty electrified him. It
seemed that his imagination was still impressed by the

1. Bourienne, op. cit., I, p. 174.
2. One of them appears in the background, immediately to
the left of the entrance to the mosque.
3. Wearing their helmets, they appear in the very center
of the composition.
4. One of them, represented running and brandishing his
saber, is the most prominent figure on the left of the paint-
ing.
5. Girodet, OEuvres posthumes, op. cit., I, Notice histo-
rique by Coupin, p. xvij.

memories of the scene which he wanted to represent, and,
each day, he was depicting some of its parts, as if he
were continuing a story."[1]

Girodet's interest in oriental subjects could already be
noted in 1797, in a letter addressed to Talleyrand. In this
letter, the artist asked to be granted the commission to
paint the presentation of the Turkish Ambassador to the
members of the Directory. Speaking about this subject,
Girodet underlined the interest of this theme, which would
bring out the "opposition and the contrast between Asiatic
sumptuousness and the dignity of the Constitutional cos-
tume."[2] Moreover, though this project was never realized,[3]
the artist painted several isolated Oriental figures such
as odalisques, Turks, and Mamelukes, one of which was very
favorably noted in the Salon of 1804.[4] Naturally, this in-
terest of Girodet only paralleled the well-known general
fashion for orientalism, which had received a particular
emphasis through Bonaparte's Egyptian expedition of 1798-
1799, and which had been already abundantly illustrated in
art.[5]

1. Girodet, OEuvres posthumes, op. cit., I, Notice histo-
rique by Coupin, pp. xvij-xviij.
2. Letter of Girodet to Talleyrand, July 28, 1797, Du-
brunfaut Collection, quoted in Leroy, Girodet-Trioson, pein-
tre d'histoire, op. cit., p. 45.
3. "Girodet did not have the means to make a gift of a
painting which would necessitate more than two years of
work." (Idem.)
4. Infra, pp. 367 ff.
5. Supra, p. 277, note 2.

Girodet's conception of the Orient is reflected in his poems of the Veillées and Le Peintre. His limited knowledge and understanding of the African atmosphere are suggested by his use of such general and vague terms as: "winds of Kapsim,"[1] "burning sands,"[2] or "Libyan rocks."[3] Influenced by Volney[4] and perhaps also by the archaeologist Balzac,[5] Girodet's descriptions of the Near East emphasized the Egypt of the Pharaohs, with its "mystic obelisk,"[6] "lotus of Isis,"[7] "palm tree of Horus,"[8] and sphinx.[9] However, the painter was fascinated by the contemporary inhabitants of the Oriental lands, and wrote very emotionally about the "Barbarous hordes of the sons of Mahomet,"[10] who, for him, combined courage and extreme fanaticism:

1. Girodet, OEuvres posthumes, op. cit., I, Le Peintre, Chant IV, p. 145.
2. Idem.
3. Idem, p. 148.
4. Girodet, in his Discours préliminaire to Le Peintre, admitted that he never saw the Orient and that he took his inspiration from travelers' descriptions (Girodet, OEuvres posthumes, op. cit., I, pp. 24-25). In his notes to Girodet's poem, Coupin clearly implied that Volney, the most famous contemporary authority on the Orient and the author of Voyages en Egypte et en Syrie, was one of Girodet's sources (Girodet, OEuvres posthumes, op. cit., I, Le Peintre, Notes du Chant IV, p. 309, note 10).
5. In 1811, Girodet painted the portrait of Balzac who was the architect of Napoleon during the Egyptian expedition. This portrait was engraved by Malbeste in 1818.
6. Girodet, OEuvres posthumes, op. cit., I, Le Peintre, Chant IV, p. 146.
7. Idem, p. 147.
8. Idem.
9. Idem.
10. Idem, p. 143.

" . . . the proud Mameluke, in wandering tribes,
Falling on the enemy whom he likes to defy,
Makes his formidable steel shine and whistle."[1]

Thus, in his poems, the artist seems to have been more sensi-
tive to the exotic picturesqueness of the people of the
Orient than to the setting and atmosphere of their country.
The conception of the Rebellion of Cairo reflects a similar
attitude. With the exception of a few orientalizing archi-
tectural details, the setting of the Mosque of El Azhar is
strongly reminiscent of much earlier classicizing settings
like that of Joseph Making Himself Known to his Brothers[2]
(fig. 4). The most important source of the exotic feeling
suggested in Girodet's painting is derived not from the set-
ting but rather from the costumes and the ethnic types of the
personages. This can be seen in the elaborate, over-detailed
rendering of the Oriental attire[3] as well as in the variety
of ethnic types.[4] Girodet's Turks are specifically

1. Girodet, OEuvres posthumes, op. cit., I, Veillées, III,
p. 380.
2. The general disposition of the two settings, with the
opening on the left, is almost identical.
3. A quality which is particularly striking in the render-
ing of the costume of the expiring young pasha. The attire of
Girodet's Oriental personages seems to correspond to various
Oriental costumes described by Pérignon in his catalogue of the
sale of Girodet's possessions after the death of the artist
(Pérignon, op. cit., "Turkish costumes," pp. 106-107, nos. 902-
910). The painter also had in his possession a collection of
Oriental helmets, shields, and weapons (idem, p. 104, nos.885 ff.).
4. Thus, one can recognize negroes, mulattoes, and Arabs.
Benoit noted that this concern for an exact rendering of cos-
tumes and ethnic types was typical in the historical paintings
of the period (Benoit, op. cit., p. 408).

characterized and are no longer conceived, like the Indians in _Atala_ or the Austrians in the _Keys of Vienna_, as idealized personages dressed in outlandish costumes. Nevertheless, it may be noted that Girodet's conception of an Oriental subject was far from equalling Gros' feeling for the exotic African atmosphere suggested in _Jaffa_ or _Aboukir_.

Girodet's contemporaries never attempted to identify the figures of the _Rebellion of Cairo_. This fact seems to indicate that the artist did not represent any known historical personage in his painting, and that he interpreted his subject in a much more imaginative manner than the _Keys of Vienna_. At any rate, the combination of Oriental elements with a battle scene excluded for the painter any possibility of conceiving this basically historical theme as a subject of apparat.[1]

Girodet's interpretation of this battle scene still preserves some iconographical elements derived from the classical conception of the subject. It can be seen that the painter concentrated the attention of the spectator upon two leading heroes, the French officer of hussars[2] and the naked Arab supporting the young pasha. Their dramatic opposition is

1. It is impossible to agree with Coupin who classified the _Rebellion of Cairo_ as a subject of _apparat_ (Girodet, _OEuvres posthumes_, op. cit., II, _De l'Ordonnance en peinture_ p. 207, note by Coupin).
2. This figure, brandishing a sword, appears in the left foreground.

conceived, as in the case of Romulus and Tatius in David's
Sabines, as a symbolical summary and the climax of the
battle. These personages are singled out by being placed
in the foreground, and by being given a size which is clearly
out of scale in relation to the other figures of the painting.
This device, denounced as primitive by Benoit,[1] was often
remarked and criticized by Girodet's contemporaries.[2] Another
classical factor, derived from the ideas of Lessing and
Quatremère, can be seen in the artist's concern with hiding
the "grim results" of combat and the "details of slaughter."[3]
This idea was emphasized in Girodet's Veillées:

"Without a stream of blood inundating his armor,
I can understand that a warrior is mortally wounded
By his staggering body, by his dimmed glance.
His shield, his sword, which have fallen from his hands,
His pale face are sufficient to tell me,
But without horrifying me, that this warrior is dying."[4]

One can note that in the painting, the young pasha is dying
in the very manner prescribed by these lines, and that Giro-
det carefully avoided the depiction of blood or wounds.[5] A
major exception seems to be suggested by the head of a

1. Benoit, op. cit., p. 404.
2. As for instance, by Coupin himself (Girodet, OEuvres
posthumes, op. cit., I, Notice historique by Coupin, p.
xviij).
3. Girodet, OEuvres posthumes, op. cit., I, Veillées, III,
p. 379.
4. Idem.
5. The inconspicuous neck wound of the pasha cannot be
considered a serious departure from this principle.

decapitated hussar[1] which a negro warrior is holding by the
hair. However, this idealized Leonardesque head, reminiscent
of the Medusa which fascinated Girodet,[2] suggests very little
horror, and was perhaps conceived as a political allusion.[3]
Thus, the artist, influenced by traditionally classical ideas,
eliminated from his painting any unpleasantly realistic repre-
sentation of death. There is nothing in the Rebellion of
Cairo which can parallel the naturalism of the greenish
corpses depicted in Gros' Battle of Eylau.

In 1810, Stendhal, writing his impressions of the Re-
bellion of Cairo in his Journal, stated his admiration for
"two or three superb infuriated heads."[4] However, noting the
psychological obviousness of Girodet's personages, the writer
significantly added: "It is the A B C of expression."[5] This

1. His braids identify him as such.
2. Girodet painted a Medusa (Museum of Perpignan) and de-
scribed the same subject in an exalted passage of his poem.
It may be suggested that Girodet was also inspired in the ren-
dering of the head of this hussar by the traditional representa-
tions of Salome and Saint John the Baptist or of Judith and
Holophernes. Girodet himself interpreted the latter subject
at an earlier period (Bruun Neergaard, op. cit., p. 157).
3. Historically, the insurrection of Cairo was followed by
savage French reprisals. One of the most atrocious incidents
of this retaliation was a public display of the heads of a
great number of decapitated rebels (Bourienne, op. cit., I,
p. 177). The head represented in the painting, stressing
the barbarism of the Oriental rebels, may be considered as a
possible allusion to a justification of the well-known French
atrocities which followed the revolt.
4. Stendhal, Journal, op. cit., IV, p. 26, November 10,
1810.
5. Idem.

remark is to a great extent justified, and at first glance,
one is struck by the general psychological unsophistication
of the personages. Many figures of the Rebellion roll their
eyes[1] and seem definitely to overact their roles.[2] However,
in spite of this tendency toward exaggeration, Girodet made
an effort to qualify the passions of some of his personages.
His interest was particularly concentrated on depicting bar-
baric fanaticism, a quality which was commonly attributed to
Orientals. Thus, a negro warrior is holding the head of a
beheaded hussar, while an Arab is throwing himself, bare-
handed, on the sword of a French dragoon.[3] Moreover, the
painter qualified his interpretation with his usual pessi-
mistic accent by transposing into the scene of the Rebellion
an iconographical idea derived from the Deluge. In both
cases, the artist depicted a pathetically heroic personage
on whose strength depends the fate of his companions. In
the Deluge, the rotten tree symbolized the futility of man's
efforts amidst the upheavals of life.[4] In the Rebellion of
Cairo, the futility of the naked Arab's fanatic courage is

1. Stendhal, contradicting his earlier opinion on the ob-
viousness of Girodet's psychology, wrote in 1824: "In his Re-
bellion of Cairo, Monsieur Girodet succeeded in rendering with
great talent the eyes of a man who is fighting for a cause
which he believes to be sacred." (Stendhal, Mélanges d'art et
de littérature, op. cit., "Salon de 1824," p. 207.)
2. However, this comment cannot be applied to some of the
French soldiers, whose facial expressions suggest an almost
complete classical impassivity.
3. This figure appears immediately behind the negro holding
the head of the beheaded hussar.
4. Supra, p.251.

brought out by the fact that he is fighting for a lost cause and a dead master.[1] His bravery is only helping the treacherous savagery of the warrior crouching behind him and holding on to his leg. It must be admitted that Girodet also introduced into this painting an isolated imaginative psychological incident, which can be seen in the action of one of the rebels who, full of futile anger, defiantly makes the gesture of firing a pistol without holding one.[2]

In the Rebellion of Cairo, Girodet still used the old idea of time dissection. The disposition of the figures informs the spectator about the general sequence of events. The painting represents in succession: the entrance of the French into the mosque,[3] the combat,[4] and the defeat and withdrawal of the rebels.[5] Moreover, some of Girodet's personages show attitudes which are reminiscent of the old composite passions.[6] However, in the Rebellion, the chronological development of events is not stressed in the rigid, logical

1. The expiring youthful pasha, "whose life has passed like that of a flower" (Girodet, OEuvres posthumes, op. cit., I, Notice historique by Coupin, p. xvii). This is the "touching episode" recommended for a battle scene in Girodet's Veillées: "Let a touching episode soften the horror . . . Of your paintings which are filled with rage and terror" (Girodet, OEuvres posthumes, op. cit., I, Veillées, III, p.378.
2. This gesture can be noted on the extreme right of the painting, immediately below the balcony.
3. In the upper left of the painting, in the background.
4. In the foreground.
5. In the upper right of the painting, in the background.
6. As for instance can be seen in one of the figures in the background whose attitude duplicated that of the Roman women of Horatius Killing his Sister (the second Arab from the left of the column on the right of the painting.)

succession of moments typical of the early historical paint-
ings,[1] or even of the Deluge. Furthermore, the painter gave
a new emphasis to the momentary qualify of certain attitudes.
For the first time in his production, he represented one of
his principal personages running and touching the ground with
only one foot.[2] Moreover, the artist depicted a figure in
the attitude of falling, halfway between two positions of
equilibrium.[3] Girodet's stress on the momentary factor sug-
gests an emotional vividness which is also derived from the
timing of the chosen incidents. Instead of representing only
the moment before or after a given action,[4] the artist, in
several incidents of the painting, depicted the action it-
self, taken at its climax. Thus, one of the rebels is repre-
sented in the act of throwing himself upon the sword of a
French dragoon,[5] and several figures are shown interlocked in
battle.[6] In the conception of the Rebellion, the depiction
of the action itself was given as much importance as that of
the passions.

1. As for instance in Joseph Making Himself Known to his
Brothers.
2. The French officer of hussars in the left foreground.
3. One of the Oriental figures climbing the stairway in
the background, slightly to the right and above the center
of the painting. A colorful study for this figure appears
in one of Girodet's preliminary drawings (fig. 57).
4. However, the action of the two principal heroes, the
running French officer of the hussars and the naked war-
rior, is depicted before its climax.
5. Supra, p. 282, note 3.
6. As for instance the Arab and the hussar, in the middle
ground, on the extreme left of the painting.

The emotionality of the painting also originates from the striking complexity of the composition. Some groups of the scene show an extraordinary complication of interlocked bodies and limbs, in which it is sometimes difficult to single out the individual figures. At first glance, one is impressed by an accumulation of seemingly unconnected anatomical elements.[1] This character of the painting was very graphically described in Stendhal's Journal:

> "Imagine a nest of vipers which one uncovers by moving an ancient vase. It is difficult to follow the same body if one looks at it for a long time, it makes one feel dizzy. This is the effect of the Rebellion of Cairo."[2]

Thus, Girodet applied one of the ideas expressed in his De l'Ordonnance en peinture whereby "the effects /of a painting/ must be in physical and moral harmony with the character of the represented subject."[3]

1. Particularly in the foreground, in the center of the painting.

2. Stendhal, Journal, op. cit., IV, p. 26, November 10, 1810.

3. Girodet, OEuvres posthumes, op. cit., II, De l'Ordonnance en peinture, p. 212. However, Girodet's interpretation contradicted another idea of the Ordonnance suggested in the artist's criticisms of certain compositions of his contemporaries: ". . . the figures /of these compositions/ are so numerous, so crowded, and in such strange attitudes that it is extremely difficult for the eye to relate the various limbs to their respective bodies. They all seem to be amalgamated together. Looking at these undigested compositions, the spectator, tired by an unfruitful exploration, has no longer the courage to seek the beauty of the details in the confusion of this chaos." (Idem., pp. 220-221.)

Coupin, commenting on the Rebellion, wrote:

"This painting . . . /shows/ so many beauties . . . of
the kind which can be created only by an ardent and
passionate man . . . I believe that the Rebellion of Cairo
is one of Girodet's productions which will prove to be
the best assurance of his reputation."[1]

Coupin's opinion seems to have been confirmed by the fact
that the Rebellion of Cairo was the work of Girodet which was
the most admired by the painters of the next generation. De-
lacroix considered it "full of vigor" and of a "great style";[2]
and Géricault is reported to have exclaimed: "Oh! it is very
beautiful, they /the figures of the painting/ are even more
beautiful than those of Gros."[3]

1. Girodet, OEuvres posthumes, op. cit., I, Notice histo-
rique by Coupin, p. xviij.
2. Delacroix, Journal, Paris, Plon, 1950, I, p. 72, April
11, 1824.
3. Leroy, Girodet-Trioson, peintre d'histoire, op. cit.,
p. 13. This admiration can perhaps be partially explained
by the fact that the Rebellion of Cairo is by far one of
Girodet's most coloristic and most freely painted works.

III.

COMMON CHARACTERISTICS

The common characteristics of the paintings of this group can be considered from the point of view of their new heroic scale, of Girodet's return to a rationalistic conception, and of his attempt to explore new sources of emotion.

Scale

The heroic size of the paintings of this group contrasts with the modest proportions of the great majority of Girodet's works executed before 1802.[1] This change of scale reflects a general trend at the beginning of the nineteenth century. During the period of the revolutionary years, the writers of the salon frequently noted and criticized the tendency of the painters of important subjects, like history or mythology, to confine their interpretation to a small scale. One of these critics wrote:

1. With the exception of the _Pietà_ of Montesquieu-Volvestre and of _Endymion_.

". . . it can be noted . . . that there seems to be too
great a tendency toward reducing the genre of history to
a small scale. A great number of interesting subjects
have been rendered this year on canvases of a small size
. . . the historical genre seems to show a trend toward
miniature."[1]

One of the reasons for the critics' disparaging attitude
toward "miniature" and for their preference for works of
large size was derived from the opinion that:

". . . the difficulty /of painting7 decreases not only
in relation to the nature of the subjects but also in
proportion to the size of the painted objects."[2]

Girodet seems to have been greatly concerned with this
type of criticism. This is clearly shown in a letter to Ber-
nardin de Saint-Pierre, in which the painter attributed to
the factor of size the popularity of Endymion and the com-
parative lack of success of Hippocrates and of Ossian:

"One of the shortcomings of this painting /Ossian7, with-
out which it would have been more effective, can be seen
in the fact that the figures were not life-size. Hippo-
crates showed the same inadequacy. If Raphael's Transfig-
uration and Rubens' Descent from the Cross had only been
of a small size, how far would these beautiful paintings
be from the reputation they have acquired. And yet, they
would have had the same degree of merit in the eyes of the
enlightened connoisseurs. However, what is large is al-
ways striking, and a deformed giant is more imposing than
a beautifully proportioned pygmy. If some day these three
paintings /Endymion, Ossian, Hippocrates7 are, as I wish,

1. Observations critiques sur les tableaux du Sallon de l'an-
née 1789, Paris, 1789, Deloynes, op. cit., XVI, 410, p. 7.
2. M. Rob..., Exposition publique des ouvrages des artistes
vivans, dans le Salon du Louvre au mois de septembre, année
1795, Deloynes, op. cit., XVIII, 469, Ms.', p. 436.

engraved, this level of equality will perhaps re-estab-
lish among Endymion, Ossian, and Hippocrates a comparative
evaluation contrary to that of the hitherto established
opinion."[1]

Girodet's letter shows that, for his contemporaries, this
question involved both the size of the total area of the
canvas and the relative scale of the figures within the
painting.

Girodet's letter to Bernardin de Saint-Pierre, writ-
ten at the time of the composition of the Deluge,[2] shows that
the artist was sufficiently disturbed by adverse criticisms
to abandon the demi-nature size of the figures of Ossian for
the titanic proportions of the personages of the Deluge. How-
ever, Girodet's desire to satisfy his critics was not the
sole cause of this change of scale. Without any doubt, the
specific requirements of the Academy and of various commis-
sions frequently compelled the painter to adapt his subject
to an area of precisely defined dimensions. Thus, Academic
rules had requested the small size of the Prix de Rome

1. Girodet, OEuvres posthumes, op. cit., II, Correspondance,
Letter III, to Bernardin de Saint-Pierre, pp. 281-282. Giro-
det's concern with the factor of size also appears in his
letter to Pastoret, in which he stated that the merit of his
illustration of Virgil and Racine was equal to that of larger
paintings (Girodet, OEuvres posthumes, op. cit., II, Corres-
pondance, Letter XXVII, to Pastoret, p. 343).
2. The list of Girodet's paintings mentioned in this let-
ter shows that it was written after the completion of Ossian
and before the exhibition of the Deluge, between the years
1802 and 1806.

paintings,[1] while Imperial magnificence was the direct source of the heroic scale of the Keys of Vienna and of the Rebellion of Cairo.[2] For the works executed independently of any specific commissions, the situation was different, and the scale of the paintings was, to a great degree, influenced by the financial resources of the artist. During the difficult times of the Directory, Girodet could not afford the prolonged and unremunerated effort necessitated by a painting of large dimensions.[3] It was only during the relative prosperity of the Empire that the artist was to be able to carry out such monumental noncommissioned projects as the Deluge and Atala.

Finally, this change of scale corresponded to a general stylistic development marking the end of the eighteenth century. A few large paintings by David and Regnault make one

1. The same influence regulated the size of Endymion. The proportions of Hippocrates were selected with a view to fitting the painting into a particular place of the cabinet of Dr. Trioson (Girodet, OEuvres posthumes, op. cit., II, Correspondance, Letter XXXVI, to Trioson, Rome, July 20, 1790, p. 369; and Girodet, OEuvres posthumes, op. cit. Correspondance, Letter XXXVIII, to Madame Trioson, Rome, November 24, 1790, p. 378). Most probably similar considerations influenced the scale of the Seasons, the first Danaë, and Ossian.
2. Supra, p. 209.
3. This is the reason for which the artist did not execute the subject of the introduction of the Turkish ambassador to the members of the Directory in 1797: "Girodet could not afford to offer a painting gratuitously which would have necessitated more than two years of work." (Leroy, Girodet-Trioson, peintre d'histoire, op. cit., p. 45.) The difficult position of the artists at the end of the eighteenth century is reflected in the fact that David organized a paying exhibition of his Sabines. Regnault did the same for a group of his paintings.

frequently forget that, during the Directory and the Consulate, a great number of works, by minor artists, had shown a definite trend toward a miniature-like precision and trompe-l'oeil.[1] This tendency is even reflected in some of the comparatively large paintings of Girodet, such as Endymion and Ossian, executed during the same period. The small scale of the personages of Ossian was characteristic of this trend. In contrast to this taste for a minute, quasi-illusionistic rendering, the Imperial period, influenced by the Napoleonic grandeur, showed a strong inclination toward a heroic largeness, a frieze-like conception, and in general, a grande manière of interpretation, which can be seen in Girodet's most important works painted between 1806 and 1810.[2]

1. This trend culminated in the trompe-l'oeil of Boilly (Salon of 1800) and of Laurent Dabos (Salon of 1801). See infra, p. 357, note 1.

2. It can be added that this change coincided in Girodet's paintings with evident signs of Michelangelo's influence. However, it must be noted that this influence had already appeared in Ossian (supra, pp. 213 - 214), in other words, before the execution of the group of works in which this change of scale took place.

Return to a Rationalistic Conception

Girodet's new predilection for a grandiose scale was
paralleled by his abandonment of the esoteric symbols and of
the irrational emotionality which characterized the mytholo-
gical works before 1802.

During the first decade of the nineteenth century,
the painter completely eliminated from his conceptions the
refined and complex allegories of the preceding years. It is
difficult to find many hidden meanings in the large machines
executed between 1806 and 1810. The very few symbols intro-
duced by Girodet in the paintings of this group, such as the
purse of the old man in the Deluge (fig. 42) or the cut flower
in Atala (fig. 49), are far from suggesting the esoteric pre-
ciosity of The New Danaë (fig. 26) or of Ossian (fig. 29).
In contrast to the iconographical obscurity of the paintings
of the mythological group, the content of the works of this
period can always be immediately understood.

Similarly, the settings of Girodet's paintings executed
between 1806 and 1810 were no longer conceived as a vague and
mysterious nowhere. The mountainous landscape of the Deluge
(fig. 42), the Viennese countryside of the Keys of Vienna (fig.
55), the American wilderness of Atala (fig. 49), and the Ori-
ental mosque of the Rebellion of Cairo (fig. 56) are more or
less successfully localized. At any rate, they are much more
precisely defined than the mystic bosket of Endymion (fig. 14)

or the higher regions of the atmosphere of <u>Ossian</u> (fig. 29).
Moreover, the personages of the paintings of the <u>grande manière</u>
group (figs. 42, 49, 55, 56) do not seem, any longer, to be
floating and emerging from a cloudy atmosphere. Sculpturally
isolated against the background, they suggest a definite
feeling of weight and are logically related to the ground.
It can be added that these paintings show indications of
Girodet's interest in a more coloristic approach -- a qual-
ity which was frequently noted by his contemporaries.[1] This
new interest resulted in the painter's abandonment, for a
short period, of the purplish tonalities for which he was so
often criticized.

The consideration of the psychological interpretation
of the personages represented in the paintings of this group
shows that Girodet, to a great extent, subdued his earlier
tendencies toward eroticism and morbidity. While certain
figures, like the young pasha of the <u>Rebellion of Cairo</u> (fig.
56), still suggest a somewhat effeminate rendering, none
shows an androgynous characterization comparable to that of

1. Thus, in relation to <u>Atala</u>, the critics found the drapery
too green (<u>Première journée d'Cadet Buteux au Salon de 1808</u>,
Paris, Aubry, 1808, p. 3), the sky "too blue and not vaporous
enough" (<u>Examen critique et raisonné des tableaux des peintres
vivans formant l'exposition de 1808</u>, Paris, Vve Hocquart, 1808,
p. 11); and the trees "of too frank a green" (<u>Exposition des
ouvrages de peinture, sculpture, architecture et gravure des
artistes vivans (A,..Z)</u>, Deloynes, <u>op. cit.</u>, XLIV, 1140, Ms.,
p. 215). Coupin noted the "extreme freedom of execution" of
the <u>Rebellion of Cairo</u> (Girodet, <u>OEuvres posthumes, op. cit.</u>,
I, <u>Notice historique</u> by Coupin, p. xviiJ).

Endymion (fig. 14). Similarly, the principal figure of Atala
(fig. 49) or even the mother in the Deluge (fig. 42) are far,
in spite of their undeniable sensuality, from suggesting the
frank eroticism of the Ossianic feminine figures (fig. 29).
Moreover, although Girodet still used the device of contrast-
ing muscular contraction with atonic relaxation,[1] this opposi-
tion no longer gives the impression of the quasi-neurotic
quality which was seen in the early mythological paintings.
The painter made an effort to eliminate all suggestions of
ambiguity from the psychological interpretation of his per-
sonages. With very few exceptions,[2] the emotions of Girodet's
figures show little subtlety and achieve the "A B C of ex-
pression" noted by Stendhal. They are based upon a repertory
of facial expressions which, though derived from Lavater, had
already been greatly simplified and codified by Flaxman.[3]

Naturally, this return to a more rationalistic concep-
tion corresponded to Girodet's abandonment of mythological
themes. It must be admitted that the very nature of the latter
was more favorable to esoteric irrationality than the subjects

1. As for instance the husband and the wife in the Deluge
(fig. 42) or the nude warrior and the young pasha in the Rebel-
lion of Cairo (fig. 56).
2. See p. 283, note 2.
3. It is almost needless to recall the tremendous popular-
ity of Flaxman's works during the early years of the nineteenth
century. The typical personages of Flaxman, as for instance
exemplified in his illustrations of The Iliad, show a very
limited range of stereotyped, exaggerated expressions which
undoubtedly provided an often-used source for the artists of
the time.

of 1806-1810. However, the painter's change in the type of
his themes is significant in itself. Moreover, the artist's
new rationalism was most probably greatly influenced by the
critics' protests against the tendency of certain young
painters toward "bizarreness."[1] Girodet was undoubtedly hurt
by the attack of the Revue du Salon de l'an X in which his
Ossian was described as the "fruit of a delirious imagina-
tion."[2] These criticisms may explain the abrupt change which
occurred in the painter's conception between 1802 and 1806.
Thus, it can be understood why the esoteric Ossian, with its
transparent, floating figures, was immediately followed by
the dramatic, but very rational, Deluge, in which the laws
of gravity play such an important part. It must also be
pointed out that this change of conception corresponded to
similar cultural and social developments, which occurred with
the establishment of the Empire in 1804. The chaotic rest-
lessness, the anxiety, and the loose sensuality of the pre-
vious years were progressively replaced by a new emphasis on
order, pompous dignity, and moralistic prudery which marked
Napoleon's attempts to emulate the spirit of the siècle de
Louis XIV.[3] Finally, the Emperor, in spite of his taste for
Ossianic literature, preferred above all what he called "truth"

1. "Salon de 1802," Journal des Débats, Deloynes, op. cit.,
XXVIII, 778, p. 693.
2. Revue du Salon de l'an X ou examen critique de tous les
tableaux qui ont été exposés au Museum, Paris, Surosne, 1802,
IIe Supplément, p. 183.
3. Benoît, op. cit., p. 157.

in a painting.[1] Thus, it is only natural to see these new
tendencies reflected in a revival of certain academic tradi-
tions.

New Sources of Emotion

With the exception of the Keys of Vienna, which was
considered a subject of apparat, the paintings of this group
clearly show that emotion was still Girodet's chief concern.
However, this emotion was now derived from different sources.
It was related to elements more adaptable to the rationalistic
trend which, as was seen, characterized Girodet's production
during the years 1806-1810. The artist's new sources of emo-
tion were based on two main factors of unequal importance:
a qualification of the setting and a dramatization of the
action.

It has been seen that the setting of the paintings of
the grande manière group was no longer conceived as a com-
pletely neutral background, as in Hippocrates Refusing the
Presents of Artaxerxes (fig. 6), or as a mysterious nowhere,
as in Ossian (fig. 29). The painter's new comparative locali-
zation of the scenery stressed its relation to the drama
enacted by the personages. Thus, the wild Alpine landscape
of the Deluge (fig. 42) directly echoes and intensifies the

1. Benoit, op. cit., p. 171, note 2.

human tragedy of the subject. Similarly, the American wilderness of Atala (fig. 49) and the Oriental mosque of the Rebellion of Cairo (fig. 56) accentuate the emotion of these scenes, by qualifying it with an accent of exotic remoteness. This harmonization of the setting with the drama anticipates the later Romantic conception. However, with the exception of the Deluge, Girodet applied to his settings the archaeological approach which he used in his early historical paintings. He seems to have thought that a particular atmosphere could be recreated through an addition of accurate details. Thus, during the execution of Atala, he spent long hours in the Botanical Garden of Paris,[1] and also made exact studies for the smallest details of his other paintings in this period.[2] It is understandable why this somewhat dry, almost scientific approach could not achieve the emotional effectiveness of Gros' exotic paintings, in which precision was frequently sacrificed for the sake of a lyrical pictorialism.

1. Lettres de Girodet-Trioson à Madame Simons Candeille, op. cit.
2. Girodet, OEuvres posthumes, op. cit., I, Notice historique by Coupin, p. xlj.
 This attitude was typical of the great majority of Davidian artists who had to interpret exotic settings. Thus, Chaussard, in his Pausanias français, praised Lejeune's Battle of the Pyramids in the following terms: "Monsieur Lejeune was the first to feel how much the plants and the vegetation of a climate helped to make it known. He skillfully used this ingenious device. Nothing is neglected: everything, even the details and the accessories, is perfectly rendered. And there is in this painting such a convincing feeling of truth, that one seems to be actually walking in it" (op. cit., pp. 219-220).

A much more important source of emotion can be found
in Girodet's new dramatic emphasis on action in his paint-
ings. In his early historical works, the artist stressed
the idea of a comparatively long chronological sequence of
psychological reactions. In this group, the central action
of a theme, as for instance Hippocrates' gesticulation, was
seldom a strong emotional factor in itself.[1] It was basic-
ally conceived as the starting signal for the waves of pas-
sions which it originated. In his mythological paintings of
1791-1802, Girodet abandoned his previous emphasis upon a
well-defined action and a strongly articulated chronological
conception. Thus, in Ossian, one of the chief factors of
emotional suggestiveness was derived from the very ambiguity
and indecision of the action. These interpretations of the
early historical and mythological groups contrast with Giro-
det's conception of the action, as depicted in the works of
the grande manière group. Instead of being only the starting
point for a psychological sequence, the action becomes, for
the artist, the main object of the painting. It is now con-
sidered at least as important as the depiction of passions.
Moreover, far from being vague, the action, though sometimes
extremely complicated as in the Rebellion of Cairo (fig. 56),
is nevertheless definitely specified and logically articulated.
Finally, it is given an intensified dramatic quality through

1. An exception to this tendency can be seen in the Death of
Tatius (fig. 3), in which the principal action is the actual
killing of the king.

an emphasis on a violent or pathetic content. The sequence
of the suggested events is always short. The spectator is
aware that the muscular tension of the hopelessly struggling
father in the Deluge (fig. 42); the broken attitude of Chac-
tas succumbing under his grief in Atala (fig. 49); and the
clash of the warriors in the Rebellion of Cairo (fig. 56),
will be imminently followed by an ultimate tragedy: the fall
of the family into the abyss, the descent of Atala's body
into her grave, and the massacre of the rebels in the mosque.
Thus, a drama devoid of mystery is nevertheless, by its very
logic and by its stress on a crucial moment, intensified to
an emotional pitch hitherto unparalleled in Girodet's paint-
ings.[1]

It can be seen that Girodet's works of this group sug-
gest the artist's definite tendency to compromise between two
opposed contemporary currents. On the one hand, these paint-
ings show a return to certain rationalistic ideas of the
academic tradition. On the other, they still reflect the
artist's never-ending striving to achieve high-strung emotion-
ality. This compromise frequently resulted in melodrama and
sensationalism. Yet, the large machines of this period are
not devoid of a certain impressiveness, and represent Girodet's

1. Naturally, this emphasis on the action and on a dramatic
moment can also be seen in the works of some of the more pro-
gressive painters like Gros. Yet, as suggested to me by Dr.
Deknatel, this tendency is also reflected in some of the con-
temporary classicizing paintings of David, like Leonidas at
Thermopylae.

last continuous effort to be recognized as an artist respect-
ful of tradition but aware of the more progressive currents
of his time.

CHAPTER V

PORTRAITS

CHAPTER V

PORTRAITS

Portrait painting, in spite of the condemnation of
Quatremère,[1] reached a seldom paralleled development during
the Revolutionary and Imperial years. All the critics pro-
tested against the "flood of portraits."[2] While the great
majority ridiculed the unjustified numerical importance of
this genre, others deplored its new magnified scale. For many
of the portraits were executed in "full length and on canvases
of 8 to 10 feet."[3] The critics believed that this size had
been achieved at the expense of the scale of historical paint-
ing which, in their opinion, revealed a tendency "toward
miniature."[4]

1. As well as that of the "ultra-idealist" school (Benoit,
op. cit., p. 45).
2. Arlequin au Museum, quoted in idem, p. 377.
3. Observations critiques sur les tableaux du Sallon de
l'année 1789, Paris, 1789, Deloynes, op. cit., XVI, 410,
p. 7.
4. Idem.

The multiplication of portraits corresponded to some of the essential strivings and needs of the period. It echoed the contemporary emphasis on the individual, as well as the sentimental cult of the family and the hope of preserving the features of the deceased or the absent, a most important preoccupation in times of war and political unrest. Moreover, it reflected the self-assertion of the rising bourgeoisie and that of the new officialdom created by the successive changes of regime. Finally, for many painters, portraiture was frequently the only obtainable type of commission and the unique source of livelihood.

This paradoxical situation, in which the official anathema cast on the very concept of portraiture by the classical theorists was contrasted by the contemporary popularity of the genre, seems to have greatly influenced Girodet's attitude, as it is expressed in his writings. For the painter, portraiture seems to have been a "secondary art," a refuge for the artists unable to succeed in a higher sphere:

> ". . . if, deaf to your pleas, the severe Urania
> Refuses to crown your efforts with the palms of genius,
> Attempt to achieve success in a more modest field;
> Abandon history and come down to paint portraits."[1]

However, Girodet thought that even "simple portraits . . . require, more than is commonly believed, a great deal of art

1. Girodet, OEuvres posthumes, op. cit., I, Veillées, IV, p. 391.

in composition."[1] He did not consider a painter who specialized in
portraits as being irremediably lost to the fame of posterity. Thus,
Van Dyck, who

> ". . . almost succeeded in equalling Titian and Raphael,
> . . . became immortal for his portraits alone."[2]

From the great number of portraits mentioned by Coupin and Pérignon,
it is possible to infer that portraiture formed a considerable part of
Girodet's production. However, a great number of these portraits are
lost or forgotten in the attics of private collectors, and only a
relatively small portion is available for direct study.

Before attempting a consideration of Girodet's portraits, it is
necessary to state the general ideas of the painter and to trace their
relation to his actual works. In a previous chapter,[3] it was pointed
out that the contemporary sway of Lavater's ideas greatly influenced
Girodet's conception of the human figure in his historical paintings. It may

1. Girodet, OEuvres posthumes, op. cit., II, Correspondance,
Letter XXXII, to Mademoiselle Robert, January 26, 1823, p. 354.
The idea that a portraitist needs the knowledge of a historical
painter was frequently expressed by the critics (Benoit, op. cit.,
p. 75). They often noted that Girodet's "great knowledge . . . gives
him an advantage in interpreting the genre of the portrait" ("Exposition
de peinture, sculpture, architecture, gravures et dessins," Journal
d'Indications, 1798, Deloynes, op. cit., XX, 541, Ms., p. 208).
2. Girodet, OEuvres posthumes, op. cit., I, Veillées, IV, p. 391.
3. Supra, pp. 65 ff.

be recalled that the artist advised observing humanity with
the minute, objective scrutiny derived from physiognomical
theories:

"The painter, ingenious disciple of the learned Lavater,
Also observes with curious eye,
The countenance, the color, the shape of the face;
He distinguishes a stupid man from a coxcomb, a fool from
a wise man.
His eye, better than any other eye, under sinister features
Sees thoughtful Crime meditate on its evil deeds;
He lifts up the impenetrable veil of the hearts,
Reads the condemnation written on the forehead of the
guilty,
And soon discovers, under a deceiving mask,
The defects of the mind, the weaknesses of the heart;
. .
He sees
The calm and serene countenance of the virtuous man,
The crawling attitude of the poor, the haughty air of the
rich."[1]

This idea of a strong moral characterization influenced Giro-
det's theoretical rejection of sitters who, in spite of their
beauty, fail to show any specifically defined psychological
quality, and his praise of those who, though ugly, have in-
teresting and well-marked features:

". . . there are some features, the stupid beauty of which
Offers to disgusted art only an insipid image;
There are also others which, in their nullity,
Without vice, without ugliness, without grace, without
beauty
And without expression, as well as without character,
Cannot move us, far from being able to please us.
Abandon them to obscure painters.
.
Genius often sparkles without beauty;
Grace reveals itself in incorrect features;

1. Girodet, OEuvres posthumes, op. cit., I, Le Peintre,
Chant II, p. 101.

The mind makes one adore a lovable ugliness;
Sappho, without being beautiful, chained more than one
heart.
Michelangelo was ugly
But this ugliness was the ugliness of a great man . . ."[1]

At any rate, the depiction of the sitter's _caractère_ seems
to have been considered by Girodet as the primary aim of the
portraitist. From this point of view, in his opinion, the
works of Maurice Quentin de La Tour provided the best example:

"Latour, in his portraits, depicted the mind and the soul.
A dolt, under his brush, would undoubtedly have looked like
a dolt,
But, painted by him . . .
Molière would have observed some comical vice;
.
Pascal, leaning gravely, would have meditated;
Corneille would have thundered with his fiery glance;
.
By his witty laughter one would have recognized Voltaire;
And when Latour himself painted his own portrait,
One can see there a scamp truthfully depicted.
Following his example, in this fashion, paint character,
Habits, manners; let not an austere philosopher
Have the haughty attitude of a frisky cavalier."[2]

Girodet warned the portraitist to avoid, in his depiction of
his sitter's _caractère_, the ridiculous disguises of the ro-
coco portraits,[3] the "factitious freshness" and the "insipid
colors" of Roslin[4] as well as the "emphatic pomposity" of
Rigaud.[5] Eliminating all traces of affectation, the artist

1. Girodet, OEuvres posthumes, op. cit., I, Veillées, IV,
pp. 393-394.
2. Idem, pp. 392-393.
3. Idem, p. 395.
4. Idem,
5. Idem, p. 391.

must be as direct and as simple as possible.[1]

However, Girodet's eulogy of simple, truthful, and
penetrating portraiture should not be taken too literally.
Thus, he advised the portrait painter to subdue the suggestion of any strong emotion which would disfigure the sitter:

> "All the gentle, calm and concentrated feelings
> May be shown in your portraits.
> A slight tint of pain or joy
> Can be introduced without disfiguring them."[2]

Avoiding the depiction of vices, the portraitist must stress
his sitter's virtues and make him congenial or lovable to
the onlooker:

> "Let one read on their features goodness, frankness,
> Desire for glory, and love of honor.
> The long habit of these noble virtues
> Which one cannot simulate . . .
> Can you express it in a successful portrait?
> I feel for the model an invincible attraction;
> Without ever having seen him, I feel that I love him,
> So much is virtue pleasing, even only in its image! . . ."[3]

Similarly, the artist should eliminate any striking physical
unpleasantness and introduce a certain degree of flattery:

> "Know how, sometimes using an honorable artifice,
> To be an obliging liar in attenuating a defect,
> And, without hiding the simple truth,
> To alleviate ugliness and embellish beauty . . ."[4]

1. Girodet, OEuvres posthumes, op. cit., I, Veillées, IV,
p. 391.
2. Idem, p. 395.
3. Idem, p. 394.
4. Idem, p. 391.

In other words, for Girodet, a portrait must be:

"'Always true, but flattered; as it is, but embellished.'"[1]

An attempt to relate Girodet's self-contradictory ideas
to his actual portrait painting does not suggest any definite
conclusions. The artist's portraits, like his writings, show
a great variety of often paradoxical conceptions.

It is difficult to evaluate the part of Lavater's ideas
in Girodet's portraits. Undoubtedly, his influence can be
seen in the painter's caricatures of the _Carnet de Rome_[2] (fig.
10) or those of the _New Danaë_[3] (fig. 26). Perhaps the same
influence, which was so important in spreading the fashion
of profiles, silhouettes, and of Chrétien's _Physionotrace_,[4]

1. Girodet, _OEuvres posthumes_, op. cit., I, _Veillées_, IV,
p. 391. The painter was quoting from Gentil Bernard.
2. This type of caricatural profiles, represented in suc-
cession and overlapping each other, is frequently found in the
work of Lavater (as for instance in the French edition, op. cit.,
La Fite, Caillard, and Reufner trans., I, pp. 187 and 248-249).
The caricaturized women of the _Carnet de Rome_ (fig. 10) in turn
express intense joy, surprise, and sadness. It may be sugges-
ted that they correspond to Girodet's account of the changing
emotions of _Mesdames_, the king's aunts who had taken refuge in
Rome at the beginning of the Revolution, at the news of the
flight of Louis XVI to Varennes: "On the day of the great
news, the portrait of _Mesdames_ has been sketched, with strongly
uplifted corners of the mouth. However, if it is finished, I
think that it will be necessary to lower them." (_Lettres
adressées au baron François Gérard_, op. cit., I, Letter of
Girodet, Rome, July 13, 1791, p. 179). This identification
is to a certain degree corroborated by the coiffures of Giro-
det's caricatures, suggesting an earlier fashion of the time
of Louis XV.
3. _Supra_, p. 169.
4. It was a pseudo-scientific device enabling the artist to re-
produce the profile of the sitter by projecting his shadow on a
transparent screen. The small engraved profiles of Chrétien, work-
ing in collaboration with the miniaturist Fouquet, were very popular
during the Revolutionary years.

was indirectly responsible for Girodet's delineation of some
sensitive profile-portraits such as that of Mademoiselle Bec-
querel[1] or Gérard[2] (fig. 58). Moreover, the rendering of
some of Girodet's sitters, like J. J. Belley[3] (fig. 65),
Raymond de Sèze[4] (fig. 63), or Dr. Trioson[5] (fig. 87), with
their strongly accented and scrutinized features, could also
be interpreted as a possible echo of Lavater's theories.
This is suggested by some of Boutard's comments on the
strongly characterized portrait of the Mameluke which was
exhibited in the Salon of 1804.[6] In these comments, the
critic, without specifically naming Lavater, praised Girodet
for having followed some of the most typical ideas of the
Swiss philosopher:

> ". . . not only the features, but also the age, the man-
> ners, the complexion of the personage . . . His long
> white beard and the shape of his clothes are not the
> only signs by which I can recognize his age and deter-
> mine under what sky he was born. Even if only the torso
> of this portrait remained, one would still be able to
> realize . . . that it was the torso of an old man, of a

1. Drawing; Pilleuil Collection, Montargis.
2. 1789; a drawing engraved by François Girard, reproduced
in Correspondance de François Gérard, Henri Gérard ed., Paris,
Laine et Havard, 1867, facing p. 40. It must be noted that
these profiles are very far from indicating a Lavater-like
characterization. Their interpretation is very subtle, com-
bining the feeling of a delicate fragility with that of a
youthful, impetuous rebellion.
3. An V (1796-1797), Versailles.
4. 1806.
5. In the Lesson of Geography, 1806, Itasse Collection.
6. The painting is now lost and is known only through a
mediocre drawing.

phlegmatic temperament and brought up in the softness of
Oriental life."[1]

One cannot deny that Girodet, through a graphic study of fea-
tures, the choice of a psychologically revealing posture, and
a suggestive setting and accessories, succeeded in achieving
in several cases a very vivid characterization of his sit-
ters. Thus, the attitude of Bourgeon[2] (fig. 64) unmistakably
suggests the conceited sophistication and the elegance of a
dandy; that of de Sèze (fig. 63), the saddened dignity of a
frustrated aristocrat; and that of Chateaubriand[3] (fig. 66),
the lyrical isolation and the rebellion of a poet. However,
it is evident that the general idea of such characterizations
continued an old tradition, as for instance that of Maurice
Quentin de La Tour, specifically mentioned by Girodet, and
by no means needed the justification of a possible influence
of Lavater. One can suggest that Lavater's theories could
have been used by the critics or by Girodet himself as a
fashionable explanation without having necessarily been his
guiding principle.

Whatever the influence of Lavater, the painter's ten-
dency toward uncompromising characterization was far from being

1. "Salon de l'an XII -- no. IX," Journal des Débats, Novem-
ber 15, 1804.
2. 1800, Chaix d'Est-Ange Collection. Coupin dated the
painting 1798 (Girodet, OEuvres posthumes, op. cit., I, Liste
des principaux ouvrages de Girodet, p. lix).
3. 1808, Versailles.

typical of all his portraits. A great number of them, such as that of Queen Hortense[1] (fig. 77), Guiseppe Pavrega[2] (fig. 62), La Belle Elisabeth,[3] or Romainville Trioson[4] (fig. 87), show various degrees of idealization which sometimes reaches an almost saccharine quality. A typical case can be seen in the portrait of Madame de Prony (fig. 78), who was described as always having been of the same age.[5]

These parallel tendencies toward a strong characterization and a flattering idealization were frequently simultaneous and occasionally appeared in the same painting, as in the case of the Lesson of Geography (fig. 87). The causes of this seemingly paradoxical situation appear to have been fairly simple. In general, Girodet's attitude, regardless of any of his theories on portraiture, was influenced, on the one hand, by political or social considerations, and on the other, by the personality of the sitter and the artist's own feeling of congeniality toward him. To a certain degree, this attitude explains the abyss which separates Girodet's neutralized idealization of Napoleon from his acute characterization of Belley or the sympathetic subtlety which marks the depiction of the members of his family.

1. Filleull Collection, Montargis.
2. 1795, Marseille.
3. Lithographed by Aubry-Lecomte.
4. In the Lesson of Geography, 1806, Itasse Collection.
5. In the verses appearing in Aubry-Lecomte's lithograph (fig. 79) (1822) of the painting, which was executed in 1810 and is now in the Museum of Orléans.

It can be seen that a consideration of Girodet's portraiture from the point of view of his own ideas does not provide telling results. It is necessary to study his portraits, not on the basis of a simplified formula opposing characterization to idealization, but rather in their relation to the development of specific trends and types.

Girodet's portraits are very unequal from the point of view of quality or historical significance. It would be tedious and unrewarding to consider this production in its entirety. Many of the painter's portraits, as for instance the effigies of apparat of Napoleon[1] (fig. 74), Charles Bonaparte[2] (fig. 75), and Louis XVIII,[3] or the series of busts, such as those of Larrey[4] (fig. 76) and Boucher,[5] show little more than the general mediocrity of the time. It is much more important to trace the formation of certain conceptions which, though characteristic of the period, reveal the individuality of Girodet's contribution.

The starting point for the study of the development of Girodet's types is his 1789 oval portrait of Dr. Trioson[6] (fig.

1. Girodet received the commission for thirty-six identical portraits of Napoleon for all the Courts of Appeal of France (see p. 230).
2. 1804, Versailles. Charles Bonaparte was the father of Napoleon.
3. Pérignon, op. cit., p. 25, no. 134.
4. 1804, Louvre.
5. 1819, Versailles.
6. Montargis Museum. The date is taken from Coupin's Liste des principaux ouvrages de Girodet (Girodet, OEuvres posthumes, op. cit., I, p. lix).

59). This painting is strongly suggestive of the mood of
the eighteenth century.[1] Dr. Trioson, with his scarf care-
lessly tied around his neck, makes one think of the familiar,
intimate conception which was exemplified by so many por-
traits of Encyclopedists, homme? de lettres, or artists of
the eighteenth century.[2] The features of Girodet's sitter
give a strong feeling of immediacy. His mouth, slightly
open, suggests the beginning of a smile, while his eyes, al-
most humid with their exaggeratedly highlighted pupils, seem
to follow the onlooker. Dr. Trioson is conceived as a typi-
cal homme sensible of the reign of Louis XVI, as ready for
Voltaire's irony as for Rousseau's tears. While the strong
modelling is reminiscent of David, the emotional quality is
more suggestive of Madame Vigée-Lebrun or Greuze.

The homme sensible, exemplified by Girodet's portrait
of Dr. Trioson, typified for Diderot's contemporaries the

1. The portrait of Dr. Trioson is representative of a
group of Girodet's portraits of the members of his family,
painted between 1781 and 1789. In this group, the eighteenth
century flavor is suggested by an occasional use of pastel,
as in the case of the portrait of Antoine-Florent Girodet,
the father of the artist, painted by the latter at the age of
fourteen (mentioned by Coupin in his Liste des principaux ou-
vrages de Girodet (Girodet, OEuvres posthumes, op. cit., I,
p. lix). It is also indicated by the frequent recurrence of
an oval frame, exemplified in the portraits of Monsieur Cornier
(idem), Mademoiselle Cornier (idem), and Girodet's brother (idem,
Filleuil Collection, Montargis).
2. For instance the Portrait of an Artist, attributed to
Watteau, in the Louvre, or the portrait of Diderot by Frago-
nard. David's portrait of Leroy (1783, Fabre Museum, Mont-
pellier), shows the continuation of the same conception.

most cherished virtues _du coeur et de l'esprit_. The men of
one of the most literary centuries of all time could not re-
fuse to this ideal type the indispensable power of creation
in the various fields of culture. From this attitude was
probably derived the concept of representing the sitter,
naturally an _homme sensible_, in the very act of creation,
burning with the fire of inspiration. The most vivid illus-
tration of this theme can probably be seen in Fragonard's
portrait of Monsieur de la Bretèche, generally known by the
title of _Inspiration_[1] (fig. 60). The personage, holding a
pen, is seated at a table covered with papers on which he is
about to write. His head is forcefully turned, and his glance,
directed outside the field of the picture, seems to receive
the divine spark. This theme, undoubtedly one of the most
emotionally representative conceptions of the reign of Louis
XVI, was repeated ad infinitum with many possible variations.
David, in his portrait of Lavoisier[2] (fig. 61), used the
same idea, though complicating it by introducing a second
personage, Madame Lavoisier, conceived as the source of her
husband's inspiration.[3]

Girodet executed two portraits which seem to have been
derived from the theme of the inspiration-portrait. They are

1. 1769, Louvre.
2. 1788, Rockefeller Collection.
3. This idea had already been used by J.-B. Perronneau in
his portrait of Monsieur and Madame Oudry (1753, Private Col-
lection).

those of Guiseppe Favrega[1] and Raymond de Sèze,[2] painted in
1795 and 1806 respectively. These paintings show Girodet's
development of the inspiration-portrait during the Revolu-
tionary and Imperial period.

In the portrait of Favrega (fig. 62), the attitude of
the sitter, which seems to have been inspired by David's
Lavoisier (fig. 61), as well as the accessories, continue in
a general manner the tradition of the type. However, the
momentary feeling is completely eliminated. The sitter is
not the homme de lettres sensible creating amidst an inspira-
tional fever, but a man lost in a vaguely Wertherian, melan-
choly dream.[3] This feeling is stressed by the idealized
features of the personage, the mysterious chiaroscuro, and
the relative scale of the figure, isolated in the largeness
of the canvas. While using the staging of the inspiration-
portrait, Girodet conceived his sitter as the melancholy hero
typical of the emotional trends of the late eighteenth cen-
tury.[4]

1. The title under which this painting is exhibited in the
Museum of Marseilles, Portrait of Guiseppe Favrega, Doge of
the Republic of Genoa, appears to be erroneous. There is no
Genoese Doge of that name.
2. He defended Louis XVI during the trial of 1792-1793.
3. It is interesting to compare Favrega's left hand (fig.
62) with that of Fragonard's de la Bretèche and David's La-
voisier (figs. 60 and 61, respectively). In Girodet's paint-
ing, the left hand is represented as nonchalantly hanging over
the sitter's thigh; in Fragonard's painting, the sitter seems
to rise by supporting himself on his left hand; and in David's
painting, Lavoisier's hand seems to underline his words.
4. Supra, p. 221 ff.

The portrait of de Sèze (fig. 63) shows a further
evolution. As in the case of Favrega, the presentation of
the sitter is reminiscent of the earlier inspiration-portrait.
However, this conception is now combined with another tradi-
tional type of portraiture. In this type, exemplified by
David's portrait of Monsieur Desmaisons,[1] the personage was
represented in a rather formal and self-conscious attitude,
seated at a table and looking at the spectator without any
particular action or emotion.[2] In his portrait of de Sèze
(fig. 63), Girodet suppressed all the traces of emotional
poetization or intimacy characteristic of the inspiration-
portrait as well as of Favrega. Fully aware of being painted,
de Sèze is looking directly at the spectator, posing with a
serious air of semi-official dignity. The numerous acces-
sories which surround him symbolically point out his individ-
ual achievements.[3] Thus, after having attempted, in his
Favrega, to infuse the inspiration-portrait with the concept

1. 1782, David Weill Collection.
2. It could be suggested that this type is the only source
for the portrait of de Sèze. However, the resemblance between
de Sèze and Favrega is too striking to ignore the probability
that Girodet was thinking of his portrait of 1795 while paint-
ing that of 1806.
3. The statuette of Hermes and the tomes of Cicero, Demos-
thenes, and Isocrates underline de Sèze's fame as an eloquent
lawyer. More specifically, the volume of Cicero's oration Pro
rege Dejotaro, on which de Sèze is leaning, alludes to his de-
fense of Louis XVI, during the latter's trial by the members
of the Convention. The idea of making a parallel between de
Sèze's plea for the French monarch and Cicero's defense of
the unjustly accused king of Galatia, Deiotarus, is naturally
typical of Girodet.

of the melancholy hero, Girodet completely abandoned this
idea in the portrait of de Sèze. The type was no longer used
by the painter as a basis for a poetized, emotional portrait-
ure.[1] The reasons for this change were probably of a complex
nature. On the one hand, the inspiration-portrait was a part
of the old rococo repertory. On the other, it compelled the
sitter to take an attitude too full of action, difficult to
reconcile with the dreamy languor which was to be required in
the new poetic characterization.

A group of three portraits, J.-J. Belley[2] (fig. 65),
Chateaubriand[3] (fig. 66), and the Baron Auguste de Staël,[4]
characterizes Girodet's new idea of a poetized masculine
portraiture. In this conception, the sitter, standing in a
classicizing attitude reminiscent of the Praxitelean Faun of
the Capitoline Museum, is represented isolated in an open

1. However, the old eighteenth-century tradition was con-
tinued in such portraits as David's Alexandre Lenoir (Louvre)
as late as 1817.
2. 1798, Versailles. Belley was a former slave who became
the député of Saint-Domingue. His portrait was one of the
works which contributed most to Girodet's reputation. It was
enthusiastically praised by the contemporary critics. Among
many others, Chaussard wrote: "It is one of the most know-
ingly painted paintings that I know of. I advise several
artists to study this painting; it will cause their despair
or their genius. I shall often go to dream before this por-
trait. So many sublimities! Raynal, the freedom of negroes,
and the brush of Girodet." (Chaussard, "Exposition des ou-
vrages de peintures, sculptures, architecture, gravures" tirée
de La Décadaire, 1798, Deloynes, op. cit., XX, 539, Ms., p.
118).
3. Supra, p.259 , note 3.
4. Château de Coppet.

landscape, leaning against a piece of architecture. The fig-
ure rises well above the low horizon and is emphatically
silhouetted against the sky, which occupies by far the larg-
est area of the background. The remaining part of the land-
scape is fragmentary and appears in the far distance.[1] In
this conception Girodet was undoubtedly inspired by the
traditional type of aristocratic portraiture which, formu-
lated by Van Dyck, was broadly exemplified in the English
painting of the eighteenth century.[2] Several factors differ-
entiate this traditional conception from that of Girodet. In

1. Certain elements of the background are directly related
to the personality of Girodet's sitters. In the portrait of
Belley (fig. 65), the landscape seems to be anonymous and
classicizing. However, the bust on the left of the sitter is
that of Guillaume Thomas François Raynal, the "eloquent advo-
cate of colored peoples." One of the contemporary critics
wrote: "If he /Belley/ has been embracing the sacred image
/of Raynal/, one could have entitled this painting: homage
of gratitude." ("Exposition des peintres vivans commencée
le 19 Juillet 1798," Mercure de France, Deloynes, op. cit.,
XX, 538, Ms., p. 34.) Raynal's bust reproduced by Girodet
was probably the work of Espercieux, exhibited in the Salon
of 1796 (Explication des ouvrages de peinture, sculpture,
architecture, gravures, dessins, modèles, etc., exposés dans
le grand Salon du Musée central des Arts, Paris, Impr. des
Sciences et Arts, 1796, p. 95, no. 614). In the portrait of
Chateaubriand (fig. 66), as has been seen (p. 259), the view
of the Colosseum alludes to the writing of Les Martyrs. In
the portrait of Auguste de Staël, a view of the Château and
of the lake of Coppet, traditionally associated with Madame
de Staël, appears in the background (Léandre Vaillant, "Le
Château de Coppet," L'Art et les Artistes, XVII, April-Sep-
tember 1913, p. 167).
 2. For instance the portrait of John Eld by Gainsborough
in the Boston Museum of Fine Arts. It must be stressed that
this type was by no means limited to England. It belongs to
the general baroque European tradition, as can be seen for in-
stance in the self-portrait of Augustin Coppens (1695-1700) in
the Royal Museum of Brussels.

the portraits of the French painter, the landscape suggests
an idyllic serenity and a sobriety devoid of the exuberance
or the drama which often qualify the English conception.
Moreover, the emotion reflected by Girodet's personages is
an internal one, without the aristocratic baroque buoyancy
of the traditional prototype. Girodet's interpretation
stresses a certain classical simplicity as well as a mood
of melancholy meditation and lyrical isolation which echoes
the two indispensable qualities of the nascent Romanticism.
These three portraits by Girodet represent a type characteris-
tic of the early nineteenth century, amply exemplified by
such different artists as Madame Vigée-Lebrun[1] or Ingres.[2]

In 1824, this type was used by Girodet as a basis for
another characteristic form of early nineteenth-century por-
traiture, the historical portrait en action,[3] exemplified by
the effigies of two Vendean generals, the Marquis Charles de
Bonchamps (fig. 67) and Jacques Cathelineau[4] (fig. 68). The

1. For instance the portrait of William, third Earl of Rod-
nor, 1800, Longford Castle.
2. For instance the portrait of Monsieur Cordier, 1811, Louvre.
3. This is the term used by Coupin (Girodet, OEuvres post-
humes, op. cit., I, Liste des principaux ouvrages de Girodet, p.
lxj). This type of portraiture, representing a military hero
placed in a setting alluding to a famous battle, was most fre-
quently illustrated during the Imperial period, as can for in-
stance be seen in Gros' Fournier-Sarlovèze (1812, Louvre).
4. Both of these portraits are in the Museum of Cholet.
Girodet's paintings seem to have been executed in relation to
the numerous commissions ordered by the government of the
Restoration to celebrate the royalist heroes who opposed the
Republican armies during the wars of the Revolution.

conception of these portraits is even closer to the original
English prototype than the paintings of the previous group.
The personages are now represented in full length and are
placed in a landscape which is much more spacious and pictur-
esque than in the case of Belley (fig. 65) or Chateaubriand[1]
(fig. 66). Moreover, one can note that Girodet attempted to
stress the emotional atmosphere of his portraits by qualify-
ing the action of the personages. Bonchamps (fig. 67), who
has just been wounded, is represented about to write his
famous order[2] to pardon the Republican prisoners held in the
Church of Saint-Florent-le-Vieil, which is depicted in the
background of the painting. Cathelineau (fig. 68), placed in
a typical Vendean landscape marked by a Calvary Cross,[3] is
represented holding his saber and giving his troops the order
to attack.[4] In spite of these specific characteristics,
Girodet's personages are too closely related to the group
exemplified by Belley and Chateaubriand[5] to suggest any
convincing action. Their facial expression, softened by an

1. This factor itself stresses the relation of Girodet's
conception to that of the traditional English portraiture.
2. "Mercy for the prisoners, I want it, I order it!" (Quoted
in Georges Chesneau, Les OEuvres de David d'Angers; Catalogue,
Angers, Impr. Centrale, 1934, pp. 32-33) The inscription GRACE
AUX PRISONNIERS, which appears on the rock behind the figure
of Bonchamps, evidently alludes to the same order.
3. This Cross as well as the rosary worn by Cathelineau prob-
ably refer to the well-known piety of the royalist hero who had
been often called the Saint of Anjou (Stendhal, Mélanges d'art
et de littérature, op. cit., Salon de 1824, p. 207).
4. Stendhal believed that Cathelineau's expression was that
of an "angry peasant" (idem).
5. The attitude of Bonchamps repeats in reverse that of
Belley.

emphatic chiaroscuro treatment,[1] indicates the same melancholy dreaminess and is in complete contrast to their action. Stendhal considered this disparity one of the most striking paradoxes of the Salon of 1824.[2] Regardless of this quality, or perhaps because of it, these two portraits emanate a certain restrained charm which is completely lacking in the great majority of the portraits en action of the same period.[3] Girodet did not attempt to exploit the possibilities of the portrait en action in the manner of Gros. The portraits of Bonchamps and Cathelineau lack the extrovert self-assertion, the bravura, and the picturesque theatricality which were characteristic of portraits en action such as Gros' Fournier-Sarlovèze. For Girodet, the poetic mode in portraiture always remained that of a soft, Leonardesque melancholy, regardless of whether his sitter was a poet or a military hero.

A group of drawings reveals a more directly literary and fantastic type of Girodet's portraiture. This group, perhaps composed of projects for paintings which were never executed, includes the imaginary effigies of Raphael[4] (fig. 69)

1. This chiaroscuro was the object of a particularly bitter attack by Stendhal. He wrote: "It is impossible that the shadows of a figure represented in open air have the black tonality, to which the desire to produce an effect has led Girodet." (Stendhal, Mélanges d'art et de littérature, op. cit., Salon de 1824, pp. 206-207.)
2. Idem, p. 207.
3. For instance the portraits of other Vendeans: Nicolas Stofflet, Henri de la Rochejaquelein, or François-Athanase de Charette.
4. 1820, lithographed by Sudre. It was conceived as an illustration for Le Peintre (Girodet, OEuvres posthumes, op. cit., I, facing p. 198).

and Michelangelo[1] (fig. 70), studies of Napoleon[2] (fig. 71), and the portraits of Canova[3] (fig. 72) and Firmin Didot[4] (fig. 73). In these drawings, the personage, more exactly his head, or at most his bust, appears suspended in the air and seems to be mysteriously emerging from a cloudy atmosphere, like an Ossianic ghost.[5] This conception seems to suggest an esoteric or an almost visionary trend. Girodet's personages appear as if transposed to a supernatural level, being conceived almost as their own ghosts. It would probably be in vain to look for the precise meaning of this idea. While the original inspiration was undoubtedly derived from Ossian,[6] one may suggest that Girodet wanted to express poetically some kind of transcendental existence of his personages, fused in the continuity of time and space and emphatically isolated.[7]

To these types of Girodet's masculine portraits corresponds a parallel conception of feminine representations. Such

1. 1820, lithographed by Sudre. It was executed for the same purpose as Raphael (Girodet, OEuvres posthumes, op. cit., I, Le Peintre, facing p. 90).
2. 1812, engraved by Maile. These are two studies of Napoleon's head drawn by Girodet in the Emperor's chapel.
3. Louvre.
4. 1823, Louvre.
5. Raphael (fig. 69) and Michelangelo (fig. 70) appear surrounded by personages derived from their paintings: the Christ from the Transfiguration, the Madonna della Seggiola, and figures from the Sistine Chapel. Canova (fig. 72) and the heads of Napoleon (fig. 71) are surrounded only by clouds and stars, while in the portrait of Didot (fig. 73) there is a suggestion of an Alpine landscape.
6. In the frontispiece of Letourneur's translation (op. cit., I), Ossian is represented in an almost similar manner.
7. This interpretation would not be too far-fetched in regard to Girodet's Neo-Platonic leanings.

works as the portrait of Queen Hortense[1] (fig. 77) or that of
La Belle Elisabeth[2] can be considered characteristic examples
of Girodet's interpretation, which was evidently inspired by
Italian Renaissance models.[3] In these representations, Giro-
det's emphasis seems to have been placed not so much on mel-
ancholy as on a feeling of dreamy, enigmatic sensuousness,
suggested by the Leonardesque smile of the sitter and the
soft sfumato of the atmosphere. This mood is echoed by the
staging. Girodet's sitter appears in a dark grotto, through
the opening of which one can see a waterfall, rocks, and
trees. The general conception of such a portrait is typical
of the early nineteenth century and is abundantly reflected,
with variations, in the works of many of Girodet's contempo-
raries like Gérard.[4]

Girodet's portraits of children are incontestably
among his most interesting works. His representations sug-
gest neither the sprightly self-assurance of the little
gentlemen of Chardin[5] nor the saccharine sentimentality of
the children of Madame Chaudet.[6] Girodet's portraits are
marked by a very individual and perceptive quality for which

1. Filleuil Collection, Montargis.
2. Girodet's model, celebrated for her beauty.
3. La Belle Elisabeth seems to combine elements from Mona Lisa and Titian's Laura de' Dianti.
4. For instance in his portraits of Madame Barbier-Wal-bonne and Madame Visconti, both in the Louvre.
5. For instance, L'Enfant au toton, Louvre.
6. For instance, Petite fille qui veut faire apprendre les lettres de l'alphabet à son carlin.

they deserve an almost unique place in the art of the last
years of the eighteenth century. This quality is manifested
in such works as the drawing of the young girl in the Museum
of Besançon,[1] (fig. 80), revealing Girodet's particularly
sensitive understanding of certain moments in which the
delicate fragility and the subtle sadness of childhood are
felt with an almost pathetic intensity.

Girodet's most important paintings of this kind are
undoubtedly the two portraits of Romainville Trioson, the
young son of the artist's foster-father, both painted in the
very last years of the eighteenth century.

The earliest of these two portraits[2] (fig. 81) shows
Romainville as a very young boy, with long hair falling on
his shoulders and giving him a girlish appearance.[3] He is
represented seated at a table, looking at the spectator, and
turning the pages of a volume of the Figures de la Bible
placed before him. An ivory cup-and-ball is protruding from
the pocket of the boy's trousers, and mingled playing cards
appear in the half-open drawer of the table. The general
conception of this portrait is reminiscent of some of the
most typical child-representations of the eighteenth century.
The attitude of the boy, as well as the idea of depicting him

1. 1816.
2. Salon of 1798, no. 195; private collection, Montargis.
3. This portrait was exhibited in 1936 under the erroneous
title of La Jeune Trioson.

turning the pages of a book, seem to have been derived from
such portraits as Perronneau's Child with a Book.[1] Playing
cards had an important part in the iconography of the child-
portraits of the eighteenth century, as for instance in
Chardin's The House of Cards[2] (fig. 82), or Card-Tricks.[3]
The idea of associating children with cards, representing
them blowing bubbles,[4] or playing with such toys as tops,[5]
camouflets,[6] knuckle-bones,[7] or, as in the case of Girodet's
portrait, cups-and-balls, seems to have been used as a tradi-
tional allusion to the fragility of youthful dreams and to
the unpredictable hazards of life.[8] Finally, the Figures de
la Bible, open to a passage of the story of Tobit,[9] refers to
the filial love of the young Romainville, a virtue which was
most admired during the Revolutionary period and which inspired
such works as Boizot's Filial Piety.[10] The Figures de la Bible

1. Hermitage Museum, Leningrad.
2. National Gallery, Washington.
3. National Gallery of Ireland, Dublin.
4. Chardin, Metropolitan Museum, New York.
5. Chardin, Louvre.
6. Drawing by Cochin, engraved by N. Dupuis.
7. Chardin, Baltimore Museum.
8. For instance the following legend appears under The
House of Cards, a drawing by Cochin, engraved by N. Dupuis:
 "You are building, charming child,
 The lightest wind destroys your construction:
 In his plans, wavering man
 Feels the same instability."
Theodore Rousseau studied the symbolism of the theme of blow-
ing bubbles in his "A Boy Blowing Bubbles by Chardin," The
Metropolitan Museum of Art Bulletin, Vol. VIII, no. 8, April
1950, pp. 221 ff.
9. The title, partially hidden by the right hand of Romain-
ville, appears on the top of the page. The other page, held
open by the boy's left hand, is mostly unreadable and seems to
refer to Saint Ambrose and Saint John Chrysostom.
10. Salon of 1795, no. 1010.

also makes one think of Girodet's verses in Le Peintre:

"The old woodcut in his Old Testament
Plunges him into ecstasy and rapture."[1]

In spite of the illusionistically depicted accessories and
the traditional pseudo-philosophical allusions, the artist
emphasized neither the narrative nor the symbolical aspects
of his portrait. In his interpretation, Girodet seems to
have sympathetically striven to echo a subtly fugitive sug-
gestion of the boy's helplessness and of an almost frightened
expectancy.

The second portrait of Romainville Trioson[2] (fig. 83),
painted in 1800, shows a further departure from traditional
eighteenth-century child-portraiture. The young boy is repre-
sented standing behind an armchair on which he is leaning.
He is supporting his head with his left hand and is holding
a book of Latin grammar in the other. The armchair is cov-
ered with a great number of heterogeneous objects (fig. 84),
among which one can see a violin, a beetle, fragments of a
nutshell, a piece of bread, a charcoal pencil in its holder,
sheets of paper, and a butterfly pinned on the armchair and
attached to a thread which is entwined around the charcoal
and fastened to the violin. The meaning of Girodet's concep-
tion cannot be as easily understood as in the case of the

1. Girodet, OEuvres posthumes, op. cit., I, Le Peintre,
Chant I, p. 53. This type of theme is not unusual. Thus Drol-
ling exhibited in the Salon of 1800 A Young Man Reading the Bible.
2. Filleuil Collection, Montargis.

earlier portrait. The mood indicated by the attitude and
the expression of Romainville suggests the boy's sensitivity
and dreaminess much more dramatically and conventionally
than in the previous painting. However, it is difficult to
relate this mood to the accumulated accessories displayed on
the armchair. It is impossible to accept literally the ex-
planation provided by the title of A Young Child Studying
his Grammar, under which the portrait was exhibited in the
Salon of 1800.[1] Far from studying his Latin grammar, Romain-
ville seems to be about to let it slip from his hand. The
other educational objects show the same neglect. The violin
is broken, and the sheets of paper are covered with a meaning-
less calligraphy. An understanding of Girodet's idea is
helped by the letters he wrote to the Trioson family. In
these letters, the painter frequently reassured Romainville's
parents on the subject of the mischievousness of the child:

> "I do not think that Romainville's great vivacity and his
> passion for playing with the top should cause Madame Tri-
> oson as much anxiety as it may give her annoyance. Isn't
> this turbulence the distinctive character of this age?
> . . . I would rather hear for a certain time that he is
> wearing out his shoes, his clothes, and that he is break-
> ing his toys, than know that he is up to his neck in his
> books."[2]

1. Explication des ouvrages de peinture et de dessins, sculp-
ture, architecture et gravure des artistes vivans, exposés au
Musée central des Arts, Paris, Impr. des Sciences et Arts, An
VIII (1800), p. 30, no. 169.
2. Girodet, OEuvres posthumes, op. cit., II, Correspondance,
Letter XXXVI, to Dr. Trioson, Rome, July 20, 1790, p. 369. The
same idea is expressed in Girodet, OEuvres posthumes, op. cit.,
II, Correspondance, Letter XXXVIII, to Madame Trioson, Rome,
November 24, 1790, p. 377.

Girodet's indulgence toward Romainville's exaggerated live-
liness corresponds to the general ideas on education as ex-
pressed in Rousseau's Emile:

> "What must one think of this barbaric education . . .
> which binds the child with all kinds of chains, and which
> begins by making him miserable in order to prepare for
> him, in a faraway future, I do not know what supposed
> happiness which he will probably never enjoy? . . . how
> can one see without indignation poor unfortunate children
> submitted to an unbearable yoke and condemned to continu-
> ous labors like convicts . . . The age of gaiety is spent
> amidst tears, punishments, threats, slavery . . .
>
> "Love childhood; encourage its games, its pleasures,
> its lovable instincts."[1]

The idea of depicting the tortures of child-education was
not unusual in the portraiture of the time. Commenting on
Bonnemaison's A Schoolboy Studying his Lesson, Chaussard
wrote in 1798:

> ". . . he is asleep . . . and the book is about to fall
> from his hand which . . . is becoming weaker and heavier
> . . . miserable pedants, you have tormented his child-
> hood! Beware of awakening him."[2]

Thus, Romainville's character, as well as Rousseau's very
popular ideas, suggest an explanation for such details as
the butterfly mischievously pinned to the armchair and the
revenge the boy seems to have taken on his instruments of tor-
ture: the scribbled pages of his grammar and the broken

1. Rousseau, J. J., Emile ou de l'éducation, Livre II,
Paris, Garnier, pp. 56-57.
2. Chaussard, "Exposition des ouvrages de peintures, sculp-
tures, architecture, gravures" tirée de La Décadaire, 1798,
Deloynes, op. cit., XX, 539, Ms., p. 163.

violin repaired with a walnut shell. This idea is further stressed
by the ironic contrast between Romainville's obvious melancholy and
the Latin grammar mockingly open to the declension of the verb gaudere.
To underline this contrast, Girodet emphasized the present tense of the
verb, which appears in capital letters:

GAUDEO, JE ME REJOUIS

It can be noted that, in contrast to Bonnemaison's interpretation,
Girodet did not represent the boy of his portrait asleep and seems to
have stressed his dreaminess as much as his boredom. It is perhaps
significant that one of the contemporary critics described the portrait
of Romainville as that of a "true nebulo,"[1] thereby suggesting a kind
of nebulous day-dreaming. This idea seems to be confirmed by such
details as the walnut shell fragment on the armchair affecting the
likeness of a crescent moon with a human profile, which probably
alludes to the boy's being perdu dans la lune, or the minuscule donkeys
and bats, perhaps the products of his imagination, which emerge from
the various objects displayed on the armchair.[2] A childishly schematic soldier,

1. "Exposition des ouvrages de peinture, sculpture, gravure,
architecture, composés par les artiste vivans," Journal du Bull. universel
des Sciences, des Lettres et des Arts, Deloynes, op. cit., XXIII,
634, Ms., p. 30.
2. One of the donkeys appears upside down in the background
near the angle formed by the open grammar (fig. 84); another donkey,
in almost the same position, can be seen emerging from the piece of
bread, in the general direction of the pencil. Bats are visible on
either side of the pencil, emerging from behind the sheets of paper.

drawn on the open page of the grammar, points toward the word
JE, thus suggesting one of the aspects of the boy's reverie.
Allusions to the heroic cravings of childhood were a not un-
common theme in portraiture, as can be seen, for instance, in
such works as Madame Davin-Mirvault's A Child Preferring
Weapons to his Objects of Education.[1] The combination of the
theme of childish tumultuous revolt against education with that
of day-dreaming by no means exhausts all the implications of
Girodet's portrait. It is qualified by an atmosphere of mys-
tery suggested by the strong chiaroscuro, the cast shadows,
and the bizarre complication of seemingly unrelated objects.[2]

1. Salon of 1801, no. 78.
2. The themes of education and day-dreaming are not suffi-
cient to account for the meaning of all the objects shown on
the armchair. Naturally, it is possible to consider all these
objects as the result of the painter's display of skill, a kind
of illusionistic still life. However, this interpretation does
not seem convincing in regard to Girodet's consistent predilec-
tion for symbols as well as to the fact that some of the objects,
like the moon-shaped walnut shell or the open page of the gram-
mar, undoubtedly have an occult meaning. One can attempt to
explore the meaning of these objects from the point of view of
the already stated themes. The butterfly pinned to the armchair
may figuratively allude to the tortured captive soul of Romain-
ville, chained to his studies. The beetle, having a traditional
French connotation of heedlessness, may refer to the character
of the boy. From this point of view, it may be noted that the
butterfly is connected by a thread to several educational in-
struments of torture, such as the pencil and the violin. Fin-
ally, the piece of the bread and the walnut shells could have
been used to indicate the natural appetite of childhood, a
quality which was stressed by such authors as Cabanis or Rous-
seau (Emile, Livre II, op. cit., p. 159).
 Another interpretation can be derived from the possibil-
ity that the portrait of Romainville is a posthumous one. In
a letter to Girodet, Mulard expressed his sympathy to the pain-
ter over the death of Romainville Tricson. In this letter, he
referred to a painting by David, about to be completed, which
was identified by Coupin as the Sabines (Girodet, OEuvres post-
humes, op. cit., II, Correspondance, note, pp. 313-314). This
would place Romainville's death in 1799, one year before the

These qualities seem to relate the portrait of Romainville
to Girodet's contemporary esoteric paintings like The New
Danaë (fig. 26) or Ossian (fig. 29). It may be seen that
the artist developed the eighteenth-century conception of
child-portraiture into a completely different medium, re-
flecting the strivings shown in his mythological compositions
of the time.

Girodet does not seem to have been particularly fas-
cinated by his own image, and his representations of himself
are much less numerous than those of David. His early self-
portrait at Versailles (fig. 85), executed in Genoa in 1795,[1]
seems to continue the traditional formula for self-portraits

2 (Continued from preceding page).
portrait, which is signed and dated 1800. In such a case,
which is far from being certain becauseof the general unre-
liability of Coupin, certain objects displayed in the portrait
could be considered as having a completely different symbolical
meaning. The pinned butterfly could then allude to the death
of Romainville (a classical, orthodox meaning). The broken
violin could have the same significance. The use of broken
musical instruments as symbols of death was not uncommon in
the late eighteenth century, as can be seen in the broken lyre
appearing in the allegorical engraving alluding to the death
of Louis Joseph Xavier François, Dauphin de France (June 4,
1789, Versailles, no. 98). Finally, the beetle could, in
Girodet's painting, replace the scarab as a symbol of resur-
rection (it was described as such in certain iconologies of
the time).
While the first interpretation seems to be more probable,
none is completely satisfying.
1. Attributed to the school of David in Les Arts, no. 55,
July 1906, p. 2. However, there is little doubt that this por-
trait is the one painted for Gros, who had taken care of Giro-
det during the latter's illness in Genoa (Girodet, OEuvres
posthumes, op. cit., I, Liste des principaux ouvrages de Giro-
det, p. lix).

illustrated by Poussin.[1] The first impression suggests the
severe simplicity and the resolute self-assurance of the
seventeenth-century master.[2] Yet, the traditional conception
is qualified by the bizarre attire of the artist, combining
a toga-like cape with a contemporary broad hat. Moreover,
the dishevelled hair and the disquieting intensity of the
glance contradict the superficial impassiveness of the ex-
pression and suggest a deep-set, anxious emotionality. In
this portrait, Girodet makes one think of an esoteric fol-
lower of Maurice Quay.[3] A much later self-portrait in Dijon,
probably executed in 1824[4] (fig. 86), is based on a different
though also traditional idea.[5] Girodet, draped in a carrick
and holding a pencil and a compass, is seated at a table cov-
ered with drawing paper. On the right and behind the artist
appears an Etruscan vase, which probably belonged to his col-
lection.[6] The light color scheme and the simplicity of the

1. As for instance in his self-portrait in the Louvre. The
same type can also be exemplified by Philippe de Champaigne
(Louvre) and by Raphael Mengs (Munich).
2. The same impression is suggested by Girodet's own image
in Hippocrates (fig. 6).
3. The Christ-like, bearded self-portrait of Gros in Ver-
sailles, which the painter gave to Girodet in Genoa, gives
the same impression.
4. Magnin Museum. The dating of this portrait is suggested
by its resemblance to two drawings, one in the Bonnat Museum, LB
718, and the other in the Orléans Museum, no. 744, (frontis-
piece) and to the frontispiece of Girodet's AEneid lithographed
by Lambert and dated 1824 by Coupin (Girodet, Oeuvres posthumes,
op. cit., I, Liste des principaux ouvrages de Girodet, p.
lxiij).
5. For instance, exemplified by David's self-portrait of
1813 (Fleury Collection).
6. Musée Magnin, Dijon, Jobard, 1938, p. 100.

composition underline the classical quality of the concep-
tion. Girodet seems to have represented himself more as
the illustrator of Virgil than the painter of the Deluge.
However, the almost painful intensity of the expression once
more contradicts the traditional quality of the portrait.
It may be seen that in both portraits Girodet was basically
following old Academic forms of self-portraiture. Yet, the
painter could not psychologically subjugate himself to tradi-
tional types. Perhaps in spite of himself, Girodet, through
a pathetic scrutiny of his features, revealed his almost
morbid inner anxiety, echoing his contradictory striving for
traditionalism and originality. Thus, these self-portraits
achieve a strong egocentric quality and almost give the feel-
ing of a confession.

Girodet seems to have been ill at ease in the execu-
tion of group-portraits, a type which is exemplified by only
one important painting, Dr. Trioson Giving a Lesson of Geog-
raphy to his Son (fig. 87), executed in 1806.[1] The theme is
one of the most characteristic of the period. An identical
subject, the Portrait of M. D... Giving a Lesson of Geography
to his Son by De Lubersac, was exhibited in the Salon of the
same year.[2] In general, analogous conceptions, depicting a

1. Itasse Collection. The painting was dated 1802 by Cou-
pin (Girodet, OEuvres posthumes, op. cit., I, Liste des prin-
cipaux ouvrages de Girodet, p. lx). However, the date of 1806
appears in the upper right corner of the painting.
 2. /Chaussard/, Le Pausanias français, op. cit., p. 441.

family group united in study, appeared from time to time in
the salons of the late eighteenth and early nineteenth cen-
turies.[1] The meaning of such portraits was explained by
Chaussard in his comments on Mérimée's Family Scene:

> ". . . woe to all those who do not feel the moving
> quality of these family gatherings. Read, read in the
> first pages of Emile the enchanting scene of the pleas-
> ures related to this comforting exchange of care."[2]

Naturally, besides the sentimental implications of Girodet's
portrait, the very subject of a lesson of geography had a
particular significance in a period which was so fascinated
by travels and discoveries.[3] The accessories and the details
of this painting, such as the globe, the fly, the grapes,
the volume of Caesar's Commentaries, and the bust and tomes
of Hippocrates,[4] show the illusionistic qualities which have

1. For instance, Gérard's Portrait of C... and his Family,
Salon of 1798, no. 192, in which the mother is represented in-
structing her two sons ("Exposition des peintres vivans commen-
cée le 19 Juillet 1798," Mercure de France, Deloynes, op. cit.,
538, Ms., p. 15).
2. Chaussard, "Exposition des ouvrages de peintures, sculp-
tures, architecture, gravures," tirée de La Décadaire, 1798,
Deloynes, op. cit., XX, 539, Ms., pp. 171-172.
3. Chaussard wrote in his Pausanias français: "Travels are
a fertile mine for the artists . . . /they/ have the double
merit of exciting curiosity and interest. They can be praised
for their novelty." (Op. cit., p. 428.)
4. Naturally some of these accessories allude directly to the
profession of Dr. Trioson. However, as in the case of the 1800
portrait of Romainville, certain details, like the grapes or the
fly, are more difficult to explain. The grapes can be under-
stood as a symbol of the painter's friendship toward the Trioson
family (Noël, op. cit., I, p. 76). The fly can perhaps be con-
sidered as a philosophical allusion, derived from Ossian (op.
cit., Letourneur trans., I, Gaul, p. 193), in which the vanity
of the past fame of great conquerors (in this case Caesar, re-
ferred to by the Commentaries), is opposed to the reality of
such an humble, living creature as a gnat.

already been noted in the single portraits of Romainville Trioson. However, in the Lesson of Geography, one does not feel the unity which, in spite of their complication, characterized these earlier portraits. The specific gestures of the personages do not convey any genuine feeling of movement and fail to show any convincing psychological relation between the father and the son. One is painfully aware that Girodet's intense concentration on individual details prevented him from achieving a coherent whole.

As can be seen, Girodet's contribution to the field of portraiture was a very uneven one. He was not, in contrast to Gérard, considered by his contemporaries a representative portrait-painter of his time. His works seldom received unequivocal praise and were frequently criticized.[1] However, in a few cases, Girodet, because, as wrote Delacroix, "of the tenseness with which he considered the model,"[2] succeeded in capturing some of the emotional and psychological aspects of his time which were not often rendered in the more representative portraits of the period.

1. He was especially criticized for his predilection for details and his exaggerated chiaroscuro (Stendhal, Mélanges d'art et de littérature, op. cit., Salon de 1824, pp. 206 ff).
 2. Delacroix, op. cit., III, p. 426.

CHAPTER VI

LANDSCAPE

CHAPTER VI

LANDSCAPE

Landscape shared with portraiture the disdain of
the classical theorists, who hesitantly granted to this
genre not more than the right to be used as a backdrop for
human figures.[1] One of the critics of the salon expressed
his contempt in different terms by writing in 1791:

> "I shall not tell you anything about landscape, for in
> my opinion it is a genre which should not exist . . . in
> this respect I call upon the man of nature. If one should
> tell him that the fifteen lieues of the horizon which he
> sees from his hut, the sky, the rivers, the seas, the
> enormous oaks which surround him are contained in six
> square pouces, I think that his answer would be a big
> laugh, unless he took a stick."[2]

These extreme opinions were by no means characteristic of all
the contemporary critics.[3] Moreover, they were in direct
contradiction to Rousseau's exaltation of nature as well as

1. Benoit, op. cit., pp. 44-45.
2. Lettres analytiques, critiques et philosophiques sur les
tableaux du sallon, Paris, 1791, Deloynes, op. cit., XVII,
441, pp. 25-26.
3. Benoit, op. cit., p. 76. This is also suggested by the
multiplication of treatises on landscape (idem).

to the current predilection for descriptive poetry, exempli-
fied for instance by Delille's _Les Jardins_. Thus, land-
scapes, which continued to be regularly exhibited in the
salons in a relatively great number, responded to an actual
widespread need.

However, it cannot be denied that from a stylistic
point of view, landscape painting, during Revolutionary and
Imperial times, was evolving through a difficult and confused
phase. Several independent currents characterized the land-
scape painting of the period. The tendencies expressed by
the most significant masters of landscape during the reign
of Louis XVI, such as Joseph Vernet and Hubert Robert, were
still continued by numerous followers. However, the great
majority of the landscape painters of the end of the eighteenth
and the beginning of the nineteenth centuries seem to have
been divided between the _Dutch_ school exemplified by De Marne
and the _Poussinesque_ school illustrated by Pierre Henri de
Valenciennes. The latter attempted to infuse the genre of
landscape with classical ideas paralleling those of David.
For this reason, his ideas, formulated in his _Reflexions et
Conseils_,[1] should be considered, at least in theory, the most
significant of the period. Yet, he never exerted an influ-
ence comparable to that of the painter of the _Horatii_ and did
not succeed in dissipating the confused diversity which was

1. Valenciennes, P. H., _op. cit._

perhaps the most striking aspect of the landscape painting of his time.

Girodet's importance in relation to landscape lies not so much in his very few paintings or drawings as in his intense fervor and his ideas on the subject.

The painter's trip to Italy seems to have played a determining part in his passion for landscape, a passion which he often felt the need to express in his correspondence with Gérard and Dr. Trioson. In his early letters from Rome, Girodet described his admiration for the Italian countryside;[1] spoke of his intentions of visiting, for the purpose of study, such sites as Tivoli, Frascati, Grotta-Ferrata, Albano, and Marino;[2] and mentioned his disappointment at not being able to afford a special type of field easel.[3] At this time, the artist's interest in landscape was expressed in relation to its usefulness to the historical painter:

1. Girodet, OEuvres posthumes, op. cit., II, Correspondance, Letter XXXVI, to Dr. Trioson, Rome, July 20, 1790, p. 369. Writing to Gérard, Girodet said: "Italy is a superb country, and much more precious for itself and its monuments than for its paintings" (Lettres adressées au Baron François Gérard, op. cit., I, Rome, August 11, 1790, p. 151).

2. Girodet, OEuvres posthumes, op. cit., II, Correspondance, Letter XXXVII, to Dr. Trioson, Rome, September 28, 1790, p. 374.

3. Girodet, OEuvres posthumes, op. cit., II, Correspondance, Letter XLI, to Dr. Trioson, Rome, May 15, 1791, p. 390.

". . . it is an occupation which is as entertaining as
it is instructive, necessary to a painter of history,
and much too neglected, as can be easily seen from the
production of many of our artists."[1]

Girodet's fondness for the genre seemed to increase with
time. A few months later, he spoke of his passion for land-
scape,[2] endangered his health by drawing at Virgil's tomb,[3]
or by spending nights sketching near Naples,[4] and dared to
write these words, almost incredible for a former pupil of
David:

"It was in the vicinity of Rome that I was going to in-
dulge this year in the study of landscape, the universal
genre of painting to which all the other genres are subor-
dinated, because they are contained in it."[5]

Girodet's love for landscape seems to have grown under

the influence of Jean-Pierre Péquignot,[6] who was one of his

1. Girodet, OEuvres posthumes, op. cit., II, Correspondance,
Letter XXXVII, to Dr. Trioson, Rome, September 28, 1790, p. 373.
2. Girodet, OEuvres posthumes, op. cit., II, Correspondance,
Letter XLV, to Dr. Trioson, Rome, November 25, 1791, p. 401.
3. Girodet, OEuvres posthumes, op. cit., II, Correspondance,
Letter LV, to Dr. Trioson, Naples, July 25, 1793, p. 437.
4. Girodet, OEuvres posthumes, op. cit., I, Le Peintre,
Chant III, p. 132.
5. Girodet, OEuvres posthumes, op. cit., II, Correspondance,
Letter LIV, to Madame Trioson, Naples, March 1, 1793, p. 431.
Girodet's exalted conception of landscape was not unique. Echo-
ing a similar idea and in contrast to the almost apologetic at-
titude of Valenciennes, a critic of the Chronique de Paris
wrote in 1791: ". . . landscape is the richest, the most var-
ied, the most fruitful of all the genres of painting, for there
is nothing which could be depicted outside the realm of land-
scape." ("De l'exposition de 1791 en général et particulière-
ment de celle des tableaux déjà connus par les précédentes
expositions," Chronique de Paris, Deloynes, op. cit., XVII,
452, Ms., p. 614).
6. (1765-1806 or 1807). Péquignot was a painter of humble
origin, born at Baume-les-Dames. He received the advice of Jo-
seph Vernet before becoming a pupil of David. He spent the
major part of his life in Naples.

most intimate friends during his Italian sojourn. This landscape painter, though completely forgotten today, had a certain reputation during his lifetime and was considered by Girodet a true genius.[1] From a note by Coupin and from Girodet's correspondence, he appears to have been a dipsomaniac, careless of his appearance, avoiding society,[2] and without any ambition for personal success.[3] However, he was interested in music,[4] extremely imaginative, and capable of generous impulses.[5] Coupin described his tendency toward bizarreness and his striving for originality, qualities which seem to have attracted Girodet to him:

"His talent, which had a striking resemblance to that of Girodet, could not fail to impress our great artist who was so sensitive to the charm of anything which bore the marks of originality and beauty. Thus, the first productions of Péquignot which he saw aroused in him transports of admiration, and he always spoke of his friend with enthusiasm."[6]

There is little doubt that Péquignot's ideas, though practically unknown, played a considerable part in the formation of Girodet's theories on landscape.

1. Girodet, OEuvres posthumes, op. cit., I, Le Peintre, Notes du Chant III by Coupin, p. 299.
2. Idem, p. 298.
3. Girodet, OEuvres posthumes, op. cit., I, Le Peintre, Chant III, p. 134.
4. Girodet, OEuvres posthumes, op. cit., I, Le Peintre, Notes du Chant III by Coupin, p. 298.
5. Girodet, OEuvres posthumes, op. cit., I, Le Peintre, Chant III, p. 134.
6. Girodet, OEuvres posthumes, op. cit., I, Le Peintre, Notes du Chant III by Coupin, p. 299.

Girodet's belief that landscape should be considered
"the universal genre of painting to which all the other
genres are subordinated" seems to correspond to several of
his philosophical ideas. These ideas, derived from hetero-
geneous sources, were never arranged in any unified, coherent
system. Their only common factor can be found in Girodet's
persistent emphasis upon the universal significance of land-
scape. Some of these ideas were inspired by the attitude of
the Encyclopedists. Thus, the painter's frequent references
to the preconceived harmonies of nature[1] are directly remin-
iscent of Bernardin de Saint-Pierre,[2] while his conception
of landscape as a chaotic result of the geological struggles
of elements[3] was evidently derived from Buffon.[4] There are
also suggestions of a Neo-Platonic mysticism. Girodet spoke
with reverence of Venus Urania, the "spiritual soul of the
world."[5] Pantheistically, its influence is diffused throughout
nature:

"From Man endowed with an immortal principle
To the worm which crawls and does not see the sky;
From the eagle to the gnat, from the cedar to the fern;
Everything speaks to the painter, everything, the proud
 mountain,

1. Girodet, OEuvres posthumes, op. cit., II, Dissertation
sur la grâce, p. 155, or for instance, Girodet, OEuvres post-
humes, I, Le Peintre, Chant III, p. 123.
2. Etudes de la Nature, 1784.
3. Girodet, OEuvres posthumes, op. cit., I, Le Peintre,
Chant III, p. 133.
4. Epoques de la Nature, 1778.
5. Girodet, OEuvres posthumes, op. cit., II, Dissertation
sur la grâce, p. 130.

The haughty ocean, and the humble brook
Running on the grass in small rivulets.
The torrent which is gushing amidst abysses;
The glaciers, the avalanche and its sublime fall;
The veil of the fogs and the lightning of the volcanoes;
.
Everything charms his eyes by varied contrasts:
It is for the painter . . . that God made the universe."[1]

For the artist, the contemplation of nature is an almost
mystical experience:

". . . the sources of admiration continually succeed
each other, and the emotions are infinitely multiplied
at each step that he /the artist/ takes, at each new
object that he discovers; for such is the power of the
eloquent voice of nature when it is heard by the only
one of the created beings who is worthy of meditating
upon its marvels and of rising by thought to their
divine Creator."[2]

The most significant of Girodet's ideas, frequently
recurring in his writings, is the one in which he stressed
the deep emotional and spiritual relationship between the
elements of landscape and man. For instance, for the artist,
the clouds are "similar to the fleeting and vain thoughts of
men,"[3] and the seas "alternately furious and serene are at
the same time the symbol of the storms of the heart and of
the so often deceiving calm which follows them."[4] These
ideas, which already prophesied the Romantic cliché Le paysage

1. Girodet, OEuvres posthumes, op. cit., I, Le Peintre,
Chant II, p. 102.
2. Girodet, OEuvres posthumes, op. cit., II, Dissertation
sur la grâce, p. 152.
3. Idem, p. 160.
4. Idem.

est un état d'âme, were expressed by the painter in various
ways. They are basically related to the old theory of
Hippocrates,[1] taken over by the eighteenth-century philosophers
like Montesquieu,[2] whereby climate shapes the personality,
the physical appearance, and the emotional behavior of men.[3]
However, Girodet developed this thought far beyond its
pseudo-scientific implications. For him, inanimate objects
like trees or stones are endowed with only a "physical grace-
fulness"; yet:

> ". . . often . . . these objects intensely arouse in us
> the feeling of spiritual gracefulness by the magic of
> sympathetic affections and by the illusions of sensibil-
> ity . . . It is thus that a beautiful location which was
> loved by a charming person preserves from this person,
> in relation to the one who was in love with her, as it
> were the imprint of the gracefulness and the charm which
> were particular to her . . .

> ". . . the impressions of grace and beauty find a new
> strength in the state of our soul and in our memories.
> They are further developed by this continuous reaction
> which sensitive beings exert on each other and by the in-
> fluence of this indissoluble bond which unites them to
> everything which exists in nature.

> "But, even if there were only one living being on the
> earth, if we suppose him to be a man of intelligence and
> sensibility, what would he not feel at the mere aspect of
> the universe? Therefore, how much more powerfully must

1. Airs, Waters, and Places.
2. L'Esprit des lois, 1748. This idea was also developed
by Lavater.
3. Girodet, OEuvres posthumes, op. cit., II, Dissertation
sur la grâce, pp. 151-152. In one of his notes to Le Peintre,
Girodet wrote: ". . . the inhabitant of the mountains differs
from the inhabitant of the plains from the point of view of ex-
terior form, character, and imagination as much as the places
where they live differ themselves from each other." (Girodet,
OEuvres posthumes, op. cit., I, Le Peintre, Notes du Chant I,
p. 210.)

he be moved, since this great theater of marvels is in-
habited by beings who correspond to him in all physical
and spiritual aspects? Undoubtedly, the powerful charm
of all the beauties offered by landscapes is the natural
result of this relation." [1]

Thus, for Girodet, a landscape was potentially a human drama.[2]
To paint a landscape was to create an emotional field of
force, and the chief purpose was to satisfy "the thirst for
feeling and seeing" which Girodet so strongly experienced at
the beginning of his Italian trip.[3]

For Girodet, this concept raised a very important
question: may a landscape be considered a self-sufficient
subject per se, or should it be, as exemplified by Poussin
and advocated by Valenciennes,[4] supplemented by a historical
or mythological scene enacted by personages? Girodet, in his
writings, did not dare to reach the logical conclusion which
could have been derived from his ideas, and only timidly sug-
gested the possibility of a self-sufficient landscape:

"Although I do not entirely agree with the good La Fon-
taine when he says that trees seldom talk, yet I like to
see the location of a scene inhabited; and, if the aspect
of a beautiful landscape pleases me,

'I want to find someone by my side to whom I can tell it.'

1. Girodet, OEuvres posthumes, op. cit., II, Dissertation
sur la grâce, pp. 150-151.
2. This idea occasionally recurred in contemporary writings,
as for instance in "De l'Exposition de 1791 en général et par-
ticulièrement de celle des tableaux déjà connus par les précé-
dentes expositions," Chronique de Paris, Deloynes, op. cit.,
XVII, 452, Ms., p. 614; or Valenciennes, op. cit., p. 309.
3. Girodet, OEuvres posthumes, op. cit., I, Le Peintre,
Chant I, p. 59.
4. Valenciennes, op. cit., p. 397.

These magnificent conceptions of Poussin: Polyphemus, Phocion, Orpheus, Diogenes, which can be compared in painting to the poetic productions of the descriptive genre, would always be admirable by the mere beauty of their majestic sites. However, this very beauty is still increased by the interest added by the presence and the character of the personages put into action by the painter."[1]

In his actual works, Girodet occasionally did follow these ideas. We cannot be completely exculpated from having attempted to suggest through the personages of his landscapes the "heroic," "antique," "lyric," "tragic," or "comic" genres, a tendency shown by such painters as Valenciennes and Rivard, and ridiculed by one of the critics of the Année littéraire.[2] In Girodet's landscapes, besides very minor and almost decorative themes, such as the one of nymphs throwing apples at a sleeping satyr[3] or that of the resting traveller,[4] one can find more specific subjects. Some of them, like the young girl frightened by a snake and falling over a precipice[5] (fig. 88), are of a directly dramatic nature. Others, such as Orpheus[6] or Sappho,[7] are based on definite mythological or

1. Girodet, OEuvres posthumes, op. cit., I, Le Peintre, Discours préliminaire, p. 30.
2. Observations sur les peintures et sculptures exposées au Salon du Louvre tirées de L'Année littéraire, nos. 35-40, De-loynes, op. cit., XVI, 422, Ms., p. 303.
3. Memories of the Alps, lithographed by Châtillon.
4. Memories of Italy, lithographed by Châtillon.
5. Landscape with a Snake, Magnin Collection, Dijon. This subject was one of the most popular of the time, frequently exemplified in the salons, and favored by Valenciennes (op. cit., p. 367).
6. Mentioned by Coupin in his Liste des principaux ouvrages de Girodet, in Girodet, OEuvres posthumes, op. cit., I, p. lxxviij.
7. Idem.

literary sources. However, it must be noted that all these
landscapes with personages are drawings. The paintings, now
lost or destroyed, described by Coupin in his Liste, do not
seem to have included any personages.[1] Similarly, Girodet's
most important extant landscapes, the three paintings in
the Magnin Museum[2] (figs. 89, 90, 91), are devoid of any
human figures,[3] and appear to have been conceived as com-
pletely self-sufficient. Such a conception should not be
approached from a modern point of view and should probably
be understood as the artist's emphasis on the element of iso-
lation, the poetic virtues of which were so often praised in
the contemporary literature.

At any rate, the emotion toward which Girodet was
striving was to be fundamentally achieved by the landscape
itself. For this purpose, the painter had to find a repetory
of emotionally suggestive images.

Girodet frequently expressed his admiration for the
beauty of a classical type of calm and friendly nature

1. Girodet, OEuvres posthumes, op. cit., I, Liste des prin-
cipaux ouvrages de Girodet by Coupin, pp. lvj-lvlj and lxx.
This is suggested by the fact that Coupin seems always to have
been careful to mention the presence of personages in describ-
ing Girodet's landscapes.
2. Dijon. They are exhibited under the titles of The Tor-
rent (fig. 91), Italian Landscape (fig. 89), and A Lake in
the Mountains (fig. 90).
3. In the Italian Landscape (fig. 89), human life is ac-
tively suggested only by smoke rising in the distance from one
of the houses, a device which was also used in the landscape
of the portrait of Belley(fig. 65).

"constantly intent on anticipating . . . /man's/ needs and pleasures."[1] This kind of Poussinesque landscape, qualified by a subtle feeling of melancholy, is well exemplified in such paintings as the Lake in the Mountains (fig. 90) or the Italian Landscape (fig. 89), undoubtedly two of Girodet's best landscapes. However, in his search for an emotional repertory, the artist was frequently inclined toward more violent moods and gave a special importance to what he called "accidents":

> "This profusion, this luxuriance of accidents
> Which water and fire have spread in the fields;
> This strong nature which on these great landscapes
> Lavishes blessings as well as devastations."[2]

Thus, the painter seems to have been particularly fascinated by the features breaking the monotony of a landscape, the striking irregularities of nature suggesting the Buffonian "old chaos of scattered elements."[3] Several landscape drawings in the Carnet de Rome (figs. 92, 93) appear to have been conceived in this spirit of geological upheaval and cataclysmic evolution. This feeling is even more strikingly expressed than in the paintings of Turner. These landscapes of Girodet are marked by deep crevices; bizarre rocks spread through the

1. Girodet, OEuvres posthumes, op. cit., II, Dissertation sur la grâce, p. 166.
2. Girodet, OEuvres posthumes, op. cit., I, Le Peintre, Chant III, p. 133.
3. Idem, Chant I, p. 59.

scene give the impression of a recent catastrophe; and fan-
tastic, Mantegna-like crags seem to be about to crash to
the ground.

While the idea of a geological drama was always la-
tent, it was not always specifically emphasized, and Girodet
often qualified the interpretation of his "accidents" from a
different point of view. Some of the "accidents" seem to
have particularly attracted the painter, and it would be
interesting to consider the meaning attached to such ele-
ments as grottoes, volcanoes, and mountains.

The importance of the grotto in Girodet's art has al-
ready been sufficiently stressed in previous chapters and
does not need any further emphasis.[1] The role of the vol-
cano, in Girodet's writings, was given an even greater prom-
inence. In Le Peintre, one finds a lyrical description of
the nocturnal excursions during which Girodet painted Vesu-
vius in the company of Péquignot:

> "Sometimes we depicted the peak of the volcano
> Covered with snow, peaceful and smoking;
>
> How often did Diana see us, solitary strollers,
> Spend entire nights in the harbor,
>

1. Besides having been used in such paintings as the Pietà
(fig. 11), Democritus (fig. 13), Atala (fig. 49), and Anacreon
(fig. 119), the grotto also appears in Girodet's landscapes,
as for instance in the Landscape with a Snake (fig. 88) in
the Magnin Museum.

. . . when illuminating the fury of Vesuvius
Her gentle light reflected with its silvery luster
The black and smoky slopes of the irritated volcano."[1]

The six studies of Vesuvius mentioned by Coupin[2] probably
represented the result of these nightly wanderings. Girodet
dedicated to the theme of the volcano five pages of the most
exuberantly enthusiastic prose in his Dissertation sur la
grâce.[3] In spite of the confused emotionalism of the writer,
one can note several specific ideas. For Girodet the volcano
appeared to be the richest and the most complete manifesta-
tion of natural forces:

> "Let one imagine, if it is possible, the simultaneous
> apparition of all the most extraordinary forms; all the
> magnificences and all the contrasts of color; the most
> exciting and the oddest plays of light . . . ; all the
> metamorphoses of water; all the combinations of sound;
> all the agitations of air in the terrible struggle which
> all the elements are waging."[4]

Such a spectacle suggests devastation, death, "sublime hor-
rors" which would seem to eliminate "the idea of any associa-
tion with grace."[5] However, the impression is more complex
than it appears on the surface:

1. Girodet, OEuvres posthumes, op. cit., I, Le Peintre,
Chant III, p. 132.
2. Girodet, OEuvres posthumes, op. cit., I, Liste des prin-
cipaux ouvrages de Girodet by Coupin, pp. lvj and lxx. Four
of these studies depicted the volcano in eruption. These
studies were probably the ones from which Girodet was planning
to complete several paintings for the Cabinet d'histoire natu-
relle of Dr. Trioson (Girodet, OEuvres posthumes, op. cit.,
II, Correspondance, pp. 458-459, Letter LX, to Dr. Trioson,
Genoa, June 16, 1795, pp. 458-459).
3. Girodet, OEuvres posthumes, op. cit., II, Dissertation
sur la grâce, pp. 161-166.
4. Idem, pp. 161-162.
5. Idem, p. 163.

". . . let us ask the poets, the painters, and the
musicians who could witness /these scenes/ . . . if,
in the midst of their greatest fear and their most in-
tense emotions, they did not feel an imperious urge to
admire; if . . . they were not transported into a state
of ecstasy."[1]

Artists can derive direct advantages from this contemplation.

How can it fail to impress their minds with the desire to

discover

"amidst this great turmoil some combinations and rela-
tions of forms, sounds, movements, and colors which
would not be completely . . . opposed to the charm of
grace."[2]

The sounds of the volcano perhaps inspired the "orchestral

storms" of Gluck, Sacchini, and Mehul,[3] and its flames gave

ideas to the pyrotechnists.[4] There is no reason why the

painter as well should not take his inspiration from this

source.[5]

Girodet's fascination for mountains almost equalled

his interest in volcanoes. It seems to have originated from

a deep personal experience when the painter discovered the

Alps:

1. Girodet, OEuvres posthumes, op. cit., II, Dissertation
sur la grâce, pp. 163-164. One is reminded of some of the
ideas of Delille or of Stendhal's morbid ecstasy in imagining
his death during a storm, while crossing the English Channel
(Journal, op. cit., IV, May 1, 1811, p. 117).
2. Girodet, OEuvres posthumes, op. cit., II, Dissertation
sur la grâce, p. 164.
3. Idem, p. 165.
4. Idem, p. 164.
5. Idem.

"Everything strikes, everything absorbs and amplifies the
thought
Of the painter, frightened by these vast sights.
Motionless, voiceless, his chest oppressed,
He feels his unsteady knees bend under him;
He dizzily sees vacillating objects;
Overwhelmed but enraptured by the beauty he admires
Only a cry of ecstasy arises from his delirium.
. .
As for myself . . .
. .
At the surprising sight of these threatening rocks,
A new turmoil upset my feelings;
My eyes were devouring skies and abysses,
And my soul was immersed in these sublime grandeurs."[1]

Girodet developed his idea in one of his notes to Le Peintre.
While the mineralogist studies the geological structure of
the mountains, and the botanist considers their flora:

> "the painter . . . lets his imagination wander in the
> infinite combinations of their forms, their movements,
> and their effects. It fills them . . . with fantastic
> beings in harmony with their colossal structure. It
> makes them become the realm of the gods, giants, and
> monsters."[2]

The artist's attraction for mountains can also be seen in
the fact that they constitute an almost permanent part of his
landscape repertory. He had a special predilection for the
Swiss Alps, which he crossed in returning to France from Italy,
and which frequently appear in his landscapes.[3]

1. Girodet, OEuvres posthumes, op. cit., I, Le Peintre,
Chant I, pp. 58-59.
2. Girodet, OEuvres posthumes, op. cit., I, Le Peintre,
Notes du Chant I, p. 210.
3. As for instance in the Memories of the Alps, lithographed
by Châtillon, or the views of the Rheatic Alps, mentioned by Cou-
pin (Girodet, OEuvres posthumes, op. cit., I, Liste des princi-
paux ouvrages de Girodet, p. lvj), one of which probably corres-
ponds to the Lake in the Mountains of the Magnin Museum.

In his concept of "accidents," Girodet stressed the
importance of their essential irregularity and of the ele-
ment of surprise which they provide. This was the reason
for the painter's comparative dislike of French gardens and
his interest in the English type:

> "If gardens with long straight walks and regular quin-
> cunxes have a severe, but often sad and always predict-
> able beauty, the English parks . . . have . . . an un-
> expected pleasantness: their beauty and their very
> gracefulness originate from happy accidents."[1]

Similarly, for Girodet, the factors of unexpectedness and
surprise were directly related to the relative distance at
which the "accidents" appeared in a given landscape:

> "The distant view of the Alps is beautiful and majestic,
> but it arouses only a vague admiration . . . the distance,
> in weakening the aspect of their extraordinary accidents,
> also limits the impression which they unfailingly create
> at a closer view. It is by going through them that one
> meets surprise after surprise. It is in their heart that
> the secret of the enthusiasm which they arouse is kept.
> It is here also that man feels small and weak in the
> presence of these magic palaces of the great architect;
> but, it is this very feeling which reveals and increases
> in him the extent and the energy of thought."[2]

Girodet's preference for close-up views over panoramic concep-
tions reveals an unorthodox approach. The artist himself,
with the exception of the _Torrent_ (fig. 91) in the Magnin
Museum and a few drawings in the _Carnet de Rome_, seldom applied

1. Girodet, OEuvres posthumes, op. cit., I, Le Peintre,
Discours préliminaire, p. 27.
2. Girodet, OEuvres posthumes, op. cit., I, Le Peintre,
Notes du Chant I, pp. 210-211.

this particular point of view, and most often resorted to the classic panoramic solution.

Girodet, in his depiction of "accidents," besides the element of surprise, also gave great importance to the factor of time. As has previously been seen, for the painter, as well as for his literary contemporaries, night was the hour of predilection par excellence,[1] and it can be recalled that he painted several nocturnal views of Vesuvius.[2] However, the question of the time element involved another problem which was expressed in Valenciennes' Reflexions et conseils. Valenciennes advised landscape painters to avoid the depiction of a transitional moment which might create confusion:

> "Although nature is always beautiful . . . in all moments
> of the day, artists have generally noted that by dividing
> the day into four parts one could find in each of them,
> and at a particular moment for each division, more force-
> ful contrasts . . . and more distinct effects."[3]

Girodet seems to have followed this conception in a series of landscapes mentioned by Coupin,[4] depicting the four hours of the day. Yet Girodet, who had expressed so often his fascination for the effects of ambiguity and mystery,[5] could not possibly completely subscribe to this rationalistic point of

1. Supra, pp. 84, 85.
2. Four of the six studies were night scenes.
3. Valenciennes, op. cit., pp. 353-354.
4. Liste des principaux ouvrages de Girodet (Girodet, OEuvres posthumes, op. cit., I, p. lvij).
5. Supra, pp.198 ff.

view of Valenciennes, who specifically warned the artists to refrain from painting sunsets.[1] Thus, writing in Le Peintre, he often revealed his inclination for the subtle uncertainty, "the mysterious harmony and the indecisive struggle" of certain hours.[2] This quality is unequivocally suggested in such landscapes as the Lake in the Mountains[3] (fig. 90) or the Mountainous Seashore at the End of the Day[4] (fig. 94).

With the exception of the backgrounds of Atala (fig. 49), the Rebellion of Cairo (fig. 56), and Paul and Virginie (fig. 52), Girodet did not execute any independent exotic landscape.[5] Yet, his predilection for interesting "accidents" led him to advocate for the landscape painter the right to accompany "'maritime expeditions or to follow our ambassadors'" to distant lands.[6] In this manner, the painter would become a "'professional cosmopolite'" and would not be reduced to "'continuously making pastiches of Orisonti, Le Guaspre, and Poussin.'"[7] Nothing can better render the extent

1. Valenciennes, op. cit., p. 367.
2. Girodet, OEuvres posthumes, op. cit., I, Le Peintre, Chant II, p. 102.
3. Magnin Museum, Dijon.
4. Magnin Museum, Dijon.
5. For Girodet's conception of the exotic landscape, see supra, pp. 277 ff.
6. Girodet, OEuvres posthumes, op. cit., I, Le Peintre, Notes du Chant I, pp. 208-209. The painter wrote that he was quoting from a contemporary pamphlet published by an amateur. In the same passage, Girodet protested against the rule of having the concours open only every four years to the landscape painters.
7. Idem, p. 209.

of Girodet's fascination for unknown or unusual landscapes
with a "physiognomy" than his description of the imaginary,
fantastic sites suggested during the winter on frozen window-
panes:

> ". . . observe, on the windowpanes of our houses, these
> blurred and bizarre landscapes which, during long nights,
> the icy hand of Winter has traced, and which the imagina-
> tion uses as a canvas where it likes to embroider its
> memories and its picturesque creations . . . You might
> think to see there the eternal icy peaks of the Alps or
> of the Pyrenees and the deep pine forests rising on their
> steep slopes. Suggestions of unknown plants often decor-
> ate, with a kind of particular grace, the foreground of
> these fantastic paintings."[1]

These emotional trends and this love for the fantastic
did not influence Girodet to favor a loose vagueness in the
treatment of details. He was also opposed to Valenciennes'
conception of "ideal nature,"[2] "as it should be,"[3] devoid of
any imperfections, with trees represented "tall, majestic,
healthy, and happy in the ground" in which they are growing.[4]
Girodet's attitude toward reality of details was reflected
in his Discours préliminaire for Le Peintre:

> ". . . at first glance and in general, mountains resemble
> other mountains; ruins resemble other ruins; and each
> living being other living beings of his species. The poet
> as well as the painter must strive to grasp in these gen-
> eralities the precise character of the details of which

1. Girodet, OEuvres posthumes, op. cit., II, Dissertation
sur la grâce, pp. 157-158.
2. Valenciennes, op. cit., p. 305.
3. Idem, p. 310.
4. Idem, p. 306.

they are composed, in order to avoid this vague, monoton-
ous, and loose manner, which is the continually recurring
cause of trite representations and of productions with-
out physiognomy."[1]

In his Notice historique, Coupin stressed Girodet's pains-
taking conscientiousness as an example to "young men who
think that one can improvise a painting":[2]

"His studies were so thorough that, to paint a stone,
moss, a blade of grass, nature was always present,
consulted, selected."[3]

Girodet believed that in order to render the specific charac-
ter of reality a direct study from nature should be reinforced
by an almost Leonardesque spirit of investigation. The
painter as well as the poet should:

"deepen his observations rather than extend them; un-
ceasingly turn around the objects he wants to paint;
expose all the sides under different lights, not in or-
der to represent them all, but to provide the possibility
of selecting the aspects the effects of which can, either
by their similarities or by their contrasts, give the
most unity, movement, and interest to his work."[4]

It can be noted that in his most important landscapes such as
the Lake in the Mountains[5] (fig. 90) or the Italian Landscape[6]
(fig. 89), Girodet succeeded in avoiding the additive effect

1. Girodet, OEuvres posthumes, op. cit., I, Le Peintre,
Discours préliminaire, p. 31.
2. Girodet, OEuvres posthumes, op. cit., I, Notice histo-
rique by Coupin, p. xl.
3. Idem, p. xlj.
4. Girodet, OEuvres posthumes, op. cit., I, Le Peintre,
Discours préliminaire, p. 31.
5. Magnin Museum, Dijon.
6. Magnin Museum, Dijon.

and the lack of homogeneity which might have derived from such an approach. He seems to have been very conscious of the importance of the factor of unity in landscape painting. For this reason, as Coupin reported, "The modern school of landscape appeared to him to be on the wrong path."[1] Girodet believed that "the majority of the productions of our day were mere studies, awkwardly sewn together and lacking a primary, generating idea."[2] From his sketches in the Carnet de Rome, it can be seen that he was not studying only isolated elements of landscape, such as stones or trees, but was also attempting to render the general configuration of a given site[3] (figs. 95, 96). Naturally, both the studies of separate elements and the overall sketches were to be combined in the final painting executed in the artist's atelier.

At first glance, it is somewhat paradoxical that Girodet managed, in his writings, to reconcile his love for emotional picturesqueness to his interest in a minute, pseudo-scientific rendering of details. The first tendency seems to reflect the leanings of the late followers of Vernet, like Girodet's friend Péquignot, who, under the influence of contemporary literature, were tending to intensify the Romantic

1. Girodet, OEuvres posthumes, op. cit., I, Notice historique by Coupin, p. xxxix.
2. Idem. Valenciennes also showed his awareness of this danger (op. cit., p. 340). Yet, he did not hesitate to advise the painters to compose their landscapes from isolated studies (idem, p. 348).
3. The best example can be seen in two very sketchy drawings (figs. 95, 96), one of which (fig. 96) shows the written indications of the colors which were to be used later, in the final painting.

emotionalism of their master's art. The second trend appears
to suggest Girodet's awareness of the passion for facts of
the late Encyclopedists, which, at another level, was paral-
leled by the contemporary interest in the illusionistic tours
de force of Boilly.[1] One must note that Girodet's writings
were not an isolated case of such a combination of contrast-
ing trends, which was amply exemplified in the contemporary
literature, as, for instance, in André Chénier's L'Astronomie
or Delille's Les Trois règnes.

In general, it can be said that Girodet's ideas,
though never fully realized in his actual landscapes, and
though frequently echoing the rationalistic theories of
Valenciennes, already significantly pointed toward some of
the most characteristic concepts of Romanticism.

1. At the end of the eighteenth century, illusionism be-
came one of the central topics of discussion among the critics
of the salon. Boilly's trompe-l'oeil paintings such as The
Broken Pane aroused a particularly intense interest (Le verre
cassé de Boilly, et les croûtiers en déroute ou N^lle critique
des objets de peinture et sculpture, exposés au salon, en
prose, en vaudeville et en vers, faisant suite à Gilles et
Arlequin, Paris, An IX, Deloynes, op. cit., XXI, 625, p. 5.

CHAPTER VII

LAST YEARS: MINOR PRODUCTIONS

AND LATE CLASSICAL THEMES

358

CHAPTER VII

LAST YEARS: MINOR PRODUCTIONS
AND LATE CLASSICAL THEMES

The last years of Girodet's life showed a marked de-
cline in his pictorial productivity and inventiveness. The
works discussed in the present chapter are for the most part
related to the period 1810-1824. During this period, the
artist's interest seems to have been divided between themes
derived from the typical early nineteenth-century Romantic
ideas and traditional subjects based on classical history
and mythology. While the former are mostly exemplified by
minor works, drawings, and sketches, the latter are illus-
trated by far more important productions such as the decora-
tions of Compiègne[1] (figs. 115, 116, 117, 118) and _Pygmalion
and Galatea_[2] (figs. 125, 126). This phase can be considered
as follows:

I. The late years of Girodet's life.

II. Minor productions.

III. Late classical subjects.

1. 1822.
2. 1819.

I. This period was marked by Girodet's exhaustion, caused by his efforts of the previous years, an almost continuous illness, and a profound disillusionment. Most of the painter's time and energy seem to have been devoted to literary activity. As a result, the greatest part of his production consists, with very few exceptions, of drawings and sketches.

II. These minor productions reflect Girodet's awareness of the growing contemporary interest in Oriental themes, subjects of the troubadour type, and other various currents which were shaping Romantic iconography in the first quarter of the nineteenth century. However, Girodet's selection of these themes appears to have been only the result of their widespread popularity. At any rate, his timid interpretation of these subjects is in no way suggestive of any sympathy for the Revolutionary art of Géricault and Delacroix.

III. Themes based on classical history and mythology represent the most important part of Girodet's production during this period. In contrast to the paintings of the Grande Manière group, those late classical works show the artist's reaction against his own so long cherished credo of originality, and his return to a more conservative, traditionalistic art. Thus, Pygmalion and Galatea was considered by Girodet's contemporaries the masterpiece upholding the classical ideals against the surge of the Romantic tide.

I.

THE LATE YEARS OF GIRODET'S LIFE

The Restoration was for Girodet a period of a half-hearted official recognition. In the first salon organized after the fall of Napoleon, the artist, by displaying practically all his major works,[1] seems to have begged for a public condemnation of the injustice he had incurred under the Imperial regime. Thus, he exhibited, well in evidence, in the grand salon, the portraits of Chateaubriand (fig. 66) and of de Sèze[2] (fig. 63). The former had been "placed in an obscure spot" in the Salon of 1808, while the latter had been rejected from that of 1806 by Denon's administration.[3] Girodet's dramatized showing of the portraits of/the two prominent royalists, who were known to have conspired against Napoleon,

1. David, J. L. Jules, op. cit., I, p. 513. Among the most important works exhibited by Girodet in the Salon of 1814-1815 were: Hippocrates, Endymion, the Deluge, and his own copy of Atala (Boutard, "Beaux-Arts, Salon de 1814 -- no. 1," Journal des Débats, November 6, 1814).

2. The two portraits were exhibited, facing each other, in the grand salon (Boutard, "Beaux-Arts, Salon de 1814 -- no. 6," Journal des Débats, Feuilleton, December 3, 1814).

3. Boutard, "Beaux-Arts, Salon de 1814 -- no. 1," Journal des Débats, November 6, 1814.

was advertised in the Journal des Débats by Boutard,[1] and appears to have greatly influenced the attitude of Louis XVIII in favor of the artist. In 1815, Girodet became a member of the Institut;[2] he received the decoration of Saint-Michel;[3] he was granted several official commissions; and in 1818, the government acquired Endymion, Atala, and the Deluge for the total sum of sixty thousand francs.[4] However, these proofs of royal favor seem to have disappointed Girodet, who expected much more from the new regime.[5] These honors came too late and were not to be compared to the distinctions received by Gros and Gérard. While stimulating a rivalry between these painters and Girodet, Louis XVIII seems to have preferred the former, especially Gérard.[6] Girodet was never granted the title of Baron or that of Painter of the King, and the dignity of officer of the Légion d'honneur was bestowed upon him only after his death.[7]

Nevertheless, probably because of his royalist connections,[8] Girodet was well liked in the court circles, and was

1. Boutard, "Beaux-Arts, Salon de 1814 -- no. 1," Journal des Débats, November 6, 1814.

2. Lettres de Girodet-Trioson à Madame Simons Candeille, op. cit., Paris, June 11, 1815.

3. Girodet, OEuvres posthumes, op. cit., I, Notice historique by Coupin, p. 11J.

4. Idem.

5. Lettres de Girodet-Trioson à Madame Simons Candeille, op. cit., June 11, 1815.

6. Correspondance de François Gérard, op. cit., pp. 324-325, Letter II of Count Decazes to Gérard, Paris, August 1, 1817.

7. Girodet, OEuvres posthumes, op. cit., I, Notice historique by Coupin, p. 11J.

8. It may be recalled that, besides being the friend of Chateaubriand and de Sèze, Girodet was the adopted son of Dr. Trioson, the former physician of Mesdames.

on particularly friendly terms with the Duchess of Berry.[1]
From time to time, he made appearances in various mundane
gatherings, in which he was noted for his somewhat artificial
wit and affected elegance.[2] He still occasionally played a
prominent role during artists' meetings. He created a minor
storm when he tried to impose his definition of painting of
apparat in one of the sessions of the Institut.[3] Because of
his eloquence, he was chosen, at Talma's reception in honor
of Kemble, as the spokesman for all the painters who had
participated in the execution of a portrait of Shakespeare,
offered to the English actor on this occasion.[4]

However, Girodet's public appearances were fairly
rare, and in general, he spent most of his time in a compara-
tive retirement. During those years, the painter lived in a
house which he had built for himself in the rue Neuve-Saint-
Augustin.[5] Its interior was never decorated or completely
furnished.[6] There, the artist hoarded rare pieces of furni-
ture, Chinese vases, books, fabrics, precious weapons, and

1. Adhémar, Jean, "L'Enseignement académique en 1820," op.
cit., pp. 273-274.
2. Delécluze stressed this affectation and even noted Giro-
det's habit of using perfume when appearing in society (op.
cit., p. 271).
3. Girodet, OEuvres posthumes, op. cit., II, De l'Ordonnance,
p. 207, note by Coupin.
4. Bouilly, J. K., op. cit., III, pp. 92-93.
5. Girodet, OEuvres posthumes, op. cit., I, Notice histo-
rique by Coupin, p. liij.
6. Idem; Delécluze, op. cit., pp. 270-271.

other objects of various descriptions.[1] His drawings and
the manuscripts of his writings were hanging on the walls
or spread in disorder about the rooms.[2] Amidst this confu-
sion, the master of the house received his friends, attired
in old, torn garments which gave him a "most savage appearance,"[3]
so often criticized by Julie Candeille.[4]

With the exception of Pygmalion and Galatea and the
decorations of Compiègne, the greatest part of Girodet's pro-
duction during this period consisted of lithographical essays,
drawings, and illustrations. Undoubtedly, one of the reasons
for this pictorial paucity was the artist's continuous ill
health and the weakness resulting from his previous exhaust-
ing labors.[5] However, another cause of this unfruitfulness
originated from Girodet's disillusionment and bitter resigna-
tion, which led him to concentrate his interest in the liter-
ary field. This particular mood is unexpectedly reflected in
Balzac's La Maison du chat qui pelote, written four years af-
ter the death of the artist. The author of the Comédie humaine
actively introduced Girodet into this novel, in which the

1. Girodet, OEuvres posthumes, op. cit., I, Notice histo-
rique by Coupin, p. liij; Delécluze, op. cit.,pp. 270-271.
 2. Idem.
 3. Delécluze, op. cit., pp. 270-271.
 4. Julie Candeille in her letters to Girodet continually
referred to the painter's neglect of his appearance (letters
of Julie Candeille to Girodet in the possession of Mr. Fil-
leuil, Montargis).
 5. During these years, practically all the painter's cor-
respondence reflected his complaints on the subject of his
health.

artist is described as the friend of the hero, the young painter Théodore de Sommervieux. When Théodore shows his works to Girodet, the "great painter"[1] says:

> "I do not advise you to exhibit such works in the salon
> . . . These true colors, this tremendous work, cannot
> yet be appreciated. The public is no longer accustomed
> to such profoundness. The pictures we are painting . . .
> are not more than superficial screens . . . let us rather
> write poetry and translate the ancients! One can expect
> more fame from it than from our pitiful paintings."[2]

Girodet seems to have taken his role of author with the utmost seriousness. With the exception of a few theoretical writings,[3] his literary production consisted mostly of poetry, such as imitations of Anacreon, Sappho, the Latin satirists, and his own poem Le Peintre. His correspondence with Firmin Didot[4] and with the Princess of Salm[5] showed a genuine preoccupation with problems of style and versification. He joined the literary society of the Enfants d'Apollon[6] and

1. Balzac, La Maison du chat qui pelote, in L'OEuvre de Balzac, op. cit., p. 8.
2. Idem.
3. As for instance, Considérations sur le génie particulier à la peinture et à la poésie, Dissertation sur la grâce, De l'Originalité dans les arts du dessin, and De l'Ordonnance en peinture.
4. Girodet, OEuvres posthumes, op. cit., II, Correspondance, Letters XVI and XVII, to Firmin Didot, pp. 315-319.
5. Quelques lettres extraites de la correspondance générale de Madame la Princesse Constance de Salm de 1805 à 1810, Paris, F. Didot frères, 1841, Letter of Girodet, March 15, 1809, and answer of the Princess of Salm, March 16, 1809, p. 38. This correspondence seems to suggest that Girodet was experimenting with the visual effect of verses symmetrically arranged on a page.
6. 1817 (Letter of Girodet to the President of the society, July 13, 1817 and to the Secretary, Paris, July(?) 18, 1817, Ms., Morgan Library, New York). This society had an amateurish character; it included musicians like Méhul, doctors like Orfila, scientists like Lacépède, and several artists like Carle-Vernet, Couder, Gois, and Bervic (Bouilly, op. cit., III).

cultivated the friendship of such prominent writers and
poets as Delille, Chateaubriand, and Alfred de Vigny. Giro-
det's progressive literary taste at the end of his life is
suggested in Vigny's letter to Victor Hugo, written after
the painter's death:

> "I shall no longer have with him /Girodet/ the long con-
> versations in which I was awakening the dying fire of his
> genius by reciting your /Hugo's/ most beautiful verses
> and all that poetry inspired in me by looking at the di-
> vine forms which he had created."[1]

Exhausted by his continuous illnesses, the painter
frequently fled Paris for his estate of Bougoin, near Montar-
gis. There, he proudly hid his sufferings in a complete soli-
tude. Writing to Julie Candeille about what she called his
"system of isolation,"[2] he said: "I assure you that not only
do I know how to suffer alone, but that I really need to be
alone when I am suffering."[3] At the end of his life, Girodet's
condition was aggravated by a gangrenous infection which neces-
sitated a very painful operation. Coupin and Delécluze gave
an almost melodramatic account of his last days. Shortly be-
fore his operation, the artist escaped from his bed and
"dragged himself to his atelier."[4] There, he glanced for the

1. Vigny, OEuvres complètes, Correspondance, Paris, Louis
Conard, 1923, I, p. 86, Letter of Vigny to Hugo, January 16,
1825. Girodet gave drawing lessons to Vigny.
2. Julie Candeille wrote in a note to one of Girodet's let-
ters: "The cruel man stressed so far this system of isolation
that he died without my knowing it." (Lettres de Girodet-
Trioson à Madame Simons Candeille, op. cit.)
3. Idem.
4. Delécluze, op. cit., p. 273.

last time at the place which had witnessed "so many vigils, so many studies, so many meditations which had embellished his life." Unable to sustain any longer such a moving sight, he slowly withdrew, and looking back at his atelier he said: "'Farewell! I shall never see you again!'"[1] The operation performed by the artist's friend Larrey, with the help of Portal and L'Herminier, succeeded in prolonging Girodet's life for only five days, and he died attended by the _abbé_ Feutrier on December 12, 1824.[2]

1. Girodet, _OEuvres posthumes_, _op. cit._, I, _Notice historique_ by Coupin, p. xxj.
2. Delécluze, _op. cit._, p. 273; Girodet, _OEuvres posthumes_, _op. cit._, I, _Notice historique_ by Coupin, p. xxij.

II.

MINOR PRODUCTIONS

Girodet gave comparatively little attention to themes
influenced by the contemporary interest in exotic oriental-
ism, medievalism, and other characteristically romantic
literary trends of the early nineteenth century. Moreover,
the artist's interpretation of these themes, far from show-
ing any signs of innovation, was more conservative than the
average contemporary rendering of similar subjects.

Oriental Themes

As was noted in a previous chapter, Girodet liked to
speak of his interest in Oriental subjects.[1] Yet, with the
exception of the Rebellion of Cairo, the works embodying this
interest consist chiefly of small drawings and sketches.
They seldom reveal the painter's experimentation with com-
positional ideas of any importance. Some of them, such as

1. Supra, pp. 277-278.

the pastel representing the Sussen of Tunis, Mustapha,[1] are
portraits of well-known personages.[2] Others, like the Oda-
lisque[3] (fig. 97) or the Circassian Woman,[4] appear to have
been executed with a view to commercial lithographic repro-
duction. Only one work of this group, a drawing (fig. 99)
conceived as an illustration for Girodet's Le Peintre,[5] shows
several full-length personages arranged in a fairly elaborate
composition. It represents a Byronian young artist, attired
as a Giaour, meditating near the ruins of the Athenian Acrop-
olis occupied by the Turks.

However, such works were extremely rare, and the
great majority of Girodet's orientalizing themes consists of
heads or busts of isolated personages, which seem to have
been conceived independently of any specific purpose. With
the exception of a Mameluke[6] silhouetted against a blue sky,

1. Executed on August 15, 1819. This work was mentioned
by Pérignon (op. cit., p. 28, no. 165) and by Coupin (Girodet,
OEuvres posthumes, op. cit., I, Liste des principaux ouvrages
de Girodet by Coupin, p. lxxxv).
2. Girodet also painted an Officer of the Mamelukes (exhib-
ited in the Salon of 1804, Journal des Débats, November 15,
1804), and made a drawing of Asker-Kan, the Persian ambassador
to Napoleon in 1808 (Louvre, 4258-856 RF).
3. Painted in 1820 and lithographed by Aubry-Lecomte in
1823.
4. Lithographed in 1825 by Léon Noël.
5. Executed in 1820. H. C. Muller's lithograph of this
drawing appears in the first tome of Girodet's OEuvres post-
humes (op. cit., I, facing p. 142). It was published under the
title of Genius of Greece and corresponds to a passage of Le
Peintre describing the sadness of the young painter upon con-
templating the desecration of Athens by the Mohammedans (Giro-
det, OEuvres posthumes, op. cit., I, pp. 139-143).
6. Pilleuil Collection, Montargis.

these figures appear before a neutral background. Girodet's
interest did not go beyond an ethnic characterization, devoid
of any specific action. In his list of the painter's works,
Pérignon was careful to make a distinction between Mamelukes,[1]
Hindus,[2] Negroes,[3] Arabs,[4] Bedouins,[5] and Turks.[6] In this
respect, Delacroix' statement that "such devilish hooked
noses, pug noses, etc., which nature makes, are his /Girodet's/
despair"[7] was far from being justified. Girodet very seldom
gave "an ideal quality to the head of an Egyptian" by making
"it resemble the profile of Antinous."[8] In reality, he was
responsible for some of the most powerful ethnic characteri-
zations of his time, and Delacroix' rendering of Orientals
was not to show any significant progress in this direction.

Though devoid of any specific action, Girodet's depic-
tion of Orientals shows a definite tendency toward dramatiza-
tion and sentimentalization of expression. Most of the mas-
culine figures, such as the Turk in the Museum of Avignon (fig. 100) or
the Janizary in the Louvre[9] (fig. 101), combine a suggestion of
fierceness and haughtiness, reflecting the fanaticism and the

1. Pérignon, op. cit., p. 27, no. 152.
2. Idem, p. 8, no. 2.
3. Idem, p. 27, no. 155.
4. Idem, p. 27, no. 149.
5. Idem, p. 27, no. 148.
6. Idem, p. 17, no. 55.
7. Journal de Eugène Delacroix, op. cit., III, p. 345.
8. Idem.
9. Pastel, Louvre 660.

primitive pride which, as has been seen,[1] Girodet attributed
to Orientals. In contrast, the feminine figures, like the
Odalisque of the Filleuil Collection[2] (fig. 98), show traces
of the "soft voluptuousness of oriental life,"[3] and are
qualified by a languid sentimentality.

Girodet did not really attempt to recreate the local
color of an exotic Orient. Yet, Oriental themes influenced
him to adopt a freer technique and a more coloristic inter-
pretation. This trend was particularly marked in Girodet's
pastels, a medium which he frequently used for his studies
of Orientals,[4] such as the Louvre Janizary (fig. 101). How-
ever, it must be emphasized once more that, in general, Ori-
ental subjects had a very minor place in Girodet's production.
From a historical point of view, they form a transition from
the classical têtes d'expression to the Oriental subjects of
Ingres and Delacroix.

Troubadour Themes

Undoubtedly, the most frequently quoted passages of Le
Peintre and the Veillées are those in which Girodet praised
the genre troubadour, in other words subjects provided by

1. Supra, pp. 277-278.
2. Montargis.
3. "Salon de l'an XII -- no. IX," Journal des Débats, No-
vember 15, 1804.
4. For instance, Pérignon, op. cit., p. 27, nos. 148, 149,
151, 152, 153, 155, 158; p. 28, nos. 160, 161, 164, etc.

French history, Renaissance and medieval times:

> "There is a special genre, derived from history,
> Which celebrates love, pleasure, and glory;
> In which the naïve, elegant, and ingenious artist,
> Without borrowing from the Greeks their heroes and their
> gods,
> Paints the romanesque deeds of our valiant knights.
> The chatelains are still picturesque;
> Their Gothic dungeons armed with black battlements,
> Their long apartments decorated with blazons
> And with portraits of the time of the heroes of the Crusades,
>
> Recall to the mind . . .
> The touching memory of our brave ancestors.
>
> Therefore, read, meditate in our old chronicles
> The heroic deeds of men like Dunois, Bayard,
> The naïve songs of the happy troubadours. [1]

However, in spite of Girodet's literary glorification of
these themes, the genre troubadour, which was to be so im-
portant in shaping one of the most characteristic aspects of
Romantic iconography, occupies in the artist's production a
place which is even smaller than that of the Oriental sub-
jects. Significantly enough, while Gros with his Visit of
Charles V to Saint-Denis[2] and Gérard with his Entrance of
Henry IV into Paris[3] gave important pictorial illustrations
of this type of theme, Girodet did not execute a single paint-
ing based on a troubadour subject. His entire production

1. Girodet, OEuvres posthumes, op. cit., I, Veillées, IV,
pp. 387-388. Naturally, this quotation is only a small part
of the lengthy passages devoted by Girodet to this genre. The
painter by no means limited himself to medieval times. Thus,
one can find references to the Renaissance (idem, pp. 362-363)
and to the seventeenth century (idem, p. 390). Some of these
passages were quoted by Benoît (op. cit., p. 320), Rosenthal
(op. cit., p. 36), and Jacoubet (op. cit., p. 193).
 2. 1812, Louvre.
 3. 1817, Versailles.

related to this genre is exclusively composed of a small
number of drawings.

Very few drawings of this series, as for instance The
Legend of the Dog of Montargis[1] (fig. 102), undoubtedly inter-
preted by the painter because of its direct relation to his
native city,[2] were based on the traditional French repertory
of legends. Three drawings were contributed by the artist
to illustrate Bathilde reine des Francs[3] (figs. 103, 104) and
Agnès de France,[4] (fig. 105), two historical novels by his
friend Julie Candeille, while another was executed by the
painter for La Côte des deux amants,[5] a poem by the then

1. Museum of Montargis. One may also include in this
group the drawing of Bayard Refusing the Presents of his Hos-
tess at Brescia which was discussed in a previous chapter
(supra, pp. 24, 26, 27).
2. This drawing represents the famous Jugement de Dieu which
took place in Montargis. It shows the fight between a Dalma-
tian dog and an officer of the court of Charles VIII, who had
been accused of having assassinated Mont-Didier, the master of
the dog. It is possible that Girodet's drawing was inspired
by a painting of the same subject, executed in the time of
Charles VIII, which could still be seen in the Château of Mont-
argis in 1794. Girodet had a great love for this castle, of
which he made several drawings (fig. 1) and which he offered
to buy for thirty thousand francs to save it from destruction
by the bande noire (Girodet, OEuvres posthumes, op. cit., I,
Le Peintre, Notes du Chant II by Coupin, pp. 275-276).
3. Madame Simons Candeille, Bathilde reine des Francs, Pa-
ris, Le Normant, I, Scène du jardin (". . . Viens! . . . Viens!
. . . J'ai besoin de toi.") (fig.103) Scène de la confession ("Elle
implorait le Dieu; elle implorait le Ministre.") (fig. 104).
The first illustration was engraved by B. Roger, and the sec-
ond by Pigeot.
4. Madame Simons Candeille, Agnès de France ou le XIIème
siècle, Paris, Maradan, 1821, I, frontispiece (fig. 105) en-
graved by R. Adam, mentioned in Coupin's Liste des principaux
ouvrages de Girodet, in Girodet, OEuvres posthumes, op. cit.,
I, p. lxxxij.
5. Ducis, J. F., OEuvres, Paris, F. Didot, 1813, III ("Lui
mourut de fatigue, elle de sa douleur"), engraved by S. Goulu.

famous Ducis. Finally, three drawings, An Atelier of the
Renaissance[1] (fig. 106), Raphael Painting amidst his Pupils[2]
(fig. 107), and Michelangelo Taking Care of his Sick Servant[3]
(fig. 108), were based on subjects derived from the accounts
of Vasari, Condivi, or Lanzi.

It must be noted that all these drawings are of small
size, and for the most part of a very mediocre standard of
execution. They do not reveal any element which could single
them out from the average contemporary productions of the
same type. Girodet's sentimentalized and melodramatic illus-
trations for the novels of Julie Candeille (figs. 103, 104,
105) provide a characteristic example of the troubadour group.
In these drawings, the painter occasionally transposed some

1. Formerly in the Vivenel Museum, at Compiègne. The draw-
ing was exhibited under the title of Personages around a Table.
I suggest the title of An Atelier of the Renaissance because
of the attire of the personages and their occupation: read-
ing, drawing, or studying each other's features with a magni-
fying glass. The subject could perhaps be the coming of Ra-
phael into the atelier of Perugino, or of a young painter into
the atelier of the Caracci. This interpretation of the draw-
ing is suggested by the figure of a young man who seems to be
introduced to a group of artists working at a table. Girodet
made an elaborate description of Caracci's atelier in his Notes
to Le Peintre (Girodet, OEuvres posthumes, op. cit., I, Notes
du Chant I, pp. 223-229).
2. Fabre Museum, Montpellier. Mentioned in Coupin's Liste
des principaux ouvrages de Girodet, in Girodet, OEuvres post-
humes, op. cit., I, p. lxxxij.
3. 1813, Fabre Museum. Mentioned in Coupin's Liste des
principaux ouvrages de Girodet, in Girodet, OEuvres posthumes,
op. cit., I, p. lxxxij. Coupin believed that this subject
was derived from a letter of Michelangelo to Vasari. Coupin
related that his brother, who was a pupil of Girodet, became
interested in the subject and that the master playfully decided
to compete with him. (Girodet, OEuvres posthumes, op. cit.,
Le Peintre, Notes du Chant VI by Coupin, p. 335.)

of his earlier ideas[1] into a vaguely medieval setting in-
spired by Willemin's Monuments français inédits.[2] From the
point of view of quality and interest, an exception must be
made for the compositions of Raphael Painting amidst his
Pupils (fig. 107) and Michelangelo Taking Care of his Sick
Servant (fig. 108). Both show a typical troubadour sentimen-
tality. It can be felt in such details of Girodet's inter-
pretation as the portrait of the Fornarina and the eager
adolescent disciple in Raphael Painting amidst his Pupils,
as well as in the very conception of Michelangelo Taking Care
of his Sick Servant.[3] However, these two drawings show a
more energetic execution and richer tonalities than the re-
maining compositions of the series. The handling of space
and the strong contrast of values create a chiaroscuro effect
no longer suggestive of Leonardo or Correggio but directly
reminiscent of Rembrandt.[4]

1. Thus, the drawing for Agnès (fig. 105) is reminiscent
of Atala.
2. Willemin, Monuments français inédits pour servir à l'his-
toire des arts depuis le VIe siècle jusqu'au commencement du
XVIIe, Paris, Mademoiselle Willemin, 1839, 2 vols. Girodet's
name appears in the list of subscribers. This work was the
standard French recueil for medieval accessories.
3. Girodet's group of Michelangelo upholding his servant
seems to have been derived directly from a similar group
formed by Francis I and the dying Leonardo in Ménageot's Death
of Leonardo (1781, Museum of Amboise).
4. In these drawings Girodet abandoned the classical relief
conception of space for an almost baroque spaciousness with
strong repoussoirs. The possible influence of Rembrandt is
further suggested by the asymmetry and the intimate quality of
the compositions, as well as by such details as the curtains
in the case of Michelangelo Taking Care of his Sick Servant.
One may note that the rather paradoxical combination of a sub-
ject based on the life of Raphael and an influence derived from
Rembrandt can also be found in Ingres' Raphael and the Fornarina

Supernatural and Religious Themes

Besides the works inspired by the contemporary inter-
est in Oriental and troubadour themes, Girodet interpreted
various subjects reflecting the complex character of the
early Romantic nineteenth-century iconography.[1] The two
most important trends influencing this group were those
which were derived from the current fascination for the super-
natural and the revival of religion. The importance of these
two trends has already been discussed in relation to earlier
works such as Ossian[2] and Atala,[3] and the purpose of the pres-
ent consideration is only to show the manifestations of
these two currents in Girodet's late minor productions.

Girodet's rendering of supernatural subjects was
strongly influenced by ideas derived from Ossian. Occasion-
ally, as in the 1817 lithograph illustrating a passage from
the Chants de Selma,[4] Girodet directly interpreted Letour-
neur's translation of Macpherson. However, the painter more

[4] (Continued from preceding page).
painted in the same period (1814). In Ingres' painting, the
grouping of Raphael and the Fornarina seems to have been in-
spired by Rembrandt's self-portrait with Saskia in Dresden.
 1. It must be noted that Girodet, in the late period of his
life, was still occasionally interpreting such typical late eigh-
teenth-century Pre-Romantic themes as Young Burying his Daughter
(Pérignon, op. cit., p. 49, no. 365), or The Fear of the Rep-
tiles and The Fear of the Storm (both in the Museum of Bernay),
inspired by the restless eroticism of Parny.
 2. Supra, pp. 173 ff.
 3. Supra, pp. 257 ff.
 4. Macpherson, op. cit., Letourneur trans., I, pp. 227-229.
Girodet's lithograph represents Armin sitting on a rock by the
sea and seeing the shades of his drowned children, while the
perfidious Erath is tied to an oak.

often transposed the Ossianic atmosphere, with its dark
clouds and its floating personages, into other themes. This
tendency was already noted in the artist's treatment of his
late Ossianic portraits (figs. 69, 70, 71, 72, 73), dis-
cussed in a previous chapter.[1] It can also be seen in Dante
Swooning in the Arms of Virgil upon Seeing the Torments of
Paolo and Francesca[2] (fig. 109), a small painting, in the
Fabre Museum,[3] which is the only example of Girodet's il-
lustration of Dante. One can note that Girodet, in selecting
one of the most currently popular incidents of the Inferno,
chose to interpret it in a fantastic, dark, Ossianic manner,
instead of giving it, as did Ingres,[4] the usual sentimental-
ized troubadour rendering. A similar transposition of Ossian-
ism can be seen in Girodet's interpretation of a passage of
Delille's Les Jardins, describing the apparition of the an-
cestors of Abdalonymus,[5] in a small oil sketch of the Magnin
Museum[6] (fig. 110). Finally, a drawing representing A Pro-
cession of Ghosts and of Fantastic Apparitions[7] suggests that

1. Supra, pp. 320-321.
2. The group formed by Virgil and Dante seems to have been
inspired by the engraving representing Theseus and Laya, by
Thoenert, illustrating the 1781 edition of Winckelmann's His-
toire de l'art de l'antiquité, op. cit., II, p. 25.
3. Montpellier.
4. In his Francesca da Rimini (Condé Museum, Chantilly).
5. Delille, op. cit., I, Les Jardins, Chant IV, p. 110.
6. Dijon. Naturally, the Ossianic treatment of the scene
explains the error of the Catalogue, in which this work is
listed under the title of The Dream of Ossian (Musée Magnin, op.cit.,
Dijon, Jobard, 1938, p. 100, no. 432).
7. Mireur, H., Dictionnaire des ventes d'art faites en France
et à l'étranger pendant les XVIIIème et XXème siècles, Paris,
C. de Vincenti, 1911-12, III, pp. 317 ff.

Girodet, like Boulanger and other typically romantic artists of the following generation, at times indulged in supernatural horror for its own sake.

Two works can exemplify Girodet's interpretation of religious themes during this period. The first, a painting of the Virgin[1] (fig. 111), exhibited in the Salon of 1812, is the only important, purely religious -- in an ecclesiastical sense -- work of these years.[2] Girodet's Virgin, with her Raphaelesque type, her Renaissance attire, and her saccharine, sentimental expression, prefigures the typical pietism of the Restoration, while echoing the troubadour interest in costume. The second of these religious works, a composition representing Saint Louis Welcoming Louis XVI and his Family to Heaven[3] suggests a similar pietistic trend, this time combined with an Ossianic interpretation and qualified by a political allusion.

This kind of political allusions fairly frequently appeared in Girodet's productions of this late group, in which they were combined with supernatural, Oriental, and troubadour themes. This can be exemplified in such subjects

1. Engraved by C. Normand.
2. Perhaps with the exception of two undated drawings mentioned by Pérignon: Christ Crowned with Thorns (op. cit., p. 38, no. 260) and Jesus among the Doctors (op. cit., p. 39, no. 271).
3. 1816, intended for the Church of the Madeleine (Leroy, Girodet-Trioson, peintre d'histoire, op. cit., p. 60).

as Beheaded Ghosts Showing Their Heads to a Septembrist Who
Had Been Responsible for their Decapitation[1] and Saint Louis,
While a Prisoner in Egypt, Refusing to Give the Oath which
the Emirs Required from him Before Setting him Free.[2] As
can be seen, Girodet, in this latter theme, about which he
was thinking a few days before his death,[3] planned to unite
the glorification of the Bourbons with the classical idea
of refusal, reminiscent of Hippocrates, as well as with
exotic and medieval elements.

1. Drawing mentioned by Coupin (Girodet, OEuvres posthumes,
op. cit., I, Liste des principaux ouvrages de Girodet, p.
lxxxij).
 2. Mentioned by Coupin (Girodet, OEuvres posthumes, op.
cit., I, Notice historique, p. xlv).
 3. Idem.

III.

LATE CLASSICAL SUBJECTS

During the last years of the Revolution and the Im-
perial period, Girodet gave little attention to themes based
on classical sources.[1] However, at the end of the Empire
and with the coming of the Restoration, the artist showed a
renewed interest in classical subjects, which he interpreted
in several relatively important paintings. It is convenient
to divide the consideration of these late works into two
groups, based respectively on the tradition of classical
history and on classical mythology.

Classical History

The works of this group were not based on specifically
historical sources; however, their interpretation by Girodet
continued a pattern traditionally associated with classical

1. All of Girodet's works derived from classical history,
executed after Hippocrates Refusing the Presents of Artaxerxes
(1791), were interpreted on a very small scale and consist
largely of drawings and sketches.

historical painting. On the whole, they can be defined as being derived from classical themes devoid of any supernatural elements.

The Seven Chiefs against Thebes, inspired by the tragedy of Aeschylus,[1] can be taken as a typical example of Girodet's tendencies in interpreting such subjects during the last years of the Empire. The artist's conception of this theme, which he originally planned to depict on a large scale,[2] is reflected in several preliminary studies, among which the most interesting are an oil sketch in the Bonnat Museum[3] (fig. 112) and a drawing lithographed by Aubry-Lecomte[4] (fig. 113). Girodet's interpretation of Seven Chiefs against Thebes is in sharp contrast with his characteristic early rendition of classical historical themes, as exemplified in the paintings of the Prix de Rome. In opposition to the daylight treatment of these early works, the Seven Chiefs

1. Girodet's conception was inspired by the following lines of the Greek author: "Seven warriors, gallant captains, shedding bull's blood into a black-bound shield, and touching with their hands that gore of bulls, swore direst oaths by Enyo and bloodthirsty Dread" (Aeschylus, The Seven Against Thebes, T. G. Tucker trans., Cambridge, University Press, 1908, pp. 17-19).
2. This is indicated by the size of the head of The Blasphemer and of other "colossal" heads "larger than nature" executed as preliminary studies for the projected painting (Pérignon, op. cit., p. 9, nos. 7, 8, 9).
3. Bayonne. In this oil sketch, Girodet displayed a surprising pictorial freedom, comparable to certain works of Géricault.
4. This lithograph was executed in 1825. Among other studies for the Seven Chiefs against Thebes, one can mention the drawing in the Ecole des Beaux-Arts.

<u>against Thebes</u> is conceived as a night scene, dramatized by lightnings

and a striking chiaroscuro effect.[1] Moreover, instead of emphasizing,

as in the <u>Prix de Rome</u> paintings, a subtle play of <u>passions</u> and <u>caractères</u>,

the <u>Seven Chiefs against Thebes</u> shows a theatrical sensationalism and

a paroxysmal violence of gestures and expressions.[2] It can be seen

that in his rendition of the <u>Seven Chiefs against Thebes</u>, Girodet,

undoubtedly influenced by such of his own paintings as the <u>Deluge</u>,

completely abandoned the Davidian conception of classical history.

A characteristic example of Girodet's interpretation of classical

historical subjects during the Restoration can be seen in his drawing

1. This chiaroscuro conception, as applied to classical historical
subjects, though generally rare before the Revolution, was not without
precedents, as can be exemplified by Doyen's <u>Priam Bringing back the
Body of Hector</u> (1779). It had already appeared in Girodet's <u>Antiochus
and Stratonice</u>, executed in 1793, in gratitude for the "enlightened and
affectionate care" of Dr. Cirillo during the artist's illness in Naples
(Girodet, <u>OEuvres posthumes</u>, <u>op. cit.</u>, I, <u>Notice historique</u> by Coupin,
p. xi). This painting, already lost in 1829 (<u>idem</u>), is known only
through a drawing in the Bonnat Museum (fig. 40) (Inv. L.B. 2135).
Among other early instances of Girodet's chiaroscuro treatment of clas-
sical historical subjects, one can also mention the drawing representing
<u>The Death of Hannibal</u> in the Museum of Montargis (it is described
as a <u>Mythological Scene</u> in the Catalogue of this Museum: Voisin,
<u>Catalogue</u>, 4e ed., Montargis, Impr. Du Loing, 1937, p. 39, no. 260),
and a painting of <u>Phaedra and Oenone</u> in the Museum of Lyon (fig. 39)
(it illustrates a passage from Scene III, Act I of Racine's <u>Phèdre</u>;
the same composition, engraved by Massard, appears in Didot's edition
of Racine, <u>op. cit.</u>).
2. <u>Antiochus and Stratonice</u> (fig. 40) (1793) seems to have
been one of the last subjects based on classical history, in which
Girodet showed an interest in a subtle depiction of <u>caractères</u> in
the manner of <u>Hippocrates Refusing the Presents of Artaxerxes</u>. This
psychological concern was soon abandoned for a more directly emotional
and theatrical interpretation, which can be exemplified in <u>Phaedra and
Oenone</u> (fig. 39) in Lyon.

of <u>Apelles and Campaspe</u> (fig. 114), executed as an illustration for
<u>Le Peintre</u>.[1] In this drawing, the artist, while preserving the
chiaroscuro treatment which characterized the <u>Seven Chiefs against</u>
<u>Thebes</u>, renounced the theatrical sensationalism of his rendition of
this earlier theme. In <u>Apelles and Campaspe</u>, dramatic violence is
replaced by a gentle, saccharine sentimentality. This change of mood
in Girodet's classical historical works corresponded to a change in the
type of subjects which took place during the Restoration period.
Abandoning tragic, violent themes, the painter showed a new predilection
for quieter, more gentle subjects in which he could display the sentimentalism
of the <u>troubadour</u> genre.

1. 1820, engraved by Bein. This composition illustrates Girodet's
verses describing the Greek painter falling in love with the mistress
of Alexander (Girodet, <u>OEuvres posthumes</u>, <u>op. cit.</u>, I, <u>Le Peintre</u>,
<u>Chant</u> V, pp. 169-171; Bein's engraving appears in <u>idem</u>, facing p. 170).

Girodet's very last works which can be included in
the classical historical group show a surprising return to
a pre-Revolutionary conception. They are four large paint-
ings, which were executed by the artist in 1822 for the
decoration of the ceiling of the Salon bleu, in the château.
of Compiègne: The Departure of the Warrior (fig. 115), The
Combat of the Warrior (fig. 116), The Triumph of the Warrior
(fig. 117), and The Return of the Warrior[1] (fig. 118). Far
from being conceived in a dark manner, these works show
light tonalities reminiscent of the 1785 Horatius Killing
his Sister (fig. 2) and a neutral setting of a Davidian
type. Moreover, any suggestion of high-pitched emotion is
completely eliminated. In spite of the fact that The Combat
of the Warrior (fig. 116) was meant to represent a violent
action, the attitudes of the personages are completely frozen
and their facial expressions suggest a paradoxical calm. Sim-
ilarly, though some of the gestures of The Departure of the

1. In the Catalogue of the Museum of Compiègne, The De-
parture of the Warrior was given the title of The Parting of
Hector and Andromache (Le Château de Compiègne, Edition des Mu-
sées nationaux, 1950, Pl. 26). While the author of the cata-
logue did not specifically mention the remaining three paint-
ings of the series, he seems to have implied that they were
also based on the same general theme. However, Aubry-Lecomte's
lithographs of these four paintings, executed in 1824 under
the direction of Girodet, bear only the titles of The Depart-
ure, The Combat, The Triumph, and The Return of the Warrior.
It can be noted that this sequence is difficult to associate
with Hector's life; and the paintings of the Salon bleu seem
to have a general meaning, referring to an ideal warrior of
antiquity, independent of any precise historical or literary
connotation.

Warrior (fig. 115) are derived from earlier, more dramatic
compositions,[1] the total effect is that of an Arcadian
serenity. In this respect, these paintings almost equal
the productions of the most faithful followers of Winckel-
mann. If it were not for a certain sensual amorphousness in
the treatment of the nude, a complete lack of energy, and
a strong tendency toward sentimentalization,[2] these works
could be mistaken for very early examples of Girodet's clas-
sical historical paintings of the Prix de Rome group.

Classical Mythology

Girodet's late works based on classical mythology
are much more numerous than those derived from classical
history. The great majority consists of illustrations of
classical authors like Anacreon,[3] Ovid,[4] and Virgil;[5] small

1. The gesture of the standing woman repeats that of Oenone
in Phaedra and Oenone (fig. 39) in the Museum of Lyon.
2. It can be seen in such details as the young boy carrying
the weapons of his father in The Departure of the Warrior and
in The Return of the Warrior.
3. Girodet's illustrations of Anacreon's Odes were already
begun before 1813 (Anacreon, Odes, J. B. de Saint-Victor trans.,
Paris, P. Didot, 1813, pp. v-vj). Fifty-four compositions il-
lustrating Anacreon's Odes, engraved by Châtillon, were pub-
lished in 1825 with Anacreon's text translated by Girodet (Ana-
créon: recueil de compositions dessinées par Girodet---avec la
traduction en prose des odes de ce poète, faite également par
Girodet, Paris, Chaillou-Potrelle, 1825).
4. Sixteen compositions lithographed by Girodet's pupils
and published in 1826 with a text by P. A. Coupin (Les Amours
des dieux: recueil de compositions dessinées par Girodet et
lithographiées par---ses élèves, avec un texte explicatif rédigé
par P. A. Coupin, Paris, Engelmann & Cie., 1826).
5. Eighty compositions based on the Aeneid and four on the
Georgics were lithographed by Girodet's pupils and published
by Pannetier (Enéide: suite de compositions dessinées au trait

oil sketches derived from the same sources such as <u>Anacreon</u>
and a Young Girl in a Grotto[1] (fig. 119); isolated drawings
such as <u>Dibutades</u>[2] (fig. 120); and various studies for
projects which were never completed, as for instance the
<u>Birth of Venus</u>[3] (fig. 121). Moreover, this group includes
several large paintings executed for the decoration of Com-
piègne. The most important among them are: <u>The Seasons</u>[4]
(figs. 21, 22, 23, 24) and <u>Tithonus and Aurora</u>[5] (fig. 122)
in the room of Marie-Louise; the <u>Dance of the Graces</u> (fig.
123) and the <u>Dance of the Nymphs</u> (fig. 124) in the ballroom;[6]
and <u>Mercury, Minerva, and Apollo</u> in Napoleon's library.[7]
Finally, independently of the Compiègne group, one must men-
tion <u>Pygmalion and Galatea</u>[8] (figs. 125, 126), by far the most
representative painting of Girodet's last years.

5 (Continued from preceding page).
par Girodet, lithographiées par---ses élèves, Paris, Noël aîné
& Cie /1825?/; Girodet, compositions tirées des Géorgiques,
lithographiées par ses élèves et publiées par Pannetier, Paris,
Henri Gaugain, Lambert & Comp⁹.)
1. Fabre Museum, Montpellier.
2. 1820, Henriquel Dupont's engraving of this drawing illus-
trates the beginning of <u>Le Peintre</u> (Girodet, <u>OEuvres posthumes</u>,
op. cit., I, facing p. 48).
3. Girodet was reported to have executed ten different com-
positions on this subject derived from Pliny (Girodet, <u>OEuvres
posthumes</u>, op. cit., I, <u>Notice historique</u>, by Coupin, p. xxxj).
The most important preserved illustration of this theme is a
drawing in the Louvre (fig. 121).
4. 1817 (Girodet, <u>OEuvres posthumes</u>, op. cit., I, <u>Liste
des principaux ouvrages de Girodet</u> by Coupin, p. lvij).
5. 1818 (<u>idem</u>, p. lviij); this painting was dated 1812 in
the Catalogue of the Château de Compiègne (<u>Le Château de Com-
piègne</u>, op. cit., Pl. 32).
6. 1818 (Girodet, <u>OEuvres posthumes</u>, op. cit., I, <u>Liste
des principaux ouvrages de Girodet</u> by Coupin, p. lviij).
7. 1818 (<u>idem</u>).
8. 1819; this painting, acquired by Sommariva, is now lost.

In spite of their numerical importance, Girodet's classical mythological works executed during the Restoration are far from having the significance of the mythological paintings of 1792-1802. Girodet does not seem to have been any longer interested in discovering new, rare subjects. His choice was now based on the most traditional mythological repertory. In general, the classical mythological works of this period reveal a marked decline in the esoteric inventiveness which characterized such paintings as Endymion or The New Danaë. A typical example of this conservative trend can be seen in Girodet's interpretation of the 1817 Seasons for Compiègne. Summer (fig. 22), Autumn (fig. 23), and Winter (fig. 24) repeat with a few changes the earlier compositions for Aranjuez (figs. 17, 18, 19). However, the most esoterically symbolical feminine personification of Spring (fig. 16) conceived for the Spanish palace was replaced at Compiègne by a much more conventional youth holding a torch (fig. 21). Moreover, certain imaginatively precious details of the 1802 version, such as Sirius or the tongues of flame which form the hair of the personification of Summer (fig. 17), were abandoned in the paintings of 1817. In Compiègne, Summer (fig. 22) is holding a bunch of wheat and his hair has a much more naturalistic appearance.

Pygmalion and Galatea[1] (figs. 125, 126)

One of Girodet's late mythological paintings, Pygmalion and Galatea, exhibited in the Salon of 1819, represents the artist's very last attempt to achieve recognition as a great painter. Though short-lived, the success of this painting was considerable and had a genuine historical significance. Paradoxically, Pygmalion and Galatea, a work of an artist associated for such a long time with the very idea of originality, was praised by the contemporaries for having contributed to bringing "back the public of today to the path of good taste" and for having reassured "the amateurs against the danger of an imminent /artistic/ decadence."[2] The reasons for which Girodet, though ill and exhausted, decided to enter once more the arena of the salon, are not very clear. The author of the Feuilleton of the Journal des Débats wrote in 1819 that while the critics, since the Concours décennal, conceded to Girodet "the realm of Michelangelo," they nevertheless pretended to exclude him from that of Raphael and Correggio." This author added that Girodet was reported to have executed Pygmalion and Galatea "in order to expose this injustice and to answer certain malicious comments."[3] Another reason which might have incited Girodet

1. 1819, now lost, formerly acquired by Sommariva (Girodet, OEuvres posthumes, op. cit., I, Liste des principaux ouvrages de Girodet by Coupin, p. lviij).
2. "Beaux-Arts-Salon de 1819 -- No. VIII," Journal des Débats, Feuilleton, November 6, 1819.
3. Idem.

to make his ultimate major effort can perhaps be found in
the words addressed to him by Louis XVIII in the Salon of
1817. While rewarding Gérard for his Entrance of Henry IV
into Paris by naming him his premier peintre, the king said
to Girodet: "History tells us that the trophies of Miltiades
spoiled the sleep of Themistocles. We have had a Marathon,
we are waiting for a Salamis."[1]

While it is difficult to believe that Girodet spent
seven years[2] painting Pygmalion and Galatea, numerous stud-
ies attest to the thoroughness of his preparation [3] (figs.
127, 128). The artist took all possible precautions to in-
sure the success of his work. Delécluze related the manner
in which Girodet showed his painting to visitors, before its
exhibition at the salon:

> ". . . one was mysteriously introduced into the sanctu-
> ary . . . from time to time, as if he /Girodet/ had just
> had a sudden idea, he apologized to the onlooking visitors,
> asking them to be allowed to add a few more touches......
> only a few touches! to a spot /in the painting/ which
> needed to be corrected. And seizing a brush which he agi-
> tated near the palette, he lightly passed it over the out-
> lines, as if he had wanted to give them more purity or
> softness. This little scheme usually had the greatest
> success with the elegant ladies of Paris, who later told
> that they had seen Girodet painting, and that it was not

1. Correspondance de François Gérard, op. cit., Letter II
of the Count Decazes to Gérard, Paris, August 1, 1817, pp.
324-325.
2. Landon, Salon de 1819, Paris, Impr. Royale, 1820, II, p.
12. "It is known . . . that the painting of Galatea has re-
mained on the easel for seven years."
3. In the Louvre, Museum of Montpellier, Museum of Orléans
(figs. 127, 128).

surprising that the productions of this artist were so
perfect, since he corrected them up to the last moment.
This is the little comedy which the painter enacted when
he allowed his Galatea to be seen in 1819, a work the
weakness of which he undoubtedly felt, since he took so
much care to insure its success."[1]

Moreover, perhaps to discourage any possible criticism, Giro-
det, before exhibiting his painting in the salon, succeeded
in publicly receiving the official praise of the king him-
self. On November 5, 1819, the Journal des Débats published
a lengthy account of Girodet's visit to Louis XVIII. The
article stressed the king's desire to see Pygmalion and Gala-
tea, which was brought by the artist to the royal palace;
his flattering comments; and his reiterated promise to go to
see the painting in the salon. The account also mentioned the
names of the Duke of Duras, the Count of Predel, and the Count

1. Delécluze, op. cit., pp. 271-272.
 Coupin gave a tragi-comic account of an accident in
which the falling of a lamp, pushed by an awkward servant,
imperiled the painting of Pygmalion and Galatea: "Girodet
who has not seen the direction of the fall of the lamp ut-
ters a cry and runs away." His model "calls Girodet who
does not answer." After a lengthy search for the painter,
the model finds him "seated on the floor, holding his head
in his hands. 'Monsieur, she says, your painting is un-
harmed.' Thinking she is deceiving him, he does not answer
and remains in the same position. She reiterates her state-
ment . . . Girodet . . . asks her in a pitiful voice if this
is really true." After having reassured himself that his
painting is intact his mood changes, and, seizing his maul-
stick, he threatens his guilty servant "who, seeing the ges-
ture, hastily escapes, and does not dare to show himself to
his master for three days." (Girodet, OEuvres posthumes, op.
cit., I, Notice historique by Coupin, pp. xlix-l). Girodet's
temper seems to have been the source of his atelier pupils'
puns, as can be seen in the caricature (fig. 129) entitled:
C'est à tort qu'on croigait qu'il prend la mouche (Cabinet
des Estampes, Bibliothèque Nationale, Paris).

of Forbin, the illustrious personages witnessing the king's admiration. It quoted four verses from an imitation of Ovid by Girodet, which the painter presented to the king on this occasion, and it concluded by auguring for Pygmalion and Galatea a triumph in the salon, where the painting was to be exhibited the next day.[1] It can be seen that this dramatic introduction could not fail to safeguard Girodet's work from any exaggeratedly violent criticism by his enemies.

The subject selected by Girodet was naturally based on the well-known legend of the sculptor Pygmalion's love for his statue, Galatea, which was given life through the intervention of Venus. The painting, which was acquired by Count Sommariva,[2] is now lost and is known only through engravings[3] (figs. 125, 126) and descriptions, one of which is by Girodet himself in a passage of his poem Le Peintre.[4] The setting represented in Girodet's painting is a terrace at the top of Pygmalion's palace, situated on the island of Cyprus, in the city of Amathus consecrated to Venus,[5] whose

1. Journal des Débats, November 5, 1819. The painting was exhibited in the last days of the salon (Girodet, OEuvres posthumes, op. cit., I, Notice historique by Coupin, p. xx). Thus it was not mentioned in Jal's L'Ombre de Diderot et le bossu du Marais, Paris, Coréard, 1819.
2. For whom it was reported to have been intended even before the beginning of its execution (Landon, Salon de 1819, op. cit., II, p. 16).
3. As for instance those of C. Normand (fig. 125), F. Mansard (fig. 126), or Laugier.
4. Girodet, OEuvres posthumes, op. cit., I, Le Peintre, Chant V, pp. 174-177. These were probably the verses which Girodet presented to Louis XVIII.
5. Girodet, OEuvres posthumes, op. cit., I, Le Peintre, Chant V, p. 174.

temple appears in the background.[1] The belvedere is a kind of sanctuary[2] decorated with Pygmalion's sculptures. Incense is burning before a statue of Venus at whose feet can be seen an altar adorned with the figures of Eros and Psyche.[3] Pygmalion is standing in front of his statue of Galatea, which he has conceived in the isolation of this "charming retreat."[4] The moment chosen by Girodet is that of the fulfillment of Pygmalion's prayers to Venus. The wind seems to bend the flame burning on the altar:

> "Three times, like an electric lightning,
> The prophetic flame rises from the altar."[5]

At this moment, Cupid "descends from the sky which his flight illuminates."[6] He seems to be

> "surrounded by a luminous atmosphere. From his blond hair emanate several rays, the brightness of which is fused with the . . . cloud formed . . . by the smoke of the incense. Already, blood is circulating in the veins of Galatea. Her cheeks are colored with bright vermilion. Only her feet still preserve the color and the insensibility of the marble from which she was formed. Pygmalion, moved at the same time by surprise, admiration, and love, but still afraid of being deceived by his own eyes, contemplates with as much reserve as ravishment the effect of the miracle which is fulfilling his wishes."[7]

1. Girodet, OEuvres posthumes, op. cit., I, Le Peintre, Chant V, p. 174.
2. Landon, Salon de 1819, op. cit., II, p. 10..
3. Girodet, OEuvres posthumes, op. cit., I, Le Peintre, Chant V, p. 174.
4. Idem.
5. Idem, p. 176.
6. Idem.
7. Landon, Salon de 1819, op. cit., II, p. 11.

In his Notice historique, Coupin wrote that Girodet,
in Pygmalion and Galatea, "seemed to have wanted to overcome
difficulties which seemed insurmountable and to extend the
borders of his art."[1] What appears to be praise in the words
of Coupin was the basis for a major criticism by Landon:

> "He /Girodet/ has attempted to extend the borders of his
> art, and, at any rate, he must be given credit for his
> intention. However, one must admit that he has given
> himself a goal which painting could never reach, and he
> has uselessly created insurmountable difficulties."[2]

Girodet himself was reported to have said that "the execution
of Galatea had revealed to him a new mode /of painting/, super-
ior to the one he had previously used; that it was only from
this time that he had acquired the intimate conviction that
he could paint."[3] Yet, Girodet's work is far from showing
any element which could be qualified as daringly revolution-
ary or simply new. Basically, Pygmalion and Galatea combines
two old aspects of Girodet's art: interest in esoteric mythol-
ogy and study of passions. In one of his letters to Ber-
nardin de Saint-Pierre, Girodet wrote that, in his opinion,
Endymion "had been too much praised," and he criticized his
most celebrated work by saying that "The expression of pas-
sions, always so difficult to render, because their evanescence
is equaled by their diversity, is nil."[4] Thus, it seems that

1. Girodet, OEuvres posthumes, op. cit., I, Notice histo-
rique by Coupin, p. xx.
2. Landon, Salon de 1819, op. cit., II, p. 12.
3. Girodet, OEuvres posthumes, op. cit., I, Notice histo-
rique by Coupin, p. xlv.
4. Girodet, OEuvres posthumes, op. cit., II, Correspondance,
Letter III, to Bernardin de Saint-Pierre, pp. 274-275.

the "new mode" of Pygmalion and Galatea, which gave so much confidence to Girodet, consisted merely in improving the idea of a mythological miracle by fusing it with a rational rendering of passions.

Basically, Girodet's painting of Pygmalion and Galatea, as well as his verses on the same subject in Le Peintre, were inspired by Ovid's Metamorphoses.[1] The artist's interpretation of the theme was also influenced by his early mythological paintings of the period of the Directory. Thus, instead of depicting the scene as taking place in Pygmalion's atelier, Girodet, as in his first Danaë (fig. 25), placed it on a belvedere, under the open sky.[2] Yet, the main idea behind Pygmalion and Galatea seems to have been derived from Endymion (fig. 14). Throughout his entire career, Girodet had been praised for the poetic supernatural moonlight of his

1. Ovid, Metamorphoses, The Loeb Classical Library ed., Frank Justus Miller trans., London, Heinemann, New York, G. P. Putnam's Sons, 1926, II, Book X, pp. 81 ff. Girodet's inspiration from Ovid was noted by Coupin (Girodet, OEuvres posthumes, op. cit., I, Le Peintre, Notes du Chant V, p. 327). The theme of Pygmalion was a very popular one, and it was interpreted in the poetry of the eighteenth century by J. J. Rousseau, Saint-Lambert, and Saint-Ange.
2. Needless to say, the subject of Pygmalion and Galatea was most frequently illustrated both in painting and sculpture. The painting of J. B. Regnault (1785) in the Salon de la Reine at Versailles and the group of E. M. Falconet (1763) in the Ambatielos Collection in Paris can be taken as typical examples of the eighteenth century rendition of the theme. In both of these works, as well as in the traditional conception of the subject, the scene takes place in Pygmalion's atelier. For this reason, the Journal des Débats suggested that Girodet combined the conception of Ovid with that of Clement of Alexandria, Meursius and Lutatius who described Pygmalion as a king of Cyprus who had fallen in love with an ivory statue of Venus ("Beaux-Arts-Salon de 1819 -- no. VIII," Journal des Débats, Feuilleton, November 6, 1819). This would explain the palatial surroundings of Girodet's setting.

Endymion, and there is little doubt that, in Pygmalion and
Galatea, the painter was striving to re-create a similar
luminous miracle. As before, Girodet endowed light with a
magic virtue. It emanates from the prophetically rising flame
of the altar;[1] from the head of the statue of Venus, thus
marking "the moment of the miracle";[2] and from the body of
Cupid, whose contact "like the flame of an electric spark
has given a soul to the statue."[3] However, instead of
mystically replacing an invisible divinity as in Endymion,
the rays of light emanate from the figures and objects repre-
sented in the painting. Moreover, in contrast to Endymion,
Girodet, in Pygmalion and Galatea, seems to have thought
that a multiplication of luminous sources would add to the
interest of the composition. This elaboration of an idea
derived from Endymion only lessens the general effect and
dispels the feeling of esoteric mystery which characterized
the painting of 1791.[4] At any rate, the very idea of a lumin-
ous miracle seems to have lost its fascination for the critics
of 1819:

1. Supra, p. 390, note 5. The idea of the prophetic flame
was derived directly from Ovid.
2. Landon, Salon de 1819, op. cit., II, p. 10.
3. Kératry, Annuaire de l'école française de peinture, ou
Lettres sur le Salon de 1819, Paris, Maradan, Lettre XVI, p.
238.
4. Thus, Kératry expressed his disappointment at not find-
ing in Girodet's Pygmalion and Galatea the unified effect
of Correggio's Night (Kératry, op. cit., Lettre XVI, p.
241).

"Art does not have the means of imitation which could be
powerful enough to render in a satisfactory manner these
rays, this luminous, electric explosion, which seems to
be the principal basis of Monsieur Girodet's composition,
and which, far from increasing its interest, only weakens
it by turning away the attention of the spectator from
the essential subject. This purely fantastic effect of
light, even if it had been possible to make it convinc-
ing, would only have had the merit of a surmounted diffi-
culty . . . The spectator does not want to know by what
supernatural means Venus has manifested her power."[1]

The majority of the critics, including Louis XVIII,[2]

admired the subtle transitions by which Girodet suggested

the progressive awakening of the statue, as well as the idea

of having represented Galatea with closed eyes.[3] Yet, they

did not unanimously approve of the pantomime of Pygmalion.

Certain writers criticized some of the comparatively second-

ary aspects of the attitude of this figure, such as the gen-

eral affectation or the gesture bringing Pygmalion's hand

toward his eyes.[4] However, others disapproved of a much more

fundamental aspect of Girodet's conception, his exaggerated

use of "composite passions" in interpreting Ovid's:

1. Landon, Salon de 1819, op. cit., II, p. 11.
2. Journal des Débats, November 5, 1819.
3. Louis XVIII erroneously compared this idea to that of
Timanthes' representing Agamemnon with a veiled face in The
Sacrifice of Iphigenia (idem). The king gave psychological
praise to Galatea's closed eyes: ". . . a positive glance
and a determined expression of these eyes, which have not
yet seen any object, would have been impossible" (idem).
Generally, Galatea's closed eyes were praised as a sign of
modesty, the first feeling expressed by a woman who is about
to come to life (as for instance Kératry, op. cit., Lettre
XVI, p. 236).
4. ". . . to assure himself that his eyes are not deceiving
him" (Girodet, OEuvres posthumes, op. cit., I, Notice histo-
rique by Coupin, p. xx).

"Dum stupet et dubie gaudet fallique veretur,
Rursus amans rursusque manu sua vota retractat."[1]

Condemning the very mechanics of the pantomime of Girodet's
figures, Landon wrote:

"The painter probably thought he could express simultane-
ously in the attitude, the gesture, and the features of
Galatea's lover the various feelings which he believed to
be moving him. However, in wanting to unite in the same
view several nuances, some of which are evidently in
opposition to each other, he could not fail to weaken
them. The painter, less fortunate than the poet, can
represent only one action, one determined moment, and
can at one time show on the physiognomy of the same per-
sonage only one sensation, and only one passion. It is
for this reason that the features of Galatea's lover seem
to have lacked warmth and energy."[2]

As can be seen, the old idea of "composite passions," which
had been so admired in the late eighteenth century and which
was still praised by Girodet's followers like Coupin in 1829,[3]
was found artificial and wanting by an exponent of pure clas-
sicism like Landon.

It must be noted that Girodet's combining an esoteric
supernatural mood with rationalized "composite passions" re-
sulted in an awkward compromise which weakened both of these
factors. Girodet's "new mode" and his attempts "to extend
the borders of his art" must be understood from this point of

1. Ovid, op. cit., II, Book X, verses 287-288, p. 84. These
verses were quoted by Louis XVIII during his examination of
Girodet's painting (Journal des Débats, November 5, 1819).
 2. Landon, Salon de 1819, op. cit., II, p. 13.
 3. Girodet, OEuvres posthumes, op. cit., I, Notice histo-
rique by Coupin, pp. xxxv ff.

view. Landon by this criticism was not condemning the artist's use of revolutionary ideas, but was rather stating his disbelief in the effectiveness of old devices from which Girodet persisted in asking the impossible. Paradoxically, this compromising, conservative quality of Pygmalion and Galatea was one of the main reasons for its success in the Salon of 1819.[1] The great majority of the public, baffled by such controversial paintings as Géricault's Raft of the Medusa, was reassured by Girodet's work, in which they recognized already familiar elements combined with a dreamy sentimentality and a polished execution. Similarly, for the classically-minded critics, Pygmalion and Galatea represented a blow struck in honor of the healthy, traditional principles of art. Landon, though one of the most severe critics of the painting, significantly expressed this opinion by writing:

> ". . . whatever the small imperfections which we have noted in this painting, . . . Monsieur Girodet, by faithfully following . . . the noble principles of art; by rejecting this faulty and neglectful manner which is progressively making its way into the modern school, because it favors the inexperience and the laziness of the young painters too eager to display their talent in the eyes of the public; Monsieur Girodet, . . . acquires the incontestable right to the respect and gratitude of the true friends of painting."[2]

1. Besides the numerous praises diffused by the newspapers, the painting inspired several poems (for instance in the Journal des Débats, Feuilleton, November 6 and 8, 1819). Moreover, a group of enthusiastic admirers went so far as to crown the painting with a wreath (Landon, Salon de 1819, op. cit., II, p. 15, note 1).

2. Landon, Salon de 1819, op. cit., II, pp. 15-16.

Thus, the last important work of Girodet, who had beon for so long attacked for his dangerous unorthodoxy and suspect originality, was praised for its sound traditionalism hindering the threatening rise of Romantic art.

CONCLUSION

CONCLUSION

Girodet's funeral became the occasion for what Quatre-
mère called a "public mourning."[1] Six thousand persons,[2]
"several illustrious personages,"[3] as well as all the painters,
"the most famous and the least known,"[4] attended the ceremon-
ies at the Church of the Assumption and the Cimetière de l'Est,[5]
on the 14th of December, 1824.[6] Describing the scene, Coupin
wrote:

> "The pupils of all the schools /of painting/ competed with
> his own to pay him their last respects. The funeral pro-
> cession following his earthly remains was very large and
> was composed of the most distinguished persons of Paris."[7]

1. Quatremère de Quincy, Eloge historique de M. Girodet, read
at the meeting of the Académie Royale des Beaux-Arts, October 1,
1825, in Recueil de notices historiques, Paris, Adrien Le Clère,
1834, p. 333.
2. Galerie du Musée de France, Filhol ed., Paris, Vve Filhol,
1828, XI, sixième livraison, p. 2.
3. Brainne, Debarbouiller, Lapierre, op. cit., pp. 63-70.
4. Delécluze, op. cit., p. 273.
5. Girodet, OEuvres posthumes, op. cit., I, Notice historique
by Coupin, p. xxij. The tomb was executed from the drawings of
Percier, and Girodet's bust was the work of Desprez.
6. Vigny, Correspondance, I, op. cit., p. 85.
7. Girodet, OEuvres posthumes, op. cit., I, Notice historique
by Coupin, p. xxij.

At the request of the president of the Académie des Beaux-Arts, Chateaubriand placed on the artist's coffin the insignia of the Légion d'honneur granted by the king.[1] As reported by Delécluze, "Gérard was pale, silent, and sad."[2] Gros, who, among other people, had been asked to speak at Girodet's grave, broke into tears and "cried like a child."[3] Commenting on the funeral, Quatremère wrote that one had never seen the loss of an artist "give rise to more intense regrets and to manifestations of a more profound sensibility."[4]

Besides these expressions of grief, Girodet's death seems to have aroused a strongly marked, though short-lived, interest in his works. As stated by Quatremère, the public showed a "posthumous admiration for the smallest productions of the man who had been asked to execute so few important ones during his lifetime."[5] Gérard tried to persuade the Vicomte de La Rochefoucauld to purchase for the government the "so rare" and "so precious" collection of Girodet's atelier, which was put on sale after his death.[6] This posthumous

1. Chateaubriand, who had been asked to make a speech, declined by saying that he did not consider himself qualified (Bruel, François-Louis, "Girodet et les Dames Robert," Bulletin de la société de l'histoire de l'art français, 1er fascicule, Paris, 1912).
2. Delécluze, op. cit., p. 273.
3. Idem.
4. Quatremère de Quincy, Eloge historique de M. Girodet, op. cit., p. 333.
5. Idem.
6. Lettres adressées au Baron François Gérard, op. cit., II, Letter to the Vicomte de La Rochefoucauld, Paris, April 5, 1825, p. 241. This request was only partially fulfilled (idem, Letter of the Vicomte de La Rochefoucauld, to Gérard, Paris, April 7, 1825, p. 243).

glory of the painter was unequivocally reflected in 1825 by
the multiplication of lithographs and engravings reproducing
even some of the least important of his studies.[1]

One of the most significant interpretations of this
public reaction can be found in Quatremère's Eloge historique.
The critic explained it as a need of the contemporaries to
sorrowfully "underline by these belated manifestations of
respect the neglect of his /Girodet's/ century" and to ex-
press regret at having "allowed such a talent to pass by on
earth without realizing it."[2] In other words, it seems to
have been a reflection of a feeling of guilt and an attempt
at a "kind of public reparation."[3] Girodet came to be con-
sidered a great artist misunderstood and killed by his own
time. This idea was echoed in many contemporary writings
dedicated to the painter, such as the poetic essays on his
death by Valori[4] and Madame de Salm.[5] Alfred de Vigny, liv-
ing in the Pyrenean region, where he composed his Déluge, as
well as his poem posthumously dedicated to Girodet,[6] was un-
able to attend the artist's funeral. Yet, approximately one

1. Adhémar, Jean, "L'Enseignement académique en 1820,"
op. cit., p. 281.
2. Quatremère, Eloge historique, op. cit., p.333.
3. Idem.
4. Marquis de Valori, Sur la Mort de Girodet, Paris, A.
Boucher.
5. Princesse Constance de Salm, Sur la Mort de Girodet
(1825), in OEuvres complètes, Paris, F. Didot, 1842, II, pp.
117-123.
6. "La Beauté idéale, aux mânes de Girodet," Mercure de
France au XIXe siècle, 1825, XI, p. 197.

month later, he wrote a letter to Victor Hugo, in which, after having

praised the English for placing "genius above all," he added:

> "They would not have killed the Raphael of our age, my
> dear and great Girodet. Injustice had wounded him to
> death: he repeatedly told me so, and he was not mistaken."[1]

This aura of martyrdom which surrounded the painter's death seems to

have started a tradition which lasted several years, before being

replaced by a final oblivion. In literature, Girodet was introduced

as one of the characters of Balzac's <u>La Maison du chat qui pelote</u>,[2]

in which he was depicted as a disillusioned, solitary, great artist,

while in painting, his pathetic last moments inspired Menjaud's

<u>Girodet's Farewell to his Atelier</u>.[3] Thus, Girodet's life became, in

the eyes of his contemporaries, the first striking example of the

tragedy of the genius placed by destiny in opposition to his time,

perhaps one of the earliest instances of the heroic failures of Romanticism.

One must conclude this study by attempting to summarize the meaning

of Girodet's contribution. His general significance as a Pre-Romantic

and as an artist of transition, a significance which has already been

so often underlined, is evident and unquestionable. The problem does not consist i

1. Alfred de Vigny, <u>Correspondance</u>, <u>op. cit.</u>, I, Letter to Victor
Hugo, January 16, 1825, p. 86.
 2. <u>OEuvre de Balzac</u>, <u>op. cit.</u>, pp. 1 ff.
 3. Salon of 1827.

finding for the artist a label so frequently applied to other
painters like Gros or Prud'hon. It is true that Girodet's
art shows a great confusion and innumerable contradictions;
that it is literary; that certain of its aspects are reminis-
cent of Italian mannerism; and that it is classical in its
form and Romantic in its imaginative quality. However, such
formulas, which have been commonly used in modern criticism
to characterize the painter, fail to reveal the complexity
and the uniqueness of Girodet's role.

To grasp the meaning of this role, one must go beyond
the limits of the purely pictorial realm and evaluate his
contribution in the light of the contemporary cultural and
historical background. Girodet seems to have sensed more in-
tensely than any other artist of his time the deep trans-
formations which were affecting French civilization at the
end of the eighteenth century. Facing the threatening chaos
resulting from the cataclysmic political upheavals and from
the crumbling of the old cultural values, Girodet sought
refuge in himself. This essential egocentrism was reflected
in his pathetic attempts at self-assertion and in his search
for originality. Few men of his time more eagerly strove to
survive and to astonish their century.

However, in astonishing his contemporaries, Girodet was
very far from wanting to shock them. From this point of view,
his attitude was very different from the romantic gillets rouges
of the thirties. The painter's resolution to survive his

century never completely eliminated a hope of being recognized
in his own time. His simultaneous attempts to surprise and
to please the public became one of the causes of his undoing.
Divided between his search for an original art which would
embody his self-assertion, and a cautious observance of a
certain traditionalism which would reassure his critics,
Girodet could never find a continuous unity of purpose which
would have enabled him to achieve a coherent vehicle of ex-
pression.

He was constantly obsessed with the idea of extending
"the borders of his art."[1] As was seen, his earliest works,
such as Horatius Killing his Sister, were characterized by a
thoroughly Davidian conception. However, this approach was
soon abandoned, and in his Hippocrates Refusing the Presents
of Artaxerxes, Girodet was already betraying the principles
of Winckelmann by blurring the classical ideals with his
"multiplicity of intentions."[2] Similarly, in his early reli-
gious paintings, such as the Pietà of Montesquieu-Volvestre,
he showed his eagerness to escape the worn-out paths of
Academism and his capability of revitalizing old subjects
through the sheer intensity of his emotionalism. Then he
turned to mythology, and completely renouncing the rational-
istic tradition, strove to invent new subjects, such as The
New Danaë and Ossian, in which he thought to display his

1. For instance, supra, p. 107 and supra, p. 391.
2. Supra, p. 71.

originality through a feeling of supernatural mystery and
esoteric bizarreness. During his mature years, he gave up
this mode and attempted to retain attention by adopting a
grande manière, and by indulging successively in the sensa-
tionalistic theatricality of the Deluge, the pietistic senti-
mentalism of Atala, and the exotic Orientalism of the Rebel-
lion of Cairo. Finally, during the last period of his life,
paradoxically hailed as a champion of traditionalism, he
went back to a mild, compromising Classicism which is re-
flected in his Pygmalion and Galatea and in his decorations
for the Château of Compiègne. It must be emphasized that
this development does not reveal the diversity of Girodet's
interests, also suggested in his passion for landscape, his
sensitive child portraits, his troubadour compositions, as
well as in the ideas expressed in his writings.

Girodet's continuous shifting was determined not solely
by his hope to be recognized as a unique, great artist. It
also was, to a great degree, influenced by the contemporary
chance of emotional and cultural trends. Yet, his extreme
sensitiveness; his ever-doubting, restless character; his
broad culture; and his intellectual curiosity left his art
open to the influence of both the most important and the
least consequential currents of his time. He was equally
responsive to the tenets of Winckelmann and the ideas of
Lavater; to the philosophy of Rousseau and the esoteric the-
ories of the Illuminists; and to the art of Michelangelo and
the illusionism of Boilly. He was compelled to follow a

hopeless meandering path of contrasting trends and opposed
disciplines, none of which ever provided him with a con-
sistent and permanent solution. This unsuccessful search
strikingly reveals the disconcertedness felt by some art-
ists who were unable to reconcile the emotional restlessness
of the period with the rigid formulas of the Neo-Classical
theorists. Girodet's literary tendencies and his pseudo-
philosophical outlook hid from him the only valid answer,
which was to be found by Delacroix in a basically pictorial
reconsideration of the problem. Thus, Girodet was led to
adopt a purely iconographical approach full of exaggera-
tions and preciosities, which he mistook for his own in-
ventions.

It is true, as wrote Benoit, that Girodet did not
exert an "energetic influence" on the evolution of the art
of his time.[1] The artist's followers were few, and their
importance, with the exception of Antonin Moine and Eugène
Dévéria, was minimal. Yet, this point of view distorts
Girodet's historical significance. His importance is to be
found not in an active role in shaping the painting of the
Revolutionary and Imperial years, but rather in his passive
function as a witness-phenomenon, a catalyst, or an extremely
sensitive mirror registering and amplifying the intellectual
and emotional vibrations of his period. This quality did not

1. Benoit, op. cit., p. 322.

escape Girodet's contemporaries. Thus, Quatremère de Quincy, whose character was so diametrically opposed to that of the painter, pompously wrote in his _Eloge historique_:

> "If among those /artists7 whose praise we have had to write until now, we have found one who, by a talent even greater than his fame; by productions the number of which unfortunately did not equal the merit; and by the particular course of a destiny which does not seem to have responded to his vocation, could give us a mirror in which would be reflected the genius of his period; the vicissitudes and faults of taste; the errors of direction; the changes of position, points of view, and strivings, which have made the course of the Fine Arts into a completely new arena for the fighters as well as for the spectators and the judges, you will agree, I believe, Messieurs, that this artist was M. Girodet."[1]

1. Quatremère de Quincy, _Eloge historique de M. Girodet_, op. cit., pp. 308-309.

BIBLIOGRAPHY

WORKS CONTAINING ILLUSTRATIONS
BY GIRODET

Les Amours des dieux; recueil de compositions dessinées
par Girodet et lithographiées par...ses élèves, avec
un texte explicatif rédigé par P. A. Coupin, Paris,
Engelmann et Cie., 1826.

Anacreon, Odes, translated by J. B. de Saint-Victor,
Paris, P. Didot, 1813.

Anacréon: recueil de compositions dessinées par Girodet
avec la traduction en prose des odes de ce poète faite
également par Girodet, Paris, Chaillon-Potrelle, 1825.

Ducis, J. F., OEuvres, Paris, F. Didot, 1813, Vol. 3

Enéide: suite de compositions dessinées au trait par Girodet,
lithographiées par...ses élèves, Paris, Noël aîné et Cie.,
/1825?/

Girodet, compositions tirées des Géorgiques, lithographiées
par ses élèves et publiées par Pannetier.

Racine, OEuvres de Jean Racine, Paris, P. Didot l'aîné, An
IX, 3 vols.

Saint-Pierre, Bernardin de, OEuvres complètes, Paul et Vir-
ginie, Paris, Mequignon-Marvis, 1818, Vol. VI.

Simons Candeille, Madame, Agnès de France ou Le XIIeme siècle,
Paris, Maradan, 1821, Vol. 1.

_____, Bathilde reine des Francs, Paris, Le Normant, 2
vols.

Virgilius Maro, Publius, Opera, Paris, P. Didot, 1798.

SALES CATALOGUES

Catalogue de 170 dessins de Girodet; compositions pour l'Enéide et les Géorgiques de Virgile; 16 dessins de de Mallet; estampes anglaises et françaises; portraits par Nantouil, Drouet, Reynolds et autres -- 15 Avril 1887, Paris, Renoir et Maulde, 1887.

Mireur, Hippolyte, Dictionnaire des ventes d'art faites en France et à l'étranger pendant les XVIIIme et XIXme siècles, Paris, C. de Vincenti, 1911, Vol. III

Pérignon, Catalogue des tableaux, esquisses, dessins et croquis de M. Girodet-Trioson, Paris, Chez Pérignon et Bonnefons-Lavialle, 1825.

MANUSCRIPTS, BOOKS, AND PERIODICALS
CONTAINING OR QUOTING WRITINGS BY GIRODET

Manuscripts

Girodet, Letter to Gros, Montargis, October 30, 1823, Museum of Amiens, Maignon Collection.

Girodet, Letter to La Rivière, Bourgoin, July 30, 1823, Museum of Amiens, Maignon Collection.

Girodet, Letter to the president of the Société des Enfants d'Apollon, July 13, 1817, New York, Morgan Library.

Girodet, Letter to the secretary of the Société des Enfants d'Apollon, July (?) 18, 1817, New York, Morgan Library.

Lettres de Girodet Trioson à Madame Simons Candeille, Bibliothèque d'Orléans.

Preliminary manuscript for the description of The Seasons, Museum of Orléans.

Books and Pamphlets

Bellevue, Count X. de, editor, Lettres inédits du peintre Girodet-Trioson, de Suvée, et du Général Gudin à Ange-René Ravault, peintre, graveur et lithographe de Montargis.

/Girodet/, La Critique des critiques du salon de l'an 1806, étrennes aux connaisseurs, Paris, F. Didot, 1806.

Girodet-Trioson, OEuvres posthumes, edited by P. A. Coupin, Paris, Renouard, 1829, 2 vols.

Lettre de Monsieur Boher, peintre et statuaire, et la réponse de Monsieur Girodet, peintre d'histoire et membre de l'Institut, Perpignan, Alzine.

Lettres adressées au baron François Gérard, edited by Henri Gérard, Paris, A Quantin, 1886, Vol. 1.

Quelques lettres extraites de la correspondance générale de Madame la Princesse Constance de Salm de 1805 à 1810, Paris, F Didot frères, 1841.

Recouvreur, A., Nos dessins, quelques dessins et deux lettres inédites de Girodet-Trioson, Angers, Editions de l'Ouest, 1935.

Periodicals

Girodet, "Essai poétique sur l'école française," Mercure de France, August 29, 1807.

Girodet, "Lettre aux rédacteurs," Journal de Paris, September 21, 1806.

Pommier, "Notes sur des manuscrits et lettres autographes du peintre Girodet," Bulletin historique et philosophique du Comité des travaux historiques et scientifiques, Paris, Imprimerie Nationale, 1908.

PUBLICATIONS IN WHICH GIRODET IS DISCUSSED
OR MENTIONED

Manuscript

Candeille, Julie, Letters to Girodet-Trioson, Montargis,
Filleul Collection.

Books and Pamphlets

Arlequin au Museum ou Critique des tableaux en vaudevilles,
no. 3, Paris, Marchant, 1802.

Arnault, A. V., Souvenirs d'un sexagénaire, Paris, Garnier,
Vol. 2.

Balzac, Honoré de, L'OEuvre de Balzac, La Maison du chat qui
pelote, Sarrasine, Les Editions du Vert-Logis.

Baudelaire, Charles, Curiosités esthétiques, Le Musée clas-
sique du Bazar Bonne Nouvelle, Paris, Conard, 1923.

Beaucamp, Fernand, Le Peintre lillois Jean-Baptiste Wicar,
Lille, E. Raoust, 1939, Vol. 1.

Benoit, François, L'Art francais sous la Révolution et l'Em-
pire, Paris, Henry May, 1897.

Bouilly, J. N., Mes Récapitulations, Paris, Louis Janet, Vol. 3.

Brainne, C., Debarbouiller, J., et Lapierre, Ch. F., Les Hommes
illustres de l'Orléanais, Biographie générale des trois
départements Loiret, Eure-et-Loir et Loir-et-Cher, Orléans,
A. Gatinau, 1852, Vol. 1.

Bruun Neergaard, Sur la situation des Beaux-Arts en France,
ou Lettre d'un danois à son ami, Paris, Dupont, 1801.

Le Château de Compiègne, Paris, Editions des musées nationaux,
1950.

Chateaubriand, François Auguste René, vicomte de, OEuvres com-
plètes, Les Martyrs, Table analytique et raisonnée, Paris,
Garnier, Vols. 4 and 12.

/Chaussard, Pierre Jean-Baptiste7, Le Pausanias français:
état des arts du dessin en France à l'ouverture du XIXe
siècle; Salon de 1806, Paris, Buisson, 1806.

Correspondance de François Gérard, edited by Henri Gérard,
Paris, Laine et Havard, 1867.

David, J. L. Jules, Le Peintre Louis David: Souvenirs et
documents inédits, Paris, Havard, 1880, 2 vols.

Delacroix, Eugène, Journal, Paris, Plon, 1950, Vol. 1.

Delécluze, E. J., Louis David, son école et son temps, Paris,
Didier, 1855.

Delestre, J. B., Gros et ses ouvrages, Paris, Labitte, 1845.

Examen critique et raisonné des tableaux des peintre vivans
formant l'exposition de 1808, Paris, Veuve Hocquart, 1808.

Explication des ouvrages de peinture et de dessins, sculp-
ture, architecture, et gravures des artistes vivans, ex-
posées au Musée central des Arts, Paris, Imprimerie des
Sciences et Arts, An VIII (1800).

Explication par ordre des numéros et jugement motivé des
ouvrages de peinture, sculpture, architecture et gravure
exposés au Palais National des Arts, Paris, Jansen, Col-
lection Deloynes,* Vol. XVIII, no. 458.

Exposition des ouvrages de peinture, sculpture, architecture,
et gravure des artistes vivans (A...Z), Collection De-
loynes, Vol. XLIV, no. 1146, manuscript.

Exposition des tableaux en 1808 -- A.P., Collection Deloynes,
Vol. XLIV, no. 1145, manuscript.

Galerie du Musée de France, edited by Filhol, Paris, Veuve
Filhol, 1828, Vol. XI, sixième livraison.

Goncourt, Edmond et Jules de, Histoire de la société fran-
çaise pendant le Directoire, Paris, Flammarion/Fasquelle,
1928.

Jacoubet, Henri, Le Genre troubadour et les origines fran-
çaises du Romantisme, Paris, Les Belles Lettres, 1929.

* Collection de pièces sur les beaux-arts imprimées et manu-
scrits recueillis par Pierre Jean Mariette, Charles Nicolas
Cochin et M. Deloynes, known as Collection Deloynes, Paris,
Bibliothèque Nationale, Cabinet des Estampes.

Jal, Gustave, L'Ombre de Diderot et le bossu du Marais, Paris, Coréard, 1819.

Kératry, Annuaire de l'école française de peinture, ou Lettres sur le Salon de 1819, Paris, Maradan.

Landon, C. P., Annales du muséeset de l'école moderne des Beaux-Arts, Paris, Landon, 1807, Vol. XIII.

_____, Salon de 1808, Annales du Musée, Paris, Landon, Vol. I.

_____, Salon de 1808, Annales du musée et de l'école moderne des Beaux-Arts, Paris, Imprimerie des Annales du Musée, 1808, 2 vols.

_____, Salon de 1819, Paris, Imprimerie Royale, 1820, Vol. II.

_____, Salon de 1822, Annales du Musée, Paris, Landon, Vol. II.

_____, Salon de 1824, Annales du Musée, Paris, Landon.

Le Breton, Rapport sur les Beaux-Arts, Paris, 1808.

Leroy, A., Girodet-Trioson, peintre d'histoire, Orléans, H. Herluison, 1892.

Marmottan, Paul, Le Peintre Louis Boilly, Paris, Gateau, 1913.

Mauricheau-Beaupré, C., Versailles, l'histoire et l'art, Guide officiel, Paris, Éditions des musées nationaux, 1949.

Musée Magnin, Dijon, Jobard, 1938.

Noël, François, Dictionnaire de la fable, Paris, Le Normant, 1803, 2 vols.

Observations sur le salon de l'an 1808, no. 12: Tableaux d'histoire, Paris, Veuve Gueffier et Delauney, 1808, Collection Deloynes, Vol. XLIII, no. 1139.

Percier et Fontaine, Recueil de décorations intérieures, Paris, Les Auteurs, 1812.

Polyscope, Quatrième lettre sur les ouvrages de peinture, sculpture, etc., exposés dans le grand salon du museum, Collection Deloynes, Vol. XVIII, no. 474, manuscript.

"Portrait de la Citoyenne M. Simons, née Lange," Explication
des ouvrages de peinture, dessins, sculpture, architecture
et gravure des artistes vivans, exposés au Museum central
des Arts, 1er Fructidor, An.VII, Paris, Imprimerie des
Sciences et Arts, An VII.

Première journée d'Cadet Buteux au Salon de 1808, Paris,
Aubry, 1808.

Quatremère de Quincy, Recueil de notices historiques, Paris,
Paris, Adrien Le Clère, 1834.

Recouvreur, Jules, Histoire de l'art pendant la Révolution
considerée principalement dans les estampes, Paris, Veuve
Jules Renouard, 1863.

Rosenthal, Léon, La Peinture romantique, Paris, Henry May,
1900.

Salm, Madame la Princesse Constance de, OEuvres complètes,
Paris, F. Didot, 1842, 4 vols.

Saunier, Charles, La Peinture au XIXe siècle, Paris, Larousse.

Stendhal, Mélanges d'art et de littérature, Paris, Calmann-
Lévy, 1927.

_____, Histoire de la peinture en Italie, Paris, Le
Divan, 1929, 2 vols.

_____, Journal, Paris, Le Divan, 1937, Vol. 4.

Stenger, Gilbert, La Société française pendant le Consulat;
5e serie: Les Beaux-Arts, La Gastronomie, Paris, Perrin

Valenciennes, P. H., Elémens de perspective pratique à l'usage
des artistes, suivis de réflexions et conseils à un élève
sur la peinture et particulièrement sur le genre du paysage,
Paris, A. Payen, 1820 (first edition 1801).

Valori, Marquis de, Sur la mort de Girodet, Paris, A. Boucher.

Van Tieghem, Paul, Ossian en France, Paris, Rieder et Cie.,
1917, 2 vols.

Voisin, Catalogue, Montargis, Imprimerie du Loing, 1937, 4e
édition.

Periodicals

Adhémar, Jean, "L'Enseignement académique en 1820 -- Girodet et son atelier," Bulletin de la société de l'histoire et de l'art français, IIᵉ fascicule, Paris, 1934.

_____, "Girodet un fou," Arts, J I 3, 1936.

Antal, Friedrich, "Reflections on Classicism and Romanticism," The Burlington Magazine, Vol. lxviii, no. CCCXCVI, March 1936.

Archives de l'art français, 2eme série, I, 1879.

Arnauldet, T., "Estampes satiriques relatives à l'art et aux artistes français pendant les XVIIᵉ et XVIIIᵉ siècles," Gazette des Beaux-Arts, Vol. 4, 1859.

Les Arts, no. 55, July 1906.

"Beaux-Arts, Musée central des Arts," Mercure de France, Collection Deloynes, Vol. XXI, no. 505.

"Beaux-Arts, Salon de 1819 -- no. VIII," Journal des Débats, Feuilleton, November 6, 1819.

Boutard, "Beaux-Arts, Salon de 1814 -- no. I," Journal des Débats, November 6, 1814.

_____, "Beaux-Arts, Salon de 1814 -- no. VI," Journal des Débats, Feuilleton, December 3, 1814.

Bruel, François-Louis, "Girodet et les Dames Robert," Bulletin de la société de l'histoire de l'art français, Ier fascicule, Paris, 1912.

Chaussard, C., "Exposition des ouvrages de peintures, sculptures, architecture, gravures," tirée de La Décadaire, 1798, Collection Deloynes, Vol. XX, no. 539, manuscript.

_____, "Exposition des ouvrages de peinture, sculpture, architecture, gravure, dessins, modèles composés par les artistes vivans et exposés dans le salon du Musée central des Arts," Journal de la Décade, 1799, Collection Deloynes, Vol. XXI, no. 580, manuscript.

"Exposition au salon du Palais National des ouvrages de peinture, sculpture et gravure," Petites Affiches de Paris, Collection Deloynes, Vol. XVIII, no. 459, manuscript.

"Exposition de peintures, sculptures, architecture, gravures, et dessins," Journal d'Indications, 1798, Collection Deloynes, Vol. XX, no. 541, manuscript.

"Exposition des ouvrages de peinture, sculpture, gravure, architecture, composés par les artistes vivans," Journal du bulletin universel des Sciences, des Lettres et des Arts, Collection Deloynes, Vol. XXIII, no. 634, manuscript.

"Exposition des peintre vivans commencée le 19 juillet 1798," Mercure de France, Collection Deloynes, Vol. XX, no. 538, manuscript.

François peintre, "Exposition du salon de peinture," Journal du Mois, 1799, Collection Deloynes, Vol. XXI, no. 581, manuscript.

Journal des Arts, 1802, Collection Deloynes, Vol. XXVIII, no. 761.

Journal des Débats, September 5, 1802.

Journal des Débats, October 17, 1802.

Journal des Débats, November 15, 1804.

Journal des Débats, November 5, 1819.

Journal des Débats, Feuilleton, November 6 and 8, 1819.

Lemonnier, Henry, "L'Atala de Chateaubriand et l'Atala de Girodet," Gazette des Beaux-Arts, 4e période, Vol. 11, May 1914.

"Précis historique de ce qui s'est passé au sujet du portrait de la Citoyenne Lange, femme Simons," Journal des Arts, Marant, 1799, Collection Deloynes, Vol. XXI, no. 584, manuscript.

Le Publiciste, Feuilleton, October 14, 22, and 27, 1806.

"Salon de l'an X," Journal des Débats, October 1, 1802.

"Salon de l'an XII -- no. IX," Journal des Débats, November 15, 1804.

"Salon de l'an 1806 -- no. III," Journal des Débats, September 27, 1806.

"Salon de 1808," Journal de l'Architecture, des arts libéraux et mécaniques, des sciences et de l'industrie, Collection Deloynes, Vol. XLV, no. 1157.

"Second précis historique au sujet du portrait de Madame Simons," _Journal des Arts_, 1799, Collection Deloynes, Vol. XXI, no. 585, manuscript.

Stein, Henri, "Girodet-Trioson, peintre officiel de Napoléon," _Annales de la société historique et archéologique du Gâtinais_, Fontainebleau, 1907, Vol. 25.

"Tableaux commandés pour le gouvernement," _Journal de l'Empire_, Collection Deloynes, Vol. XLIII, no. 1126, manuscript.

Vaillant, Léandre, "Le Château de Coppet," _L'Art et les Artistes_, Vol. XVII, April-September 1913.

Vigny, Alfred de, "La Beauté idéale, aux mânes de Girodet," _Mercure de France au XIXe siècle_, 1825, Vol. XI.

OTHER WORKS USED IN THIS THESIS

Books and Pamphlets

Abry, E., Audic, C., et Crouzet, P., _Histoire illustrée de la littérature française_, Paris, Didier, 1931.

Aeschylus, _The Seven Against Thebes_, translated by T. G. Tucker, Cambridge University Press, 1908.

L'Ami des artistes au sallon, Supplément, précédé de quelques observations sur l'état des arts en Angleterre, Collection Deloynes, Vol. XV, no. 380.

Andrieux, OEuvres, _Les Nouveaux papillons_, Paris, Nepven, 1818, Vol. 3.

Annonce de l'arrivée à Paris de la femme hydropique de Gérard Dow, Collection Deloynes, Vol. XX, no. 551, manuscript.

Les Anti pitture delle terme di Tito, no. 24.

Arlequin au Museum ou Critique des tableaux en vaudevilles, no. 1, Paris, Marchant, 1802.

Arlequin au Museum ou Des tableaux en vaudevilles, Paris, Clairvoyant, Collection Deloynes, Vol. XXI, no. 561.

Bergerus, L., _Thesaurus ex Thesauro Palatino Selectus_, Heidelberg, P. Delborn, 1685.

Bourienne, L. A. F. de, Memoirs of Napoleon Bonaparte, edited by R. W. Phipps, New York, Scribner, 1891, Vol. I.

Cabanis, OEuvres complètes, Paris, F. Didot, 1824, Vol. 3.

Cenini, Iconografia, Rome, 1669.

Challamel, Augustin, Histoire -- Musée de la République française, Paris, Challamel, 1842, 2 vols.

Chateaubriand, François Auguste René, vicomte de, OEuvres complètes, Atala, Paris, Garnier, Vol. 3.

Chesnau, Georges, Les OEuvres de David d'Angers, Catalogue, Angers, Imprimerie Centrale, 1934.

Condillac, Traité des sensations, Londres et Paris, Chez de Bure l'aîné, 1754, Vol. I.

Corneille, Pierre, Horace, Classiques illustrés Vaubourdolle, Paris, Hachette, 1935.

De l'Aulnay, De la saltation théatrale ou Recherches sur l'origine, les progrès, et les effets de la pantomime chez les anciens, Paris, Barrois, 1790.

Delille, Jacques, OEuvres, Paris, Lefèvre, 1844, 2 vols.

Description des ouvrages de peinture, sculpture, architecture et gravures, exposés au sallon du Louvre le 10 Août 1793, Paris, Hérissant.

Descriptions des ouvrages de peinture, sculpture, architecture et gravures, exposés au sallon du Louvre le 10 Août 1793, Supplément, Paris, Hérissant.

Dimier, Louis, Histoire de la peinture française du retour de Vouet à la mort de Lebrun, Paris et Bruxelles, G. Vanoest, 1926, Vol. I.

Dionysius of Halicarnassus, The Roman Antiquities, The Loeb Classical Library edition, translated by Earnest Cary, Cambridge, Mass., Harvard University Press, London, Heinemann, 1937-1945, Vols. 1 and 2.

Dupuis, Origine de tous les cultes ou Réligion universelle, Paris, Rosier, 1835, Vols. 3, 4 and 7.

Encore un coup de patte, pour le dernier, ou Dialogue sur le Salon de 1787, 1er partie, Collection Deloynes, Vol. XV, no. 378.

Entretien entre un amateur et une admiratrice sur les tableaux exposés au sallon du Louvre de l'année 1789, Collection Deloynes, Vol. XVI, no. 412.

Explication des ouvrages de peinture et dessins, sculpture, architecture et gravure des artistes vivans, exposés au Museum central des Arts, Paris, Imprimerie des Sciences et Arts, An IX (1801).

Explication des ouvrages de peinture et dessins, sculpture, architecture et gravures, exposés au Musée central des Arts, Paris, Imprimerie des Sciences et Arts, An VI (1798)

Explication des ouvrages de peinture, sculpture, architecture, gravures, dessins, modèles, etc., exposés dans le grand salon du Musée central des Arts, Paris, Imprimerie des Sciences et Arts, An V (1796).

Explication des peintures, sculptures et gravures de messieurs de l'Académie royale, Paris, 1791, Collection Deloynes, Vol. XVII, no. 432.

Explication des ouvrages de peinture, sculpture, architecture, gravures, dessins, modèles, etc....exposés dans le grand sallon du Museum au Louvre au mois de Vendémiaire, An IV, Paris, Hérissant.

Le Frondeur ou Dialogue sur le sallon par l'auteur du Coup-de-Patte et du Triumvirat, 1785, Collection Deloynes, Vol. XIV, no. 329.

Gessner, Salomon, OEuvres, Dufart, 2 vols.

Gillet, Louis, La Peinture au musée du Louvre, Paris, L'Illustration, 1929, Vol. 1.

Goncourt, Edmond et Jules de, L'Art du XVIIIme siècle, Paris, Bibliothèque-Charpentier, E Fasquelle, 1914, 3 vols.

Gorlaeus, Abraham, Dactyliothecae, Lugdini Batavorum, Petrus Vander Bibliop:, 1695, 2 vols.

Horace, The Complete Works, edited by Rhys, London, Dent and Sons, New York, Dutton and Co.

Landon, C. P., Annales du musée et de l'école moderne des Beaux-Arts, Paris, Landon.
 1801 -- Vol. I.
 1802 -- Vol. III.
 1803 -- Vol. V.

Lavater, John G., Essai sur la physiognomie destiné à faire connoître l'homme et à le faire aimer, translated by La Fite, Caillard and Reufner, La Haye, 1781-1803, Vol. 1.

Lavater, John C., Essays on Physiognomy, translated by T. Holcroft, London, Blake, 1840.

Lebrun, Charles, Conférence sur l'expression générale et particulière des passions, Verone, Chez Augustin Carattoni, 1751.

Le Mercier, Observations sur cette exposition de dessins, Collection Deloynes, Vol. XIX, no. 505, manuscript.

Loroy, Alfred, Histoire de la peinture française au XVIIIe siècle, Paris, Albin Michel, 1934.

Lettres analytiques, critiques et philosophiques sur les tableaux du sallon, Paris, 1791, Collection Deloynes, Vol. XVIII, no. 441.

Livius, Titus, The History of Rome, translated by D. Spillan, New York, Harper and Brothers, 1889, Vol. 1.

Locquin, Jean, La Peinture d'histoire en France de 1747 à 1785, Paris, H. Laurens.

Lucian of Samosata, Works, Dialogues of the Gods, Oxford, Clarendon Press, 1905, Vol. 1.

Macpherson, James, Ossian fils de Fingal, poésies galliques, translated by Letourneur, Paris, Dentu, 1810, 2 vols.

Madame B. A R T. L. A. D. C. S., Avis important d'une femme sur le Sallon de 1785, Collection Deloynes, Vol. XIV, no. 344.

Mâle, Emile, L'Art religieux de la fin du XVIe siècle, du XVIIe siècle et du XVIIIe siècle, Paris, Armand Colin, 1951.

Mantzius, K., A History of Theatrical Art, translated by Archer, New York, Peter Smith, 1937, Vol. 6.

Maréchal, P. S., Antiquités d'Herculanum, Paris, F A. David, 1780, Vols. 3 and 4.

Martial, Epigrams, London, Bell and Sons, 1890, Book 14.

Matter, M. J., Saint-Martin le philosophe inconnu, Paris, Didier, 1862.

Michaud, Biographie universelle, ancienne et moderne, Paris, Chez Delagrave, Vols. 6 and 23.

Michel, André, Histoire de l'art, Paris, Armand Colin, 1905-1929, Vol. 6, 1re partie, Vol. 8, 1re partie.

Molière, OEuvres, Les Femmes savantes, Paris, F Didot, 1860, Vol. 2.

Monglond, André, Le Préromantisme français, Grenoble, Arthaud, 1930, 2 vols.

Monsieur l'A. P., L'Ami des artistes au salon, Paris, Esclapart, 1787.

Monsieur Rob...., Exposition publique des ouvrages des artistes vivans, dans le salon du Louvre. 1795, Collection Deloynes, Vol. XVIII, no. 469, manuscript.

Montabert, Paillot de, Traité complet de la peinture, Paris, Bossange, 1829, Vol. 5.

Montfaucon, Bernard de, L'Antiquité expliquée et représentée en figures, Paris, F Delaulne, 1722, Vol. 1.

Notice des dessins originaux, Cartons, gouaches, pastels, émaux et aussi miniatures au Musée central des Arts, 1ere partie, Paris, Imprimerie des Sciences et Arts, An V (1797).

Notice des tableaux des écoles françaises et flamandes exposés dans la grande gallerie du Musée central des Arts, Paris, Imprimerie des Sciences et Arts, An VII (1799).

Noverre, Jean Georges, Les Horaces, ballet-tragique, Paris, Delormel, 1777.

_____, lettres sur les arts imitateurs en général et sur la danse en particulier, Paris, Colin, Le Haie, Immerzeel, 1807.

_____, Lettres sur la danse et sur les ballets, Stutgard et Lyon, Chez Aimé Delaroche, 1760.

Observations critiques sur les tableaux du Sallon de l'année 1789, Paris, 1789, Collection Deloynes, Vol. XVI, no. 410.

Ovid, Metamorphoses, The Loeb Classical Library edition, translated by Frank Justus Miller, London, Heinemann, New York, G. P. Putnam's Sons, 1926, Vol. II, Book X.

Panofsky, Irwin, Albrecht Dürer, Princeton, Princeton University Press, 1945, 2 vols.

Petit de Julleville, L., Histoire de la langue et de la littérature française des origines à 1900, Paris, Armand Colin, 1899, Vol. 7.

Pinel, P., Nesographie philosophique ou La Méthode de l'analyse appliquée à la modedne, Paris, Maradan, An VI, Vol. 2.

Plutarch, Lives, The Loeb Classical Library edition, translated by Bernadotte Perrin, New York, G. P. Putnam's Sons, 1914, Vol. 1.

Quatremère de Quincy, Essai sur la nature le but et les moyens de l'imitation dans les Beaux-Arts, Paris, Strasbourg et Londres, Treuttel et Würtz, 1823.

Racine, Jean, OEuvres complètes, "Première préface de Britannicus," Paris, Hachette, 1856, Vol. 1.

Réflexions impartiales sur les progrès de l'art en France et sur les tableaux exposés au Louvre, Londres et Paris, 1785.

Reinach, S., Répertoire de la statuaire grecque et romaine, Paris, E Leroux, 1897, Vol. 1.

_____, Répertoire de peintures grecques et romaines, Paris, E Leroux, 1922.

_____, Répertoire de reliefs grecs et romains, Paris, E. Leroux, 1912. Vols. 2 and 3.

Réponse à cette observation de le Mercier /par un/ disciple de Lavater, Collection Deloynes, Vol. XIX, no. 506, manuscript.

Revue du Salon de l'an X ou Examen critique de tous les tableaux qui ont été exposés au museum, Paris, Surosne, An X, (1802).

Revue du Salon de l'an X ou Examen critique de tous les tableaux qui ont été exposés au museum, IIme Supplément, Paris, Surosne, An X (1802).

Robertson, E G., Mémoires récréatifs, scientifiques et anecdotiques, Paris, Würtz, 1831, 2 vols.

Rocheblave, S., Charles-Nicolas Cochin, Paris et Bruxelles, G Vanoest, 1927.

Rollin, Charles, Histoire romaine, Paris, Veuve Estienne et fils et Desaint et Saillant, 1752, Vol. 1.

Rousseau, Jean-Jacques, Emile ou De l'éducation, Paris, Garnier.

Saint-Marc, B., and Boubonne, Marquis de, Les Chroniques du Palais-Royal, Paris, Belin, 1881.

Saint-Pierre, Bernardin de, OEuvres complètes, Paul et Virginie, Paris, Mequignon-Marvis, 1818, Vol. VI.

Sigismundi Augusti Mantuam adventis perfectio ac. triumphus Iulij Romani in Ducali Palatio quod del T., Romae, typ. Iacobi de Rubeis, 1680.

Taylor, Francis Henry, The Taste of Angels, Boston, Little, Brown and Co., 1948.

Thiers, L. A., History of the Consulate and the Empire of France, translated by D Forbes Campbell and John Stebbing, London, Chatto and Windus, 1893, Vol. 4.

Tormo y Monzó, Elías, Aranjuez, Madrid.

Vérités agréables ou Le Salon vu en beau par l'auteur de Coup-de-Patte, Paris, Knapen fils, 1789.

Le Verre cassé de Boilly, et les croûtiers en déroute ou Mlle. critique des objets de peinture et sculpture. exposés au salon. en prose, en vaudeville et en vers, faisant suite à Gilles et Arlequin, Paris, An IX, Collection Deloynes, Vol. XXI, no. 625.

Viatte, Auguste, Les Sources occultes du Romantisme, Paris, Champion, 1928, 2 vols.

Vieil de Saint-Mart, Observations philosophiques sur l'usage d'exposer les ouvrages de peinture et de sculpture. A Madame la Baronne de Vasse, La Haye, Bluet, 1785.

Vigny, Alfred de, OEuvres complètes, Correspondance, Paris, Louis Conard, 1923, Vol. 1.

_____, Poèmes antiques et modernes, Paris, Bourdilliat et Cie., 1859.

Virgil, Eclogues, The Loeb Classical Library edition, translated by H R. Fairclough, London, Heinemann, New York, G P Putnam's Sons, Vol. 1.

Willemin, Nicolas Xavier, Choix de costumes civils et militaires, 1798.

_____, Monuments francais inédits pour servir à l'histoire des arts depuis de VIeme siècle jusqu'qu commencement du XVIIIe, Paris, Chez Mademoiselle Willemin, 1839, 2 vols.

Winckelmann, Johann Joachim, Histoire de l'art de l'antiquité, translated by Hubert Leipzig, Brietkopf, 1781, 3 vols.

Periodicals

Bonaparte, "Message des consuls au corps législatif et au Tribunat," Mercure de France, 1er Ventôse, An IX.

"De l'exposition de 1791 en général et particulièrement de celle des tableaux déjà connus par les précédentes expositions," Chronique de Paris, Collection Deloynes, Vol. XVII, no. 452, manuscript.

Esménard, "Stances," Mercure de France, 1er Ventôse, An IX.

_____, "Chant du premier Vendémiaire," Mercure de France, 1er Vendémiaire, An IX (September 23, 1800).

"Exposition des peintures, sculptures, dessins, architecture et gravures exposés au salon du Louvre," Journal de Paris, 1799, Collection Deloynes, Vol. XXI, no. 581, manuscript.

Fare, Michel, "L'Hôtel de Beauharnais," Art et Industrie, Vol. 3, April 1946.

Journal de Paris, 28 Brumaire, An VII, and 18 Nivôse, An VII.

Journal de Paris, 2 Germinal, An VIII.

Journal des Débats, 1er Ventôse, An VIII.

Mercure de France, 16 Prairial, 1er Messidor, An IX.

Mercure de France, 1er Ventôse, 16 Ventôse, An IX.

"Observations contenues dans L'Année Littéraire, Collection Deloynes, Vol. XVI, no. 422, manuscript.

Parny, "A la nuit," Journal de Paris, 16 Vendémiaire, An XII, (October 9, 1803).

Reuterswärd, Oscar, "The 'Violettomania' of the Impressionists, The Journal of Aesthetics and Art Criticism, Vol. IX, no. 2, December 1950.

Rousseau, Theodore, "A Boy Blowing Bubbles by Chardin," The Metropolitan Museum of Art Bulletin, Vol. 8, no. 8, April 1950.

"Salon de 1802," Journal des Débats, Collection Deloynes, Vol. XXVIII, no. 778, manuscript.

Wind, Edgar, "The Sources of David's 'Horaces,'", Journal of the Warburg and Courtauld Institutes, 1941-1942, Vol. 4, nos. 3 and 4, April-July.

ILLUSTRATIONS

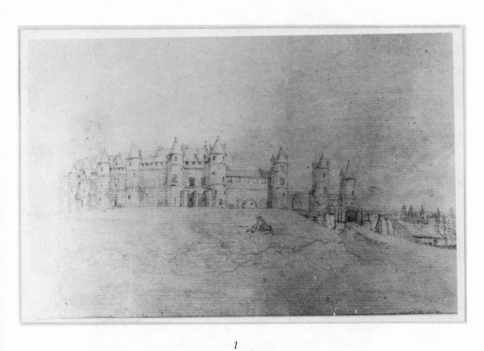

1

2

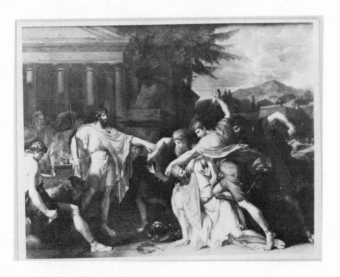

3

4

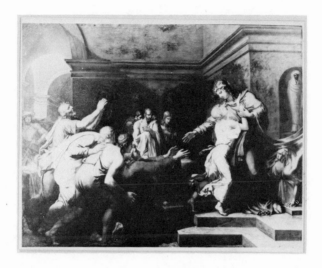

5

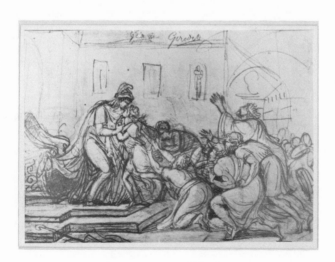

6

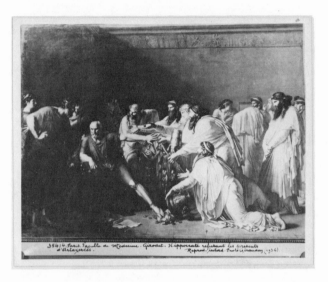

7

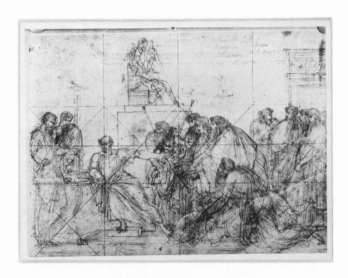

8

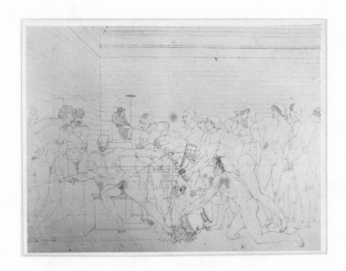

9

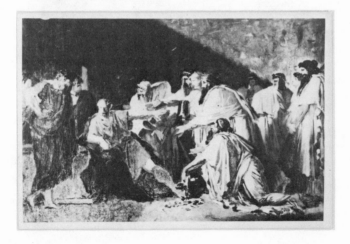

10

11

12

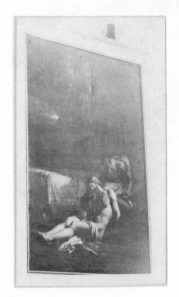

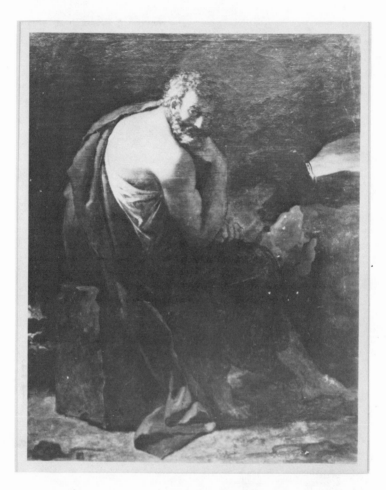

13

14

15

16

17

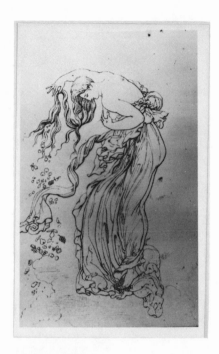

18

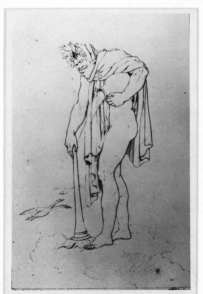

19

20

21

22

23

24

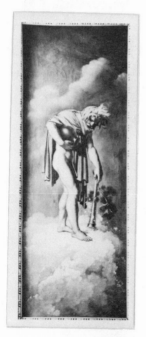

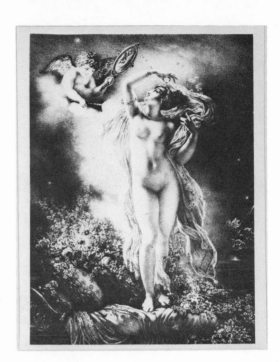

25

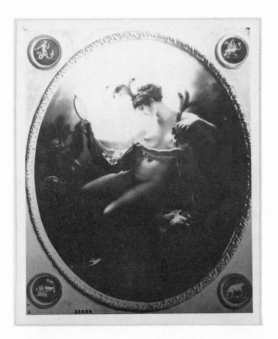

26

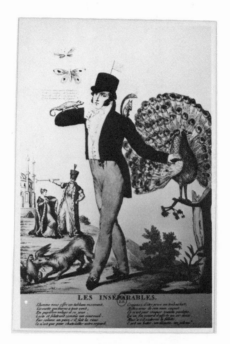

27

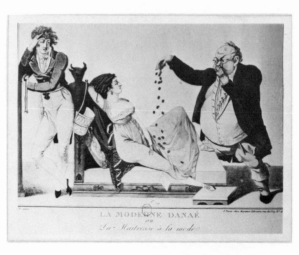

28

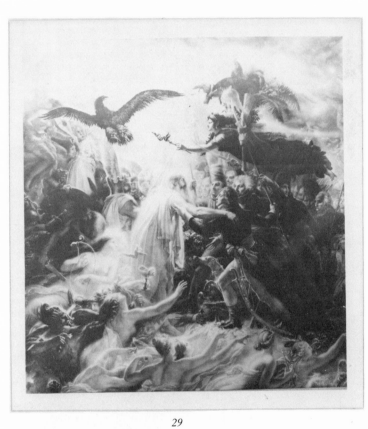

30

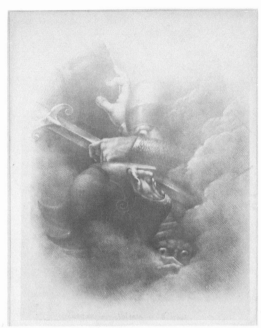

31

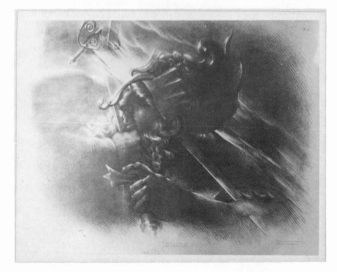

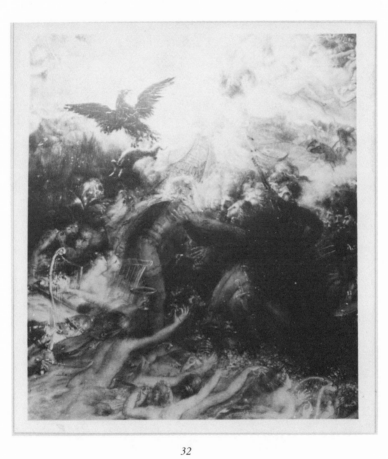

32

33

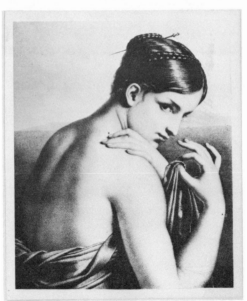

34

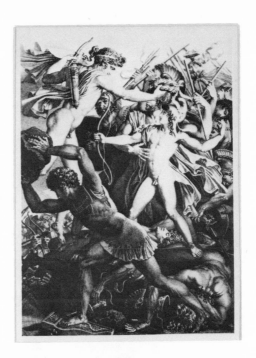

35

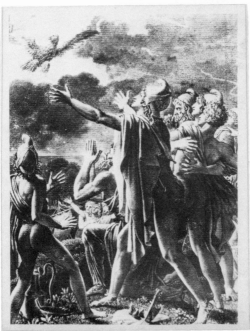

36

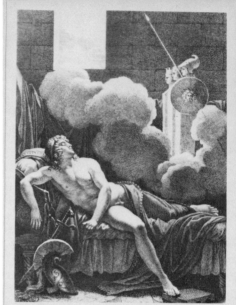

37

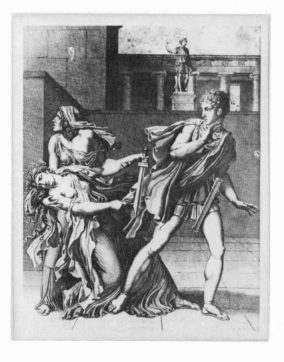

38

39

40

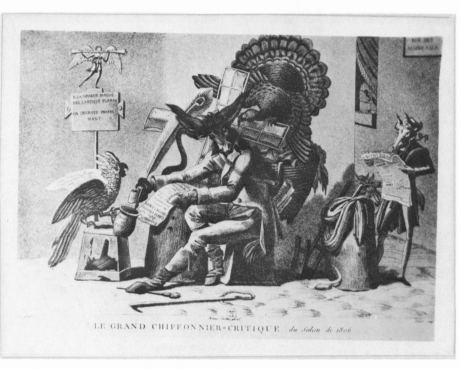

LE GRAND CHIFFONNIER-CRITIQUE *du Salon de 1806*

41

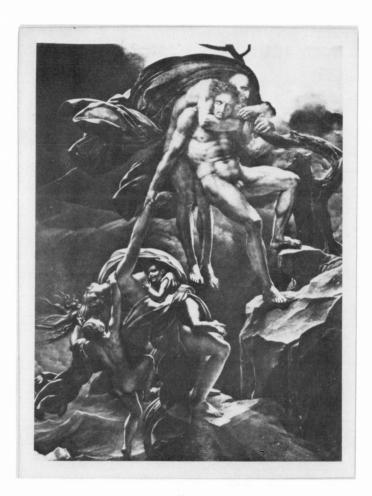

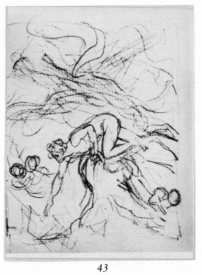

43

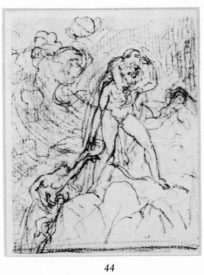

44

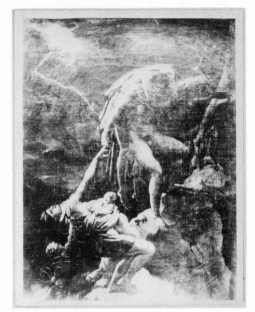

45

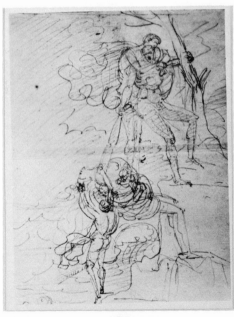

46

47

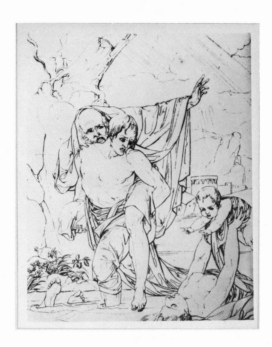

48

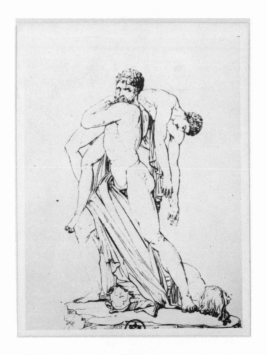

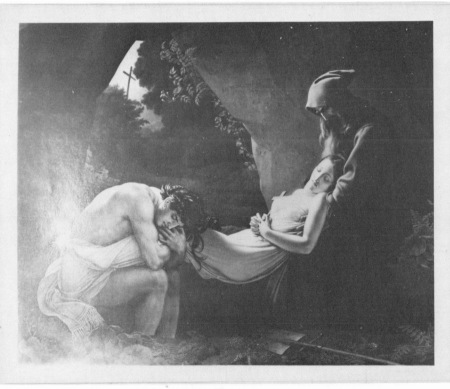

49

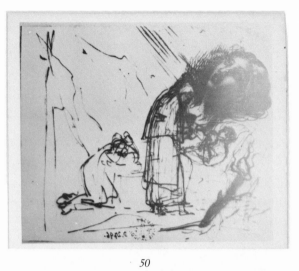

50

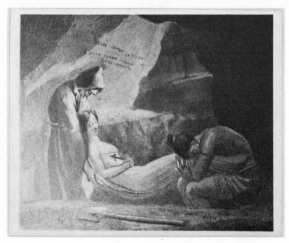

51

52

53

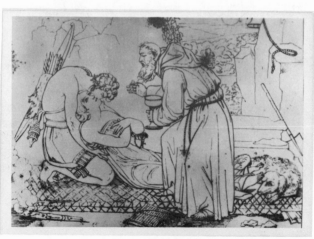

54

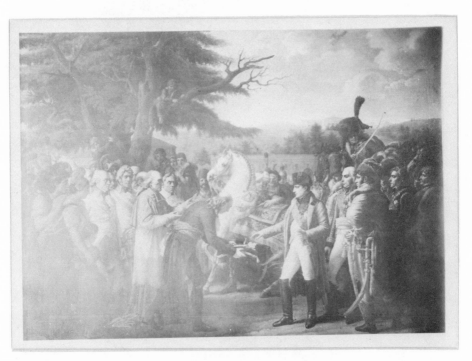

55

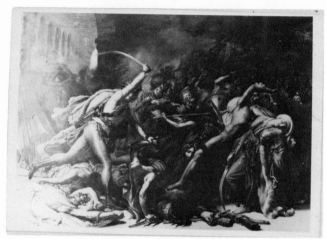

56

57

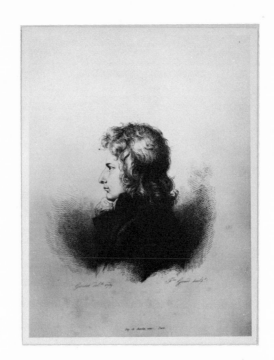

58

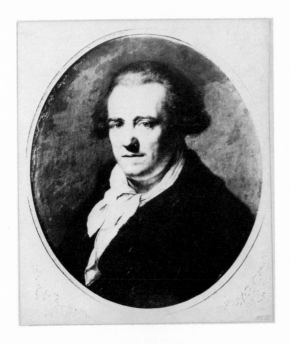

59

60

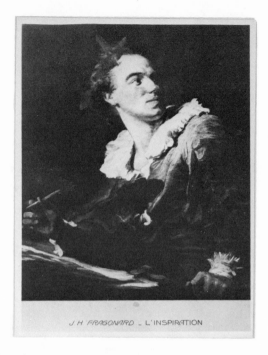

J. H. FRAGONARD _ L'INSPIRATION

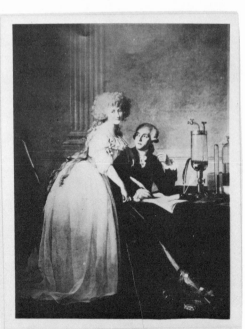

61

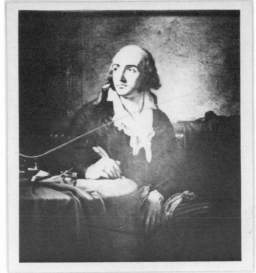

62

63

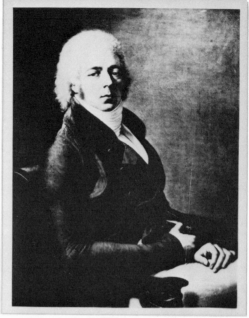

64

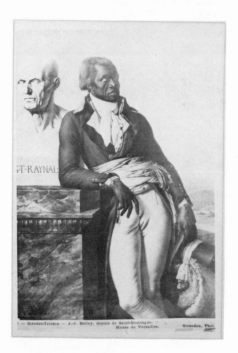

65

1 — Girodet-Trioson — J.-J. Belley, député de Saint-Domingue.
Musée de Versailles. Giraudon, Phot.

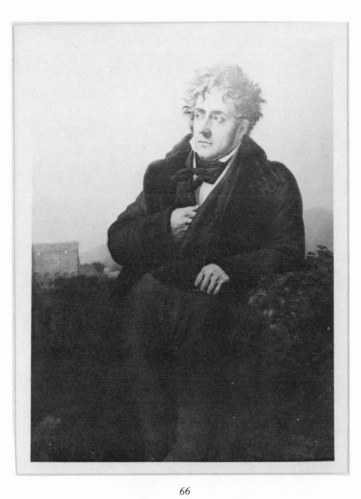

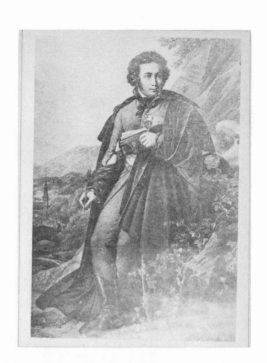

67

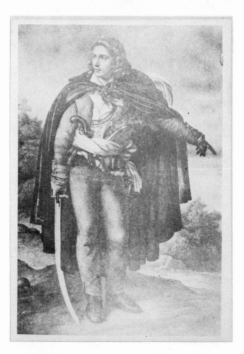

68

69

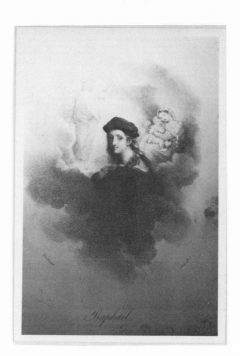

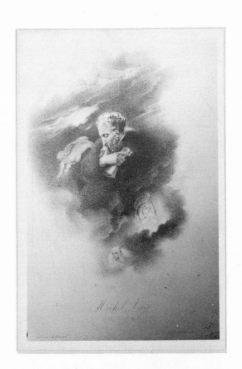

70

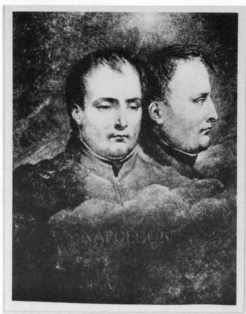

71

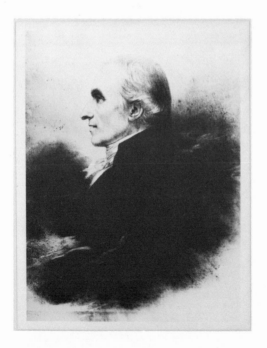

72

73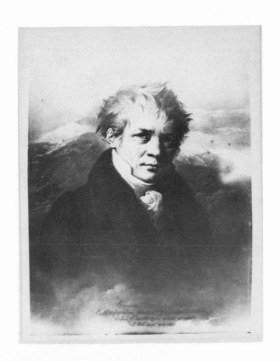

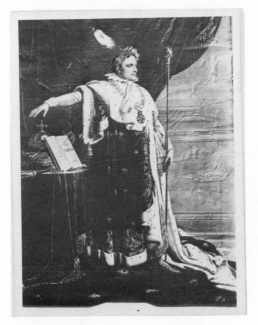 74

75

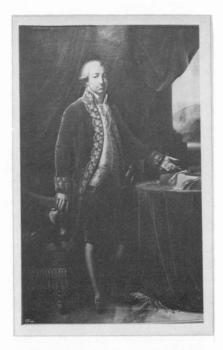

76

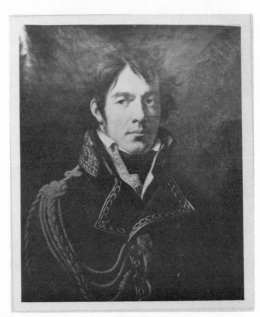

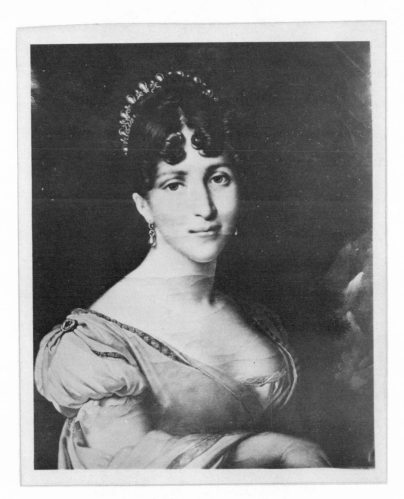

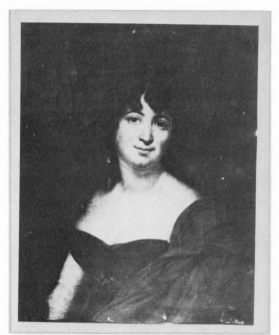

78

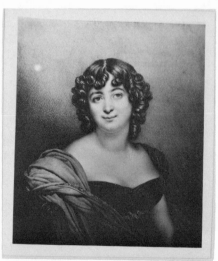

79

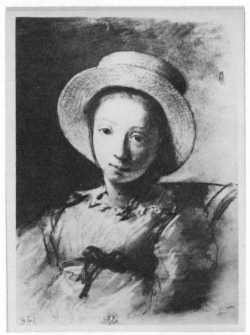

80

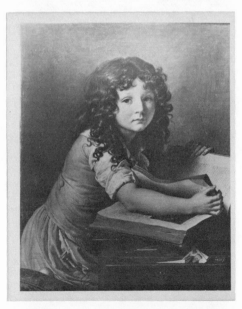

81

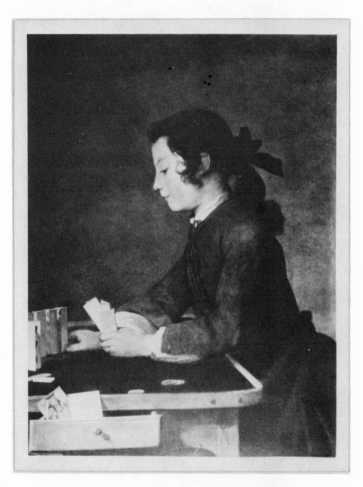

83

84

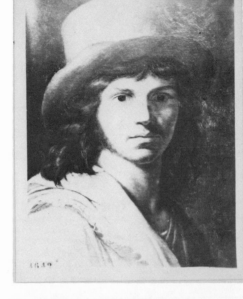

85

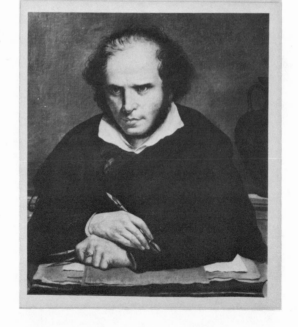

86

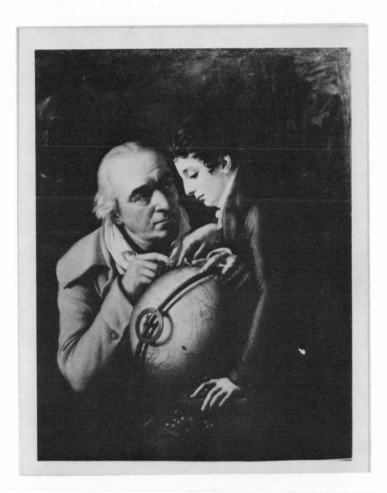

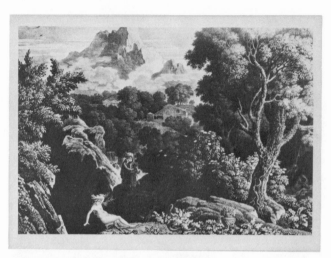

88

89

90

91

92

93

94

95

96

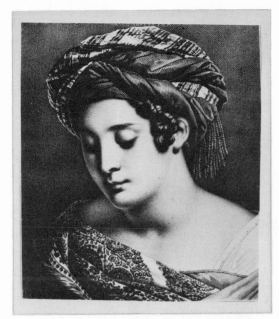

97

98

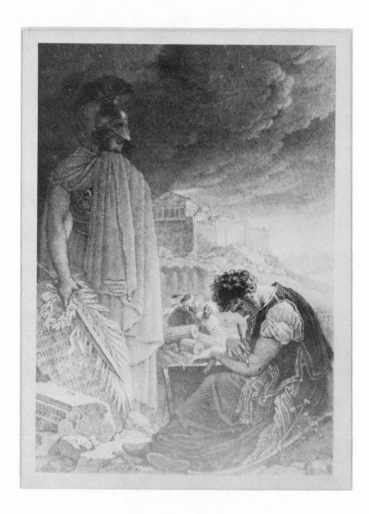

99

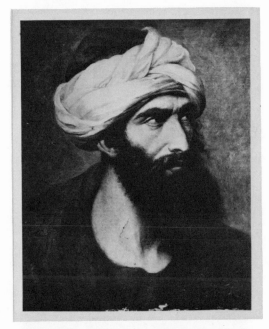

100

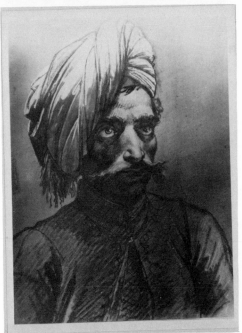

101

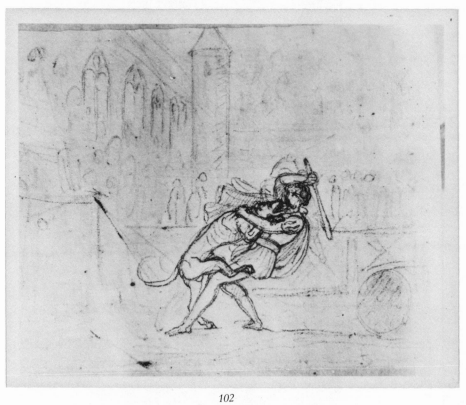

102

103

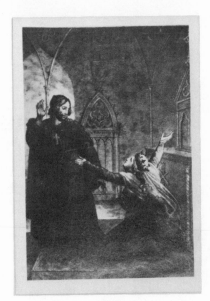

104

105

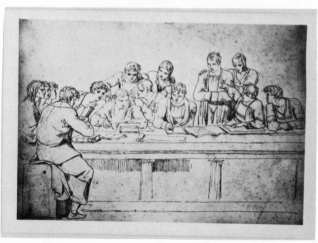

106

107

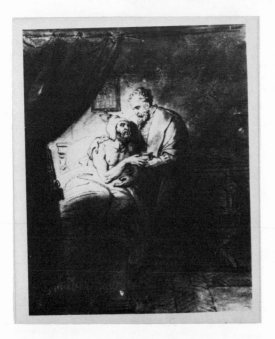

108

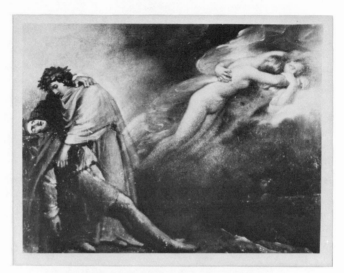

109

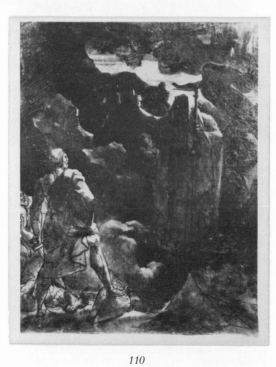

110

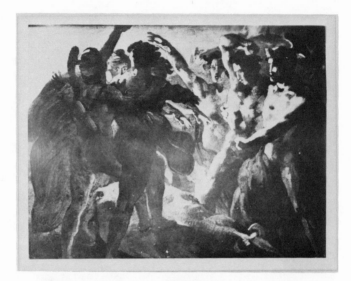

112

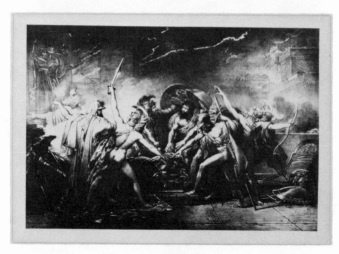

113

114

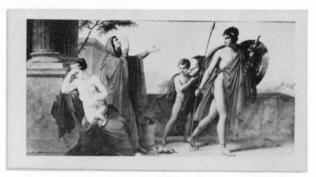

115

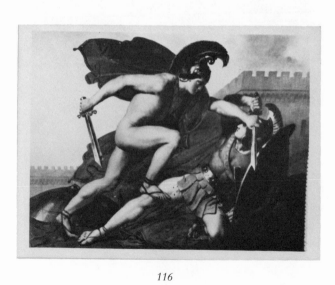

116

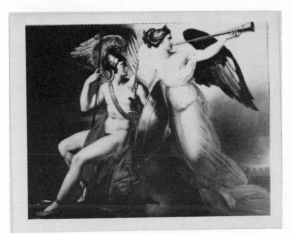

117

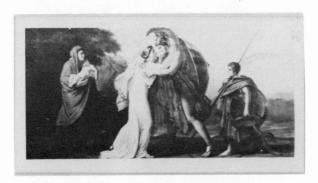

118

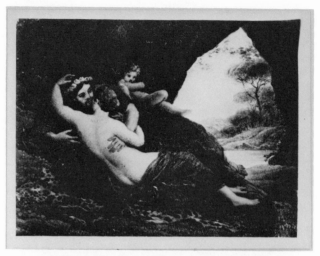

119

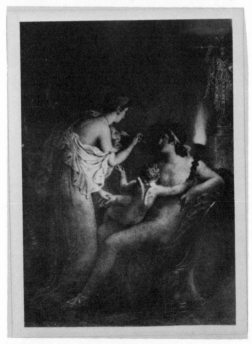

120

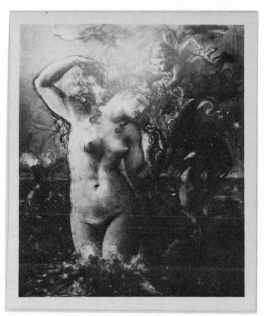

121

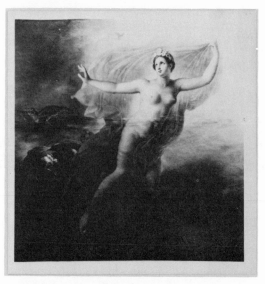

122

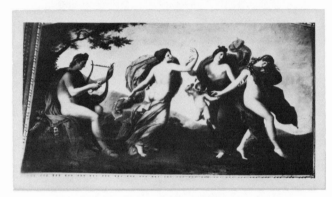

123

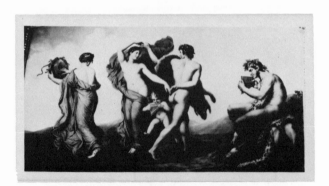

124

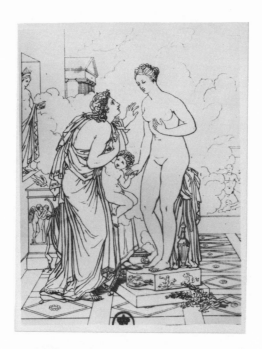

125

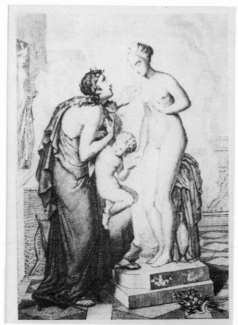

126

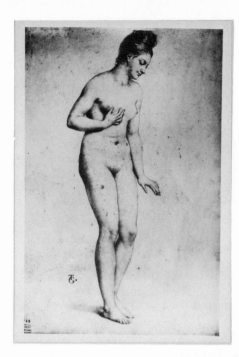

127

128

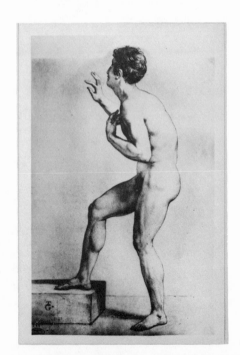

c'est à tort qu'on croyait qu'il prend les mouch...